SEXPLOSION

ALSO BY ROBERT HOFLER

*Party Animals: A Hollywood Tale of Sex, Drugs,
and Rock 'n' Roll Starring the Fabulous Allan Carr*

Variety's "The Movie That Changed My Life"

*The Man Who Invented Rock Hudson: The Pretty Boys and
Dirty Deals of Henry Willson*

SEXPL

FROM ANDY WARHOL TO
A CLOCKWORK ORANGE—HOW A
GENERATION OF POP REBELS
BROKE ALL THE TABOOS

OSION

Robert Hofler

itbooks

AN IMPRINT OF HARPERCOLLINS PUBLISHERS

FIRST EDITION

Designed by Renato Stanisic

Library of Congress Cataloging-in-Publication Data has been applied for.

ISBN 978-0-06-208834-5

14 15 16 17 18 OV/RRD 10 9 8 7 6 5 4 3 2 1

To Johnny and Louise

Contents

Preface

Sexplosion began as one of those decades books.

I'd worked as entertainment editor of *Penthouse* magazine for most of the 1970s, when publications like *Penthouse* and *Playboy* were each selling well over five million copies a month. It seemed like the sex life of America had exploded back then, and there were plenty of bestselling novels, manuals, movies, magazines, Broadway shows, and other cultural artifacts to support that hyperbole. If the 1980s were truly greedy and the 1920s actually roared, it seemed to me, in retrospect, that the 1970s were genuinely oversexed—and that this might warrant closer inspection in terms of its impact on our culture as a whole.

After visiting a few libraries to scour the microfilm files, and interviewing several writers, directors, actors, and producers, I was surprised to discover that research served me much better than memory. As a result, I decided instead to write about a slightly earlier period of history, one that did not conform nicely to any one decade but rather awkwardly straddled a couple of them. The years 1968 to 1973 coincided with what were my college years, as well as a whole generation of sex, drugs, and rock 'n' rollers who were the ideal audience for such seminal works as *Hair, Midnight*

Cowboy, Myra Breckinridge, Performance, Portnoy's Complaint, and many others.

Artists have been breaking sex taboos from the beginning of time, but probably no greater number of those totems to repression were smashed than in the year 1968. It was a veritable sexual explosion that continued and only slightly abated for the next four years, before repetition and exploitation diluted the creative pool. My college-age fantasy conjured up a world in which the writers and makers of everything from *The Boys in the Band* to *Bob & Carol & Ted & Alice* were somehow connected and actually formed a community. Writing this book, I was delighted to learn how true my youthful conjectures were and, better yet, how current and genuinely adult most of those artists' creative output during that time remains nearly half a century later.

Sexplosion is the story of how a number of very talented, risk-taking rebels challenged the world's prevailing attitudes toward sex, and, in the process, changed pop culture forever.

1966 and 1967, Caution

It was the artists. But it was also the audiences.

In 1966, director John Huston picked the plum role of Noah for himself and turned his movie *The Bible* into the highest-grossing film of the year. Also in 1966, most critics' groups drank from the same pool of holy water and anointed *A Man for All Seasons*, the story of Sir Thomas More, a Roman Catholic saint, as that year's best film.

The Bible and *A Man for All Seasons* may have been highly respected efforts but they hardly generated the most heated talk or press. That distinction of high-profile controversy went to two very different films in 1966: *Who's Afraid of Virginia Woolf?*, in which erstwhile paramours Elizabeth Taylor and Richard Burton talked dirty to each other, and Michelangelo Antonioni's first English-language picture, *Blow-Up*. Moviegoers who didn't know *L'avventura* from *L'eclisse* would sit through nearly two hours of *Blow-Up*, a murder mystery in which the murder is never solved, to get a two-second glimpse of a young woman's pubic hair, delivered in long shot, as she and a girlfriend frolic nude with star David Hemmings in a photographer's studio.

The audiences were, indeed, different then. They were curious because they had seen and heard so little with regard to graphic sex

onscreen, and even more important, they were patient. And they were patient because they were hungry for what they hadn't seen or heard.

Somewhat less patient was an especially acerbic twenty-nine-year-old Texan émigré named Rex Reed, who had only recently been enlisted as a freelance writer at the *New York Times*. Despite his intense antipathy for Antonioni's entire oeuvre, Reed had been assigned the task of interviewing the esteemed Italian film director for the Sunday newspaper's much-revered and feared Arts & Leisure section. Antonioni's *Blow-Up* had recently turned into something of a cause célèbre when the Catholic Church's Legion of Decency condemned it and the Motion Picture Production Code refused to bless it with a seal of approval. Rather than snipping those two seconds of pubic hair, MGM instead released *Blow-Up* through a corporate front, given the classy name of Premier Productions; then the studio aggressively pushed the film into Oscar competition, releasing it in the final two weeks of 1966. Reed, whose movie aesthetic had never really evolved beyond the pleasures of *All About Eve*, much preferred the year's front-runner for the Oscar, *A Man for All Seasons*, which, in its faithful mix of sainthood and knighthood, couldn't get any classier. Or duller.

In his *Times* profile of Antonioni, Reed emphasized his own total lack of appetite for the assignment at hand by openly complaining in print that watching an Antonioni film was surpassed in tedium only by trying to conduct an Antonioni interview.

The feeling was mutual. Antonioni actively resisted Reed's questions about "your favorite" this and that—until he finally just spat it out.

"No American films," he told Reed. "I go today to see Andy Warhol's film *The Chelsea Girls*. I am told we make movies alike. I also think *Scorpio Rising* is lovely," he added.

"Lovely" is a word few people in the 1960s (or any other decade)

ever applied to Kenneth Anger's short experimental film about contemporary Nazi homosexual bikers who wield S&M leather gear the way most kids play with their toys.

Upon hearing Antonioni's critique, Reed did not do what any mildly curious journalist would do; he didn't ask follow-up questions (anyway, none that made it into print) about *The Chelsea Girls* or *Scorpio Rising*, an underground film that had played (and been busted) at grungier basement venues around the world.

The Chelsea Girls was also an underground film, and it also would run into trouble with the law here and there. But unlike *Scorpio Rising*, *The Chelsea Girls* managed to graduate rather quickly from its lowly birthplace, the Film-Makers' Cinematheque basement theater on West Forty-First Street, to the plush Cinema 57 Rendezvous on the prime Manhattan moviegoing turf of West Fifty-Seventh Street. *The Chelsea Girls* was, in fact, the first underground film to make the leap to the mainstream, and its upgrade thoroughly outraged another writer at the *New York Times*, in this case, its chief film critic.

"It was all right so long as these adventures in the realm of independent cinema stayed in Greenwich Village or on the south side of 42nd Street," wrote Bosley Crowther. "But now that their underground has surfaced on West 57th Street, and taken over a theater with real carpets . . . it is time for permissive adults to stop winking at their too-precocious pranks."

And the carpet at the Rendezvous was the least of it. Unaware of how lucrative really bad publicity can be, the Chelsea Hotel's manager was threatening to sue Warhol!

The Chelsea Girls. It wasn't really so much a movie as it was a dozen short movies, projected side by side on a double screen; these short movies had little to do with each other but what Warhol and his codirector, Paul Morrissey, had dreamed up after the fact. Their idea of filmmaking was to load the camera's magazine (limited to

thirty minutes of film), point the lens at some of the more colorful denizens of Warhol's entourage, and let them talk and carry on with all due extravagance. It took patience to follow *The Chelsea Girls'* story line for the simple fact that there was no story line.

Warhol and Morrissey never bothered with things like a script, but at some point Morrissey realized that whenever he and Warhol filmed their actors, whom they called superstars, "it was in someone's bedroom," he recalled, "and many times it was in the Chelsea Hotel." So why not make it look like all the scenes were taking place simultaneously in rooms at the Chelsea? Morrissey gave Warhol credit for the word "girls" in the title. "But it was my idea that it looked like a hotel movie. So we brought it to the Cinematheque and showed it."

If *Scorpio Rising* was about gay leather bikers, *The Chelsea Girls* was about hothouse flowers who seemingly never left their hotel rooms. They told wild and obscene stories, as if lifted from Allen Ginsberg's *Howl* but without the poetry, and they swore more than Lenny Bruce at the Cafe Au Go Go; they also took drugs on camera, and rather than have sex—real or simulated—they occasionally exposed themselves. There was also Nico, who was a singer with the Velvet Underground. She did not sing in *The Chelsea Girls* but rather cut and combed her long blond hair for thirty minutes. In other words, it took patience to sit through the entire three and a half hours of Warhol and Morrissey's film to get to the parts of it that would shock or titillate or simply not bore.

An underground film like *The Chelsea Girls* might never have been mentioned in the same anticipatory breath as *Blow-Up* and *Who's Afraid of Virginia Woolf?* if not for two very aboveground publications that alternately loved and loathed it.

In his review titled "Underground in Hell," *Newsweek*'s Jack Kroll called it "a fascinating and significant movie event. It is as if there had been cameras concealed in the fleshpots of Caligula's Rome."

Even better for the movie's box office, a reviewer from *Time* labeled *The Chelsea Girls* "a very dirty and very dull peep show." Never a stickler for accuracy, the newsweekly went on to complain that "the characters are all homosexuals and junkies," despite the fact that Nico had sired a child by actor Alain Delon and committed other flagrant acts of heterosexuality. The review in *Time* fixated on what made its anonymous critic apparently nauseous: "A faggot who calls himself the Pope advises a lesbian to sneak into church and do something obscene to the figure on the cross. There is a place for this kind of thing, and it is definitely underground. Like in a sewer."

Whether or not he'd read those twin opinions, Michelangelo Antonioni went to see the newly released *Chelsea Girls*, a trek to the Rendezvous that had already been made by many other notable directors, writers, and producers, as well as more than a few socialites, including Honey Berlin. She was wife of Hearst Publications president Richard Berlin and mother of Brigid Berlin, whose performance as a lesbian in *The Chelsea Girls* required her to stick a hypodermic needle into her buttocks without first removing her trousers. Honey summed up her daughter's performance in just one sentence: "I can't believe you would lower your family like that."

Others were equally impressed, but in a good way—writers like Gore Vidal and directors like Tom O'Horgan and John Schlesinger and, perhaps most important, United Artists president David Picker, who felt *The Chelsea Girls* would open doors for artists due to the film's frank language, nudity and subject matter. It signaled a new artistic freedom for the American cinema.

The French, surprisingly, were a little less accepting of what Warhol and Morrissey had wrought. Invited to the Cannes Film Festival, Warhol arrived there only to be told that the festival's film board had second thoughts about *The Chelsea Girls* and would not be screening it at the Riviera movie confab as promised. That

spring, *A Man for All Seasons* did, indeed, win the Oscar for best picture, beating *Who's Afraid of Virginia Woolf?*, which, for all its bold language, never let the word "fuck" cross the lips of Elizabeth Taylor and Richard Burton. That movie taboo was broken in 1967 by British actress Barbara Jefford when she essayed the role of Molly Bloom in Joseph Strick's small-budget film adaptation of *Ulysses*, which carefully used the F-word only as a direct quote from James Joyce's much-revered prose.

The Cannes film board, which ultimately barred *The Chelsea Girls* from its festival, did go ahead that spring with its decision to screen *Ulysses*, but at the last minute, unbeknownst to Joseph Strick, they protected their French moviegoers by failing to provide several significant subtitles. Strick was not happy, and stormed the projection room to try to bring an end to the screening.

Compared to the movies, book publishing had pretty much sorted out its major censorship contretemps by the mid-1960s, thanks to court cases regarding the long-banned novels *Lady Chatterley's Lover*, *Tropic of Cancer*, *Fanny Hill*, and *Candy*. The theater also had been something of a refuge for the more sexually provocative: In Tennessee Williams's 1959 play *Sweet Bird of Youth*, Paul Newman's hustler character ended up being castrated for having deflowered and impregnated his girlfriend Heavenly Finley, while in the movie version, made three years later, the Production Code saw to it that Newman's Chance Wayne got to keep Heavenly, as well as his penis.

With *Blow-Up* and *Ulysses*, however, the movies suddenly leapt ahead of Broadway, which had yet to permit full nudity or allow the ultimate four-letter word to be uttered there. Television, with its conservative sponsors and huge viewership, remained literally stuck in the Eisenhower era. The most incendiary show in the mid-1960s was *Peyton Place*, ABC's recycling of Grace Metalious's 1956 potboiler about people who conceived children out

of wedlock in small-town America. The discovery of illegitimate children so shocked the public that the network had no choice but to air the nighttime soap opera three times a week.

In 1967, Hollywood's most cutting-edge films—major-studio films that many historians would later say signaled a New Hollywood—included *Bonnie and Clyde*, in which Warren Beatty's Clyde went from being bisexual in the script's original draft to merely impotent in the finished film, and *The Graduate*, in which director Mike Nichols, as he put it, had "to sneak in" a condom in long-shot for one bedroom scene. That kind of cautious approach to sex pretty much summed up 1967, the year that the U.S. Supreme Court finally got around to making interracial marriage legal in all fifty states, and the year that B-movie star Ronald Reagan took office as governor of California after promising to "clean up the mess in Berkeley." Steps forward were met with steps backward. The following year, however, such timidity would be put aside for good, lost in a veritable sexual explosion that would rock not only the movies but the theater and publishing worlds as well.

"I think this is a golden age for creative work of any kind," *Candy* novelist Terry Southern said as he embarked on writing what he thought would be another groundbreaking book, *Blue Movie*. "The people who go all out will make it. We've only scratched the surface of our Freudian heritage. We are undertaking an exploration of the mind and we're making some interesting discoveries. We have discovered the value of not being prejudiced. The assumption has always been that there have been limits. But we now know that there are no limits."

Until the courts, a corporate culture, arbiters of political correctness, a Silent Majority president, and the public's ennui with the sexually exploitive coalesced to form new limits—or reimpose old ones—many writers, directors, and producers agreed with Southern.

These artists knew each other, often collaborated, and just as often competed to be first at discarding whatever the censors threw at them. In many cases, there is only one degree of separation between the novels, movies, TV shows, and plays that they created in the Sexplosion years.

This is their story—a tale of the pop rebels who broke all the taboos.

SEXPLOSION

Winter 1968, Guts

For purveyors of the moral status quo, the first four weeks of 1968 emerged as an unqualified disaster.

In January alone, Off-Broadway performances began for Mart Crowley's play *The Boys in the Band*, about an expletive-laden, gay birthday party gone bad. Terry Southern fulfilled his fantasy, and then his nightmare, of seeing his long-banned *Candy* finally go before the movie cameras. Jane Fonda, still filming *Barbarella* in Rome, fretted over the film's outer-space striptease, which director-husband-svengali Roger Vadim had promised to fix in postproduction by hiding her privates with the film's opening credits. Kenneth Tynan went from theater critic to theater impresario, asking everyone from Samuel Beckett to Jules Feiffer to contribute skits for his new erotic stage revue, *Oh! Calcutta!* Director Lindsay Anderson began filming *If . . .* , set in an English boys' school rife with anarchy, homosexual love, and a heterosexual wrestling match. United Artists green-lit John Schlesinger's exploration of the Forty-Second Street hustler scene, *Midnight Cowboy*. Director Tom O'Horgan toyed with adding a nude scene to his upcoming Broadway incarnation of the new musical *Hair*. Little, Brown published Gore Vidal's novel about a transsexual, *Myra Breckinridge*, while over at Knopf,

Inc., they began printing the first seventy thousand copies of John Updike's tome on suburban spouse-swapping, *Couples*. And Lance Loud, only a few years away from being TV's first gay star, was so inspired by seeing Warhol's *Chelsea Girls* that he promptly dyed his hair silver to match his idol's wig.

In 1968, the world did not yet know of the teenager from Santa Barbara, but Lance Loud was already well on his way to being the Zelig of the Sexplosion years as he filtered and absorbed the rapid changes in pop culture, not to make art but to turn his life into art. All he needed was a little help from some documentary filmmakers, the yet-to-be-launched Public Broadcasting Service, and, of course, Andy Warhol himself.

That January, Warhol continued to challenge the sexual status quo, but not from his Factory. He left Manhattan to visit Oracle, Arizona, where he was making a new film, a Western, which was of such concern to the men of J. Edgar Hoover's FBI that they decided to open a file on him. Almost overnight, *Chelsea Girls* (the title lost its original "the" on its way up from the underground) had turned Warhol into a target, the bureau's need to rout out revolutionaries no longer limited to just communists.

Warhol's go-to movie-guy Paul Morrissey doubted that he could ever top those *Chelsea Girls* reviews in *Newsweek* ("fleshpots of Caligula's Rome!") and *Time* ("a sewer!") with this new, as yet untitled movie. And there were other challenges. If three thousand dollars and a four-day shooting schedule were good enough for *Chelsea Girls*, Warhol thought it would be good enough for the half dozen or so subsequent films that Morrissey was to make, including this new Western that updated Shakespeare's tale of two star-crossed lovers. "I had this idea of doing *Romeo and Juliet* with groups of cowboys and cowgirls," Morrissey explained. "But no girls came because they had a quarrel with Viva."

Viva, aka Janet Susan Mary Hoffmann, took her name from

Viva paper towels. And there were other reasons she morphed into the number-one superstar in the Factory firmament after Warhol fashion icon Edie Sedgwick demanded and got herself removed from *Chelsea Girls*. In addition to her Garbo-esque beauty, which included none of the great Swede's discretion or fear of exposure, Viva knew how to get attention in a room, if not a movie, full of flamboyant male homosexuals. As she explained it in her lazy soprano whine, "Take off your clothes!"

She was also one of the first Warhol actors to be called a superstar. "They felt they were doing something special with those movies," said Joe Dallesandro, who started at the Factory as a doorman and later graduated to appearing before Warhol's camera, usually stark naked to the delight of everyone except himself. "How can you be doing something special in three or four days?" he asked.

Since a Western, even an Andy Warhol Western, couldn't be shot in New York City, the movie Morrissey envisioned, about a cowboy Romeo and his cowgirl Juliet, needed the appropriate locale. Morrissey chose Oracle, Arizona, where a few John Wayne pictures had been shot. The citizens of Oracle liked the Duke. They didn't like Warhol or Morrissey. After all, in what other Western did a woman ride into town with her nurse—her male nurse!—and end up being raped by a few bored cowboys who'd much prefer bedding a handsome male drifter?

Viva put it more succinctly. "The story is I run a whorehouse outside of town," she said.

Warhol wanted to call it *Fuck*, then he considered *The Glory of the Fuck*, but ultimately settled on the more atmospheric, less graphic *Lonesome Cowboys*.

On the first day of shooting in Oracle, Viva showed up in a very proper English riding habit, complete with a stock and black leather boots. She'd picked the outfit herself, explaining, "I just woke up from a bad LSD trip and I think I'm in Virginia with

Jackie Kennedy." As it turned out, she needed the stock, being the only woman in the company, which turned out not to be quite as one hundred percent gay as she had hoped. "We were staying together at this guest ranch and it just went on all night. Every night I'd change rooms and every night they'd all be in there with me," she complained to Andy Warhol.

It concerned Andy, especially what was happening off-camera between his leading lady and the film's cowboy Romeo, an actor named Tom Hompertz. "Stay away from Tom, save it for the movie!" he kept telling Viva.

Viva claimed she was being attacked by other men on the set. "I was just raped again," she told Andy on morning two of what was only a four-day shoot.

As with every scene in a Paul Morrissey–directed movie, the actors made it up as they went along. Like the scene where five of them rush Viva as she gets off her horse and everybody screams, "Fuck her! Fuck her!" and proceed to tear off her clothes and then mount her.

It was this scene that compelled one resident of Oracle to lodge a complaint with the FBI, which promptly sent an agent or two out west. "There were planes overhead," Joe Dallesandro said of the shoot. "That was pretty funny."

The FBI opened a file on Andy Warhol, created under the category "ITOM: Interstate Transportation of Obscene Matter," and in his report an agent didn't stint on the details. As he recorded it, "All of the males in the cast displayed homosexual tendencies and conducted themselves toward one another in an effeminate manner. . . .

"One of the cowboys practiced his ballet and a conversation ensued regarding the misuse of mascara by one of the other cowboys. . . .

"There was no plot to the film and no development of character throughout. It was rather a remotely-connected series of scenes

which depicted situations of sexual relationships of homosexual and heterosexual nature."

Luckily for Warhol and company, *Lonesome Cowboys* had long wrapped by the time the FBI report made its way back to Washington, D.C.

IF THE FBI CAME lately to the work of Andy Warhol, J. Edgar Hoover's men had already opened and closed its file on Terry Southern when his novel *Candy* (written ten years earlier with limited input from the drug-addled Mason Hoffenberg) went into production as a movie that January at the Incom Studios in Rome.

The bureau had opened its Southern investigation in February 1965. Only the year before, G. P. Putnam's had made Southern's "dirty book," about an adventurously promiscuous American girl, legally available in the United States, where it quickly rose to the top of the bestseller lists despite having already sold over twelve million contraband copies under both its original title and *Lollipop*. The novel got a boost stateside when *Publishers Weekly* labeled it "sick sex."

After *Candy*'s initial publication in France, Southern had gone on to write the screenplay for Stanley Kubrick's *Dr. Strangelove* and been nominated for an Oscar. The FBI, however, didn't care about awards not won. Its file labeled him a "pornographer," and *Candy*, in the bureau's estimation, was the least of it:

"With reference to [Southern's] pornographic library of films . . . it is not known to this office whether it is a local violation in Connecticut to display films to 'guests' and it is therefore left to the discretion of the bureau as to whether such information should be made available, strictly on a confidential basis, to a local law enforcement agency covering Southern's place of residence."

Regarding the novel *Candy*, the FBI's internal review found it "not a suitable vehicle for prosecution." As the file concluded,

" 'Candy,' for all its sexual descriptions and foul language, is primarily a satirical parody of the pornographic books which currently flood our newsstands. Whatever erotic impact or prurient appeal it has is thoroughly diluted by the utter absurdity and improbability of the situations described."

The makers of the *Candy* movie weren't quite as liberal as the FBI. They flat out rejected Southern's script for its sin of inclusion regarding the book's infamous hunchback character, who performs an unusual sex act at the heroine's insistence. As it was described in the novel, "The hunchback hesitated, and then lunged headlong toward her, burying his hump between Candy's legs as she hunched wildly, pulling open her little labias in an absurd effort to get it in her. 'Your hump! Your hump!' she kept crying, scratching and clawing at it now."

In fact, the hunchback pages of *Candy* ("Give me your hump!") were second only to the novel's closing incest scene ("Good Grief— It's Daddy!") as required late-night reading at better frat houses everywhere.

Southern just couldn't bear to lose the hunchback in the movie version. "These scenes were very dear to Terry's heart because it was the first he wrote for the book," noted his longtime partner, Gail Gerber. "Holding firm and refusing to delete them from the screenplay, he was fired and lost control over his property."

The Texas-born Southern, who had been described as having all the charm of a walking hangover, put the controversy a bit more delicately. "I have nothing to do with it," he said of the movie, "having withdrawn when they insisted on taking out the hunchback."

Worse than their deleting the hunchback was their hiring director Christian Marquand, who'd never directed a movie before and whose major qualification for the job had something to do with his helping good friend Marlon Brando buy the French Polynesian atoll of Tetiaroa. Brando was nothing if not loyal, and through his efforts Marquand not only landed the *Candy*

gig but was able to hire, at fifty thousand dollars a week per star, other high-profile actors, including Walter Matthau, James Coburn, Ringo Starr, and Richard Burton, who never quite forgave Brando the indignity that was to be *Candy*, the movie.

"We were all kind of gathered around the idea of doing a 1960s movie," said Coburn, who played Dr. Krankheit. "Our attitude was 'Let's see if we can do it.' Nudity was beginning to come in, fucking on-screen, and it was all much freer."

Buck Henry wrote the screenplay—or, more aptly, was in the process of writing it as the production progressed. Southern kept calling him that "sit-com writer," referring to Henry's *Get Smart* days, unaware that Henry had also recently enjoyed a fair degree of success with his screenplay for *The Graduate*.

Henry returned the insult by saying that the direction of his screenplay would be "every one conceivable away from the book."

When Coburn's week of work on the film approached that January, he flew to Rome, only to be met at the airport by the film's novice director. "Well, there's been a little problem," Marquand informed him. "We'll probably have to close down for a week, or at least until we can do some shooting that Ewa isn't in."

Ewa was Ewa Aulin, an unknown Scandinavian actress who'd been cast as the all-American girl Candy. Her accent didn't matter, Marquand insisted. She would be dubbed.

As Coburn and Marquand spoke on the tarmac, Ewa Aulin was no longer in Rome, having undergone what was politely being called a "rest cure," which had something to with her being put "to sleep out in a little resort town on the coast, Taormina."

Aulin had trouble playing her scenes opposite Marlon Brando, cast as the Great Guru Grindl, who, outfitted in Indian robes and long black wig, seduces Candy in a big semi-truck that doubles as his meditation room as he roams America. Brando couldn't stop wanting to have sex with Aulin, and Aulin couldn't stop laughing at Brando.

"She had a wonderful ass, man, and Marlon just couldn't resist," said Coburn. "He'd started coming on to her pretty strong, turning on his great charm, even during their scenes together. . . . She would look at him in this fright wig, and just get hysterical. He was so funny and ingratiating to begin with—only now he wanted to fuck her, so that was the icing on the cake. It was overwhelming. She just went over the edge."

Stuck away in a hotel in Taormina, Aulin was given injections to keep her sedated until she ceased giggling. "Soon, rumors reached Hollywood that the decadent production had kept Aulin high just for the fun of it," reported Southern's son, Nile.

No one knew how the movie—or, for that matter, the production—would end. "We're keeping it a secret," said Buck Henry.

Brando described the ensuing chaos more graphically. "This movie makes as much sense as a rat fucking a grapefruit," he said.

IT WAS NOT GORE VIDAL'S intention to top Terry Southern or Andy Warhol, who was less than a year away from bringing transsexuals, in *Flesh* and then *Trash*, to America's movie theaters. In fact, Vidal's impetus, if not his inspiration, for creating the trannie character Myra Breckinridge came from the other side of the sexual divide. At that moment in time, the strictly heterosexual Kenneth Tynan was conceiving his own carnal entertainment, one that was to be militant in its exclusion of homosexuality, if not all things sexually adventurous.

Vidal, flush from the Broadway success of his political drama *The Best Man*, was not averse to currying the favor of London's most famous theater critic, which Tynan arguably was before leaving his post at the *Observer* to become literary manager of Sir Laurence Olivier's National Theatre. Those two lofty posts, first at the *Observer* and then the National, helped to propel Vidal's generosity when it came to his caustic theater friend. Vidal lent Tynan one thousand

British pounds shortly after the critic remarried and found himself financially strapped due to exorbitant alimony payments to the first Mrs. Tynan, writer Elaine Dundy, who confessed that she had once been "madly in love" with Vidal.

In their literary circle, Vidal was well-known for being bisexual and Tynan was equally well-known for being a philanderer. And not just any old philanderer, as his ex-wife explained when giving the reason for their divorce. "To cane a woman on her bare buttocks, to hurt and humiliate her, was what gave him his greatest sexual satisfaction," Dundy recalled with her usual novelistic precision. Perhaps more injurious to their union was Tynan's severe double standard when it came to Dundy's replication of his chronic infidelity—like the time he returned home to find a naked man in the kitchen with Dundy, and promptly threw the man's clothes down the elevator shaft.

If Vidal had any objections to Tynan's conduct, it would have been that his critic friend had gotten married—and not once but twice. Vidal strenuously objected to the institution of marriage—and not because it excluded homosexuals. He credited his own life-long partnership with Howard Austen to the fact that the two men never had sex a second time after their first meeting in a New York City bathhouse in 1950. An ardent believer in quick, anonymous sex—and the more the better, regardless of the cost—Vidal had a thing for whores. "I love prostitution," he once said. "I think it's just absolutely the greatest institution there is and it's the most honest."

Their reputations for being libertines—or at least indulging in a lot of sex—made Vidal a natural contributor to Tynan's new theater endeavor.

Like so many critics, Tynan didn't write plays. He wrote about plays. If he could have written plays, he would have. But since he couldn't, he didn't, and instead he asked several other writers to write his play for him. What Tynan had in mind wasn't a play at all

but a revue, each element of which would carry a sex theme. Since Vidal was one of the first writers he approached, Tynan was a bit vague on the concept. "If you have any comment to make on the erotic relationship between men and women, write it down. It can be a skit, a song," he offered.

That Tynan was to go public with his sexual obsession came as no surprise to Vidal. First off, Tynan needed the money. And second, Tynan had long been a major foe of censorship in any form, and in recent months was no longer best known for his reviews or his job at the National Theatre but rather for being the first man to utter the word "fuck" on TV. It happened on November 13, 1965, on a late-night live show, *BBC-3*. The on-air commentator had wondered if censorship should be abolished and if Tynan, as literary manager of the National Theatre, could conceivably see producing a play in which a couple had sexual intercourse onstage. "Oh I think so, certainly," Tynan replied without hesitation, except for, perhaps, the pauses caused by his incessant stutter. "I doubt if there are very many rational people in this world to whom the word 'fuck' is particularly diabolical or revolting or totally forbidden."

In time, the hard-driving, chain-smoking, sadomasochistic Tynan would regret the "fuck" remark. "So that's my obit? This is what I'm going to be remembered for, having said 'fuck' on television?" he used to complain—that is, until his sex revue, *Oh! Calcutta!*, became as familiar a title as *Hello, Dolly!* or *Mary Poppins*.

Back in the late 1960s, Tynan's show didn't have a name. It was just an idea, and not a very specific one as Tynan further explained it to Vidal for the first time.

"It's to be an erotic evening with no purpose except to titillate, arouse, and provoke," he said. The whole thing, Tynan believed, would be "very elegant and perverse, every heterosexual fetish fully catered for. And no crap about art."

Well, maybe just a little crap. Tynan did stress that no less an

estimable talent than playwright Harold Pinter, author of *The Birthday Party*, would be "co-devising and co-directing" his erotic show. And thanks to the connections of his London-based producer, Michael White, he'd been able to secure a promise from Samuel Beckett that he'd write *something* for the show. (White recalled meeting the absurdist playwright at a pub near the Royal Court Theatre in London. "He knew I was a fan, in absolute awe of him," said the producer. "I'd been at the world premiere of *Waiting for Godot* in Paris in 1953.") Other famous names were also bandied about to provide the skits: Tennessee Williams, Edna O'Brien, Jules Feiffer— impressive, prestigious writers.

Vidal was intrigued, and in the correspondence that followed Tynan offered one vague sex scenario to his writer-friend-lender, now living in Rome. In a letter, Tynan suggested that Vidal write "a sketch on the organization of an orgy." Back in London, Tynan was already having a good time of it, collecting ideas for skits from a number of celebrities who came to his flat to drink, carouse and fantasize. John Lennon offered one inspired bit. "You know the idea," the soon-to-be ex-Beatle began, "four fellows wanking, giving each other images—descriptions—it should be ad-libbed anyway. They should even really wank, which would be great."

Perhaps that wasn't the kind of orgy Tynan had in mind when he suggested a skit about group sex to Vidal. He made it clear to other potential participants that only "non-queers" would be involved in the production of his sex revue. Fantasies and fetishes of every stripe would be depicted, with only one caveat: no homosexuality. "There's been enough of that around," he told more than one invitee to the project. He saw the show as an aphrodisiac, a "gentle stimulation, where a fellow can take a girl he is trying to woo."

If Tynan didn't yet have a title for his show, he did have a poster or, at least, an image: a Turkish harem odalisque, painted by Clovis Trouille in 1946. The buttocks-fixated Tynan had admired the painting

for years, thought it symbolized what he wanted his revue to be, and he even liked how the painting's title, O *quel cul t'as!*, translated to "What an arse you have!" That's what Tynan would call his show, *Oh! Calcutta!*

If Vidal was offended by the general hetero ambiance of Tynan's project, he kept it to himself. Besides, he had something else in mind—something playful, ironic, and perverse in a way that would severely tweak a militant heterosexual like Tynan. In the late 1960s, the story of a transsexual didn't qualify as gay so much as outrageous. "Generally, [Tynan] wanted something far out," said Vidal. "Myra'd do business for spanking. After all, if she was just dildo wielding . . . ," it didn't give him much room to add many participants to Tynan's imagined orgy.

Vidal toyed with writing a skit for Tynan, then came to his creative, as well as his commercial, senses.

As with most of Vidal's fictional works, "I seldom start with any more than a sentence that has taken possession of me," the author revealed. In this case, that sentence was "I am Myra Breckinridge whom no man may possess; clad only in garter belt and one dress shield."

That's all Vidal needed. A sentence grew into a paragraph, a paragraph into a chapter, a chapter into a book. He didn't know where his novel was going, but Vidal envisioned something far greater than a ten-minute sex skit. "I hadn't even made up my mind about the sex-change at that point. I heard this voice in my head. Absolutely like Joan of Arc, telling me to liberate my native land."

And so Vidal discarded his *Oh! Calcutta!* assignment, since his "native land" never included Tynan's projected audience of tired businessmen in need of wooing instructions.

Somewhere in that evolution between paragraph and first chapter, Vidal decided to keep Myra for himself. "It got more interesting," he said of his newest project, "and I certainly wasn't going to waste it on a review-sketch."

Vidal "vividly" recalled the day that he began writing the novel *Myra Breckinridge* in earnest, when that first sentence had already bloomed into a few untidy paragraphs. He and Howard Austen were in the process of fixing up their new flat in Rome. "I had a pile of lined yellow legal pads on my writing table, which was opposite my bed," Vidal recalled. Across from the table, a French door opened onto the terrace that overlooked the Largo Argentina—"a great square with several Roman temples beneath the pavement's level, as well as a large colony of cats." There was a new moon. It had just risen over the Vatican to the west of the apartment, a sign for him of good luck. "The moon, not the Vatican," he noted.

When he wrote his historical novels *Julian* and *Washington, D.C.*, Vidal indulged in a great deal of note-taking from the necessary records. With what he called "an entirely invented book like *Myra*," he simply let that first sentence "I am Myra Breckinridge whom no man may possess . . ." take possession of his imagination.

Two weeks into the project, it occurred to Vidal: "Myra had been a male film critic who had changed his sex." He laughed. He continued writing. Furiously. Then Christopher Isherwood came to visit. The author of *The Berlin Stories*, which became the play *I Am a Camera*, which became the stage musical *Cabaret*, had recently toured India with his lover, Don Bachardy, thirty-two years his junior; and back on terra Italiano, Isherwood wondered aloud to Vidal if the teeming peoples of color would eventually wipe out their "fragile white race." Then they shared another vodka tonic to mull over the ensuing genocide.

Vidal and Isherwood shared the same ironic, if not downright camp, attitude toward sex that allowed them to find amusement in everything from the coming apocalypse to the eminent demise of Caucasians. Isherwood devised a plan for the latter: "But we must set aside reservations for the better-looking blonds, the Danes and such," he pontificated. "They must be preserved like

rare unicorns. Certainly, the Indians will enjoy them in their reservations along with all that snow we'll shovel in to provide the right Arctic touch."

Isherwood's detachment, along with the vodka, put his writer-friend in the proper mood. Vidal also thought of Norman Mailer as he continued writing his new novel. He had once told the author of *The Naked and the Dead* that he put too many orgasms in his novels. Mailer, in turn, faulted Vidal for being cold and clinical about sex. "So I stuffed it with cold, clinical sex," Vidal said of *Myra Breckinridge*, in which his transsexual heroine buckles on a dildo in order to rape a recalcitrant young actor-pupil whom she/ he is mentoring. Otherwise, "Myra sprang out of my head like Minerva, speaking with the humourlessness of a Susan Sontag. As an old movie buff, I also drew on Parker Tyler, one of the first intellectuals to take the movies seriously." Vidal especially liked that Tyler wrote ponderously, for example, about Lana Turner's ankle and how it "reminded him of something Spengler once said" in such 1940s classics of film criticism as *The Hollywood Hallucination* and *Magic and Myth of the Movies*. (After Vidal sent Tyler an autographed copy of *Myra Breckinridge* and inscribed it "le maitre Tyler," Tyler himself claimed, "I don't think Gore Vidal would have ever conceived this heroine otherwise, because Myra really is a disciple of mine. That's the simple truth!")

There were other fathers of Myra as well. In addition to Sontag and Parker, Vidal conjured up Anaïs Nin. He used the words "hot stuff" to describe her book *Incest, from a Journal of Love: The Unexpurgated Diary of Anaïs Nin, 1932–1934*. As he devoured *Incest*, Vidal realized that the voice of Myra Breckinridge "was actually that of Anaïs in all the flowing megalomania of the diaries. Lying had become her first, not second, nature; yet even that would not have mattered so much had she not set herself up as a diarist who told the absolute truth."

For Myra's dress and physique, Vidal took to the street. His trannie mimicked a huge statue of a Las Vegas showgirl that used to rotate outside his fifth-floor window at the Chateau Marmont hotel on Sunset Boulevard, where he resided in the 1950s when toiling for MGM as a screenwriter. The plaster Amazon held a sombrero in one hand, the fingers of her other begloved hand splayed out at the hip. A blue brassiere covered with white stars adorned her bosom, and from there the bra spurted red and white stripes to cover her equally Brobdingnagian derriere and crotch. "Oh God, to wake up in the morning with a hangover and look out and see that figure turning, turning, holding the sombrero—you knew what death would be like," Vidal noted.

Then there was the name Breckinridge. It was not entirely Vidal's creation. John Cabell Breckinridge was an American actor and drag queen of little renown who starred as The Ruler in Ed Wood's cult classic *Plan 9 from Outer Space*. Born in Paris, Breckinridge was the great-great-great-grandson of U.S. attorney general John Breckinridge (and the great-grandson of both U.S. vice president and Confederate general John C. Breckinridge and Wells Fargo bank founder Lloyd Tevis). How the fictitious Myra Breckinridge came to resemble the real John Cabell Breckinridge is that both wanted to undergo a sex change operation. But unlike Myra, John was ordered by a judge in San Francisco to pay $8,500 a year to support his blind mother in England. Later, when Bunny—John Cabell Breckinridge called himself Bunny—traveled to get an inexpensive castration in Mexico, a bad car accident prevented him from doing so, and he gave up on the idea of becoming a woman à la Christine Jorgensen, his idol. As Vidal described him, Bunny Breckinridge was "just a big queen—very rich," and he knew of him from overhearing his mother's circle of friends at the Beverly Hills Hotel when the women referred to their "feathered friends," a euphemism for fairies. Feathered friends or fairies, the subject of homosexuality was not out of

bounds for such a sophisticated group. "Bunny Breckinridge was a famous queen who had married and gone to prison in that order or, if not in that order, the other way around, and all the ladies had met him, including my mother, and that was all, and then I never thought of him again," Vidal recalled.

Until he started work on *Myra Breckinridge*.

Prophetically, when he finished the first longhand draft of that novel, there was again a new moon over the Vatican. An incredibly short pregnancy, only one month had passed from start to finish of his book.

A few weeks later, Vidal showed a polished version to his friend Jane Fonda, who was also living in Rome at the time, on the Via Appia Antica. *Barbarella*, directed by her then-husband Roger Vadim and written by Terry Southern, had brought the actress to the Eternal City, and she called her rented home, on the outskirts of the city, "part castle, part dungeon." During one dinner party, to which Vidal and Southern had been invited, the second century BC tower in which they were eating underwent an impromptu renovation. A small chunk of plaster fell from the tower's ceiling and an owl dropped onto Vidal's plate of food. "Can I have the recipe?" he asked his hostess.

If the moon over the Vatican was a sign, so was the dead bird. Regarding her interest in playing Myra onscreen, Jane Fonda mentioned that she was already in the midst of playing a sex icon and might not be in the market for another such role.

Barbarella began its life as an erotic comic strip, published in the avant-garde *Evergreen Review*, and the svengali Vadim, who'd previously romanced and directed Brigitte Bardot and Catherine Deneuve, somehow talked his current actress-wife-blonde into rejecting the female lead in Warren Beatty's *Bonnie and Clyde* to play the title role in his sci-fi film about a female astronaut traveling through space and having a few hundred orgasms along the way in the year

AD 40,000. By the time Fonda read *Myra Breckinridge*, she'd just shot the risqué title sequence of *Barbarella* in which she performed a weightless striptease in a spaceship. It was one of Southern's favorite scenes. Vadim's, too. Since it was her naked body up there onscreen, Fonda wasn't so sure. "Vadim promised that the letters in the film credits would be placed judiciously to cover what needed to be covered," Fonda reported. But again, she wasn't so sure.

Over dinner and a dead owl, Vidal confronted a rather skittish Fonda. She had no idea how moviegoers, much less critics, would respond to the cartoon sex of *Barbarella*. The actress had gotten so jittery at the Dino De Laurentiis studio in Rome that she started popping Dexedrine, while her director-husband took to binge drinking to calm his nerves. Even Vadim had to admit, "It looks more like a Brigitte Bardot type of movie, it is true. Sex is there."

One fictitious sex icon, as it turned out, was enough for Fonda, even if Vadim also wanted to bring *Myra Breckinridge* to the screen. She'd already turned down Terry Southern, who wanted the thirty-year-old actress to play the coed Candy—that is, when the *Candy* producers were still interested in his screenplay. In a way, Barbarella was much closer to Candy, screwing her way through life—only in space. Myra was from another galaxy entirely. Fonda adored Vidal and even liked his new novel. But playing a transsexual rapist onscreen mystified her, and with utmost diplomacy she informed Vidal, "I don't think I know how to play it."

Two other prepublication reviews of Vidal's novel ran the gamut. Christopher Isherwood called it his friend's "very best satirical work." But then Vidal had inoculated himself from a bad review by dedicating the book to Isherwood, who a few years earlier had dedicated his autobiographical novel *A Single Man* to Vidal.

Less flattering was the review Vidal received from his father, Lieutenant Eugene Luther Vidal. An aviation pioneer and erstwhile lover of Amelia Earhart, the lieutenant was oft mentioned many

years earlier in the same breath as his 1930s contemporaries Charles Lindbergh, J. Edgar Hoover, and Henry R. Luce. The older Vidal read the younger Vidal's as-yet unpublished novel *Myra Breckinridge* and immediately underwent an uncomfortable case of déjà vu. He'd been here before—or, at least, he felt his son's literary reputation had been here before. Back in 1946, when Gore Vidal was a mere nineteen years old, he'd written and published his first novel, *Williwaw*, set during World War II and based upon his own Alaskan Harbor Detachment duty. The novel received glowing reviews. His precocious genius reputation, however, proved short-lived, even for one leaving his teenage years. In 1948, Vidal's follow-up novel, *The City and the Pillar*, caused a furor for its graphic and nonjudgmental depiction of homosexuality and put his literary career on indefinite hold.

Vidal recalled, "It was believed in right-wing circles that I invented same sexuality in 1948 with *The City and the Pillar*, that nothing like that had ever happened in the United States until my book. I feel like Prometheus having brought fire from heaven."

The editors at the *New York Times* treated it more like fire from hell and refused to review Vidal's next five novels, as if the taint might infect the entire newsroom. At the time, Vidal took comfort in the banished company of a sex researcher whose book *The Kinsey Report* came out a month after *The City and the Pillar*. "And the shocked *New York Times* would not advertise either book," Vidal noted. Due to the press blackout, the financially strapped Vidal cranked out any number of screenplays for the Hollywood factory in the following years. By the early 1960s, however, he was enjoying a literary rebound thanks to the Broadway success of *The Best Man* and his novel *Julian*, a fictional account of fourth-century Rome, which happened to be Vidal's first major work of fiction in more than a decade.

Eugene Vidal—good-looking, tall, blue-eyed—sincerely felt that *Myra Breckinridge* might undo his son's long climb back to respectability

from *The City and the Pillar.* Regarding *Myra Breckinridge*, he believed, "Gore has slipped upon this one." He was even more blunt when he expressed that thought to his son. "I never found rear ends sexually attractive," said the lieutenant, referring to the novel's soon-to-be-infamous rape scene.

Despite his father's misgivings, Vidal traveled to New York City to deliver the unexpurgated *Myra Breckinridge* manuscript to his publisher. He kept in mind something that William Faulkner had told him years earlier about another great but compromised author. "You know, Hemingway's problem is that he never takes chances," said Faulkner. "You have got to keep going as far out as you can, as far as your imagination will take you." Vidal's imagination took him to *Myra Breckinridge*, and with Faulkner's words in mind he gave his novel to Little, Brown and Company.

While in New York City, Vidal took time to have lunch with the British film director John Schlesinger, who'd had a great success a couple of years earlier with *Darling*, which epitomized the new, hip, swinging London and made Julie Christie a star. Schlesinger was also about to release *Far from the Madding Crowd*, which would have the effect of nearly undoing everything good that *Darling* had achieved for him and Christie.

Until the movie gods reversed his fate, Schlesinger remained a proud, successful director, and he wanted to talk to Vidal about his new film, the first he would direct in the United States. They met at the Plaza hotel's tea room, and Schlesinger brought the film's producer, Jerome Hellman, who had come aboard on the project when Joseph Janni, the producer on Schlesinger's four previous movies, found himself repulsed by the thought of making a movie about a lowlife male hustler who worked the streets of Times Square.

"I'm looking for someone to adapt the novel *Midnight Cowboy* to the screen," said Schlesinger, and he wondered if Vidal might be interested in taking a whack at James Leo Herlihy's bestseller.

Vidal knew the novel about a dim-witted dishwasher who leaves Texas to become a New York City gigolo and instead ends up prostituting himself with male customers. Vidal didn't have to think long, and was brief to the point of insult. "Oh, I think I've already done that with *The City and the Pillar.* Why don't you make that into a movie?" he asked, referring to his novel, which had nothing to do with Times Square hustling or Texas dishwashing. Vidal dismissed Schlesinger's project with a quick "The subject seems kind of silly."

Then he changed the subject. "So let's just enjoy our lunch." Which was being expense-accounted to United Artists. Regarding Vidal's rejection, Hellman chalked it up to "Gore's arrogant ego."

Vidal could only hope that his editor, Ned Bradford, at Little, Brown would be more receptive, as well as diplomatic, regarding his new novel about a dildo-touting transsexual who takes on all of civilization west of the San Gabriel Mountains with little more than an encyclopedic knowledge of the world according to Twentieth Century Fox.

Vidal recalled his apprehension, which proved unfounded: "I hoped that Ned and the publisher, Arthur Thornhill, would not be too upset by Myra's exuberant pansexuality. Fortunately, they were not." Vidal never considered Bradford a problem. Thornhill was another matter. The publisher had strongly objected to a scene Vidal put in his novel *Washington, D.C.,* written the previous year, that featured a masturbation session between two boys. Luckily, Thornhill underwent a sudden liberal conversion around the time Vidal submitted his follow-up manuscript. He no longer really cared if *Myra Breckinridge* tarnished the reputation of Little, Brown or not, because he would soon be selling his publishing company to Time, Inc. He did, however, insist that Vidal sign a release holding himself solely responsible for any obscenity lawsuits resulting from the publication of *Myra Breckinridge.*

Vidal's London publisher, Heinemann, proved even more cautious than the ready-to-be-auctioned Little, Brown. Heinemann rejected the novel outright, and to see *Myra Breckinridge* published in England, Vidal had to make a deal with a smaller house, Anthony Blond, which insisted on minor cuts, such as the lead character's sex fantasies about real-life movie stars, like Ava Gardner, to avoid libel suits.

Fortunately, Vidal's American publisher knew exactly how to publicize the novel. In some ways, the press campaign to promote *Myra Breckinridge* would presage the publication strategy of most books to come in the 1970s and beyond: Little, Brown did absolutely nothing to promote the book. Suddenly, without fanfare, on January 28, 1968, the novel's discreet black-and-gold cover with a picture from Vidal's inferno—that super-sized Sunset Boulevard Amazon—appeared in bookstores and airports everywhere. No less a tome than *Newsweek* noted the anti-hype hype campaign.

"*Myra Breckinridge* was quietly distributed to bookshops without as much as a whisper of publicity," the newsweekly informed its readers. "No advance advertising, no copies sent to *Publishers Weekly*. No review copies distributed to newspapers or magazines . . . in defiance of all the usual prepublication rituals."

Time magazine asserted that Little, Brown had "coquettishly" pleaded with critics that the book not be reviewed at all since "the sexual problems of the title character represent a suspense element vital to the novel's enjoyment." *Time* scoffed at the surprise of Myra/Myron's metamorphosis, revealing that anyone who'd been "down to the local fag bar" would guess the secret. Joining the gay-bashing bandwagon, *Newsweek* charged that *Myra Breckinridge* "becomes, in the end, a kind of erotic propaganda for homosexuality." (Vidal couldn't disagree there. "Myra favors anything that would limit population," he volleyed back.) And the *New York Times*, still smarting from its *The City and the Pillar* hissy fit twenty years earlier, wrote

in its dismissive pan that the book went from "high camp to low bitchery."

In a way, the cautious Eugene Vidal, after his initial doubts, offered the best defense of *Myra Breckinridge*'s creator: "Most of us worry about being popular, but him, never," said the father of Gore Vidal.

THE *NEW YORK TIMES*'S antipathy toward homosexuals did not end when it began reviewing Vidal's novels again with *Julian* in 1964. Only the year before, the Gray Lady printed a five-thousand-word, page-one article titled "Growth of Overt Homosexuality in City Provokes Wide Concern," by staffer Richard Doty, who deeply regretted the city's harboring of "probably the greatest homosexual population in the world," and went on to reveal how "the overt homosexual has become . . . an obtrusive part of the New York scene," as well as a "subject of growing concern of psychiatrists, religious leaders, and the police." The newspaper of record had recently promoted A. M. Rosenthal to metropolitan editor, and it became his crusade to clean up the city for the upcoming World's Fair in 1964, and beyond.

"Everyone below Rosenthal spent all of their time trying to figure out what to do to cater to his prejudices," said *Times* reporter Charles Kaiser. "One of these widely perceived prejudices was Abe's homophobia. So editors throughout the paper would keep stories concerning gays out of the paper."

Or, in the case of the Richard Doty article, in the paper on page one. The result was that gay bars were increasingly raided. Theaters like the Gramercy Arts, the New Bowery, and the Writers' Stage were closed for showing such gay-themed underground films as Jack Smith's *Flaming Creatures*, Kenneth Anger's *Scorpio Rising*, and Jean Genet's *Chant d'Amour*.

And it wasn't just homosexuals who got attacked. Lenny Bruce was arrested and convicted on obscenity charges for using four-letter words and Yiddish words like "schmuck" in his act at Cafe Au Go Go.

Ironically, it was the *Times*' publication of one of its more infamous anti-homosexual tirades of the 1960s that inspired Natalie Wood's ex-secretary to write *The Boys in the Band*.

On January 23, 1966, Mart Crowley opened that Sunday's *New York Times* and, as was his custom, went right to the Arts & Leisure section, soon to be known as the Gay Sports Pages. There, at the top of page one in bold type, Crowley saw the heading "The Homosexual Drama and Its Disguises." Almost as shocking as those words was the byline. The essay had been written by the newspaper's august theater critic Stanley Kauffmann, who took the opportunity this particular Sabbath to bemoan the state of the American theater for its lionization of homosexual playwrights who wrote "a badly distorted picture of American women, marriage, and society in general." Kauffmann didn't name "the three most popular playwrights," all of whom just happened to be homosexual, but there was no mistaking the objects of his criticism: Tennessee Williams, William Inge, and Edward Albee. "Why can't they just write about their own kind?" Kauffmann wanted to know, and, in essence, leave heterosexuals alone to enjoy the theater of lesser talented, or, better yet, dead playwrights. (Kauffmann's diatribe wasn't the first of its kind: In 1965, psychiatrist Dr. Donald Kaplan attacked *Who's Afraid of Virginia Woolf?* in the *Tulane Drama Review* for being "homosexual theater.")

Vidal, Albee, and others were incensed by Kauffmann's bigotry— "Short people can't write about tall people?" Albee asked many years later—but, at the time, they didn't express their disgust in letters or phone calls to the almighty *Times*.

Crowley, once he'd put down the Sunday *Times*, taken a sip of coffee, and pondered Kauffmann's thesis, found a small morsel of

hope at the core of the essay's narrow-mindedness. He kept coming back to three sentences that Kauffmann wrote, "If [the homosexual] is to write of his experience, he must invent a two-sex version of the one-sex experience that he really knows. It is we who insist on it. Not he."

Eureka! "Why not me?" Crowley thought.

Homosexual playwrights writing homosexual characters? "It was an interesting notion that no one had done this before," said Crowley. "It would be refreshing to let it all hang out. And what did I have to lose? Nothing."

The thing Crowley hated about plays that did dare to include a gay character or two is that they invariably turned sexual orientation into a surprise factor, the big revelation reserved for the third act. "Well, life is not like that," he believed. "Not all faggots bump themselves off at the end of the play."

If Vidal wrote *Myra Breckinridge* in a four-week burst, Crowley took only a week longer to complete the first draft of *The Boys in the Band*, inspired by an all-gay birthday party he attended in Los Angeles with his good friend Howard Jeffrey. Broke and out of a job, Crowley wrote the play while house-sitting actress Diana Lynn's manse in Beverly Hills because "I had to sublet my own house to a European actor making a bad movie in Hollywood," he recalled. In his former life as Natalie Wood's secretary, he'd written a screenplay, *Cassandra at the Wedding*, in which the actress would play twin sisters, one of whom is lesbian. "Natalie was game, but Darryl Zanuck pulled the plug," says Crowley.

"Too many dykeisms," Zanuck had complained.

Then Crowley wrote *The Decorator*, a TV pilot for producer Dominick Dunne. It was to star Bette Davis as an interior designer, but the network didn't pick it up. By 1967, Crowley had "nothing to lose" writing about eight, possibly nine, homosexual men at a party in Manhattan in which one of the characters is given a hustler for his birthday present.

Crowley had nothing to lose—except his mind, in Dominick Dunne's opinion.

The two men were at opposite ends of the Hollywood totem pole. Dunne was vice president of Four Star Television. Crowley was Natalie Wood's former secretary. One night, regardless of their employment disparity, they found themselves together at a party in Malibu for the Royal Ballet of England, a fete that featured much wine, grass, line-dancing, and ogling of the most beautiful dancers in the world. Taking a break from the voyeuristic rites, Dunne asked his unemployed writer-friend to take a walk on the beach. Both men slipped off their shoes. "I'm worried about you," Dunne began. "You're drinking and not working. What's going on?"

"Oh, don't worry," Crowley replied. "I'm busy. I'm writing a play."

"Great. What's it about?"

Crowley told Dunne as much as he knew about the gestating project. "It's about a bunch of gay guys getting together at a birthday party."

Stunned, Dunne tried to be diplomatic. "Well, Mart, I think it's great you're writing a play. It's good for you. It's therapeutic. . . ."

"It's going to be terrific. It is terrific!" Crowley exclaimed.

When Dunne asked the play's title, Crowley said he liked *The Birthday Party* but Harold Pinter had beaten him to it. Then there was *Somebody's Children*, but it was too maudlin. "How about *The Boys in the Band*?" Crowley asked.

Dunne didn't know what it meant. Crowley explained: It's that line in *A Star Is Born* when James Mason tells a distraught Judy Garland, "You're singing for yourself and the boys in the band."

Still stunned, Dunne realized his friend could not be deterred. "Just don't let it throw you if it doesn't get produced," he offered weakly.

Crowley said he wasn't worried. He was going to the East Coast in a week. Natalie Wood had already talked to her fiancé, Richard Gregson, whose agency, London International, had offices in New

York City. Gregson would get him an agent to represent the play. After all, "I knew people were not going to jump to perform this play. But that's what made it different." He just knew it.

On his plane trip eastward, Crowley never considered that London International might not represent his play. That possibility occurred to him only later, when he met the agent Janet Roberts. It was clear from their initial, tepid handshake that the meeting was pro forma, a courtesy to Gregson—and nothing more.

Crowley hand-delivered his typed manuscript to Roberts, and she offered to read it that very afternoon while he went around the block to see *Bike Boy*, the Andy Warhol movie playing in a run-down movie house nearby. When he returned to her office, Roberts was "a changed woman," Crowley noted. And not in a good way. She sat at her desk, straightening pencils, scooping up cigarette ash into little piles, patting everything down, and never once looking Crowley in the eye. Finally, she said something. "I don't know anyone I can send this to," she began. "I don't know why Richard sent you. We couldn't possibly send this play out on our letterhead."

Crowley asked why not.

"This is, why, it's like a weekend on Fire Island!" she exclaimed in horror.

Crowley thought, "Not a weekend, darling. At best a day, I obey the unities!" But he didn't say that. He just sat there.

Roberts did offer him a smidgen of hope regarding a possible production. "Maybe in five years," she said. "Maybe ten years, but not now."

Crowley choked as the walls of the agent's office started to tighten around him. Maybe Dominick Dunne was right. Maybe no one wanted this play. "What about Richard Barr?" he blurted out. "Could you send it to him?"

"Of course I know Richard Barr," said Roberts. "Why him?"

"Anyone who had the courage and foresight to produce *Who's Afraid of Virginia Woolf?* would be right for this play. Would you send it to him?"

Roberts went back to her neat piles of cigarette ash. Again, she avoided looking at Crowley. "We couldn't officially submit it to him." Finally, she came up with a compromise: "We'll ask his opinion."

With Diana Lynn having returned to her Beverly Hills house and that European actor still renting Crowley's West Hollywood apartment, the author of the possibly moribund *Boys in the Band* suddenly found himself without a home, money, or options. In New York City, Crowley was staying with friends, the actor Robert Moore and his partner, George Rondo. The day after Crowley's humiliation at London International, the phone in Moore's Eighth Avenue apartment rang. It was Janet Roberts. She wanted to speak to Mart Crowley.

"Well, I don't know how to tell you this," she began. "I'm really surprised. Can you have drinks with Richard Barr and Edward Albee this afternoon at five o'clock? At Barr's apartment?"

There, six hours later in Richard Barr's apartment, Mart Crowley listened as the producer of *Who's Afraid of Virginia Woolf?* told him that he wanted to stage his play, *The Boys in the Band*, at the Playwrights' Unit, a theater devoted to new plays that was operated by him, Albee, and fellow *Virginia Woolf* producer Clinton Wilder. It would be a workshop situation. There would be only five performances.

Barr was enthusiastic in his praise of Crowley's play. Albee let Barr do the talking. Crowley noted, "Edward didn't say he liked it. He didn't say he didn't like it."

Since the Playwrights' Unit had a backlog of unproduced plays written by other young, promising writers like Sam Shepard, Terrence McNally, and John Guare, they didn't have an opening for at

least three months. Maybe there would be a slot in January to get the play up and running, and to see what they had. Crowley blurted out, "Could Robert Moore direct?"

Albee, of course, knew the actor from his upcoming Broadway production of *Everything in the Garden*, in which Moore played the supporting role of a man murdered by neighbors who operate a suburban brothel. Yes, Moore would be perfect to direct *The Boys in the Band*, it was decided. Since Albee's play was scheduled to open that November, Moore could direct Crowley's play during the day when he wasn't at the Plymouth Theatre being murdered at night.

"It was October 1967," Crowley recalled. "Out on Fire Island, I polished *The Boys in the Band*." Moore helped with rewrites; he made several suggestions, especially with regard to rearranging some of the dialogue and scenes—that is, until Crowley exploded, telling him, "I asked you to direct *The Boys in the Band*. I didn't ask you to fucking rewrite *The Boys in the Band*!"

Moore shot back, "I'm only directing this play to get you out of my apartment!"

While the show's respective playwright and director, Mart Crowley and Robert Moore, may have had "nothing to lose," the actors they chose to be their "boys" did. Laurence Luckinbill, Leonard Frey, Cliff Gorman, Kenneth Nelson, Frederick Combs, and Keith Prentice had assembled, among them, an impressive résumé of New York stage credits, including such well-known titles as *A Man for All Seasons*, *Fiddler on the Roof*, *The Fantasticks*, *A Taste of Honey*, and *The Sound of Music*. In other words, they weren't novices, and they all risked future employment by playing homosexuals onstage in the year 1968.

Agents traditionally send their clients the script before an audition. It was different with *The Boys in the Band*. The actors had to go to the theater to read the play. There were two reasons for this departure from tradition: the work's unconventional subject matter,

and the fact that the New York agencies put up an unofficial boycott of the play. Luckinbill's agent, the same Janet Roberts who was now Crowley's reluctant agent, told her actor-client, "Don't get involved. It will wreck your career." Compounding her lack of faith in the project was Roberts's fear that representing the play might expose her as a lesbian who was married to a gay man. Luckinbill, however, needed the work.

So did Leonard Frey. "I read the play and, well, I must do this because I'm out of work and it is a play. Playing a pockmarked Jew fairy didn't make me hesitate a bit," said Frey.

Cliff Gorman had just appeared in *Hogan's Goat* with Faye Dunaway and was down to his last two weeks of unemployment insurance when his agent informed him that they were casting a North Carolina production of *The Knack* at the Playwrights' Unit. He was told, "There may be a part in it for you."

The Unit, however, had already cast that show by the time he showed up for the audition. "There's nothing in *The Knack*," a casting director told Gorman, "but we are doing a play here at the Unit, an original play called *The Boys in the Band*. Now, it's about homosexuality, that's the theme. To be quite frank with you, the play's been cast, but there's one part that nobody wants to do. It's the part of a very effeminate homosexual. We've tried to get actors who are overtly gay to play the role, they won't do it. There's something that turns them off about it and they can't. Would you like to read for it?"

Gorman said, "Yeah, I don't give a shit."

He read, they liked him, but the next day they informed him, "Very good, but someone else is doing it." Then they called a day later to tell Gorman that the other actor had decided against playing such an outrageous homosexual. "You wanna do the role?"

"Yeah, I don't give a shit."

Others in the cast were less experienced or had no experience whatsoever on the stage. Like Reuben Green, who was a good-looking

print model. Or Robert La Tourneaux, whom Crowley spotted at the popular tea dance at Fire Island Pines, and thought looked right to play the empty-headed hustler, the show's "birthday present." Robert Moore took one look at La Tourneaux and nixed the idea. "You're so Hollywood in your casting," he told Crowley.

"He's only got eleven lines in the play," replied Crowley. "How bad can he be?"

Although he studied at the Yale School of Drama, Peter White had virtually no professional experience onstage. He worried about ruining his career before he got started in the business. But, "They've got respectable actors who have careers," he thought. White didn't even have a career, yet. He knew the legendary movie actress Myrna Loy, and it was she who convinced him to take the role. "Peter, if you want to be an actor, you've got to take risks," she told him.

But no sooner was White cast as Alan, the party's interloper who may or may not be gay, than his agent fired him for accepting the role. "We all lost our agents," White recalled.

Shortly before *The Boys in the Band* opened in late January for the first of its five performances at the Playwrights' Unit, White asked Crowley if the Alan character is gay or straight. "I don't know," said Crowley. "Make up whatever you want, just don't do it tonight."

Gore Vidal's *Myra Breckinridge* hit the bookstores almost to the day that Mart Crowley's *The Boys in the Band* opened in New York City. It was January 23, 1968, and the wicked six-degree temperature that night kept more than a few of the theater's two hundred seats unsold. Crowley, Robert Moore, and Richard Barr were milling about among the empty seats in the back rows at 15 Vandam Street. Crowley suddenly came down with a bad attack of dry mouth. He had trouble swallowing but managed to ask Moore, "Do you think they'll laugh?"

Moore told him not to worry. "They've been laughing at fags since Aristophanes. They're not going to stop tonight," he said.

The next morning "word somehow got out," said Crowley, and

despite the cold rain, a line of black umbrellas stretched down the street for more than a block beyond the theater's box office. Crowley told himself, "Wow! It's like the third act of *Our Town* out there! Minus the funeral."

After opening night of the workshop, *The Boys in the Band* sold out its other four performances, which quickly grew to nine—the audiences virtually all male. Richard Barr wasted no time taking out an option for a full commercial production at Theater Four on West Fifty-Fifth Street. Edward Albee, however, did not come aboard as producer or investor. "I found it highly skillful work that I despised," he said. "Barr understood the commercial value of the play. He may have liked it a great deal. I expressed my opinion that the play did serious damage to a burgeoning gay respectability movement in New York City. That's why I was opposed to it being produced."

Crowley would later scoff at that criticism. "It was 1968! There was no gay respectability movement," he said.

Albee wasn't the only one at the Playwrights' Unit to object to *The Boys in the Band*. The third partner in the triumvirate left the theater over objections to the play. As Crowley described him, "Clinton Wilder was a wealthy man, who was a patron of the arts. He was very uptight for a gay man, and he wanted nothing to do with *The Boys in the Band*."

Wilder drew the line somewhere between *The Boys in the Band* and *Who's Afraid of Virginia Woolf?*, which he'd been skittish about getting involved with half a dozen years earlier. Back in 1962, when he first showed an early draft of *Virginia Woolf* to the show's press agent, Howard Atlee, he cautioned, "Here it is, if you can get through it." And even *Virginia Woolf* did not get to Broadway without some reservations from the more liberal Richard Barr, who thought the script overused the words "fuck" and "motherfucker," which had been uttered Off Broadway but never on Broadway. Barr told Albee, "I'll take one 'fuck' uptown." The producer feared that

"the sensationalism of breaking the 'word-barrier' would prejudice" reviewers, maybe even "revolt" them. In the end, Albee substituted the word "screw" and went on to also remove "shit" and "bullshit," replacing them with "hell," "crap," and "nuts."

"Fuck," uttered a few times in *The Boys in the Band*, was minor stuff in 1968, although the word had not yet been heard in a Broadway show. "When we closed [at the Unit], word had it that maybe somebody would stage the play off-Broadway, and maybe on Broadway," Cliff Gorman recalled. "So there was a lot of laughter about that, because we said it couldn't be done. You know, you couldn't say 'fuck' on the [Broadway] stage at that time. So we all packed up our make-up and went home" after the show's initial nine performances.

Only the year before, Jules Feiffer introduced the word "shit" to Broadway with his comedy *Little Murders*, where the word was mentioned four times in as many minutes. (And perhaps as a result, Feiffer's show played only eight performances before closing. In London, the Lord Chamberlain made him change the word "shit" to "dog crap," which Feiffer found "infinitely more vulgar.")

More than uttering the word "fuck" a lot, the characters in *The Boys in the Band* broke ground in that they presented their sexual orientation as a given, and not something to be cured or revealed as a secret to titillate the audience. It's what distinguished it from *The Killing of Sister George*, by Frank Marcus, and *A Patriot for Me*, by John Osborne, both of which had run into censorship problems in their home country of Britain.

Most people involved with *The Boys in the Band* doubted it would ever resurface on Broadway or Off Broadway in a full-blown commercial production. As the show's set designer, Peter Harvey, put it, "I'm sure everyone gay in New York will come, and when they've seen it we'll close it."

Spring 1968, Partners

A few dozen blocks uptown, the powers behind the new Off-Broadway musical *Hair* had already decided to make the jump to Broadway.

Mart Crowley knew James Rado. They'd been classmates at American University in Washington, D.C. "Even in college he had a hair fetish," said Crowley, referring to Rado's premature toupee. Ironically, Rado and his lover, Gerome Ragni, had conceived this new stage musical called *Hair*, and could not wait to add all the freethinking, mind-expanding elements to the upcoming Broadway production that impresario Joseph Papp wouldn't permit when the musical opened downtown the previous October at the brand-new Public Theater. Top of their list was the song "Sodomy," which went on blasphemously to declare the joys of fellatio, cunnilingus, pederasty, and masturbation.

Ragni and Rado were on something of a mission. "We thought people should know those words, that it was a gift to the people to know these words about human sexual practices," said Rado.

That gift also included naked bodies onstage, in other words, a nude scene. "Joe wouldn't allow it," said the show's composer, Galt MacDermot. " 'Sodomy' was not in the Joe Papp version, neither

was 'Black Boys.' That's why Jerry and Jim wanted Tom O'Horgan to direct. Tom was much more the troublemaker, a controversial director. Jim and Jerry knew they could do almost anything with Tom, and they did," said MacDermot.

In one altercation with the boss at the newly formed Public Theater, Rado and Ragni had sent Papp a long memo of complaints about the nascent Off-Broadway production of *Hair*, which, being the theater's inaugural show, had much riding on it. Even though Papp's office was only a few yards away, an assistant returned to the rehearsal space, asking, "Who's Rado and Ragni?"

When the two men nodded, Papp's assistant promptly dropped several torn bits of paper on the floor in front of them. It was their memo.

How dare he? *Hair*, in Rado and Ragni's opinion, was their show. They'd conceived the story about a bunch of free-love hippies who burn their draft cards; they'd written the book and lyrics, and felt they had every right to have veto power over Papp's director of choice, Gerald Freedman, who'd not only turned *Hair* into a shrill antiwar screed but fired Rado from starring with his lover Ragni in the Off-Broadway production.

After *Hair* played a couple of months at the Public, Papp didn't so much lose interest in the musical when it closed on schedule as he became more interested in other projects, like his own production of *Hamlet*, which he directed. As he explained the situation to Rado and Ragni, "We do shows for eight weeks only."

The *Hair* story might have ended after its first eight weeks of performances, the victim of Papp's Shakespeare ambitions, if not for another would-be impresario, in this case a political dilettante with showbiz ambitions. For the handsome scion of Chicago's J. W. Butler Paper Company, it was a question of what came first, the U.S. Senate or Broadway. *Hair*, with its liberal political bent, made the choice an obvious one for Michael Butler. He promptly acquired the

Broadway rights to the show and immediately found himself more in synch with Rado and Ragni than with Papp and Freedman. Did it matter that he'd never produced a Broadway show? He'd never run for the U.S. Senate either.

Butler agreed completely with the *Hair* writers' complaints about the Off-Broadway production. "I had questions about Gerald Freedman, because he never had smoked grass," said Butler. Equally important, "I wanted Jim Rado back in the show. His relationship with Jerry, their energy, was at the core of the show." And he liked Rado and Ragni's original choice for director.

Tom O'Horgan, known as the Busby Berkeley of the acid set, came out of the burgeoning Off-Off-Broadway scene, where he immediately made waves by staging *The Maids* the way its author, Jean Genet, intended it to be performed: in drag with men playing the female roles. Rado and Ragni were impressed, and they also loved his production of Rochelle Owens's play *Futz!*, about a farm boy who falls in love with a pig.

O'Horgan knew just what to do with *Hair*: Add all the songs that Papp and Freedman found offensive. Also, "We were looking for the real thing, but the kids who did it at the Public were like glossy print kids—regular kids that they dressed up like hippies," said O'Horgan. "It was pretty awful."

He instead cast a lot of real hippies, culled from various East Village haunts. They weren't easy to find. "Frustration was so high we had taken to chasing anyone down the street who vaguely looked right," said O'Horgan. His original concept was for the actor-hippies to live in Broadway's Biltmore Theatre, which would have forced theatergoers to walk through their laundry, clutter, and garbage in order to find their seats.

"That was one of Tom's major things, he wanted to make it an environmental theater piece, like people were living in the theater,"

said Marc Cohen, a longtime friend and professional associate. "He wasn't able to do that, but otherwise he thought he got pretty much what he wanted with *Hair*."

Various city and union laws ruled out O'Horgan's environmentalism. He lost that battle, but with Papp and Freedman out of the way, there was no resistance to O'Horgan's giving Broadway its first nude scene—or, more accurately, Broadway's first group nude scene.

The nudity wasn't something Rado and Ragni dreamed up on an acid trip. In March 1967, they'd seen a couple of men strip naked during a be-in that brought ten thousand people into Central Park. Rado recalled, "These two guys in the midst took their clothes off, and everybody was just amazed and astounded, just like an audience. It sent them into this incredible place they had never been before." Undercover cops in the park alerted officers on horses, and suddenly the Sheep Meadow looked as though it was being overrun by a cavalry of men in blue. The two naked men escaped, never to be arrested, as the crowd began to chant, "We love cops! We love cops!"

"It was the perfect hippie happening," said Rado, "and we felt it had to be in the play."

So did O'Horgan. Rehearsals for the Broadway version of *Hair* were, for a while, a total meeting of four minds: O'Horgan's, Butler's, Rado's, and Ragni's.

"Galt MacDermot didn't fit in. He did his job. He didn't hang out," said Butler.

MacDermot agreed with that assessment. "I didn't find them farout," he said of his *Hair* cohorts. But they were different.

Rado and Ragni, who had recently split with wife Stephanie, were lovers who lived in Hoboken. MacDermot had a wife and four kids in Staten Island. Rado and Ragni dressed like hippies and had long hair, although the balding Rado usually wore a wig. MacDermot kept his hair short, and he even wore a business suit and tie when Rado and Ragni took him to the East Village's Tompkins Square

Park to research the hippie scene. The park's denizens, camped out in tents among the crumbling brownstones, thought he was a narc. Despite his crewcut and crisp white shirts, MacDermot wrote music incredibly well and he wrote it fast—so fast that, even though he polished off his initial batch of fifteen *Hair* songs in just two weeks, he didn't play them publicly for another two weeks, in case anybody got the impression that he'd cranked them out in only two weeks.

Rado and Ragni never talked publicly about being gay. Even decades later, Rado would prefer to use words like "pansexuality" and "omnisexual" to describe himself. Those words also described *Hair*, he said, "which is about the idea of a close friendship, a male bond, a strong male bond in which love happens. That was the thing going for it, that outward love and being unafraid to embrace and be free. In that sense, we reflected that ourselves. We went with those feelings, that was the core of the piece. One thing that came through during the hippie movement was actual physical contact between men. You see that now, but you never did before—at least not in America—until the hippies started doing it."

For Rado and Ragni, the musical's basic triangle of three men— the renegade Berger, the draftee Claude, and the openly bisexual Woof ("I wouldn't kick Mick Jagger out of bed")—might have looked like merely a tribe thing, as Rado also termed it. "With all people in the tribe, there was affection and physicality," he said.

To *Hair*'s choreographer, Julie Arenal, the tribe looked more like just a guy thing. The lone woman on the show's creative team, Arenal complained that the show's principal female characters—the free-loving Sheila and the already pregnant doormat Jeanie—were in danger of becoming minor distractions to the main event of the three men's free-roaming love affair.

It was an example of art imitating life and vice versa.

"Working on *Hair* was a very guy situation," said Arenal. She also called it a very delicate situation, working with the three men.

"They weren't militant. It's just that they liked the boys. They had a good time together. It's what they preferred. It wasn't a statement.

"Ragni and Rado were like any couple," Arenal continued. "They fought. They didn't fight."

O'Horgan was a bit more complicated. Back then, "Tom was very secretive about himself," said Marc Cohen. "He was more like a straight man who liked young guys. He wasn't very overt about it. He expressed his sexuality through his theater."

It was Michael Butler's opinion that Ragni and Rado were essentially writing about themselves, with the charismatic leader Berger being Ragni and the middle-class Claude being Rado. It's the major reason why, unlike director Gerald Freedman, Butler wanted Rado to costar with Ragni in the show when they took it to Broadway. "They were lovers," he said. "Their chemistry had a very strong effect on the show. Jim was a lost child following this crazy man. Ragni was wild, very difficult to deal with. Jim was the reverse. They were essentially playing themselves onstage."

In rehearsals, however, Arenal found the show oddly off balance. At one point, she dared to ask O'Horgan, "Why aren't the girls onstage? Are there no girls?"

Which is what made it a delicate situation.

Only twenty-seven years old, Arenal was the youngest and least experienced theater professional of the group. Even though Rado and Ragni were playing young hippies, they both now lived on the dark side of thirty and routinely shaved a few years off their respective ages in order to observe the era's "don't trust anyone over thirty" credo. The very petite Arenal was the only one who looked like a teenager, and it was her opinion that the forty-four-year-old O'Horgan had hired her at Ragni's insistence—she and the writer-actor used to hang out together at a coffeehouse on Tenth Street and Second Avenue—and, more important, "I was the least threatening,

hadn't done much, and O'Horgan didn't want anyone who had a huge presence," she said.

O'Horgan also didn't want to give Arenal any credit for choreographing *Hair.* Thanks to Galt MacDermot and the choreographers' guild, she eventually got credit. It wasn't so much their heterosexuality as their sobriety that bonded Arenal and MacDermot. "It was crazy backstage," she recalled. "They did everything. That's why I became friendly with Galt. We were the only ones who didn't do drugs."

Michael Butler had hired Dr. John Bishop, the erstwhile physician of LSD advocate Timothy Leary, to administer vitamin injections to his company. Even before the show opened on Broadway, there were suspicions among the cast that those shots contained something more than just B_{12}. At one early preview, after Dr. Bishop had made his rounds at the theater, Arenal noticed that a lot of the actors were "spaced-out. It was the worst preview."

Cast member Marjorie LiPari sampled Bishop's brew three times, then stopped. "You tasted the Vitamin B_{12} mode in your mouth instantly," she said, "and then you felt the speed mode. And when you crashed, you got a bit of depression."

Given the cast's amphetamine intake, their long hair and hippie clothes, their four-letter-word language, and the show's two male leads being openly in love backstage, it wasn't surprising that some people would take offense.

"The stagehands hated us," said Arenal. The middle-aged stagehands from Jersey wished they were employed in Eydie Gorme's and Steve Lawrence's new musical, *Golden Rainbow*, about normal people who worked in Las Vegas casinos. Instead, they had to watch night after night as a bunch of dirty longhairs burned their draft cards, yelled obscenities, and got naked.

And it only got worse when it came to getting naked. In the beginning, O'Horgan considered having the cast wear body stockings for

the nude scene, but costume designer Nancy Potts advised against it. He did, however, make it voluntary for the actors to participate in the nude scene at the end of act one. "Only a few did it at first, three or four guys and girls. Then most everybody did it," Galt MacDermot noted.

At the very first preview, on April 11, only three cast members disrobed—Ragni, Steve Curry (who played Woof) and Steve Gamet, a member of the tribe—and even they were law-bound. Nudity on the New York stage was legal only if the naked actors did not move. That very first night, the three daring young men of *Hair* took off their clothes under a slitted scrim and then rose up through the scrim's openings, their naked limbs bathed in a rather dim overhead lighting. The whole scene lasted about twenty seconds. Lighting designer Jules Fisher called the low wattage "a totally artistic decision. The brightness level was related to what was right emotionally at that moment, not to public mores."

Although O'Horgan had discussed the possibility of doing a nude scene with the cast, he never rehearsed it. When Ragni, Curry, and Gamet disrobed at the first preview, "[e]veryone was momentarily shocked," reported cast member Lorrie Davis. "They never did it at rehearsals."

In following previews, two other cast members joined the original three and stripped, but Michael Butler worried that the nude scene looked underpopulated, and talked about hiring ringers. "At first I was apprehensive about doing the nude scene," said cast member Erroll Booker. His hesitance had as much to do with exposure as the effect of Dr. Bishop's injections on his physical appearance. "The shots 'shriveled up my member,' as they say in Victorian novels. Not only mine, but you'd see all the dudes under the scrim pulling at their own, trying to straighten them out."

By opening night, more actors consented to strip, and in time, it was not uncommon for various members of the ensemble to jockey

for optimum exposure at the front of the tribe. "Many of the girls were so anxious to strip they didn't even take time off while they were menstruating, and we and the audience were treated to the sight of hanging tampon strings," reported Lorrie Davis.

Butler never had to carry out his threat to hire professional strippers, and since everybody obeyed the tableau rule, which forbade swinging penises and breasts, the authorities never made any arrests. O'Horgan, however, made up for that lack of publicity by having his nude scene accompanied by a bogus "raid" on the theater, with flashing red lights and the appearance of two actors dressed in cop uniforms to "arrest" the audience.

O'Horgan never got to see his cast actually take up residence in the Biltmore Theatre, but the show's free-love ethos permeated the place nonetheless. "There was a time when you couldn't go anywhere in the theater—hallways, dressing rooms, the balcony, and especially the johns—without falling upon two or three members of the cast doing drugs or having sex, or both," reported Lorrie Davis. "There were any number of gay or straight combinations."

If the stagehands hated *Hair*, at least they could wear earplugs to block out the loud rock music and lyrics. Likewise, the producers in the Broadway League had their own way of blocking out the show: The League denied *Hair* a place at its Tony Awards that spring, arbitrarily moving up the eligibility date to mid-March so that *Hair* with its April 29 premiere date did not qualify.

It didn't matter. The show, thanks to all those naked stationary bodies, became an immediate sellout.

"I have to thank the nude scene for getting a lot of people into the theater," said Michael Butler. "That was the end of the first act, and then we had them for the second act, which is when the antiwar message was really laid out for them."

Even before the show officially opened, it was already attracting the famous and the newsworthy. John Schlesinger and his new lover,

photographer Michael Childers, saw *Hair* in previews, and the film director was so impressed with Jonathan Kramer, who cross-dressed in the musical, that he cast him to play the sexually ambiguous Jackie in his new movie *Midnight Cowboy*.

Celebrities had their choice that spring: *Hair* or that new homosexual play, which also opened in April, at the tiny Theater Four on West Fifty-Fifth Street.

As the set designer of *The Boys in the Band* had surmised, "I'm sure everyone gay in New York will come, and when they've seen it we'll close it."

NEW YORK, AS IT turned out, had a lot of gay theatergoers. In a near state of shock, the reviewer for the *Saturday Review* felt compelled to alert readers that at the performance of *The Boys in the Band* he attended the audience was "98 percent male!" That bit of warning aside, the review was a rave. Most of the reviews were raves. Jackie Kennedy, Marlene Dietrich, Groucho Marx, and Margot Fonteyn (who had to sit on Rudolf Nureyev's lap to see the sold-out show) made their daring pilgrimage to Theater Four, giving the show the imprimatur of hipness, if not respectability. The cast, equally in awe and star struck, even fashioned a peephole in the back of the living room set so they could watch the reactions of the famous out front in the audience.

The play's detractors saw another reason for its success with nonhomosexual audiences. As Edward Albee described it, "I saw straights who were so happy to see people they didn't have to respect."

The review in *Time* magazine, while positive, could only have reinforced Albee's concern. It called *The Boys in the Band* "a funny, frank and honest play about a set of mixed-up human beings who happen to be deviates. The occasion is a birthday party for Hank, an event as ominous for a homosexual as for an aging woman with its reminder that good looks can fade and desirability diminish."

Wilfrid Sheed in *Life* applauded *The Boys in the Band*, because it "calls a fag a fag, so that we do not get the unlovely confusion that some people claimed to find in *Virginia Woolf*, where everyone got the worst of both sexes. . . ."

Unlike Albee, who had never written an overtly gay-themed play, Mart Crowley had no choice but to come out with *The Boys in the Band*, his sexual orientation a given with journalists—like the *New York Post* reporter who wrote that his play presented "a party of bitchy fags and queens."

In reply, Crowley offered a strong defense of his play's fictional characters and their real-life counterparts. "Probably most homosexuals today are unhappy," he told the reporter from the *Post*. "But that's because of stupid social taboos, not because of their state. I hope in a few years attitudes will change. There won't be the fear about blackmail, the hang-ups, the self-doubts." He especially objected to people taking out of context his character Michael's suddenly infamous line "Show me a happy homosexual and I'll show you a gay corpse."

"Michael needs his analyst, but he is aware of his problems. He's working them out gradually," the playwright offered.

But even Crowley couldn't resist the urge to protect his actors from getting the gay rap. "Cliff Gorman, the one who plays the queen, has a wife and children. He's nothing like that offstage. It's hard to believe, isn't it?" Crowley asked in answer to his own question.

In the *New York Times*, *The Boys in the Band* finally came full circle. The paper's new theater critic Clive Barnes wrote: "A couple of years ago, my colleague Stanley Kauffmann, in a perceptive but widely misunderstood essay, pleaded for a more honest homosexual drama, one where homosexual experience was not translated into false, pseudo-heterosexual terms. This I think *The Boys in the Band*, with all its faults, achieves. It is quite an achievement."

According to Edward Albee, *The Boys in the Band* couldn't lose with theatergoers: It attracted the gays who were eager to see

themselves onstage under any circumstances, as well as the straights who were eager to feel superior. The heterosexual embrace of the play even extended to Kenneth Tynan, who came to see *The Boys in the Band* and promptly asked its author to write a sketch for his new sex revue. Crowley, suddenly flush from royalties and now living at the famed Algonquin Hotel, could afford to pass on that assignment. "People like Tynan scared the shit out of me," said the playwright. "He was so ruthless as a critic. Who knew what he was going to say or do?"

But there were other takers, as well as decliners, to Tynan's offer, which apparently had gone out to nearly every New Yorker who'd ever put a sheet of paper through a Smith Corona.

Philip Roth declined the offer. Roth's friend Jules Feiffer said he'd give it a try.

Roth and Feiffer had recently taken up residence at the Yaddo artists' retreat in Saratoga Springs, New York, to work on respective projects. Roth was a Yaddo veteran; Feiffer, a Yaddo virgin. Roth had helped his *Village Voice* cartoonist friend get accepted there. Both men had sex on the brain: Roth was working on a novel about masturbation. Feiffer had this half-finished play about two men who befriend each other in college, and then proceed to go through life making love to lots of women without really liking women.

In addition to his weekly strip for the *Village Voice*, Feiffer also contributed cartoons regularly to *Playboy* and made frequent visits to Hugh Hefner's Chicago mansion, where that winter Drs. William Masters and Virginia Johnson had taken up residence to pursue their sex research under the largesse of the *Playboy* founder-publisher-editor. While the two good doctors tried to remove the mystery from sex with their bestselling *Human Sexual Response*, Feiffer was far more intrigued by those who followed the diktat of the brass plate on the Chicago mansion's front door, which gave notice in Latin, *si non oscillas, noli tintinnare* ("If you don't swing, don't ring"). Those

who rang included all these "studs and cartoonists who made out like crazy," said Feiffer. One man-to-man conversation at the Hefner mansion gave him the idea for his new play. "A *Playboy* cartoonist told me how his girlfriend was mad at him because every time they had sex he took a shower, and he didn't know why she was mad when he came back to bed."

Hearing the sex-then-shower story, Feiffer told himself, "I have to use this somehow."

That "somehow" turned out to be his next play. But it wasn't easy to write—until Philip Roth told him about Yaddo.

For Feiffer, the cold isolation of the upstate retreat that year worked like a tonic. Writing twice the hours he normally did back in Manhattan—it took an hour to walk into Saratoga Springs, if the subfreezing weather didn't kill you—Feiffer soon had a first draft of his play, which he considered calling *The Thirty-Year War*. Then he had a better idea. When he'd polished the play and come up with the new, improved title *Carnal Knowledge*, he sent the script to his friend Alan Arkin to see if he wanted to direct. But Arkin declined. He told Feiffer it was "too dark." Next on Feiffer's list was Mike Nichols, who'd rejected his previous script, *Little Murders*, without so much as an acknowledgment of receipt. This time Nichols was a little faster to reply. He phoned the next day.

"I want to do it. But I don't think it's a play. It's a movie," said Nichols.

Feiffer asked, "Can we get away with the language on film?" The word "fuck" had been heard the year before in the film adaptation of *Ulysses*, but writer-director Joseph Strick had been careful to quote directly from the James Joyce novel, long banned but now a revered work of art. Even more controversial for Feiffer's script was his use of the equivalent of the N-word for females, "cunt," never before heard in a major English-language release.

Nichols dismissed Feiffer's language concerns. "We can do

anything we want," said Nichols, who ought to know, having directed *Who's Afraid of Virginia Woolf?* and *The Graduate* back-to-back.

"Give me thirty seconds to think it over," Feiffer replied. "Okay."

But Feiffer liked his play. He thought it worked as play. Perhaps he could rework all that bitter sex into something suitable for *Oh! Calcutta!*

Philip Roth, on the other hand, wasn't about to dilute his Yaddo project with yet another spin-off, not even for Kenneth Tynan. He'd already sold a chapter of his novel, titled *Portnoy's Complaint*, to *Partisan Review*. The chapter "Whacking Off" had titillated readers of *Partisan Review* in ways that the readers of the William Shawn–censored *New Yorker* never were.

Roth had been toying with his ode to "whacking off" for years, even before he finished his most recent novel, *When She Was Good*, published only the year before.

He took stabs at writing, and even titling, two unpublished novels, *The Jewboy* and *Portrait of the Artist*, and a play, *The Nice Jewish Boy*, which had received a workshop with Dustin Hoffman at the American Place Theater in 1964. In essence, all three works were about a Jewish boy, his father, and the Gentile girls—the shiksas—whom they both desired sexually. Having taught at the Writers' Workshop at the University of Iowa, Roth noticed that there, among the cornfields and the farm boys, several of his more urban Jewish students were prone to writing, in essence, that same story. "The Jewish women are mothers and sisters. The sexual yearning is for the Other," Roth noted. The shiksa.

Meanwhile, Roth had been entertaining friends with something a bit more theatrical, something that Kenneth Tynan had heard about from friends and would have killed to get his hands on for his stage revue. It was, in fact, a slide show or, more accurately, a fantasy slide show that would exhibit the sex parts of the famous, including

"L.B.J.'s testicles, Jean Genet's anus, Mickey Mantle's penis, Margaret Mead's breasts, and Elizabeth Taylor's pubic bush," which is how Roth described them. He never got around to titling his slide show monologue, because he knew "it was blasphemous, mean, bizarre, scatological, tasteless, spirited," and therefore would always have to remain unfinished, unperformed, unpublished, and, at best, a private joke for friends after dinner and too many highballs. Roth reckoned that if this slide show monologue ever did surface, it would make his new novel *Portnoy's Complaint* "appear to be the work of Louisa May Alcott."

It could be said, however, that the imaginary slide show monologue begat the very real novel. Roth found sixty or seventy pages about jerking off in the monologue "to be funny and true, and worth saving, if only because it was the only sustained piece of writing on the subject that I could remember reading in a work of fiction."

For some reason, the most mundane sex—masturbation—had also been the least explored by writers.

But that April, *Portnoy's Complaint*, despite its "Whacking Off" chapter in *Partisan Review*, remained as unfinished as the slide show monologue. Roth was blocked, and his writer's block had something to do with hating his estranged wife, Margaret Martinson, who would not divorce him after tricking him into marriage by claiming a false pregnancy (verified at the time by her purchase of a vial of urine for ten dollars from a pregnant woman in Tompkins Square Park). For that deception, she was now receiving about 50 percent of what Roth made as an author, which left him approximately $250 a week. Maybe that had something to do with his not finishing *Portnoy's Complaint*, which, Roth knew, could make him as much money as *Couples* was now making for John Updike. It was potentially an awesome sum, 50 percent of which would go to his ex.

. . . .

COUPLES, A TALE OF upper-middle-class spouse-swapping in old New England, contained long paragraphs of sexual explicitness, the kind that the author had been forced by his editors at Knopf to excise from his first novel, *Rabbit, Run*. Back in 1959, the battles over printing and selling D. H. Lawrence's long-banned *Lady Chatterley's Lover*, Henry Miller's *Tropic of Cancer*, and William S. Burroughs's *Naked Lunch* were still being fought in the courts, and even when the respective publishers won those cases, Knopf continued to ask for revisions from its twenty-seven-year-old author, then a staff writer at *The New Yorker*. Especially egregious, thought the Knopf editors, were the eight pages it took Updike to have his hero, Rabbit, sexually mount a part-time prostitute named Ruth. A distraught Updike wrote to his parents, "The issue seems to me to amount to whether I am really going to write in my life, or just be an elegant hack."

But it wasn't just Knopf editors who were having doubts. Updike also started editing himself because, according to his one of his editors, "John could see himself having legal suits and ending up with no money and four young children to support. So he said to Alfred Knopf, 'maybe you should get a lawyer in to look at the obscene parts.' Alfred arranged for the lawyer to come in at the weekend, then telephoned John in Massachusetts. And John said: 'Oh no, I can't come down this weekend, I'm teaching Summer Sunday School.'"

Out went most of the eight pages of Rabbit mounting Ruth, as well as a few other sexually vivid paragraphs here and there.

Eight years later, that same esteemed publisher, Knopf, was only too happy to capitalize on the graphic details of married New Englanders who committed so much adultery in the fictitious town of Tarbox, Massachusetts, that in Updike's ingenious prose the Applebys and the Smiths were dubbed the Applesmiths, and the Saltzes and Constantines became the Saltines. (The story line included eight

other promiscuous couples, so many couples, in fact, that most readers couldn't tell them apart.) And the details were graphic, but for a purpose. "In *Couples*," Updike claimed, "I was sort of a crusader, in a way, trying to make the reader read explicit sex: this is what sex is, blessed reader, take it or leave it—sort of an 'in your face' approach."

That in-your-face approach pushed the book's original print run of seventy thousand copies to the top of the bestseller lists, where it did battle with *Myra Breckinridge* and Arthur Hailey's *Airport* for the number one slot for several months, and Updike's earnings of half a million dollars in royalties were quickly matched by a half-million-dollar sale of the movie rights to the Wolper Company.

None of which was hurt by the fact that *Time* magazine, then selling a few million copies a week, put Updike on its cover that April with the cash-register-friendly headline "The Adulterous Society." Word got back to Updike that the higher-ups at Time, Inc. didn't much like the profile—either they thought the book was not well written enough for their esteemed cover or that it was just too darned dirty, or both. The result was a written-by-committee article that never really praised or damned the book. Instead, readers were told that *Couples* was not an "upper-middle-class *Peyton Place*" as "some critics" had claimed, even though some of those critics happened to be editors at *Time*. Updike dismissed the whole treatment of his novel in the pages of the magazine as "kind of a mess. I didn't think they said much about American morality or, indeed, the book," he would later complain. "My observation about American morality was that the introduction of the pill, and now whatever other handy contraceptive device there is, has had an effect on sexual morality, and that the fading of the work ethic and of Protestant belief has certainly changed our way of looking at things."

Updike, the son of a junior high math teacher who raised his family of five on $1,740 a year, saw none of these things, especially the pill, as a good thing, even though it was 1968. But then, he had

always been an outsider, especially at Harvard, where his poor up-bringing, his chronic psoriasis and stammer, and fear of spiders set him apart from the blue-bloods.

Add to that his rather late-blooming sexual awareness, which did not lead him to masturbate until well into his teens, and his having to learn about sex from erstwhile banned books like *Lady Chatterley's Lover*, *Ulysses*, *Tropic of Cancer*, and *The Story of O*. The sexual revolution of the 1960s freed Updike to write books like *Couples*, and not unwrite books like *Rabbit, Run*. But that literary freedom did not make Updike any more forgiving of the sexual, as well as political, licentiousness that he saw around himself and his wife, Mary, and their four children, Elizabeth, Michael, David, and Miranda. He drove a beat-up Corvair. They lived in a white saltbox house in Ipswich, Massachusetts, population: twelve thousand. And when he wasn't working on a novel or a short story for *The New Yorker* in his office above a greasy spoon, Updike could be found devising one of those 17th-century-day pageants that the citizens of Ipswich were so fond of putting on around the holidays.

It was a pretty wonderful, comfortable life, if Updike said so himself.

"There was a surge of belonging—we joined committees and soci-eties, belonged to a recorder group and a poker group, played volleyball and touch football in season, read plays aloud and went Greek-dancing and gave dinner parties and attended clambakes and concerts and costume balls, all within a rather narrow society, so that everything resonated. . . . As a group, we had lovely times being young adults in Ipswich, while raising our children more or less absent-mindedly and holding down our jobs in much the same style."

In its cover story on *Couples*, *Time* magazine approved of this tableau of domesticity, and noted that "the Updikes are the ring-leaders of a group of like-minded couples whom the older Ipswichers called the Junior Jet Set."

For Updike, the biggest problem was how to swallow a pill, not the pill. "In Ipswich my impersonation of a normal person became as good as I could make it. I choked only when attempting an especially hearty vitamin pill, and a stammer rarely impeded my incessant sociability," he noted.

But then came *Couples*.

Originally, Updike was going to call it *Couples and Houses and Days* because, as Updike described it, life "was about not just couples but about the houses they lived in. The fascination exerted by other people's houses; the notion that more happiness is happening in those houses than in your own; the look, in a small town, of other people's lit windows and the imagined bliss and contentment transpiring behind them as you drive by. And then of course the days, the days that keep delivering sunrises to and then sunsets, and that seem, in their long parade, to bring us some treasure which we persistently misreceive."

But yes, *Couples* was a much better title, if for no other reason than it was shorter. Plus, no one would remember the short story called "Couples" that he'd written a few years earlier, which generally covered the same spouse-swapping terrain, but which, Updike felt, at forty pages was "very overcrowded."

Updike liked to use a typewriter, but he wrote this new sex tome longhand on the back of old manuscripts in between an inordinate number of book review assignments from *The New Yorker*, most of which were French novels. He joked, "I seem to get all the religious ones or the dirty ones. Somehow the two go together; they are the ultimates of life." All those reviews had a telling effect on *Couples* because that's what it was about: how the upper middle class had turned sex into a religion to replace the old church kind of prayer. Equally curiously, Updike thought up much of the novel, he claimed, when he was supposed to be praying.

"I plotted *Couples* almost entirely in church—like shivers and

urgencies I would note down on the program and carry down to the office Monday," where he would write it out longhand on an old army-green desk that rested atop a well-worn Oriental rug when he wasn't reviewing a dirty French novel.

After publication of his new novel, the Boston newspapers had a field day speculating on who the randy couples of Tarbox, Massachusetts, really were. Updike claimed that "only the marsh geography [of Ipswich] peeps through in *Couples*." If that wasn't emphatic enough, he added, "I disavow any essential connection between my life and whatever I write."

And there was the sobering fact that Updike had an in-house censor, wife Mary, a Unitarian minister's daughter who was raised to be a harsh critic of both licentiousness and literature. Upon reading *Couples*, she told her husband that she felt smothered in pubic hair. "Actually I did take some of it out," Updike confessed to *Time*.

In their slightly mixed but basically upbeat review, *Newsweek*'s editors (no doubt in competition with *Time* for an Updike interview) mused on the book's origins: "It is very tempting to believe that Updike's story is autobiographical, because his book's defects are precisely those you would expect to find in a novel based too closely on life."

Updike insisted otherwise, and the more he talked about his new book, the more conservative he began to sound. To the reporters at *Time*, he noted, "There's a lot of dry talk around about love and sex being somehow the new ground of our morality. I thought I should show the ground and ask, is it entirely to be wished for?"

A few weeks later, he stopped asking questions and gave an unqualified no to another journalist: "This book deals with the contemporary world—with people living in the atmosphere of economic affluence and the Cold War. Today, work is available and people want to do it with their left hand. They don't believe in the importance of

vocation but of varying degrees of friendship. Life in bed and around the table is what they care most about. The eight-hour day does create the kind of recreational opportunities that belonged formerly to a tiny minority of aristocrats. Now those opportunities are available to all. I guess I must feel this is bad or dangerous."

That dollop of puritanism was printed in the *Vineyard Gazette*, the local newspaper on Martha's Vineyard, where the Updikes had taken to spending their summers. Updike bantered with the *Gazette* reporter about how he'd written some of the novel's racier sections as he sunbathed out on the island's Menemsha Beach, to help cure his incipient psoriasis. The reporter was flattered that such genius had transpired on her island, and duly noted that Updike and his book "condemned" the modern morality; she never for a moment acknowledged that modern morality is what had given Updike the literary freedom to write such a book.

Perhaps because Updike agreed with the reporter. And perhaps because he had lied about his Ipswich marriage and how it bore no resemblance to the philandering spouses in *Couples*. Updike would wait more than two decades to write, in his memoir: "I seem to remember, on one endless drive back home in the dark down Route 93, while my wife sat in the front seat and her hair was rhythmically irradiated with light from opposing headlights, patiently masturbating my back-seat neighbor through her ski pants, beneath our blanketing parkas, and taking a brotherly pride in her shudder of orgasm just as we hit the Ipswich turn-off."

Updike gave the *Vineyard Gazette* his bowdlerized interview on sex at the beginning of his last summer on Martha's Vineyard, right before his royalties and movie sale from *Couples* gave him and his family the money to escape to London, where his four children would now go to school for the coming year, and he and his wife could leave behind the social and political liberals of his chosen

island—or, as Updike called them, "the almost universally anti-war summer denizens of Martha's Vineyard," which included Philip Roth, Jules Feiffer, Norman Mailer, and Lillian Hellman. That liberal/Updike divide had everything to do with the Vietnam War.

The previous September, the *New York Times* had identified Updike as the only major American writer who was "unequivocally for" U.S. involvement in Vietnam. Updike had previously taken issue with the liberals' stance on the war, especially Feiffer's, which he found to be "too reflexive, too Pop."

Indeed, Feiffer had said, "The solution to the problem is so simple I'm amazed it hasn't occurred to anyone else. Lyndon Johnson should go on nationwide TV and say to the American people, 'Ah have goofed.' "

Updike would later comment that "the protest, from my perspective, was in large part a snobbish dismissal of Johnson by the Eastern establishment; Cambridge professors and Manhattan lawyers and their guitar-strumming children thought they could run the country and the world better than this lugubrious bojunk from Texas."

Besides, Updike liked that bojunk from Texas named Lyndon Baines Johnson, a former schoolteacher. Updike's father was a schoolteacher, and if Johnson had gotten America into a war, then he could get America out. As Updike explained, "It was a citizen's plain duty to hold his breath and hope for the best, not parade around spouting pious unction and crocodile tears."

Updike's Martha's Vineyard neighbors Philip Roth and Jules Feiffer did more than spout and cry. In his syndicated cartoon strip, Feiffer came out against the war as early as 1963, and by 1968 "was in a mood of black despair about the country and where we were going. I thought the Vietnam War was going to go on for the rest of my life and my daughter's life," he said. Out on Martha's Vineyard, Feiffer wanted to picket the summer residences of Secretary of Defense Robert McNamara and Attorney General Nicholas

Katzenbach, but Roth and others dissuaded him, and instead they all chipped in to take out a full-page ad in the *Vineyard Gazette*. Roth wrote the copy and Robert Brustein and John Marquand rewrote it. Feiffer described it as a "coded assault certain to offend all those in the Pentagon or State who had attended Ivy League schools" and now supported the war. Which included John Updike, the lone major writer in America to support the war. (Updike would counter that James Michener, author of the potboiler *Hawaii*, was also a supporter.) It came to be known as "that *Village Voice* ad," a reference to Feiffer's comic strip, even though "I had not written a word of it," the cartoonist claimed.

When he wasn't writing antiwar copy, Philip Roth toiled away on the long-gestating *Portnoy's Complaint*. Then, that May—just as Updike's *Couples* and Vidal's *Myra Breckinridge* were topping the bestseller lists, and Updike was thinking that Vidal's characters were surprisingly stupid and angry, and Vidal was thinking how much he agreed with Norman Mailer that Updike was a hack's concept of a good writer—something wonderfully awful happened to Philip Roth to help him complete his own libidinous opus.

Roth's estranged wife, Margaret Martinson, was killed in a car crash in Central Park. It was a relief. Pure and simple. And since he no longer had to divide his income with a loathed ex-partner, for the first time in years, Roth splurged on a cab to ride across Manhattan to make the necessary arrangements at Frank Campbell's Funeral Chapel on Madison and Eighty-First Street. Attending that funeral a couple of days later, Roth had to wonder if many of the mourners didn't consider him an "accomplice," since the character Martinson had inspired in *When She Was Good* also came to a violent end. Roth certainly considered the man driving the car, who attended the funeral with no more than a Band-Aid over one eye as proof of the accident, as his "emancipator."

The writer's block that had prevented Roth from finishing

Portnoy's Complaint lifted like a miracle. He contacted the people who ran Yaddo. He was in need of another round of solitude at the artists' retreat, and left for Saratoga Springs in record time after putting Margaret in the ground.

He wrote of his escape with unqualified glee: "The bus from Port Authority Terminal was for me very much a part of the stealthy, satisfying ritual of leaving Manhattan for the safe haven of Yaddo, and so instead of renting a car, which would have been more in keeping with my new relaxed attitude toward taking a New York cab, I showed up at the bus station in my old clothes and boarded the north bound Adirondack bus, reading on the long trip up the thruway the rough first draft of the last two chapters of my book. At Yaddo, where there were only seven or eight other guests in residence, I found that my imagination was fully fired: I worked steadily in a secluded hillside cabin for twelve and fourteen hours a day until the book was done, and then I took the bus back down, feeling triumphant and indestructible."

In addition to finishing *Portnoy's Complaint,* Roth had survived his wife, who had been conveniently killed. "And I didn't do it," he noted. And he'd finished that fourth book, which was "unlike any I'd written before in both its exuberance and its design, had been completed in a burst of hard work."

Summer 1968, Politics

Random House publisher Bennett Cerf advanced Philip Roth $250,000, which, after his agent, Candida Donadio, took her 10 percent share, expanded the writer's bank account a hundred times over. He purchased two first-class tickets on the *France*, a luxury liner passage to England, for his girlfriend May and himself. It was there in London that he watched the 1968 Democratic National Convention on television, a spectacle that included antiwar riots on the Chicago streets, as well as a near fistfight between Gore Vidal and William F. Buckley Jr. on the little screen. The two pundits had been hired as commentators by ABC to dissect the two national conventions, which the network, unlike NBC and CBS, no longer considered worthy of gavel-to-gavel coverage. Vidal and Buckley were part of ABC's attempt to package politics in a convenient two-hour nightly program. That concept worked well for the Republican convention, which turned into a near coronation for prodigal son Richard M. Nixon. The Democratic convention turned into something much more.

Despite Vidal's insistence that his latest novel wasn't any "different from any other book I've written," he noticeably winced when moderator Howard K. Smith introduced him on-air as the author of *Myra Breckinridge* and failed to list any of his other novels.

Vidal, of course, knew better. *Myra Breckinridge* was very different. Briefly, in 1967, Vidal had considered reentering the political fray; he'd run for the elected office of a New York congressional seat, and lost, in 1960. Some supporters wanted him to run again, in 1968, for the California U.S. Senate seat. But with the publication of *Myra Breckinridge*, he knew it wasn't possible. "With this book, we won't be able to get through," he said of the press's condemnation of his transsexual-themed novel.

In between the Republican and Democratic confabs that summer, Vidal's conservative opponent on the ABC telecasts finally got around to reading *Myra Breckinridge* and immediately trashed it as "pornography." Buckley found Vidal morally unfit to ponder the political doings of the day, and in their penultimate meeting at the ABC studio, when the streets of Chicago were alive with angry cops and protesters, Buckley proclaimed, "Let Myra Breckinridge go back to his pornography!"

Vidal, for his part, had called Buckley "a crypto-Nazi," and Buckley had defended himself, saying, "Stop calling me a crypto-Nazi or I'll sock you in your goddamned face and you'll stay plastered, you queer."

"Gentlemen, please!" cautioned their referee, Smith.

For their follow-up interview on the air, a distraught Buckley demanded that a screen be erected between him and Vidal, to keep his homosexual opponent out of eyeshot.

It was a long way from *Myra Breckinridge*'s Hollywood to LBJ's Vietnam, but not for Gore Vidal. "I'm all for the breaking down of the sexual stereotypes. That was the theme of *Myra Breckinridge*," he explained that long, hot summer. "The United States is filled with fat, flabby men who think of themselves as Gary Cooper—two fisted, he-men—when actually it's a country of beer-drinking fat men looking at television. American men are the fattest in the world, incidentally, and certainly the weakest physically. Then they have all

this machismo poured into their poor fat heads, and the result is . . . that's why we're in Vietnam."

Vidal confronted those men only days later on the equally sweaty streets of New York City.

Shortly before taping *The Dick Cavett Show*, Vidal witnessed a street protest against the mayor of New York City, John Lindsay. One hard-hat banner shouted, "Lindsay is a faggot!" The incident stuck in Vidal's mind, and he mentioned it to Cavett on air, and addressing the hard-hats in the TV audience, he told them, "I saw your sign. That was just brilliant, you know, good political thinking, 'Mayor Lindsay is a faggot.' You really have added something. Now I know what happens to midnight cowboys when they get too fat to do Forty-Second Street. They become construction workers."

ANDY WARHOL SPENT THE summer in New York City, recuperating in Columbus Hospital after a near-fatal gunshot wound; it required no fewer than four surgeons to perform a six-and-a half-hour operation on his chest. Before the attack, Andy had been having these strange early-morning phone conversations with this teenager from Santa Barbara who had somehow located his home telephone number and now sent him his perfumed clothes and told him he loved him.

Actually, it was Andy who begged that Lance Loud tell him he loved him. These verbal protestations of love began when Lance told his idol that he wanted to leave his home in Santa Barbara and hang out at the Factory. "Could I please be in one of your movies?" Lance asked. He'd read about Warhol and Edie Sedgwick in *Time* magazine and seen *Chelsea Girls* and even dyed his hair silver. Since Andy and Edie were no longer speaking, Lance thought he could be the new Edie Sedgwick.

Andy told Lance that he could come to New York and appear in his movies. "Sure, but you can't stay at my house, because . . . well,

no one stays at my house, because I have a thing about that. But I'll find you a place to stay," Andy promised. Then he pleaded in his thin-as-smoke voice, "Oh, tell me you love me."

"I love you, Andy," Lance said.

"Oh, say it like you mean it. Oh, tell me again."

"I love you, Andy."

In addition to his love, Andy Warhol asked his teenage phone mate for a nude picture of himself. Lance Loud didn't have a nude picture of himself, but he had one with his shirt off, taken at the beach. He sent him that photo. He also sent him a big package of his underwear that he spray-painted fluorescent pink and soaked in his mother's perfume and then doused with his father's after-shave lotion. Lance waited patiently for the box to arrive at the Factory. After a week he called to ask Andy, "Did you get my package?"

"Ugh!" said Andy. "We gave it to people we didn't like so we'd be able to smell them coming!"

In their last phone conversation, a few days before Andy got shot, Lance told his idol that he'd just seen *I, A Man*, yet another movie that Andy had wanted to call *Fuck*.

"Did you like it?" Andy asked.

"Yeah, it was great, but I liked *Nude Restaurant* better," said Lance, referring to a Warhol film set in a diner in which everybody, patrons and waitresses, wore nothing but G-strings.

"Uh-huh," Andy agreed.

"Hey, you know that girl that plays the bull dyke in it?" asked Lance, his mind jumping back to *I, a Man*.

"Oh, Valerie, yeah," said Andy.

Valerie Solanas was one of many Factory hangers-on who saw Warhol as her ticket to superstardom. She'd given him her dreadful, albeit very pornographic script "Up Your Ass" to read and hopefully make into a movie. But it was too downbeat, too lesbian for Andy's apolitical taste. Neither he nor Paul Morrissey wanted anything to

do with it. Regardless, Valerie continued her pursuit of Warhol. Like a lot of crazies who congregated at the Factory and thought its owner should pay for their upkeep because they were so fabulous, Valerie kept demanding rent money from Andy. To shut her up, he offered her twenty-five dollars—the going rate for his actors—if she'd appear in *I, a Man*. The shoot didn't go well. It was supposed to star Jim Morrison of the Doors and his current girlfriend, Nico. They didn't have to do much, just have sexual intercourse on a couch at the Factory. But when Morrison's handlers got word of the movie, they convinced the rocker's drinking buddy Tom Baker to star instead. Baker agreed but balked at having sex on camera, much less taking off his clothes. So the movie that was supposed to be called *Fuck* ended up being a string of encounters between Baker and a lot of women, one of them being Valerie Solanas. In her improvisation, Solanas told Baker that she didn't like his "tits." He surmised she was a committed lesbian, and wondered aloud, "Wow, man! You're missing out on a lot of things."

Lance asked Andy about Valerie. "She seems so mean. Is she really like that?"

"Yes, oh, she hates me, she wants to kill me. We don't let her come up anymore, she is just too mean."

The following week, Valerie Solanas made the last of her unwanted visits to the Factory. She'd really been in pursuit of Maurice Girodias, the original French publisher of the much-banned novel *Candy*. Somewhat more impressed by "Up Your Ass" than either Warhol or Morrissey, Girodias had offered Solanas two thousand dollars in installments for her autobiography. But when she failed to write anything, the installments of money stopped. She in turn called Girodias a "thief and vulture," and wanted him dead. Fortunately for Girodias, he was away on business in Canada. Unfortunately for Warhol, Solanas went looking for someone else to hate.

When she passed Packard Electronics on the ground floor of

33 Union Square West and rode the elevator up to the Factory on the sixth floor, Andy Warhol was talking on the phone, not with a teenage friend three thousand miles away but rather his superstar actress Viva, who at that moment was having her hair done only a few blocks uptown at Kenneth's Hair Salon. The epitome of laconic aggression, Viva had never sounded more upbeat as she blurted out the good news.

"Andy, Andy, I've got the part. I'm so thrilled!" she cried into the receiver. She didn't even have to tell him the name of the project. It was John Schlesinger's new movie, *Midnight Cowboy*, and Andy knew all about it and how screenwriter Waldo Salt had taken the James Leo Herlihy novel about a Forty-Second Street hustler and added his own subplot in which two Warholesque characters, named Hansel and Gretel, roam the streets of Manhattan looking for strange and photogenic people they can put into a Warholesque movie. Schlesinger wanted Andy to play himself in the movie. Andy passed on the offer but gave his blessing to Viva to play the cinéma vérité director, who, in effect, was him. Schlesinger's lover, Michael Childers, facilitated the whole thing, him being a good friend of Paul Morrissey, the real director of Warhol's movies. Childers recalled, "John and I had dinner with Paul and Andy at Max's Kansas City, and all the Warhol superstar speed freaks were there, along with Salvador Dali and Robert Rauschenberg."

Viva, excited by her mainstream-movie breakthrough, had phoned Andy from Kenneth's, where she was having her hair dyed and frizzed for the role of Gretel. That's when she heard Andy's hideous scream above the hair dryers, "Get that woman away from me!"

Viva had once referred to the denizens of the Factory as "that bunch of perverts" but never let that assessment stop her from taking her clothes off for a Warhol movie.

But he wasn't pretending. He wasn't acting. Andy Warhol had been shot by Valerie Solanas, a militant lesbian feminist who wanted

Warhol to film "Up Your Ass," a script that Warhol found so pornographic that he thought the cops had planted it to trap him with an obscenity charge. When Solanas appeared at his door that day, Warhol had forgotten about "Up Your Ass," misplaced the script somewhere, and spent the last few days trying to avoid her, blow her off. He barely survived the shooting. Surgeons had to open his chest to massage his heart, working over his nearly lifeless body for hours.

During the filming of *Midnight Cowboy* that summer, Viva channeled her Gretel filmmaker role, and, wielding a tape recorder, she never stopped asking everyone on the set, "Say something to Andy, who's in the hospital."

Viva's big moment in *Midnight Cowboy* is the party scene where Jon Voight's hustler Joe Buck arrives and Dustin Hoffman's tubercular friend Ratso Rizzo negotiates a deal for him to sleep with an uptown matron, played by Brenda Vaccaro. The party might have been screenwriter Waldo Salt's idea, but it was Michael Childers who enlisted the Warhol troops, including Viva, Ultra Violet from *Chelsea Girls*, and Paul Morrissey, as well as *Hair*'s Paul Jabara, to make the trek from downtown way up to the Bronx at the Filmways Studios to act for one hundred dollars a day plus transportation. Not much, but it was seventy-five more than Andy would have paid them.

Morrissey wrangled a few Factory hangers-on for the party scene. "There were a few around in the back of the crowd and you couldn't see them. All the professional actors knew how to stay in front of the camera," said Morrissey.

According to Childers, he and Morrissey shot an untitled short film in which Ultra Violet enacts being raped by a young blond boy. Schlesinger found it way too graphic, but Childers told him not to worry. The film would be projected over the bodies of the party-goers, and nobody would be able to tell what the hell was going on.

"It was amazing. The party went on for three, four days," said Childers. "We weren't providing drugs."

Many of the extras, especially the Factory kids, brought their own pharmaceuticals, especially the amphetamines that helped them stay awake for the long, long shoot. And there were other ways to indulge.

"It was like a six-day bacchanal. Pot in vast quantities," said the film's producer, Jerome Hellman. "And these kids, floating around, fucking in the toilets, fucking in the dressing rooms, fucking in the wardrobe rooms. We had to establish certain characters, so we were worried about people not coming back. Boy, they were back. They couldn't wait to get back."

Even Schlesinger got into the spirit of the Warhol superstars. "Darling, they're so wonderfully eccentric!" he exclaimed. It was one of the few happy times he experienced on the set of *Midnight Cowboy.*

Schlesinger had wanted to make a movie of the male-hustler story ever since a friend had given him the Herlihy novel in 1966. "What attracted me to the character of the cowboy was his basic innocence and naïveté and need for love," he said. Also, the subject of two men in love "had never been really tackled before," he added. And also, "The idea of a new look at the city is another reason for wanting to make the film."

The British director never really cared for New York City, and as it turned out, he would like Los Angeles even less when he went there for the first time to open his film *Far from the Madding Crowd.* After an equally downbeat opening for *Crowd* in Manhattan, Schlesinger met an MGM publicist on his flight to the West Coast for the premiere there. The flack told him, "You've got to be terribly careful what you do next. What is this *Midnight Cowboy*? I don't like the sound of it. You've got to be very careful."

Schlesinger had been cautioned before. "It was a book that nobody had wanted to do," he said of Herlihy's novel. People were always asking him, "Why are you doing that terrible faggot novel?"

One of those people was Joseph Janni, who'd produced *Darling*, *Far from the Madding Crowd*, and Schlesinger's two other movies, *Billy Liar* and *A Kind of Loving*. Janni called the novel "faggot stuff" and flatly predicted, "This will destroy your career."

That's when Schlesinger approached another producer. "The book had a lot of things against it, especially the sequences of very direct homo-eroticism, but it was a very powerful story," said Jerome Hellman. "John and I had a very candid conversation . . . and he made it clear he didn't want to make a gay movie out of it, that he saw it as an oddball love story."

After *Far from the Madding Crowd* received its critical dubbing, MGM wanted nothing to do with Schlesinger's *Midnight Cowboy*, and the feeling was mutual after a reader at the studio suggested that *Midnight Cowboy* might be successful if they turned it into a movie musical for Elvis Presley.

In the very beginning, things weren't that much better over at United Artists, especially when the name Sammy Davis Jr. got tossed around as a possibility to play Ratso Rizzo. But that misfire aside, UA was the perfect home for *Midnight Cowboy*, perhaps the only home. Its president, David Picker, admired Schlesinger's work, and, even more important, "it was the only studio that would have made the film, because of its tawdry subject matter," said Picker. It helped that the UA executive had seen *Chelsea Girls* and charted its success—a success that not only brought moviegoers into the theaters but now whetted their appetite, in Picker's opinion, for stronger language, more nudity, homosexual characters, and drug-related subject matter. He wasn't alone in that opinion. Noting the box-office grosses for *Chelsea Girls* around the country, the *New York Times* reported that "commercial filmmakers here and abroad are planning to use homosexual themes in their movies on the theory that sympathetic treatment of this subject is what lures the audiences."

Commercial filmmakers ready to break a few rules had no more

sympathetic playground than UA. The studio had a reputation for taking on risky material and then leaving directors alone to make their risky film. But there was a catch. "My partners here, the older men in the company, aren't going to understand *Midnight Cowboy*," Picker told Hellman. "So it's got to be $1 million, all-in!"

Where Picker initially mentioned $1 million, the budget soon swelled to $2 million and finally topped out at $3 million. Along the way, there was great consternation from the UA accountants, and while Picker remained committed to the project, as its budget swelled, he asked that Schlesinger, Hellman, and screenwriter Waldo Salt defer much of their salaries in exchange for more profit points. As Hellman recalled, "I was able to keep increasing our percentage because they didn't think this film would make as much money as it did. At the time, United Artists would rather give us an extra ten percent than an extra ten thousand dollars."

Hellman and Schlesinger could have solved their budgetary problem by casting a big star to play the cowboy hustler and, indeed, a big star wanted the role. The director's Malibu houseguest that winter had been Julie Christie, who showed the script to her new movie star boyfriend.

"You must be kidding!" Schlesinger said when Christie gave him the news that Warren Beatty wanted to play Joe Buck. "If he were the male hustler, the lines would be out to Fire Island!" According to Michael Childers, Beatty was so keen to play the role he even asked for a "secret screen test" to put all fears to rest. But Schlesinger resisted the temptation: No one would buy Warren Beatty as a prostitute who failed, and instead Schlesinger cast newcomer Jon Voight.

Midnight Cowboy was Schlesinger's first made-in-America picture. It's what attracted him to the project—his dislike of New York City. "It's grim and it's more grim than we were able to show," he later said. All in all, making the film turned into a "miserable" time.

In addition to hating the big city, he found himself "always con-fronted by something worse on the streets than one was putting into the film." There wasn't anything in the movie that he hadn't some-how seen in some way somewhere in America: The man in a busi-ness suit lying zonked out in from of Tiffany & Company on Fifth Avenue had actually taken place in front of Bonwit Teller. The boy running a plastic mouse over his mother's face at an all-night diner was a scene that Schlesinger had witnessed at Canter's Deli on Fair-fax Avenue in Los Angeles.

Prior to making the film, Schlesinger worried obsessively about the New York crew. He was accustomed to British crews that he handpicked. United Artists, however, had assembled the grips, gaf-fers, and other technicians on *Midnight Cowboy.*

At the time, Schlesinger was still hiding his sexual orientation from the Hollywood film community. He expressed his fears to his new producer. "He was afraid of an American crew," said Hellman. "If they found out, would they turn on him, making fag jokes behind his back?"

Hellman finally told him, "John, we're the bosses here. If some-one's stupid enough to do that, we'll fire them."

Some of the fag jokes were told to his face. One of the assis-tant directors took to calling out, in front of the entire crew, "We're ready, my queen!"

Schlesinger played along as best he could. "Won't be long for you, my boy!" he shot back.

Dustin Hoffman called it a fun production. "There was a lot of frivolity on the set," he said.

But the crew's disrespect wore on Schlesinger. It also presented a real concern: A union member couldn't be fired for harassing a ho-mosexual, regardless of his position on the film. Even worse, the Brit-ish director could be sent home to England at any moment, since the U.S. Supreme Court had recently ruled in *Boutilier v. Immigration*

and Naturalization Service that homosexuals were, indeed, "psychopathic," and gay aliens were subject to deportation.

Schlesinger was afraid, but he acted fearlessly nonetheless. He further risked exposure by hiring boyfriend Michael Childers as his assistant on *Midnight Cowboy*.

Hellman approved the hire. "This is our picture," he told Schlesinger. "Let's ride this tiger. Let's put Michael on the movie and fuck anyone who doesn't like it." According to Hellman, Schlesinger was "still taking pains to hide" his sexual orientation. "All of which changed during *Midnight Cowboy*," he added. "During the filmmaking, I watched John unfold and come out and declare himself and take his place, and he became more expressive. Part of it was the result of falling in love with Michael, which hadn't happened to John before."

The reality of the crew's homophobia, however, turned out to be every bit as bad as Schlesinger anticipated.

"The crew were these Irish and Italians from Long Island. They were a terrible old boys' network," said Childers. "You had to be a son or a nephew to get into the union, which was right-wing and horrible." According to Schlesinger, the crew was bringing in its own equipment and robbing the production. The camera operators even wanted to be paid overtime for watching the rushes.

"It depressed me," said Schlesinger, "and finally angered me considerably, because I didn't think their work was of a high enough standard to warrant that kind of high-handed attitude."

Then came the expected homophobia.

"The technicians were a tough New York group who regarded me with some suspicion. I think they thought we were making a sleazy film," said Schlesinger.

Childers felt that the crew worked in a state of "total shock and disgust at the movie." When they weren't wishing out loud, saying, "We should be working on a Neil Simon picture," they rubbed their beer guts and tsked, "We've never seen anything like this!"

What disgusted the crew is what attracted Dustin Hoffman to *Midnight Cowboy*. After his breakthrough film, *The Graduate*, Hoffman was looking for a role completely different, since he felt that many reviewers had pigeonholed him as "some nebbish Mike Nichols had found who was like Benjamin Braddock," he said.

Nichols, for one, didn't like the idea that his Benjamin would be playing a sexually ambivalent lowlife for his follow-up film. He even phoned Hoffman to voice his disapproval. "So I hear you're going to do this thing, you're going to play the male prostitute," he said.

"No, no, I'm going to play the other role," Hoffman replied.

Nichols couldn't believe it—that Hoffman would settle for anything less than the starring role. "I made you a star, and you're going to throw it all away?" Nichols asked. "You're a leading man and now you're going to play this? *The Graduate* was so clean, and this is so dirty."

Dirty, of course, was the allure for Hoffman, who reveled in looking like a bum who walked with a bad limp and sounded as if he were ready to cough up blood. He even took Schlesinger on a tour of Forty-Second Street to let his director know how much he knew about people like Ratso Rizzo. The actor wanted to make his portrayal more cutting-edge than even Schlesinger desired—or knew he could get away with. Hoffman wanted to know, what exactly was Ratso Rizzo's relationship with the cowboy hustler Joe Buck? They befriend each other on the mean streets of New York, then move into an abandoned building to weather the winter together. (That dank, ramshackle apartment was built on the tiny studios of Filmways in the Bronx.) One day, Schlesinger gave his two actors some direction. "All right, Dustin's going to be on the floor and Voight's going to be on the bed."

But Hoffman wasn't buying it. "We're not just roommates, we're lovers. Why aren't we in bed together, they're lovers."

Schlesinger shook his head. "I'm sure they are, but you try and get this film financed."

The topic made the actor wonder about his director's own private life. One day, early in the production schedule, Hoffman asked Schlesinger, "Are you married? Do you have a girlfriend?"

"Oh no, no, no, dear boy," Schlesinger replied.

"How come?"

"I just couldn't bear the idea of waking up in the morning with a woman next to me."

"I see," said Hoffman. Years later, to *Vanity Fair*, the actor would comment on Schlesinger's response as being "marvelously courageous."

At the time, Michael Childers saw a different motivation in Hoffman's questioning, one that had little to do with blind naïveté. "Dustin was prodding," said Childers. "He knew me, and he knew John and I were living together. I was a friend of his ballet wife, Anne Byrne, whom I'd photographed. Dustin was trying to get John to admit he was a faggot."

Schlesinger took a dim view of such provocations, and harbored a long-held theory about young male actors, who he believed were much vainer than their female counterparts. "They also like to create a stir around somebody they know to be gay, playing games with them, wanting me to in a way fall for them, which I certainly didn't. I felt that I was being tested all the time," he said.

The other actors in *Midnight Cowboy* were less challenging, but a challenge nonetheless.

Filming on Fifth Avenue, Schlesinger needed to see Jon Voight tail a prospective female client as the two of them passed a bank. "I wanted the bank vault to open, just as he was following a particular woman across the street. That's all I was really concerned about—the cuing." Schlesinger was ready to shoot the scene when Voight sent a message via one of the assistants, asking, "What is my motivation?" Schlesinger, stationed with the film crew farther up the street, sent back the reply: "A good fuck and plenty of dollars at the end of it."

Then there was Brenda Vaccaro, who had agreed to play her sex scene with Voight in the nude. But after being cast, she had second thoughts about getting naked on camera. "In those days nobody did that. This was one of the first [American films] to do nudity," Vaccaro said of *Midnight Cowboy*.

The actress had other problems, too. As she told costume designer Ann Roth, "Oh my God, I'm not thin, I'm not skinny, I don't look gorgeous."

Schlesinger thought she looked fine. He wanted her naked. "Oh, good God! Everybody thinks I'm doing a blue movie!" he exclaimed. For him, nudity wasn't a big deal. He'd directed other actresses who'd performed without the protection of clothes. He told Vaccaro a story about shooting *Darling:* "Julie Christie wore these fucking pasties, and then in the middle of the scene she hated them, so she pulled them off." Maybe Vaccaro would also have a similar change of mind once they started filming the scene. But she didn't. Finally, "Well, do what you must," he told her.

Voight consented to doing the sex scene in the nude. Almost. A flap of cloth covered his genitals and had to be glued on. "It was a mess," said Childers.

Vaccaro played the scene wearing a fox fur, which was Roth's solution to the problem. Schlesinger ended up loving the costume compromise. "Oh love. Fucked in fox!" he exclaimed. The scene required that Vaccaro's character taunt Joe Buck for being gay when he couldn't get an erection. Finally, tired of being called "gay," the hustler character practically rapes his female client. Schlesinger hand-held the camera over Vaccaro's face as she writhed to Joe Buck's violent thrusts. "Come now, darling. Do it now. Come, darling," he directed.

In a way, the gay-straight reversal that the scene depicted also played offscreen during the production when Schlesinger and his boyfriend got into a "tiff," as Michael Childers described it. They'd rented a house at Fire Island Pines for the summer, but Childers was

so angry about something his new boyfriend had done that he refused to go one weekend. Instead, Schlesinger took his photographer friend Joe Santorum and Viva. When Schlesinger returned Sunday night, Childers asked him, "So did you have a lovely time?"

Schlesinger laughed. "We all got stoned and I got so stoned I fucked Viva!"

"That's the saddest thing I ever heard," said Childers.

It did wonders for Schlesinger's reputation on the set, however. Viva told everyone, "Absolutely one of the three best fucks I've ever had in my life!"

That veneer of heterosexual respectability faded as soon as Schlesinger came to what was called "the blowjob scene." It elicited some of the more violent reactions from the crew, which had taken to calling *Midnight Cowboy* "this faggot film." The blowjob scene marked Bob Balaban's entrée to the movies. When his parents asked him about his momentous debut, the twenty-year-old actor told them it was only one scene, with Jon Voight. They'd heard of Voight, who'd appeared in an Off-Broadway revival of *A View from the Bridge* at around the time Balaban starred in *You're a Good Man, Charlie Brown*. Of course, they wanted to know all about their son's scene in *Midnight Cowboy* with Voight.

"Well, it's in a movie. We kind of meet in the bathroom," he told them.

"Do you have many lines?" they asked.

"No, not many lines."

"So it's a walk-on?"

"Well, at least it's with the star. I give him a blowjob."

And there were other things that had not been seen or even suggested in a mainstream American movie. Although audiences who saw the finished film weren't always sure what was going on in the film's flashbacks, Childers offered a behind-the-scenes analysis of what Schlesinger and Waldo Salt intended and what the crew filmed:

"Joe, the cowboy, was abandoned by his mother and left with his grandmother, but she was a floozy and drinking Jack Daniel's with another cowboy, and she gave [the young] Joe an enema, which carries over to Joe's male fear of anal rape from this high school gang of four guys in a convertible who are cruising around looking for trouble and they find Joe with his girlfriend and they rape her and rape him anally," Childers explained.

Those flashbacks were filmed at the end of production, after the cast and crew had finished with the New York City locations. Dustin Hoffman, Viva, and the other Warhol superstars had gone on to other pursuits by the time Schlesinger called "Action!" and Jon Voight went running down a Texas road to chase an ambulance. When they'd completed the shot, the actor found his director behind one of the trailers. Schlesinger was shaking uncontrollably. "What's wrong?" Voight asked.

"What will they think of this?" Schlesinger asked. "It's about a dishwasher who goes to New York to fuck a lot of women. What will they think?"

That fear didn't let up all through the long, arduous editing process at the historic Brill Building, just north of Times Square. Next door, editors were working on Arthur Penn's *Alice's Restaurant*. The film adaptation of Arlo Guthrie's song about avoiding the draft was Broadway producer Hillard Elkins's first foray into the movies, and while he was still busy finishing up production on that movie, Elkins juggled his next venture: a new sex revue that Kenneth Tynan wanted him to produce. Elkins met Michael Childers, who made daily trips to the Brill Building to visit Schlesinger, and he asked if the young photographer was interested in meeting Tynan.

"I like your photography," Elkins told him. "There might be something for you with this new show I'm doing with Tynan. It's called *Oh! Calcutta!*"

. . . .

AS HE CONTINUED TO recuperate at Columbus Hospital, Andy Warhol was both intrigued and stressed by reports regarding *Midnight Cowboy*. Maybe if he'd accepted John Schlesinger's offer to play the underground filmmaker in the movie, then he, rather than Viva, would have been getting his silver wig coiffed. Instead, he'd been nearly murdered by Valerie Solanas.

Curiously, Viva was also having her own violent run-ins. At the closing-night party of the New York Film Festival that September, she found herself roughed up by security guards when they mistook her date's dance moves for his simulating oral sex on her. Suddenly no one was safe, it seemed, in New York City. Until Andy Warhol's near-death encounter with Solanas, the *Midnight Cowboy* party scene with its rape film sounded like something the king of pop art would have found fun. But now, sequestered away in a hospital bed for weeks, it bothered him that his whole persona, scene, shtick, and entourage of superstars were being used without any compensation to him.

"Why didn't they give us the money?" he asked Paul Morrissey. "We would have done it so real for them." Warhol meant the party, not the rape movie.

Ondine, who played the pope in *Chelsea Girls*, was one superstar who refused to appear in *Midnight Cowboy*, out of loyalty to Andy, whom he'd known for years, ever since they met at an orgy and Ondine asked Andy, an inveterate voyeur, to leave the premises if he wasn't going to actively participate. Ondine wanted nothing to do with John Schlesinger or his big-budget movie. "How dare you accept the $25 a day in blood money to go and make fun of Andy? He's the reason why you're even here! Don't you have any feelings?" said Ondine, unaware that the party extras in Schlesinger's movie had actually been paid a hundred dollars a day.

Midnight Cowboy did give Warhol an idea, maybe even two ideas, if both of them didn't originate with Morrissey. If Schlesinger was going to rip off their world, they could in turn appropriate his. Their cowboy movie, shot in January, still languished without a theater. Maybe if they called it *Lonesome Cowboys* it would be close enough to Schlesinger's title to goose interest. And better yet, maybe they could make another film, one that would be a portrait of a male hustler, like *Midnight Cowboy*, and quickly get it into theaters to beat Schlesinger at his own game.

"I vaguely knew what they were doing with *Midnight Cowboy*," said Morrissey. "When I had a chance to do *Flesh*, I thought, I'll do something like *Midnight Cowboy*, but I didn't know how *Midnight Cowboy* was handling the subject."

Morrissey thought he had a new superstar in this kid who'd appeared briefly in *Lonesome Cowboys*. Joe Dallesandro wasn't like the other superstars. He wasn't weird or show-offy or even gay. In the following decade, the legendary film director George Cukor would say of him, "Joe Dallesandro does some enormously difficult things . . . like walking around in the nude in a completely unselfconscious way."

In Morrissey's *Flesh*, Dallesandro would be naked a lot in his role as a male prostitute whose bisexual wife needs him to earn two hundred dollars to pay for her girlfriend's abortion. It wasn't all acting for Dallesandro, who was raised in foster care after his mother went to the federal penitentiary for interstate auto theft and who supported himself for a time by posing nude for pseudo-gay publications like *Athletic Model Guild*.

Dallesandro was never a hustler. But he knew the modus operandi of those who did hustle. "When you're young and beautiful, you do get a lot of propositions," he told reporters. "I always said it wasn't about a hustle. It was about how you got people who wanted

to be a part of your life. The pay was that they became a part of your life, even if for a short time."

In the hothouse world of the Factory, Dallesandro was a breath of heterosexual air but also someone who never denigrated the homosexuals who flocked around him. "If it hadn't been for the gay men and how well they treated me, I would have killed somebody," he claimed.

Dallesandro actually felt a little sorry for the drag queens that Morrissey cast as women in *Flesh*, men like Jackie Curtis and Candy Darling, who almost never appeared out of makeup. "I always felt that it is hard enough just wanting to be an actor or an actress," he said. "What roles can these people do? They can only play a person in drag. For the moment that I had to be with them, why should I burst their bubble? They were women for that moment."

Morrissey also cast a few real women as women in *Flesh*: Geraldine Smith as Joe's bisexual wife, Patti D'Arbanville as her pregnant girlfriend, Geri Miller as a stripper, Jane Forth as a customer-wife who wants Joe to have sex with her husband. Dallesandro really wasn't much of an actor, but his broad shoulders created a dramatic V shape that ended in a bubble butt in an age before gyms were as ubiquitous as Citibank branches and Starbucks. He also knew instinctively what not to do.

"Joe was not an improviser," said Morrissey. "He was a quiet person, the eye of the storm, and this lunacy going on around him therefore became very dramatic."

Andy Warhol described Dallesandro's appeal even more succinctly. "Everybody loves Joe," he said.

Sometimes it seemed everybody at the Factory wanted to see Joe naked. "There was always a reason to take my clothes off," said Dallesandro. "I was very young. What are we doing? I was uncomfortable."

Morrissey filmed *Flesh* over a period of six weekends at friends'

apartments in New York City. As with *Chelsea Girls* and the newly titled, and as yet unreleased, *Lonesome Cowboys*, Warhol gave Morrissey a budget of three thousand dollars, and he got every penny of it back in gossip from the set of *Flesh*.

Still stationed at Columbus Hospital, Andy broke out laughing when Geri Miller said how her striptease so turned Joe Dallesandro on that he got aroused and she tied a big bow around his erection. Of course, it was all improvised, like everything in the movie, and Morrissey obliged by keeping the camera running.

True to plan, Warhol and Morrissey opened their *Flesh* that autumn at the Garrick Theatre while John Schlesinger continued to edit and fret over *Midnight Cowboy*. The little picture did very well for itself, playing the Garrick for seven months and grossing an average of $2,000 a week on its $3,000 budget. Where *Chelsea Girls* offered a couple of seconds of flaccid penis, *Flesh* gave audiences a few minutes to inspect Dallesandro's erection, as well as many more minutes of his bare buttocks. Morrissey was surprised that the erection footage didn't cause censorship problems; maybe it even disappointed him. At his urging, friends phoned the police to complain.

"He'd have these plants go in and do this. It was just to get all this publicity and coverage, and it worked," said Dallesandro, who never quite understood all the commotion. "I was pretty amazed, because I couldn't sit and watch it," he said of the finished film.

Like Dallesandro, Morrissey was an odd bird in the Warhol menagerie—but for different reasons. Like Warhol and Viva, he was raised Catholic and proud of it. His conservatism, however, extended beyond mere religious practice, and the Factory stalwarts alternately described him as "a real nine-to-fiver" and "a very typical young man in a hurry."

More important, he also didn't do drugs. Ever. And not only didn't he do drugs, but he railed against them. "Think of the millions

of kids who must have died from drugs in the United States. I never knew anybody who had a relative in the Vietnam War. Yet all those hippies who were screaming against the war were hypocrites," he used to say. "Don't let the children be killed by war, but if they're killed by drugs, it's OK. The priorities are a bit strange."

Regarding the abundance of sex and drugs in *Flesh*, he didn't see a contradiction. Morrissey insisted, "I was making fun of people who accepted the hippie life of sex and drugs and rock 'n' roll."

Autumn 1968, Revelry

That autumn, Andy Warhol finally got around to using his *Fuck* title. Since Viva and Louis Waldon got on so well in the rape scene from *Lonesome Cowboys*, which continued to languish without a release date, it was decided that they should copulate for his camera. The result was *Fuck*, or *Blue Movie*, a ninety-minute film shot in one day for much less than the usual three-thousand-dollar budget.

Viva said the film was made, essentially, "to teach Andy," who "had no private life. In filming as in 'hanging out' he merely wanted to find out how 'normal people' acted with each other."

As usual, the actors' twenty-five-dollar fee was supplemented with a free meal, in this case, at Casey's restaurant. But at the last minute, Andy wasn't so sure that getting a bite after the shoot was such a good idea. Casey's, after all, wasn't Max's Kansas City.

"Oh no, we can't go in there," he warned his entourage. "There's only two women and there's eight men. It won't look good. They'll think we're gay."

IT WAS THE MOMENT John Schlesinger dreaded most: showing his first rough cut of *Midnight Cowboy* to the executives at United Artists.

Just before he and Jerome Hellman were about to enter the screening room at the West Fifty-Fourth Street Movie Lab, Schlesinger stopped to ask his producer, "Do you honestly believe anyone in their right mind is going to pay to see this rubbish?"

Maybe their attempt to translate the bucolic barnyard prose of Thomas Hardy, redolent of red ochre and sheep manure, led the makers of the movie *Far from the Madding Crowd* to seek out dark-alley encounters and urban decadence for their respective follow-up efforts.

Across the Atlantic that autumn, Schlesinger's cinematographer on the Hardy adaptation had also begun to realize a career dream: to direct his own film or, as it turned out, to codirect. Although cinematographer Nicolas Roeg and writer Donald Cammell were director-virgins on *Performance*, the screen debut that excited the Warner Bros. executives wasn't theirs but rather Mick Jagger's.

In an effort to replicate the Beatles' movie successes, Warners put the Rolling Stones' lead singer on payroll for a quarter million dollars a year, as the company's so-called "youth adviser." Warners was looking to replicate the success of *Help!* and *A Hard Day's Night*. Instead, what they got was *Performance*, a film filled with so much kinky sex and violence that the studio initially deemed it unreleasable.

Jagger and the Stones had been offered a Terry Southern–scripted, pre–Stanley Kubrick screen adaptation of Anthony Burgess's novel *A Clockwork Orange*, about a gang of thugs in futuristic London. But the rocker, who had no interest in making his screen debut alongside his bandmates, was looking for something "a bit more solo," said the Scottish writer Donald Cammell, a close friend of Jagger.

Cammell, as it turned out, had more than a bit of Burgess in him when it came to wanting to write about Old Blighty's gangland, and was as chummy with Jagger as he was the Krays, Reggie and Ronnie, who were the kingpins of organized crime on London's East End in the 1950s and 1960s. Cammell's idea for a Mick Jagger

movie was to bring the permissive druggy world of the rockers to-gether with the violent druggy world of the gangsters.

"In Britain, the underworld was typified by the Krays. The Krays were very macho, very dangerous, and rather glamorous," he en-thused. "I idolized those guys—their passion, their energy. My whole life was hanging out with those people in the dockland." Added to the mix was Cammell's deep admiration for Vladimir Nabokov's 1936 novel, *Despair*, about a man who confronts his doppelganger and is destroyed. In Cammell's version, the Stones would meet the Krays and both would be destroyed.

Cammell called his two male characters "the lover and the beast," although it's difficult to tell which is which because the drugged-out rocker of the film, who lives with two equally drugged-out girl-friends, often changes places with the violence-prone gangster, who's on the lam after a hit gone bad. Warners, for its part, didn't much care about the story as long as it starred Mick Jagger. It helped, too, that practically every major participant on the film—Jagger, Cam-mell, Roeg, and producer Sandy Lieberson—were with Creative Management Agency, which had recently entered into a deal to rep-resent the Warners' TV division. It was such a cozy relationship, at least in the beginning, that no one really noticed there wasn't much of a script. "Just a few pages that Donald had written," said Nicolas Roeg. "We would rehearse through the night sometimes, and out of that would come changes." Warners cared about only one thing: They had a movie starring Mick Jagger. What could go wrong?

Even though Cammell and Roeg improvised much of *Perfor-mance* on the spot, with the camera rolling, what happened in front of that camera often replicated what was going on behind it. What most participants in the film didn't know from the get-go is that Cammell intended to put his own private bisexual life up on the screen, as filtered through his deep admiration of the Krays and the Stones. "This ménage à trois, it was part of his scene," said

Lieberson, referring to how Cammell's life and art intersected in the film. In essence, Jagger played Cammell, with his live-in girlfriends played by Anita Pallenberg and Michèle Breton, who'd never acted in movies before (or since). From there, it got complicated.

"My first scene was the bedroom scene," said Pallenberg. She spent the next seven days in bed (and a bath tub) with Jagger and Breton. "Michèle was very nervous."

Pallenberg was going with Keith Richards at the time, and while she denied ever having an affair with Jagger, Cammell insisted they were involved and even got Richards to believe it. "Donald could be quite manipulative, even devious," said Pallenberg.

Eager to keep an eye on his liberated girlfriend, Richards visited the set regularly, and often parked his Rolls-Royce across the street from the townhouse on Notting Hill's Powis Square, where most of the movie was shot. "Jagger simply took Anita under the house for sex," said Cammell. "Keith would come on the set looking for hanky-panky, not realizing that he was standing about three feet above the action."

Richards didn't know. "But I smelled it," he recalled. "Mostly from Mick, who didn't give any sign of it, which is why I smelled it. . . . It was like Peyton Place back then, a lot of wife swapping or girlfriend swapping. . . ." It didn't really matter much who got swapped. During the filming of *Performance*, Richards was having sex with Jagger's current girlfriend, Marianne Faithfull.

Richards never wanted Pallenberg to act in *Performance*, and her impending affair with Jagger had less to do with his apprehension than his hatred of Donald Cammell, whom he called "a twister and a manipulator whose only real love in life was fucking other people up." Richards's character assassination of Cammell didn't stop there. "Donald was a decadent dependent of the Cammell shipyard family, very good-looking, a razor-sharp mind poised with vitriol," he continued. "He'd been a painter in New York, but something drove him

mad about other clever and talented people—he wanted to destroy them. He was the most destructive little turd I've ever met. Also a Svengali, utterly predatory, a very successful manipulator of women, and he must have fascinated many of them."

Into this maelstrom of sex and drugs dropped the movie's one experienced professional actor. While Jagger and Pallenberg essentially played themselves in the film, Roeg and Cammell went far afield to find their Kray-like gangster Chas. James Fox had already compiled an impressive, varied movie résumé, ranging from turns in Joseph Losey's artful *The Servant* to George Roy Hill's campy *Thoroughly Modern Millie*. Fox was upper-class, his father a theatrical agent. "I'm sure he would be much happier if I appeared in a revival of *The Importance of Being Earnest*," Fox admitted, referring to his *Performance* assignment. He didn't actually meet the film's ménage à trois—Jagger, Pallenberg, and Breton—until three weeks into the fourteen-week shoot. For those first few weeks, he stuck to a more completed, less improvised script that included a hit gone bad in which Chas is whipped by two other thugs, whom he in turn tortures and shoots, and a revenge scene that sees Chas pouring acid over his adversary's limousine after nearly scalping the chauffeur.

Fox was the consummate professional in his approach to playing Chas. Nicolas Roeg told him to cut his hair like the Krays, and he did. Cammell told him to live in the East End world for a few weeks, and he did. "He literally became a gangster in the name of research," said Cammell. "He spent evenings in the company of London's most notorious thugs, to the extent that he actually frightened people."

The thugs were the easy part for Fox. Then he started filming his scenes with Mick Jagger and Anita Pallenberg, who improvised almost every one of her lines. In one typical encounter, Pallenberg sat in bed with Fox and immediately began to threaten his sexuality, saying, "I've got two angles, one male and one female. Just like

a triangle, see, did you notice?" Later, she asked, "Did you never have female feet?"

Fox improvised right back. "No, never," he replied. "I feel like a man, all the time."

"That's awful. That's what wrong with you."

"I'm normal."

"How do you feel Turner feels like?" she asked, referring to the Mick Jagger character. "He's a male/female man."

"You degenerate."

Although Pallenberg made up the dialogue as she went along, she took her cue from Cammell, who believed that gangsters and rockers inhabited parallel worlds. He'd originally titled his script *The Performers* because, as he explained, "each of them is a performer, in one sense or another." It was his concept to bring together "the Neanderthal gangster and the effete yellow-book world of the rock star into one demonic fusion." They weren't that far apart, in Cammell's opinion. "The gangster is really more bisexual and in touch with his feminine side," he said. Cammell went on to call his film "a provocative love story," and he wasn't referring to the two female characters.

Unlike Fox, Jagger completely embraced the dual sexuality of his character. He wore makeup, wigs, ultrafeminine clothes. He so lived his part that, during filming, he walked the streets in his *Performance* drag of red lipstick, purple mascara, page-boy wig, silk scarves, and flowing velvet trousers. "Mick is not acting in *Performance*," said Cammell. "That is Mick to the teeth."

Fox went along with donning Jagger's transgender attire. He put up with Pallenberg's taunts. But he flat out refused to do a love scene with Jagger. He also parted ways with Jagger with regard to taking drugs, which to Fox were "basically harmful orally and show a lack of control." Jagger, on the other hand, had been arrested on drug charges only the year before. Fox not only refused to kiss his male costar; he also refused to consume the hallucinogenic mushrooms

that Pallenberg's character gives Chas, to break down his defenses. (In the finished film, Cammell and Roeg indicate the Chas character's homosexual thoughts by editing a scene with Fox in which Jagger rolls over in bed next to him only to morph into Michèle Breton right before they kiss.)

"Imagine this very macho, violent behavior being shattered, once again, under Jagger's influence," Cammell said of Fox. "It was perhaps a tragedy that [James] became so traumatized by Jagger's sexuality that he succumbed to it and ultimately quit acting altogether."

Fox, in fact, joined an evangelical sect shortly after he finished filming *Performance*, and went to South Africa to spread the word of the gospel. Years later, Fox explained his *Performance*-induced epiphany: "At the time I thought that if you showed something true, then it was valid. But subsequently I've thought dramatists and actors and writers have an obligation to their audience. I think there should be restrictions on things which, just because they are true, need not necessarily be valid. After I made *Performance*, for about a year and a half, I started to try and reform my life. I thought it was a mess. I did start going back to church and I started to read the New Testament."

His wasn't the only on-the-set education. Cammell, Roeg, and their producer Sandy Lieberson were new to the movie-studio process, and instead of carefully editing the first rushes they sent to Warner Bros.–Seven Arts, "We screened everything we had shot," said Lieberson, "and they saw hours of it. We were giving them an education in our ignorance."

The Warners executives didn't have to watch hours and hours of it. Amid their shock at the amount of violence and female nudity on display, they couldn't quite grasp the Jagger/Fox relationship. "Were these characters bi?" one vice president asked.

Cammell didn't know the American slang for bisexual. "Bi-what?" he asked in his thick Scottish brogue.

"I knew we were in trouble then," said Lieberson.

One executive complained, "Even the bathwater is dirty in this film."

Roeg sniffed, "Well, the water looks that way because they just took a bath."

And there were practical marketing concerns. The Warners men thought they were getting a Mick Jagger rock 'n' roll movie, and from the looks of the rushes he wasn't anywhere in the first half hour of what might be the finished film, whatever that was going to be. Their dreams of having another *Hard Day's Night* vanished in the rushes.

There was talk of not releasing the movie, and Lieberson soon doubted he'd ever be allowed to produce another. "I knew Seven Arts was angry that their production plans in Britain should have had what was considered a disgraceful start," he recalled. Also, there was something about *Performance* he couldn't quite put his finger on. Even the workers in the film lab refused to edit the movie, and Cammell and Roeg had no choice but to cut it themselves. "This film, for whatever the reasons, was having a tremendous emotional effect on people intimately concerned with it, which couldn't be countered or contained by rational argument," said Lieberson. "It was to have the same effect on nearly everyone who saw it. It changed people from relatively reasonable individuals into impassioned denouncers of the evil they claimed it represented. We really began to wonder, had we made such a corrupt film? It was a nightmare."

In an attempt to appease the people at Warners, Cammell and Roeg edited out fifteen minutes, most of it sex- and violence-related, but their efforts didn't help. Warners put *Performance* on the shelf, where it would remain for more than a year.

Mick Jagger, however, was able to unleash some of his sexual menace later that year. He and Keith Richards made their song "Sympathy for the Devil" the lead single on the Rolling Stones' new album, *Beggars Banquet*.

. . . .

MART CROWLEY'S *THE BOYS IN THE BAND* cost only $9,000 to produce Off Broadway, and it returned that investment every ten days throughout its run in 1968. *Variety* reported that, in terms of income, it generated the income of a *Hello, Dolly!* It helped that, while Broadway charged $7.50 to see a play, *The Boys in the Band*, in a two-hundred-seat theater, upped the ticket price to $10.

The play might never have happened without Crowley's Natalie Wood connection, agent Richard Gregson. Ironically, the play's success was not enough to save Gregson's agency, London International, which had to be dissolved shortly after *The Boys in the Band* opened Off Broadway. Natalie Wood was living at the time with her fiancé in London, where he undertook the necessary business measures to close shop. It wasn't a good year for either of them. The actress's own career had slid into a self-imposed two-year hiatus from the screen, her 1961 halcyon of *Splendor in the Grass* and *West Side Story* yielding a subsequent string of duds like *Inside Daisy Clover*, *This Property Is Condemned*, and *Penelope*, which was quickly followed by her suicide attempt. Wood was officially, chronically unemployed when her agent, Freddie Fields, sent her a script written by a fellow client, an actor-writer named Paul Mazursky, who had ambitions of being a movie director and wouldn't sell his screenplay about spouse-swapping unless he got to direct it. Mazursky had cowritten *Bob & Carol & Ted & Alice* with another actor-writer, Larry Tucker, and the two of them had been shopping the script around Hollywood, where they had endured the usual mindless conversations with reluctant studio VPs. Like the executive at National General who told them the screenplay was "too dirty. It's filthy."

"What if I got Paul Newman and Joanne Woodward to play one of the couples?" Mazursky asked.

"That's clean," said the executive.

Mazursky didn't know Paul Newman and Joanne Woodward, but his agent did know and represent Natalie Wood, and it was Freddie Fields and producer M. J. Frankovich who thought that she and Robert Culp, then starring on TV in *I Spy* with Bill Cosby, would be big enough household names to make the story "clean."

It helped too that, unlike John Updike's dark tale of Protestant angst in New England, *Bob & Carol* put a sunny California spin on chronic marital infidelity. Instead of cheating on each other, these glamorous Southland couples would be open about their philandering, testing the bonds of honesty with feel-good buzz words like "groovy" and "let it all hang out." In place of Updike's burning-church apocalypse, there would be Natalie Wood in a bikini at a backyard poolside barbecue. If they started production fast, *Bob & Carol* could easily beat the Wolper Company's production of Updike's *Couples* to the screen. (Regarding the competition, Mazursky later said, "I read all of Updike's novels, so I must have read *Couples*. But it wasn't an influence in any way on my movie.")

And it didn't hurt that, in 1968, as Mazursky put it, "A few new people were getting a crack at things in Hollywood. The business was in a state of chaos. The big pictures were flopping right and left. Then somebody made *Easy Rider*, and it made a lot of money. The studios were willing to try new directors, as long as the pictures didn't cost much."

Columbia Pictures would let Mazursky direct, as long as his movie cost only $2 million—and starred Natalie Wood, who had been making $750,000 a picture. For *Bob & Carol*, she would take a big cut, at $50,000, but she would also get 10 percent of the gross.

Actors, especially ones who have once been major stars, are notoriously fearful of novice directors. But Wood liked the script and she even liked the burly, ebullient, intellectual Mazursky, who flew

to London to meet her for tea at Claridge's. They followed that inter-
view with a long tête-à-tête in Hyde Park. She told him about Greg-
son and her ex-husband, Robert Wagner, whom she called her "best
friend." And Mazursky told her how *Bob & Carol & Ted & Alice*
had been inspired by a few days that he and his wife, Betsy, spent
at the new-age Esalen Institute in Big Sur, California, where they'd
experienced a "weekend marathon" of couples' therapy. He'd been
intrigued by a *Time* magazine article titled "The New Therapy,"
which was illustrated with a photograph of the seventy-five-year-
old psychotherapist Fritz Perls in a hot tub at Esalen with six naked
women. It got Mazursky thinking: There might be a movie script
somewhere in all those wet cedar barrels up north.

As Mazursky described his Esalen experience to Wood, "A group
of us, all couples, began explaining what we felt about our relation-
ships, and after four hours Betsy became upset. She complained that
I didn't let her breathe and some of the others attacked me." Wood
recognized it immediately as the first scene in his script, which went
on to speculate what would happen if a married couple, Bob and
Carol, took that let-it-all-hang-out group therapy to the next level
and swapped partners with another married couple, Ted and Alice,
their best friends.

Wood's big question was whether the two couples in Mazursky's
script go through with their plans to swap spouses at the end of the
movie. Tucker and Mazursky's script left that option open.

"I don't know. We'll see what happens," Mazursky told her.
"Some scenes I like to rehearse. Some I don't." The orgy, to be or
not to be, fell into the latter category.

Mazursky called Natalie Wood "a studio brat," with all due
affection, and felt it best to surround her with professional stage
actors, a couple of whom, Elliott Gould and Dyan Cannon, were
relative newcomers to the screen. He told Wood's costars, "Natalie's

never studied a day in her life. You all have studied. Be kind to her. Help her through this."

Mazursky also relied on a bit of typecasting with real-life swinger Robert Culp, who knew so much about the current California sex scene that he eschewed a costume designer and used his own wardrobe, which included "outfits with zippers down to the ankle and up to the neck," noted Mazursky. All those love beads, leather suits, Nehru jackets, and ruffled lace shirts were "hip," in Culp's estimation. "I sent away to London for a lot of that stuff," he bragged.

Dyan Cannon also considered herself a bit typecast as the uptight Alice, despite having done some of her own new-age psycho experimentation. "Of course I had LSD with Cary Grant," she said of her ex-husband, whom she'd divorced a few months earlier and was still fighting in the courts regarding child custody of their baby daughter, Jennifer. That battle had gotten nasty and public. Elliott Gould was well into the last quarter of his marriage to Barbra Streisand, but they were still on good enough speaking terms for her to show up on set to get advice from Natalie Wood on how to secure perks in her movie contract, like trailer size and shrink-visitation rights. "Natalie was one of the first to do all that," said Cannon.

It was a happy ensemble, but the big orgy finale weighed on the actors. Mazursky remained mum on what he wanted them to do. "We'll improvise it," he kept saying.

The big day arrived, finally. "There was an air of great expectancy on the set as the foursome arrived," said Mazursky. "I had ordered a closed set, no visitors, thereby raising the expectation of something very wild and sexual. The actors were mostly giggling nervously. I arranged Natalie, Bob, and Dyan in the king-size bed, sitting up under the covers. They were waiting for Elliott to join them."

Gould took longer than usual to exit his trailer that day. Finally, after "a last-minute breath spray and underarm cleanup," as Mazursky described it, the actor took his place next to Natalie in the bed, and

once under the covers he threw off his underwear as directed, even though he had taken the precaution of double-dressing, with "rugby jockey shorts." Gould "just couldn't be naked" next to Natalie Wood.

And vice versa. "We were all embarrassed as hell," she said. "And Dyan and I really were making sure that we were all covered up, and that we weren't nude. It seemed so shocking!" Both actresses wore pasties to cover their nipples.

Then, Robert Culp looked at Mazursky. "What do we do now, Paul?" he asked.

"Just do what you want," instructed their director.

"That scared the hell out of me," said Gould later.

"I was on the edge of the bed and ready to run at a moment's notice," said Cannon. Culp caressed her, Cannon laughed. Natalie Wood initiated her kiss with Gould. Then Culp and Cannon kissed. "Bob was kind of getting it on," said Mazursky.

"There was some degree of manipulation going on for the four of us to physically interact . . . but I couldn't do it," said Gould. "Bob would have liked to have, and I think that Dyan was hysterical enough to perhaps go on and use her hysteria, but the anchor there was Natalie. Natalie was not just there as a star, she was there as a fellow human being, like a sister."

None of them went any further than a kiss and a caress. *That* was going to have to be the big orgy scene in *Bob & Carol & Ted & Alice*—yes, but no thanks.

Mazursky was left to wonder, "What might have happened if I had told the cast to really get it on, really have an orgy. I think Bob Culp could have handled it, but no one else. I think."

ON THE WEST COAST, *Bob & Carol & Ted & Alice* wrapped in time for the holidays. On the East Coast, *Candy* opened in time to ruin the holidays for Terry Southern.

He took his girlfriend, Gail Gerber, to the December premiere in New York City. He watched the opening title sequence in which a blazing meteor-like object travels through space and lands in a desert landscape to transform itself into the very blond Ewa Aulin, who begins running across the arid earth only to end up in a high school classroom being lectured by Richard Burton's poet-professor character, MacPhisto. Gerber laughed out loud when Burton's scarf gets caught in the auditorium doors. Southern, on the other hand, began to audibly cry, "seeing the travesty of what they did to his novel," his girlfriend recalled. They left before the screening ended.

It had been years since Southern last talked to his *Candy* co-author, Mason Hoffenberg. Adversity has a way of bringing people together. Southern was so horrified by the first few minutes of *Candy* that he wrote Hoffenberg a letter, in which he reviewed the film: "It bears precious little resemblance to the true *Can*—a view which would seem substantiated by the review in both *Time* and *Newsweek* mag this week, the former going so far as say the picture is 'based on the novel in the same way a flea might be based on an elephant.' "

Southern objected strenuously to the movie's ad line, "Is Candy Faithful? Only to the Book!" He thought it might hurt sales of their novel.

Hoffenberg, now a recluse and addicted to heroin, agreed "that something ought to be done about that ' . . . faithful only to the book' nonsense," but not before letting Southern know his "extreme displeasure" of hearing from "such a sneaking fair weather s.o.b. as yours truly."

There was a lot of letter-writing that winter. A few weeks later, according to Gail Gerber, Buck Henry sent Southern a letter of apology. Henry told other detractors of the film, "In spite of the results, a good time was had by all."

And there was another indignity for Southern: The newly created

Motion Picture Association of America graced *Candy* not with an X but an R rating. The film broke no taboos regarding language, nudity, or content. If only they had left in the scene where the hunchback rubs his protruding abnormality against Candy's crotch!

In a way, the R rating fueled Southern. He believed more than ever in his long-gestating *Blue Movie* novel, about an esteemed director who makes the first X-rated studio movie, complete with A-list stars having full-penetration sex—or as Southern often put it, "full vag-pen." Southern had gotten the idea when he first met Stanley Kubrick, on assignment from *Esquire* magazine in 1962. Southern had asked Kubrick about the sex in his new film *Lolita*, and Kubrick responded with great reticence, "There's something so inappropriate about seeing it with an audience that it just becomes laughable."

Kubrick's artistic dilemma—making a film about sex but not wanting to show it—intrigued Southern, and he had been writing *Blue Movie* ever since. If it had been faithful to the novel, *Candy* should have been the first truly pornographic movie released by a major Hollywood studio. It's what Southern had wanted.

He didn't get it. After that page-to-screen debacle, a reporter from *Screw* magazine asked Southern if he'd gotten "any ideas or background" for his upcoming *Blue Movie* from the movie *Candy*.

"No," Southern replied. "I'm not aware there were any ideas at work on the filming of *Candy*."

The year also ended badly for Jane Fonda. In the end, she couldn't have won either way she played it. Not only did her rejected *Candy* bomb at the box office but so did *Barbarella*. Its failure forced Paramount Pictures to yank it from theaters and replace it with a little film the studio executives had told its producers "would never be shown" due to its scenes of violent student rebellion and equally violent love.

Even before filming began on Lindsay Anderson's *If . . .*, British censor John Trevelyan had warned about a scene in which two male

students are shown in bed together. "Since they are both sleeping, it might possibly pass," he wrote to Anderson. But Trevelyan could not have known how graphic the student rebellion would be photographed, nor did he know that a scene in which newcomers Malcolm McDowell and Christine Noonan wrestle, bite, kiss, slap, and tug at each other on the floor of a roadside greasy spoon would be filmed with the two actors completely naked. Their nudity was actually a last-minute suggestion made by McDowell, who thought it would be intriguing "if we're naked and rolling around like animals," although weeks later in the editing room the actor made sure that his director "cut out shots of me and my penis. I didn't want any of those."

Even without his genitals showing, McDowell called it "one of the most animalistic, sexual scenes ever filmed in British cinema." And audiences agreed, turning *If* . . . into the surprise hit of the holiday season, even though the movie's two "notorious" scenes took up fewer than three minutes of screen time.

Winter 1969, Bonanza

In the late 1960s, law officers raided the Atlanta, Georgia, home of Robert Eli Stanley, expecting to find evidence that would help convict him on charges of being an illegal bookmaker. Instead, they found sexually obscene materials in a desk drawer in his upstairs bedroom. That raid led to his arrest and conviction, in which the Supreme Court of Georgia found Stanley guilty of the possession of pornography. In January 1969, the U.S. Supreme Court heard the case and then unanimously overturned that lower-court decision; it was a ruling that helped to establish the "right to privacy."

The U.S. Congress, outraged that the court invalidated all state laws forbidding the private possession of pornography, immediately commissioned a study in the new year. They called it "The Report of the Commission on Obscenity and Pornography."

HAIR **HAD CELEBRATED NEARLY** a year of performances at the Biltmore Theatre before a twenty-one-year-old Broadway dancer named Margo Sappington got around to seeing it. "It was research," she said. Research, in this case, was her new gig. Kenneth Tynan had just hired her to choreograph his *Oh! Calcutta!*

Tynan first noticed the beautiful brunette with the 180-degree leg extension in the new musical *Promises, Promises*, in which she and other dancers performed the showstopper "Turkey Lurkey Time," about a drunken office party. Tynan had originally hired *Promises, Promises*'s choreographer Michael Bennett to choreograph *Oh! Calcutta!*, and it was Bennett who wanted Sappington to dance the female half of the revue's controversial centerpiece, a naked pas de deux.

"Why me?" she asked Bennett.

"Because every time I come into the dressing room at *Promises, Promises*, you're naked," he replied.

And so Sappington was cast in Tynan's revue. But before *Oh! Calcutta!* went into rehearsals that winter, Bennett left the production. "Michael had been there for the *Oh! Calcutta!* auditions," said Sappington, "but his career just took off. He got busy with other projects," one of those being Stephen Sondheim's *Company*. In a lucky break for the dancer, she inherited the assignment to choreograph *Oh! Calcutta!*—and that's when Tynan suggested she go see *Hair*. The hippie musical surprised her.

"When they took off their clothes, nobody onstage moved," observed Sappington. "They just stood there. Plus, the stage was pretty dark."

The full-frontal stasis of *Hair* was purely intentional. Naked breasts, penises, and buttocks were allowed onstage, but only to create a theatrical tableau. Private body parts attached to unclothed actors who walked, ran, danced, or otherwise moved onstage were in violation of the city's penal code. With *Oh! Calcutta!*, it would be Sappington's job to challenge that law with a nude ballet. "We just took a chance," said producer Michael White.

Tynan liked that Sappington was a "nonqueer," as he sometimes labeled people of his own sexual orientation. The dancer's heterosexual credentials were strictly in order (unlike the closeted Bennett,

who was dating *Promises, Promises* dancer Donna McKechnie at the time).

"Tynan made a hard-and-fast rule there was to be no homosexuality," said Bill Liberman, the show's company manager. "*Oh! Calcutta!* would be a completely hetero show. That was a Tynan edict."

Sappington saw *Oh! Calcutta!* as a chance to leave the chorus line and launch her career as a choreographer. For the middle-aged Tynan, the show not only meant more, it was also much more complicated, since his ambitions were driven in unequal parts by creative frustration, financial hardship, and lust. As a theater critic, he wielded power, but it was power without much financial income. He wrote thousands of words a year, but he also wrote nothing of consequence that would be read a year, or even a few weeks or maybe even a day or two after it left his typewriter for the printed page. He'd tried to write a book, even a play, but he finished neither. "*Oh! Calcutta!*, he thought, would make him money," said Michael White. *Oh! Calcutta!* would also attach his name to something other than a thousand-word review of somebody else's hard work and labor. And more important, according to Bill Liberman, "Ken had a lot of sexual fetishes, which he was very open about having to do with ladies' underwear or S&M. His doing *Oh! Calcutta!* was definitely part of that." Those sadomasochistic fetishes worked their way into a least four skits that Tynan himself wrote for the show.

Obviously, "queers" were not part of his fantasy, although Tynan did let his lead producer, Hillard Elkins, hire John Schlesinger's new lover, Michael Childers, to be the show's photographer. As Childers described the general ambiance around the project, "Tynan was a real cocksmith, and *Oh! Calcutta!* was an ode to cunt. It was a very heterosexual production."

In addition to it being a very heterosexual show, Tynan desperately wanted *Oh! Calcutta!* to be a very Broadway show.

But Broadway declined. No matter that many of those old and

venerable venues were underused and falling apart in the late 1960s; the Nederlander and Shubert organizations, the largest theater land-owners in midtown Manhattan, preferred to keep their Broadway respectability intact by eschewing the rent money from "such a dirty show," as Lawrence Shubert Lawrence Jr. described *Oh! Calcutta!* The year before, the powers behind *Hair* had run into a similar puri-tanical wall of resistance from the New York City theater monopoly, but lucked out by securing the Biltmore Theatre, one of the only Broadway venues not owned by either the Nederlanders or the Shu-berts. With the Biltmore already occupied, Tynan had no choice but to look downtown to Off Broadway to open *Oh! Calcutta!*

It fell to the company manager to secure that theater. One day, Bill Liberman found himself walking by the Gaiety on Second Avenue, just below Fourteenth Street. "It was a theater. I thought it might be appropriate, so I bought a ticket," he recalled. Inside, strip-pers bumped and grinded, and as they were finishing up their act, a movie screen lowered. "And a film came on showing a penis going into a vagina," said Liberman. "But it was light enough, and I could see it was a real theater."

An old burlesque house, to be more precise.

It had once been known as the Phoenix, popularized by a green-eyed ecdysiast named Ann Corio. Then, in a less sexually ambivalent era, the management called it the Gaiety, which sent out the wrong message for its potential new tenant. Tynan quickly rechristened it the Eden, as in the Garden of Eden. At least that's the way Amer-icans interpreted it. For the British Tynan, the theater's new name was "a tribute to a great English statesman," the British prime min-ister Anthony Eden. It was a wicked salute, since Tynan despised the conservative pill-addicted politician who spied on the members of his own cabinet by ordering government chauffeurs to report back to him any questionable activities, especially those of a carnal nature.

To rename it the Lord Chamberlain Theatre might have been

more apt, albeit a little lengthy for an Off-Broadway marquee. The Lord Chamberlain had been the British theater censor, up until the end of 1968, when the office was abolished. In the beginning, Tynan had considered opening *Oh! Calcutta!* in London. But, "I was afraid there might be some sort of backlash. The public prosecutor can still make trouble," he believed. "I've decided it will be better to be [in New York City] and go to the West End next year."

Ever since Tynan uttered the word "fuck" on the BBC, he'd harbored a paranoiac fascination with censors, and he rightly feared that his name on a sex revue might "attract the killers, the bluenoses," who, under the new, less restrictive censorship laws, could possibly still make trouble. "I don't want to be one of the first test cases," he said. As long as it didn't cost him anything, Tynan was all for freedom of speech.

He wasn't alone in his bridled licentiousness. *Hair* also delayed its London opening a year to avoid dealing with the Lord Chamberlain. But unlike *Hair*, Tynan chafed at being forced to put his show into an old strip joint rather than a prestigious Broadway house. And there were even worse indignities on his ride to notoriety. While he'd been successful in securing skits from, among others, Samuel Beckett, Jules Feiffer, and John Lennon, the coup of having a heavyweight theater director ("Harold Pinter was tempted," said producer Michael White) devolved into the mundane necessity of hiring someone who'd actually do the job—in this case, a clinical psychologist-turned-stage-director. Dr. Jacques Levy of the Menninger Clinic had recently fulfilled a lifelong ambition to direct a play, *Motel*, which Michael White had produced as part of the experimental New York–based theater group La MaMa's *America Hurrah* project in London. Hilly Elkins and Bill Liberman, despite their sizable theater résumés, had never heard of Levy, which compelled them to see a play he'd directed in New York City. It was by some equally no-name playwright.

At the final curtain of Sam Shepard's *Red Cross*, the producer

asked his company manager, "Do you know what we've just seen?"

"I have no idea," replied Liberman.

Tynan had seen *Motel* in London and told his wife, Kathleen, that he liked Levy's cool "nonorgiastic style." How could Elkins and Liberman possibly disagree?

There was, however, total agreement on one thing: what had to be done with the Eden.

"We're disinfecting the place before we move in," announced Elkins. "Speaking of whorehouses, there were at least two beds in each dressing room." Fifty-four cots, to be exact.

"They were, indeed, running a whorehouse," Liberman verified.

In addition to creating a run on Lysol at the local A&P, there were other purges as well. Before they even got to the auditions, Tynan made it clear to Elkins and Levy that he wanted an all-heterosexual cast. To American eyes, this Brit with his stiff demeanor and chronic stammer seemed an unlikely arbiter of all things machismo. It was a cultural divide that, in her review of the gay-themed film *Victim*, critic Pauline Kael pinpointed with her assessment that "actors, and especially English actors, generally look so queer anyway, that it's hard to be surprised at what we've always taken for granted. . . ."

Tall, immaculate, and very reserved, except when talking about taking a cane to a woman's behind, Tynan often showed up in a white silk suit, a pink shirt, and wine-colored patent leather loafers on his visits to the once-grungy Eden, which he promptly painted green in his re-creation of the world's first garden. Tynan's clothes screamed Carnaby Street, especially when seen in contrast to the typical costume outside the theater's doors on Second Avenue, where the real-life hippies whom Tom O'Horgan hadn't already cast in *Hair* limited their wardrobe to blue jeans, tie-dyed T-shirts, and sandals. Not that the Americans in charge of *Oh! Calcutta!* were any more adventuresome in their appearance. Jacques Levy grew his mustache big and black to compensate for the baldness above, which he tried

to disguise with a bad comb-over and cowboy hats. Hilly Elkins, an impresario who fashioned himself after the late Mike Todd of *Around the World in 80 Days* and Elizabeth Taylor fame, sported a well-trimmed goatee and naturally gray hair. According to his girl-friend of the moment, actress Claire Bloom, Elkins was also "some middle-aged urban cowboy," with his motorcycle, sun-lamp tan, and a libido that matched, if not surpassed, Tynan's. As Bloom reported, "Elkins's entire being was centered on sexual gratification; his fantasies were alternately voyeuristic and sadistic." In other words, the perfect man to produce *Oh! Calcutta!*

What Elkins also shared with Tynan was his ability to see the same bottom line. *Oh! Calcutta!* had the potential to make them wealthy. "I don't mind anything that's profitable," Elkins liked to say. "In six months, you'll be hard put to ignore this show anywhere. I'm sure you know how far a Jewish boy can go with a dirty joke."

Watching hundreds of hopeful actors audition, Elkins and Levy made sure that no one making the final cut was too well endowed, for fear of inciting the police. They weren't looking for porn bodies, because they didn't want anyone's dangling member to take focus. Still, "We wanted an attractive cast," said Elkins. "If you have a show where every cast member is going to get naked, you have to know what you're dealing with."

Equally important, all traces of effeminacy in speech or gesture from the male actors met with a forceful "Thank you very much. We'll call you." Despite the three men's gaydar, one male homosexual did make the final cut. Somehow, the fact of his employment never caused Mark Dempsey ever to feel any loyalty to his employers, calling them "heterosexual fascists! All of them!" shortly after rehearsals began in late March.

Dempsey, as it turned out, was the least of the show's problems.

That winter, a popular evangelist preacher took to walking in Times Square. In his strolls, he found nothing good to say about the

place. "When we take down all the rules and barriers and all the regulations, it all goes out and becomes like Sodom and Gomorrah," Billy Graham told the TV cameras. "And it ends in God's judgment of the country when we change our way of life!"

It wasn't the kind of change Tynan or Elkins wanted. "Simultaneously with our opening of *Oh! Calcutta!* was this push, with a lot of press, to clean up Broadway and get rid of all this nasty stuff," said Elkins. "And there we were having people simulate sexual congress, not wearing clothes. A lot of people were really pissed."

And there were other storm warnings. One week before the *Oh! Calcutta!* rehearsals began, the New York Police Department closed the Off-Off-Broadway play *Che!*, about the last days of the Cuban revolutionary Che Guevara, on charges of obscenity and indecent exposure. The actors' crime? Being naked and simulating sex onstage.

It's precisely what *Oh! Calcutta!* was promising its future audiences at the Eden.

WHAT BUSTED *CHE!* AND threatened *Oh! Calcutta!* is what kept the itinerate Living Theatre busy on the road. The actors of the Living Theatre didn't always restrict themselves to simulation when it came to sex onstage, nor did they restrict their sex partners onstage to fellow actors. Which is why the troupe rarely played more than one or two performances in any city.

That winter, Jim Morrison of the Doors saw the Living Theatre perform its signature *Paradise Now* at the University of Southern California, a theatrical experience enhanced by thirty helmeted, gas-masked Los Angeles cops who strategically positioned themselves in the auditorium lobby.

"What was great about the Living Theatre is that virile young men and nubile young women were actually taking their clothes off

onstage, outraging audiences," said the Doors' keyboardist, Ray Manzarek. "And it rang a bell with Jim."

The previous fall, at Yale University, the Living Theatre's one-night performance of *Paradise Now* saw not only many troupe members disrobe completely—Living Theatre's more modest founders, Julian Beck and Judith Malina, performed in their well-worn G-strings—but several in the audience followed suit, including critic Richard Schechner, editor of the *Tulane Drama Review*. High on LSD, a few naked actors and theatergoers groped and humped each other during the play's "Rite of Universal Intercourse" section, which preached "to overcome violence we have to overcome the sexual taboo." Everybody then left the Yale theater en masse to take to the streets, where Mace spray and paddy wagons greeted the totally naked among them.

The USC performance that Morrison witnessed was a little less raucous, not to mention more clothed, thanks to the presence of the police *inside* the theater. Undeterred by that disappointment, the rocker followed the troupe up to San Francisco for their next engagement, where things got a lot raunchier and, for their efforts, Morrison gave the cash-strapped company a $2,500 donation. From there he flew to his next gig with the Doors, in Miami, where Morrison decided to replicate on the rock 'n' roll stage what he'd just seen on the legit stage. The difference was a few thousand spectators and the fact that Dade County, Florida, is not the campus of a northern California university.

On February 28, the Doors performed for twelve thousand people at Miami's Dinner Key Auditorium, converted from an old seaplane hangar. "Jim had decided to do a whole theatrical presentation, unbeknownst to anyone else in the Doors," said Manzarek. "You could see this man was a little bit out of control." The first thing he did was berate the audience.

"Why did you people come here?" Morrison began. "You didn't

come to just hear a good rock 'n' roll band play some hit songs. You want something more, don't you? You've come to see something. What can I do? What do you want from me? I'm just a rock 'n' roll guy. What did you come for? What if I showed you my cock?"

A few men in the auditorium yelled no; quite a few women yelled yes.

Morrison tore off his shirt and placed it over the bulge in his leather pants. "Now watch!" he ordered. "I'm going to show it to you!" He moved his shirt away from his crotch, then covered it again—back and forth went the shirt. "Did you see it? Did you see it?" he taunted. "Come onstage if you want to get closer. Whatever you want to do. You're free. No one is going to tell you what to do." Sometime during this tirade, Morrison got down on his knees to put his face up to guitarist Robby Krieger's groin.

Manzarek, standing behind Morrison, doubted that the group's lead singer actually exposed himself. The concertgoers were the only ones stripping that night, as dozens of shirts, scarves, panties, socks, and shorts began to litter the stage. The audience also followed Morrison's command to storm the stage, which immediately began to list under their growing weight. That's when the Doors concert at Miami's Dinner Key Auditorium came to an abrupt halt.

Teenagers who'd attended the concert and been duly offended expressed their outrage to the local TV cameras. "I wonder if anyone has the courage to come forth and stop this kind of trash," said one distraught girl. Those teenagers who'd been thrilled by Morrison's impromptu performance somehow never received equal airtime.

Surprised by the criticism, a somewhat more sober Jim Morrison made feeble attempts to defend himself in the following days. "In the realm of art and theater there should be complete freedom for the artist and performer," he said in one interview. "I'm not personally convinced that nudity is a necessary part of a play or film. But the artist should be free to use it if he chooses."

The concerned citizens of Miami did not care about art. They

cared about nudity, and regardless of what actually happened on February 28 at the Dinner Key Auditorium, the police in Dade County charged that Morrison "did lewdly and lasciviously expose his penis, place his hands upon his penis and shake it, and further the said defendant did simulate the acts of masturbation upon himself and oral copulation upon another." It was also reported in court that Morrison screamed at the audience, "You're all a bunch of fucking idiots. Your faces are being pressed into the shit of the world. Take your fucking friend and love him. Do you want to see my cock?"

It sure sounded like the Living Theatre.

While a few concertgoers claimed to have seen the "ivory shaft," which is what Manzarek nicknamed Morrison's penis, one-hundred photographs offered in evidence at the trial recorded no such sighting.

JIM MORRISON APPEALED THE five-hundred-dollar fine and sentence of six months in jail, but would die before the case could be retried.

Dade County, where he had been convicted, was ultraconservative. Manhattan, where the *Che!* actors had been arrested, was not—and their theater was only five blocks away from where *Oh! Calcutta!* would soon be performing.

The *Che!* bust took place on March 24, moments after the play's third performance ended at the Free Store Theater on Cooper Square in the East Village. Arrested and fingerprinted but still eager to publicize their show, the *Che!* cast posed for photographers at the East Fifth Street police station. Actress Jeanne Baretich got especially cheeky when she stuck a red rose in her mouth to offer up her best Carmen Miranda impersonation. In addition to the four actors, six persons associated with the direction, writing, and production of *Che!* were arrested on charges of "consensual sodomy, public lewdness, obscenity, and conspiracy to commit such acts under the stage penal code."

It was a local clergyman who made sure that the police knew all

about *Che!* Having bought a ticket to the March 22 opening-night performance, the reverend stopped by his local precinct afterward to register extreme moral displeasure. Warrants were secured, and two days later, Assistant District Attorney Kenneth Conboy, accompanied by Judge Amos A. Basel of criminal court, broke from their usual evening of watching TV to go to the Free Store Theater to witness actress Mary Anne Shelley simulate sex with Che Guevara doppelganger Larry Bercowitz, who simulated fellatio on Paul Georgiou, who impersonated the president of the United States. There was also much "rubbing of the genital areas," as the ensuing police report noted. From what Conboy and Basel could decipher, no article of clothing prevented one actor's groin from contact with another actor's groin. In total, the two male actors tallied up no fewer than four such offenses against public decency.

"This is a clear case of political suppression," *Che!* director Ed Wode complained to reporters. "There have been seventy plays depicting nudity throughout New York City and no one arrested them. We are being singled out because of the political message in our play."

The police rejected that charge, saying that it was the physical contact and movement of the naked actors that felled *Che!* and spared works like *Hair.*

Eventually, *Che!* did continue its performances, but with a fully clothed cast. It closed a few performances later.

Kenneth Tynan saw no point in turning *Oh! Calcutta!* into another money-losing cause célèbre, even though his lead producer had an appetite for provoking audiences, if not the censors. Four years earlier, Hilly Elkins produced *Golden Boy* on Broadway, a musical that received much hate mail when its star, Sammy Davis Jr., kissed a white actress, Paula Wayne, to the sweet strains of "I Want to Be with You." Elkins remained philosophical then and he remained philosophical now with the far racier content of *Oh! Calcutta!*

"If I were afraid of trouble," he said, "I'd be selling cars."

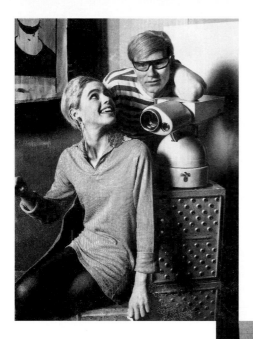

Edie Sedgwick and Andy Warhol smile for a portrait in the 1960s, before she demanded to be removed from *Chelsea Girls* (1967). *Photofest*

Chelsea Girls, despite its title, features a number of male performers in various intimate situations. *Photofest*

To promote his novel *Myra Breckinridge* (1968), Gore Vidal revisits the Sunset Strip statue of a Vegas showgirl that inspired his transsexual character. *Everett Collection*

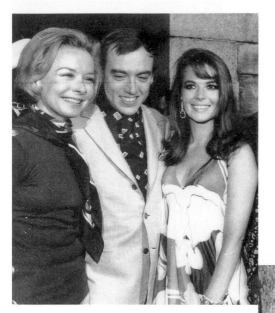

Mart Crowley greets his actress friends Diana Lynn and Natalie Wood, who were early supporters of *The Boys in the Band* (1968). *Photofest*

Reuben Greene, Cliff Gorman, and Kenneth Nelson risked their careers to play homosexuals in the original staging of *The Boys in the Band*. *Photofest*

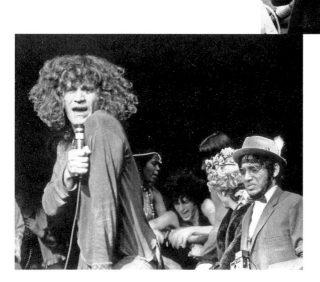

Gerome Ragni portrays draft dodger Berger in the Broadway production of *Hair* (1968), which he coauthored with boyfriend James Rado. *Photofest*

John Updike writes *Couples* (1968) and scores a *Time* magazine cover that proclaims "The Adulterous Society." *Photofest*

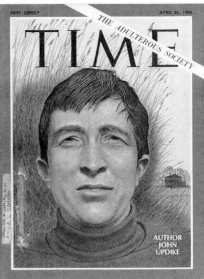

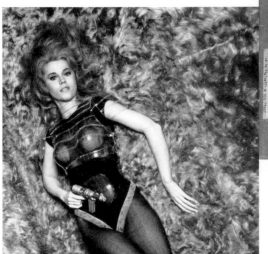

Jane Fonda brings a weightless striptease and much sex to outer space in *Barbarella* (1968). *Photofest*

Terry Southern's *Candy* is finally a movie (1968)—and a very bad one—starring Marlon Brando and Ewa Aulin in the title role. *Photofest*

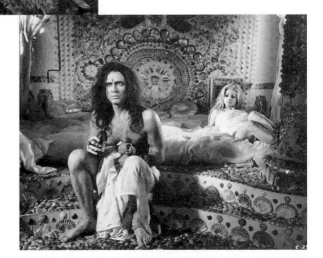

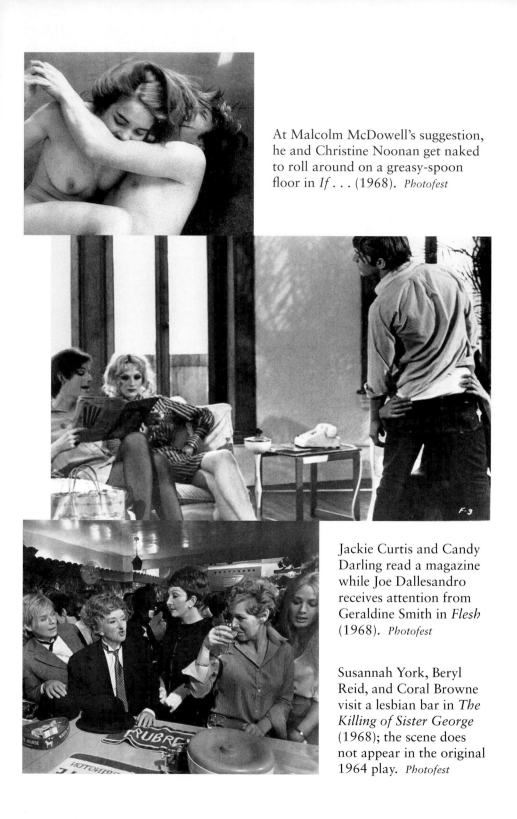

At Malcolm McDowell's suggestion, he and Christine Noonan get naked to roll around on a greasy-spoon floor in *If . . .* (1968). *Photofest*

Jackie Curtis and Candy Darling read a magazine while Joe Dallesandro receives attention from Geraldine Smith in *Flesh* (1968). *Photofest*

Susannah York, Beryl Reid, and Coral Browne visit a lesbian bar in *The Killing of Sister George* (1968); the scene does not appear in the original 1964 play. *Photofest*

Elliott Gould, Natalie Wood, Robert Culp, and Dyan Cannon get in bed together, but decide against an orgy, in *Bob & Carol & Ted & Alice* (1969). *Photofest*

The nude wrestling scene between Alan Bates and Oliver Reed in *Women in Love* (1969) challenged the censors, intrigued audiences. *Photofest*

Oliver Reed and Glenda Jackson disagree vehemently over how to play their sex scene in *Women in Love*. *Photofest*

Jennie Linden and Alan Bates take to the outdoors for their lovemaking in *Women in Love*. *Photofest*

Many more people saw the photo of a shirtless Raquel Welch and Jim Brown in *Time* magazine than their movie, *100 Rifles* (1969). *Everett Collection*

Kenneth Tynan turns Clovis Trouille's odalisque into a poster image for his sex revue, *Oh! Calcutta!* (1969). The *New York Times* subsequently banned the image from its ad pages. *Photofest*

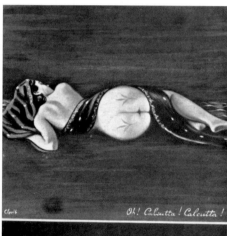

The Off-Broadway sex revue *Oh! Calcutta!* defies convention by offering performers who both disrobe and move onstage. *Michael Childers*

Jon Voight, John Schlesinger, and Dustin Hoffman film on the streets of New York City to bring the tale of a Times Square hustler *Midnight Cowboy* (1969) to the screen. *Photofest*

John Schlesinger agrees to let Brenda Vaccaro wear a fox wrap for her sex scene with Jon Voight in *Midnight Cowboy*. *Photofest*

Helmut Berger, inspired by *The Blue Angel*, performs a Marlene Dietrich impersonation in *The Damned* (1969). *Photofest*

The Night of the Long
Knives sequence from
The Damned is heavily
censored in most
countries due to its
depiction of gang rape,
homosexuality, and
transvestism. *Photofest*

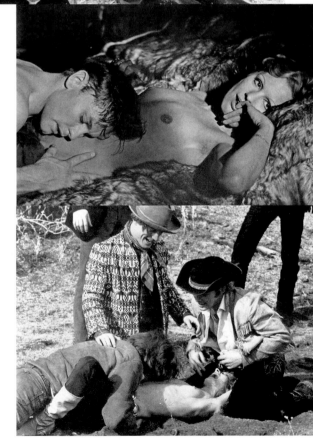

Incest is one of
the lesser offenses
committed by Helmut
Berger's son and Ingrid
Thulin's mother in *The
Damned*. *Photofest*

The rape scene in
Lonesome Cowboys
(1969), featuring Viva
and a few other Andy
Warhol superstars,
attracted the attention
of the FBI. *Photofest*

A flamboyant showman, Elkins courted controversy, even when it came to marrying his girlfriend of a few weeks, Claire Bloom. Elkins insisted on being married by a judge, not a rabbi, and asked his *Oh! Calcutta!* general manager, Gregg Platt, to find him one.

"I know a judge," said Platt. "He's up on the Grand Concourse in the Bronx."

"I wouldn't go to the Bronx to get married if Richard Nixon himself married us," said Elkins.

Platt smiled. "Oh, Bill knows a judge," he said, nodding at the show's company manager.

"But he won't marry you," said Bill Liberman.

"Why not?" asked Elkins.

"Because he's the judge who closed *Che!*"

That bit of legal prudery didn't deter either Elkins or Amos A. Basel. A judge whose flair for the theatrical matched Elkins's, Basel married the producer and Claire Bloom that winter in the producer's East Side townhouse, a residence that the bride would later described as being of "faux-Napoleonic grandeur as though purchased, top to bottom, from the basement of Bloomingdale's." The ceremony took place in the presence of Liberman and Platt and a few relatives like Elkins's father and Bloom's daughter, Anna Steiger, who would soon refer to her future ex-stepfather as "the unmentionable." It was a typical civil service, except when Basel took a few minutes to lecture the couple on show-business people's bad reputation for not taking their marriage vows seriously. "I was a little mortified," said Liberman.

Elkins knew having his wedding officiated by Judge Amos A. Basel would get him some publicity; it might even help inoculate his show from being challenged in court.

It was a real fear.

On the first day of rehearsals, director Jacques Levy told his cast, "There's a good chance we'll all be arrested. We might even be arrested today."

It had not escaped the actors' attention on the first day of rehearsals that uniformed and plainclothes cops alike waited outside the Anderson Theater as the company filed into the rehearsal space, just across Second Avenue from the Eden. "It's only fair to warn you that you're taking a chance with your livelihood," said Levy, raising the specter of some bluenose Joe McCarthy. "What we plan has never been done in America before, and a public outcry could lead to a blacklisting. In radio and television especially. You just may not be welcome anymore."

Indeed, an Actors' Equity representative would warn in the days to come, "The worst that could happen is that they be arrested and convicted, and given a sentence and very seriously have their careers compromised."

For that first rehearsal, Levy showed up in his usual cowboy outfit. The cast sat around him in a circle, wearing nothing but matching yellow bathrobes. The middle-aged Levy was balding, showed some paunch, but possessed a soft-spoken, comforting charm. "I think all of the women in the company had a crush on Jacques," said actress Boni Enten, who considered him as much "a guide" as a director.

In addition to their stage performances, Levy counseled his actors on potential personal problems. "Especially from relatives, and particularly husbands and wives," he added. For reasons of propriety, Levy instituted what he called the "no-fuck law," which quickly devolved into the abbreviated "NFL," which meant, in effect, that no cast member could sleep with another cast member. Bringing his Menninger Clinic experience to the discussion, Levy launched into a long discourse on *The Naked Ape.* Subtitled "A Zoologist's Study of the Human Animal," the book by Desmond Morris had recently made a surprise visit to the top of the bestseller lists, aided in that ascent by its cover of a naked man, woman, and child, their bare backsides completely exposed. Morris's lurid and somewhat

mundane thesis held that sex partners were territorial to the detriment and exclusion of their nonsex partners. Afraid of what was apparently commonplace in the world of monkeys, Levy didn't want any of his *Oh! Calcutta!* humans to feel left out.

But some were left out regardless.

It took three long weeks of rehearsal before Levy let his actors cast off their yellow bathrobes and perform naked. Nature soon took its course despite Levy's NFL rule. "How can you touch and fondle a person and spend so much time in getting on an intimate basis without learning to feel close to him when you're away from the theater?" asked one of the actresses. "I have been seeing somebody from the cast on the outside. It would seem unnatural not to."

If sex within the company was forbidden, anyone's spouse remained fair game. Shortly after the actors performed a number of Esalen-style "sensitivity exercises" under Levy's direction, they abandoned more than their yellow robes. When the new Mrs. Kenneth Tynan visited the theater one day to watch rehearsals, an actor in the company took the opportunity to leave the stage during a break and sit down beside her in the auditorium. "I'd like to fuck you," he said by way of introduction.

Kathleen Tynan, who had not visited Esalen or the Menninger Clinic or read *The Naked Ape*, politely thanked the actor for his interest, then voiced strong objections to her husband, who turned the matter over to Elkins, who turned it over to Levy, who just hoped the whole problem would go away.

Next up on the cast's firing line was photographer Michael Childers. Elkins had been impressed with the multimedia work Childers had done for the party scene in *Midnight Cowboy*, and thought *Oh! Calcutta!* could benefit from a similar psychedelic touch. Although the party sequence in *Midnight Cowboy* filmed for more than three days, *Oh! Calcutta!* was a two-hour show,

requiring, as Childers envisioned it, no fewer than fifty-six movie projections with superimposed photographic images fading in, out, and off several screens mounted around the stage. In one aspect, the mechanics and logistics were the easy part. The hard part came when Childers showed up to photograph the cast. Since they were going to be photographed naked, they demanded that he follow suit and get out of his street clothes, too.

"You lose a lot of inhibitions quickly!" said Childers, who was allowed to wear his tennis shoes.

Samuel Beckett did not make the trip to New York City to see the company rehearse his one-minute "Prologue," in which three naked bodies appear entangled in a lot of garbage onstage as the pre-recorded strains of female orgasms washed over them. In his place, Beckett sent a missive of minimal instructions. "Do not change a word of this script," he wrote, even though the totally mute "Prologue" contained no dialogue.

Less shy were Sam Shepard, Robert Benton, and David Newman, all of whom made visits to the Eden to oversee rehearsals of their respective skits. Benton and Newman, who wrote *Bonnie and Clyde* for Warren Beatty, contributed a dark ode to wife-swapping called "Will Answer All Sincere Replies." In Shepard's "Rock Garden" a father tells of his interest in "corn" and "cattle"; his son then tells of his interest in "fucking" and "cunts," at which point in the drama the father drops over dead.

Spring 1969, Fetishes

As Jacques Levy rehearsed his actors, Kenneth Tynan and Hilly Elkins worked out a multi-pronged approach to both stoke publicity and, at the same time, subdue reporters, police, and potential theatergoers, although not necessarily in that order.

The politically liberal and socially conservative *New York Times* held forth with one of the more uptight pre-opening reactions to the show. Although Tynan nearly genuflected at the ample derriere of Trouille's odalisque, the censors at the Gray Lady were a little less adoring of the chosen *Oh! Calcutta!* poster and insisted that the female model's tattooed buttocks be painted over in advertisements that graced the newspaper's pages.

A Tynan interview in the *Times* was equally skittish, the staff reporter resorting to a coy nom de plume. "Intelligent Puritan" asked, among other things, "The subject matter of pornography has inherent limitations. After all, how many ways are there of making love?"

Tynan replied, "A remarkable number." And so it went.

To both spur publicity and head off any problems, the makers of *Oh! Calcutta!* opened one rehearsal to the press. The invitation read: "There have been innumerable rumors about *Oh! Calcutta!* To scotch most of these rumors, to give the communication media an

opportunity to know what is going on, we are throwing down the barrier and are opening our rehearsals. You may watch the rehearsal for one hour, and for another hour you may speak to either director Jacques Levy, producer Hilly Elkins, or to Kenneth Tynan, who devised the entertainment with music."

A couple dozen members of the Fourth Estate attended. During the question-and-answer section, one reporter wondered aloud, "Will sexual intercourse be performed onstage?"

It's exactly the kind of rumor the *Oh! Calcutta!* team wanted dispelled. "No. We're not trying to top anybody," said Tynan, clearly evoking the specter of *Che!* A recent *New York Times* article on the shuttered play had indicated that *Che!* was a "guideline" for *Oh! Calcutta!*, and it was expected that the Tynan revue would, according to the newspaper, "include actual sexual intercourse," since actors had actually "done it" onstage in the Living Theatre's *Paradise Now.*

Tynan continued to pooh-pooh such reports. "I personally would not be attracted by the idea of seeing sexual intercourse onstage, because if I did I'd be jealous, and if I weren't jealous I'd be yawning," he said.

"Are you going to out-nude *Hair*?" asked another reporter.

"How would you out-nude *Hair*?" Levy replied. "They're completely nude. We'll be completely nude. Nude is nude."

Of course, the men behind *Oh! Calcutta!* had every intention of going farther than *Hair* if for no other reason than their nudes would move. A lot.

In the time-honored tradition of buyer-beware, a house board in front of the Eden both warned and enticed passersby with the suggestion "Recommended for mature audiences only."

Elkins also took out censorship insurance, of sorts, by "unofficially inviting," as he put it with great fanfare, several members of the police vice squad to see *Oh! Calcutta!* before it opened, "to check on the material."

The presence of uniformed officers surprised the cast during pre-
views. One night in the women's dressing room, Margo Sappington
looked in her makeup mirror and saw a man in blue standing there.
She turned to ask, "Well, can I put on my clothes before we go?" He
let her know there would be no arrests that night; he was getting a
VIP backstage tour, courtesy of the management.

Newsweek, which generally ignored Off-Broadway shows in its
coverage of the arts, began to offer a near-weekly report on the doings
of *Oh! Calcutta!*, and amply quoted Hilly Elkins on his success with
massaging the conscience of the NYPD. "They offered extremely rea-
sonable, nonrestrictive points of view about it," reported the producer.
"No one rendered moral judgments about it. Now I'm confident about
opening the play, because I know I'm dealing with reasonable people."

Elkins and Tynan presented a unified front to the press. Behind
the scenes, "Tynan threatened to take his name off the show at least
once," said Michael White. "He and Elkins didn't get along. It was a
tempest in a teapot." The primary riff came from Elkins's decision to
cut two of the four skits Tynan had written for *Oh! Calcutta!* Most
participants thought Elkins should have cut all four. "Tynan's skits
were very dark, not funny," said Bill Liberman.

Fortunately for the project, Tynan saw himself as a cultural rev-
olutionary, and didn't mind sharing that exalted status with any re-
porter who'd listen. "There is no theatrical consensus yet as to how
to respond to sex," said Tynan, who relished pontificating from his
newfound platform. "No one knows how he feels about watching
people make love. So, every night, we have an experimental labora-
tory in people's reaction to sex onstage."

After all the pre-opening publicity, the ticket-buying public might
have been expected to know what it had purchased.

Obviously not. Early in previews, after the closing nude scene,
actor Leon Russom turned to the audience one evening to say,
"Good night."

A woman shouted back, "Go get dressed!" And then half of the audience started applauding, while the other half booed. "And the two groups tried to drown each other out," said Russom.

The catcalls sometimes extended through the final bows. "A man in the audience was bravoing the cast until we came out fully clothed. Then he began booing," said actress Nancy Tribush.

Despite all attempts to keep *Oh! Calcutta!* a "totally heterosexual" show—"Exchanges," a short film by Tennessee Williams, in which a couple beat each other before they could enjoy sex, was excised shortly before opening night—the show received an unexpected plug from one homosexual. Rudolf Nureyev came backstage after one performance to meet the actors; he asked Margo Sappington if her partner in the nude ballet ever got an erection onstage.

"A few times in rehearsals, yes," Sappington let him know.

Nureyev then got around to asking Mark Dempsey, Sappington's partner, out to dinner. With his chiseled profile and carefully manicured satyr's beard, Dempsey was arguably the show's handsomest actor and inarguably its only gay one. Nureyev asked his dinner date, "But what about the police? Do you really think the police will permit this dance?" His concern soon surfaced in an interview he gave to the *New York Times*, in which he was asked about dancing in the nude. "Why not?" he replied. "The new permissiveness is all to the good. Of course, it must be done well. And I must say, I thought the pas de deux done in the nude in *Oh! Calcutta!* was really very beautiful. Of course, if the dancers didn't have beautiful bodies, it would not be the same," he added, as if the ballet world ever allowed its dancers' bodies to be less than perfect.

Not everyone was so thrilled, and that included some of the *Oh! Calcutta!* writers.

Jules Feiffer wrote the sketch "Jack and Jill," about the selfishness of male sexual gratification, "to see if I could make it work as a full-length play." Mike Nichols, still at work on his future bomb

Catch-22, had committed to turning *Carnal Knowledge* into a movie, but Feiffer continued to harbor theatrical ambitions for the project, and he looked forward to seeing his sketch in *Oh! Calcutta!* While he didn't attend any of the rehearsals, Feiffer did see a preview. He wasn't happy. "Tynan cast the actors for their bodies, not for their acting ability," he reported.

Finally, it was the world premiere. On June 17, one patron complained even before the opening night curtain went up, "I fully expected the girl ticket-takers would be nude." It was the kind of evening in which everything said or done seemed predigested for maximum coverage in tomorrow's gossip columns. Joe Namath arrived surrounded by a dozen fawning females. Peter Lind Hayes, Lloyd Bridges, and Abel Green came sans their respective wives. Anita Loos of *Gentlemen Prefer Blondes* fame pointed out that the naked revue had a costume designer, Fred Voelpel. And halfway through the show, Ed Sullivan walked out with much fanfare. "Guess he couldn't find anything he could use on his show," a wag remarked.

"Opening night was exhilarating," said Margo Sappington. "We were so comfortable in our skin. I think that's what shocked people."

From the other side of the footlights, the premiere registered as something less than exciting due to a theater filled with uptown swells and all the first-string critics and columnists. In other words, "People who had to be there," said Bill Liberman, "whereas the audiences in previews were all people who wanted to see *Oh! Calcutta!* and were highly responsive and appreciative."

On opening night, the jokes didn't land, there was never more-than-polite applause, and when the lights came down at the end, people raced up the aisles. "Most of them were embarrassed to be there," said Liberman. "Or maybe they knew taxis would be scarce in that neighborhood."

Afterward, at the Sardi's party, actress Hedy Lamarr thought back to swimming nude in *Ecstasy* three decades earlier. "To think

when I did it nobody could see me but the cameraman. Now it's right out in the open," she remarked. *My Living Doll* star Julie Newmar, who the year before posed nude in *Playboy*, called it "brilliant." *Funny Girl* composer Jule Styne dismissed it as "witless." And Shirley MacLaine mentioned something about playing the lead in the movie version.

Even though he didn't like how his "Jack and Jill" sketch had been performed in previews, Jules Feiffer sent Kenneth Tynan a telegram on opening night. It read: "Break a member."

Tynan never replied. "Which kind of pissed me off," said Feiffer.

At Sardi's, people asked Elkins, "You're a very nice guy. Why are you doing this dirty show?" He replied, "The same reason I do any dirty show: to make money."

Then came the reviews. In the Sardi's building on West Forty-Fourth Street, Elkins, Tynan, and Liberman took the elevator up to the Thomas-Blaine ad agency on the fourth floor to read the notices as they came in over the wire. "They were disastrous," said Elkins. "They all said it was too much and the sexuality was overbearing."

Some of the cast members started to cry when they heard the bad news, but Elkins told everybody not to worry. "Let's wait until tomorrow and see what happens." As he later explained, "They weren't bad reviews for what we needed, which is an audience."

Elkins was right. By the second night, the response at the box office exploded. By the third night, they knew they had something people wanted to see. "Our rental of binoculars was extraordinary, especially in the first row. They wanted to see and they wanted to see more of it," said Elkins.

In his syndicated gossip column, Earl Wilson reported how *Oh! Calcutta!* had made history: "A police official told me that once upon a time if a person was nude and moved, that was illegal. But that has been thrown out long ago."

Well, a few months ago.

Kenneth Tynan's sex revue opened at a cost of $234,969, including $50,000 advanced to the theater owner for renovation of the Eden. So many tickets were sold in that first week that Hilly Elkins immediately pushed the top price ticket from $10 to $15, a record for Off Broadway. "Scalpers were getting $35 a pair," he said in defense of the price hike. Others got those ducats for free: Elkins liked to give away tickets to *Oh! Calcutta!* whenever a cop stopped him for speeding on his motorcycle.

SMASHING TABOOS COULD BE profitable, and *Oh! Calcutta!* wasn't the only such venture making money.

Philip Roth's *Portnoy's Complaint*, published that May, remained on the *New York Times* bestseller list for forty consecutive weeks, a feat that more than justified the publisher's original commitment of a $250,000 advance to the author. The ultimate seal of success came when Roth's novel overtook the more than two million copies in paperback that *Myra Breckinridge* had sold, forcing Gore Vidal to attack *Portnoy's Complaint* as "the greatest blow for masturbation I've ever read."

And *Midnight Cowboy*, despite John Schlesinger's sleep-depriving doubts, dazzled the executives at United Artists. Even after its first rough-cut screening, "We were stunned by its magic," exclaimed UA president David Picker, who immediately devised a new release pattern for the film: "Open in New York for a couple of months before anywhere else, play in small theaters for long engagements, letting the word of mouth build up an audience."

There continued to be, however, major misgivings. Dustin Hoffman sat in the back of theaters at more than one early preview. "There would be seventy-five people there, and a number of people would walk out at the impending blowjob scene," he said. "They wouldn't watch the entire movie. It was a tough time."

Prior to the film's release, United Artists submitted *Midnight Cowboy* to the newly organized Motion Picture Association of America ratings board, created in the wake of the old Production Code, which never would have approved the film's language, nudity, and homosexual subject matter. Picker was surprisingly blasé when the MPAA gave the film its most restrictive rating: The X rating barred persons under the age of eighteen from entering theaters playing *Midnight Cowboy*, regardless of whether they were accompanied by an adult or parent. Schlesinger was also unfazed. "We felt the X was the correct rating for it. We had made the film for adults, not children," he said.

UA opened Schlesinger's controversial movie at the Coronet Theater in New York City on May 25, a premiere that was sullied a bit when *Midnight Cowboy* novelist James Leo Herlihy took the opportunity at the after-party to complain about a couple of scenes that he demanded be excised—and had just seen on the big screen. Incensed, Herlihy took his argument to reporters, telling them, "I didn't like the scenes were Buck shoved the telephone in the mouth of the homosexual. I wanted it out of the picture because I thought it was just too much. And I didn't like the deviate act in the balcony of the movie theater," he added, referring to the scene where Bob Balaban's character performs fellatio on Joe Buck. "They invented it, and it was hard to watch and totally unnecessary."

Herlihy's criticism hounded Schlesinger. Taking their cue from the *Midnight Cowboy* novelist, reporters began to harp on the film's homosexual sequences. Waldo Salt and Schlesinger had created the scenes Herlihy found offensive. Otherwise, "We filmed two homosexual sequences which are explicit in the novel, and this is the only question that the press seemed interested in," said Schlesinger, who noted a distinct "hostility" in the press's coverage of the movie. "They felt it was going to be a sexploitation thing, which it absolutely isn't."

While the initial reviews were mixed—the *New York Times* and the *Los Angeles Times* liked it, Pauline Kael in *The New Yorker* and Roger Ebert in the *Chicago Sun-Times* panned it—the slow release pattern and all those morally outraged journalists functioned to make the film a succès d'estime, as well as an early contender for the Academy Award. Even Herlihy came around and later apologized—that is, after the film's success goosed paperback sales of his novel. "I'm afraid I bummed-up Schlesinger's party after the premiere by harassing him," said the novelist.

Bummed or not, Schlesinger now had the clout to indulge in a pet project, one that, like *Midnight Cowboy*, he'd been nurturing for years, and one that, unlike *Midnight Cowboy*, was based on personal experience. UA's David Picker couldn't wait to hear about Schlesinger's next project.

"I want to do *Sunday Bloody Sunday*," said the director. What Schlesinger didn't tell Picker is what he was thinking: "This is the moment. Cash in the success to make something that we know going in may be a piece of slightly uncommercial chamber music."

Picker didn't quite understand the title *Sunday Bloody Sunday,* or the story. He wondered, Why would a woman be in love with a young man who was also having an affair with another, older man? "Well, we don't know where you're going with it, but if you want to make it, make it," said Picker, who had a way of okaying projects and then letting the filmmakers make their films without interference.

With *Midnight Cowboy* doing great business, Schlesinger proceeded to put together a cast and crew for his new, controversial, personal picture. It helped immensely that an old friend of Schlesinger's was showing a rough cut of his own new, controversial, personal picture, also to be released by United Artists. The executives there didn't understand that screenplay either, and again, Picker came to the rescue, leaving Larry Kramer and director Ken Russell alone to adapt D. H. Lawrence's classic novel *Women in Love* for the screen.

Regarding his relationship with Schlesinger, Kramer revealed, "I met him. We went to bed a bunch of times. He was more serious than I was."

Kramer had significantly more influence on his old boyfriend's professional life. "Because of me, Columbia Pictures released *Darling*," said Kramer, who'd been a production chief at the studio in the mid-1960s. "I told Columbia that this was a fantastic movie, and they took my advice and picked it up."

As with *Midnight Cowboy*, the executives at UA very much liked Kramer's rough cut of *Women in Love*, and Schlesinger liked it so much that he hired much of Kramer's crew, as well as the picture's leading lady, Glenda Jackson, for his *Sunday Bloody Sunday*. Kramer could only hope that the cut of *Women in Love* he'd shown to Schlesinger and Picker was the one that the British censors approved.

Kramer had not only written the screenplay for *Women in Love*; he was the film's producer, which meant that the arduous task of negotiating a final approved cut of the movie with the British Board of Film Censors fell to him. Even before shooting began, he'd sent a copy of his script to the board's chief, a man named Lord John Trevelyan, who liked to brag, "We're paid to have dirty minds." Trevelyan didn't hold out much hope for Kramer and told him he doubted his *Women in Love* script could be filmed at all. "The wrestling scene," as it was soon to be dubbed, sent immediate shock waves through the BBFC.

"Trevelyan told us in no uncertain terms that this scene would present an insurmountable roadblock to the film's release," Kramer noted, "as would, as presently constituted, the [Rupert] Birkin-Ursula wham-bam sex scene after the water party and a later scene between Gerald and Gudrun, in Switzerland, what we came to call the 'revenge fuck' scene. His final decision rested, of course, he hastened to assure us, on the taste with which Ken handled all of this, though, he also hastened to assure us, he did not see how Ken, or anyone, could get around the insurmountable problems of the wrestling scene."

Kramer and Russell gambled that Trevelyan might give his approval if all the sex scenes, when filmed, "followed the novel to the letter," said Kramer.

"I had doubts the censor would let us pull it off," said Russell. "It had never been seen in the history of the movies," he added, referring to the male nudity. "It's an essential part of the book."

Kramer and Russell proceeded to film anyway, and some time during the sixteen-week shoot of his $1.25 million production, Kramer saw the newly opened London production of *The Boys in the Band*, which featured the original Off-Broadway cast.

"It was very emotional," said Kramer. "As a writer who was writing screenplays, I knew how difficult it was to write about gay stuff, and here this play was very bold and a big success."

In some respects, *Women* would be even bolder than *Boys*.

Weighing heavily on Kramer was Trevelyan's recent decision to cut a lesbian sex scene involving actresses Susannah York and Coral Browne in the Robert Aldrich film adaptation of *The Killing of Sister George*. As the British censor had put it to Cinerama, the releasing company, "This scene is by far the most explicit scene of lesbian physical love that has ever been submitted to us, and it goes farther than any similar scene in this context, although we have, of course, accepted passionate scenes of this kind, with nudity, but only when the relationship was heterosexual. Also, as you well know, we are not ungenerous to scenes of female nudity . . . but it is a totally different matter when the context is one of lesbian physical love."

The Aldrich movie had been having a tough time of it stateside as well. In Boston that winter, *The Killing of Sister George* did ho-hum business at the box office. That is, until the seventy-two-year-old chief justice of the Municipal Court, Elijah Adlow, saw the film and promptly offered, "Certainly one lesbian scene is unsightly and lewd. That part of the picture is highly objectionable," and thereupon sentenced the theater management to six months in jail. The

defense filed an appeal, won that appeal, and when *Sister George* continued its run in Beantown, it now played to sold-out houses.

In Britain, Larry Kramer thought he might have better luck than Robert Aldrich—if he could appeal to the noble, chauvinistic, pretentious side of Lord Trevelyan. *Women in Love* was based on a classic British novel. *The Killing of Sister George* was based on a mediocre boulevard comedy. Also, Aldrich's film adaptation deemphasized the play's humor, added a lot of soap opera, and, most offensive to the censors, it made obvious what onstage was merely suggested—that the characters are lesbian. Perhaps even worse, for a snob like Trevelyan, the movie had been directed by an American, best known for having paired Bette Davis and Joan Crawford in a piece of Hollywood Gothic claptrap called *Whatever Happened to Baby Jane?*

Kramer avoided the American mistake of *Sister George* by hiring a British director, Ken Russell. He also made sure, as producer and screenwriter, to remain as faithful as possible to the novel *Women in Love*. Not that it was easy to find a cinematic equivalent for D. H. Lawrence's purple prose. In the sexually frank novel, sisters Gudrun and Ursula fall in love with two men, respectively, Gerald and Rupert, who appear to have an unspoken but strong physical attraction for each other. Shortly after the book's publication in 1921, the esteemed critic W. Charles Pilley wrote the following critique of *Women in Love*: "I know dirt when I smell it, and here is dirt in heaps—festering, putrid heaps which smell to high Heaven."

Yesterday's stinking garbage, today's high art.

Kramer and Russell knew they needed to make a movie that was very faithful to the novel, especially with regard to three sequences: In one scene, Rupert climaxes too soon when making love to Ursula in the woods; in another, Gudrun enjoys being raped by Gerald; and in a third scene, Gerald and Rupert wrestle in the nude and end up in an exhausted heap on the drawing room carpet in front of a blazing fire. The heterosexual Russell felt passionate about the rape scene,

the homosexual Kramer felt equally attached to the wrestling scene, which in the novel appears in the chapter titled "The Gladiatorial." Kramer loved that the novel ended with the thesis that opposite-sex and same-sex relationships were equal. For the film's ending, he had Rupert tell his now-wife, Ursula, "You are enough for me as far as a woman is concerned. But I wanted a man friend as something as eternal as you and I are eternal."

She replies, "You can't have two kinds of love. You can't have it because it is impossible."

"I don't believe that," he counters.

End of film.

Kramer lifted that dialogue directly from the Lawrence novel. "I wasn't quite out of the closet at the time I was writing this," he recalled. "Now you could look at it as full, ripe and redolent with gay themes."

In his research, Kramer found an unpublished section of the novel, he noted, "in which Rupert and Gerald go off and have a full-blown homosexual affair. Of course, it was not used. You get the sense, though, that Lawrence is playing around with all this, perhaps subconsciously. In a quote from the unused passage, Lawrence described the two characters' relationship: 'They scarcely knew each other, yet here was this strange, unacknowledged, inflammable intimacy between them. It made them uneasy.' "

Kramer knew he couldn't get away with reinstating what Lawrence, in a preemptive strike against the censors of his day, had cut. But he did believe he could bring a faithful adaptation of *Women in Love* to the screen, sex scenes and all.

"By God, we were going to try," he insisted. "One way is that we literally duplicated the book, which had been in print since 1921. The scene, the actors, the decor, the dialogue: We just filmed it." Regarding the wrestling scene, he remarked, "It's an incredibly passionate scene in the book. There's no question it is sexual. There's

no question these two men are battling homosexuality and the closeness of their relationship. And in the book it results in some hint of climax for them. Lawrence wrote about it in peculiar ways. Lawrence was troubled by sex. There's a great deal of homosexuality in this film. Had Lawrence written and lived today he could have been [openly] gay."

Kramer's ploy to "get around" Trevelyan's objections to the male nudity hinged on providing a "faithful adaptation" of the Lawrence novel. "The scene I wrote always had them wrestling in the manor in front of the fire, just like the novel."

His director, however, told a different story of what transpired regarding the scene. According to Ken Russell, an early draft of the script was more reticent and set the wrestling match in a forest pond so that the two actors would end up tossing in the water and, just possibly, not expose their respective genitals. Objections to that less graphic approach came from an unlikely source.

Oliver Reed, who'd been cast as Gerald, never bothered to read the Lawrence novel, but his girlfriend did—and it was supposedly she who told him how the script had bowdlerized the wrestling scene. With girlfriend in tow, Reed made an impromptu visit to Russell's home to confront the director, saying, "In the script, you've got the two naked men wrestling in the pouffy moonlight on a river bank."

"Pouffy" was one of Reed's favorite words. He used it to describe homosexuals, like Kramer, as well as the "pouffy" lace curtains in Russell's kitchen, and the "pouffy" candles Russell used there instead of electric lightbulbs.

Russell tried to explain that in the script they would start wrestling and fall into the river and "continue wrestling there in the water."

Reed apparently snorted at the notion. "All in slow motion like a pouffy commercial."

"Well, if [Rupert] Birkin and Gerald are going to strip off and

wrestle nude at all, it's more plausible if they do it in a natural setting than in Gerald's stately home amongst suits of amour."

"But that's how it is in the book."

"It's one thing to get away with it in a book and quite another to bring it off on the screen," Russell said.

"You mean it's more of a challenge."

"It's bloody impossible."

"Is it?" he asked. Reed looked around the kitchen, and then gestured to his girlfriend. "And she tells me they're both in evening clothes enjoying a drink by the light of a log fire. Make mine a large brandy." Reed then lunged at Russell and proceeded to wrestle him jujitsu style.

Whether Ken Russell or Larry Kramer's version of the story is accurate, Oliver Reed's enthusiasm for playing the scene as D. H. Lawrence wrote it definitely began to wane as the big day loomed on the production schedule. He developed a bad limp and complained of having somehow injured himself. Kramer only exacerbated the situation by reminding the zaftig actor, "You're going to be seen naked shortly by millions of your fans. You'd better start losing weight."

Alan Bates, the film's Rupert, also came down with a good reason not to film the wrestling scene, even though he'd already twice appeared nude onscreen, in *Georgy Girl* and *King of Hearts*, leading one critic to remark that he had "one of the most exposed behinds in cinematic history." *Women in Love* would mark Bates's first full-frontal nude scene before the term "full-frontal nudity" had been coined, Kramer believed.

Two days before the wrestling scene was to be filmed, Bates developed a very bad cold.

"They both had doctor's certificates to prove it," Russell said of his actors' ailments. Fearing that he might not be able to film the controversial scene as planned, the director was forced to come up

with an alternative shoot. "I had scheduled a secret scene with the girls if [the men] didn't show up," said Russell.

The night before the big shoot, Reed's longtime stand-in and friend, Reg Prince, arranged that the two actors meet for a drink in a pub. "Which relied on Reg getting the boys to visit the loo for a pee simultaneously," said Russell.

Kramer, for his part, doubted that such a look-see of the actors' penises ever took place. "Alan had very little time for Oliver Reed," he noted. "Alan was a closeted gay man, very much a gentleman. Reed was kind of a pig."

Regardless of which tale is true, at 8:30 A.M. on the day of the scheduled shoot—"The crew were taking bets," Russell reported— Reed and Bates showed up in robes, then threw off those robes simultaneously. "Tumultuous applause followed as forty pairs of eyes registered the fact that their dongles were exactly the same length . . . that trip to the loo had paid off," noted Russell. "Even so, Oliver cheated a bit by disappearing behind a screen before each take for a quick J. Arthur."

Kramer could also relax, seeing that Reed had indeed succeeded in losing twenty pounds by using a steam box every night for ten days.

On the more sensitive subject of penis size, Kramer's expert eye did note a slight discrepancy. "It was a difficult scene to shoot. Neither actor was happy about displaying it all," he said. "Oliver would disappear for a few moments before each take, we later discovered, so that he could make his penis look bigger, which on the closest of inspections it appears to be, though in reality Alan's was."

Reed wanted both men to be inebriated for the scene. When Bates refused to enhance his performance with booze, Reed observed sobriety for once in his life.

Perhaps it would have been easier to have done it drunk. "The task was quite shattering," Bates said of the scene, which took not

one but two days to film. Worse was watching the dailies. "You get to see only a few moments of it in the film, but we saw hours of it," said the actor. "It seemed to go on forever, and it was torture. I thought at the time it all looked so—well, so wrong, and that I looked so hideous. I suppose it's a great lesson in humility. If you can get over the awfulness of yourself in the flesh, you can get over anything."

The actresses, Jennie Linden and Glenda Jackson, were much less skittish than the men. Jackson, who was pregnant during the filming, summed up the prevailing nonchalance from the distaff side: "The scenes in which I've been nude were scenes about sex and it seemed absurd to pretend that the character I was playing would have sex with her clothes on." Then again, Kramer's script didn't ask Jackson to roll around on the floor with Jenny Linden, their legs up in the air, as the two men were required to do.

The script, however, did require Jackson's character to be raped. Jackson saw it one way, Reed another. Although he was playing the repressed, possibly homosexual son of a wealthy coal mine owner, the sexual ambivalence of the role eluded the macho, hard-drinking Reed, who was not about to let a woman dominate him sexually in the film.

He admired Jackson as an actress. "But I wouldn't budge one inch when it came to putting my masculinity on the line, and it came to it once, this confrontation, when Glenda said she wanted to dominate me sexually," he said of the rape scene. "Russell and I were trying to convince her that I should rape her and be the dominant factor in that particular love scene. She was so aggressive about it, saying no, she should dominate me. In the end, we had to call in the producers, because this unknown girl was being so headstrong. It made me wonder whether she'd read the book, because she thought she had to rape me, had to completely dominate me, had to climb on top of me and become the aggressor. But she wasn't experienced

enough to know that to be on top is not the be-all and end-all of the conquest. I don't think she would have compromised had she not believed that there was still enough superstition left in male vanity to warrant the leading man, and the director, to think that she should be underneath getting fucked for the things that she said."

While Reed proceeded to throw tantrums, Jackson played it calm. As *Women in Love* actor Vladek Sheybal said of his costars' fights, "Poor Ollie, because he was really jumping up and down with rage, ranting, 'This should be played like that you, you know,' she just sat quietly almost immobile and either looked out of the window at the snow and the Matterhorn, or smiled at me, but she refused to react to Ollie's behavior, refused to reply to anything he said."

Finally, it was the day Kramer dreaded most: showing the film to Lord John Trevelyan. It was not their first encounter. In the late 1950s, Kramer worked as a production assistant on *Suddenly, Last Summer*, and even before that Tennessee Williams project began filming at Pinewood Studios in London, Trevelyan smelled something foul. Homosexuality, procurement, and cannibalism in the hot Caribbean sun! The British censor demanded major revisions in Gore Vidal's screen adaptation.

"Trevelyan was a real character, a social butterfly," Kramer recalled. "England had a lot of men like that. Men who had sick sex lives, like he's into S&M or a Peeping Tom. He gave you that feeling. He loved his work, and he had an enormous amount of power." He also smoked a lot—so much, in fact, that his well-appointed suits were often so covered with ash that it turned to a kind of gray chalk covering his tweed chest.

As for Trevelyan's power, it was indeed formidable. Kramer's contract with United Artists obligated him to deliver a film approved by the British censor. If Trevelyan didn't approve *Women in Love*, UA took over control of the final edit. Like most films released in the late 1960s, *Women in Love* was screened in the British censors' own

private theater. It was an appropriately sterile place, with pale blue walls and a scattering of threadbare seats, two of which were behind desks equipped with working lights and indicators that allowed the two examiners to pinpoint items they might find objectionable. If these two examiners disagreed, Trevelyan got to cast the deciding vote.

With *Women in Love*, Kramer and Russell personally met with Trevelyan; they tried to reason with him, comparing the movie to the novel and how faithful they'd been in replicating Lawrence's story on-screen, especially with regard to the sex scenes. "How can you exercise those kinds of restrictions today?" Kramer pleaded. He and Russell had cleverly included more footage of the rape and the wrestling scene than they thought necessary, to give them some room to bargain.

"In the end, it was a compromise," said Kramer. "We snipped a couple of feet from mainly the wrestling scene and the revenge fuck, but not so you could tell in any way. That shut him up."

Fortunately, Trevelyan personally liked *Women in Love*, so much so that he didn't want to butcher it. At least, that's what he recalled. "Although there were strong and explicit sex scenes, we passed it without cuts," he reported. "This film included a remarkably brilliant scene in which two young men wrestled naked. We had to consider this carefully, but decided to pass it; in a sense this was a milestone in censorship since male frontal nudity was still a rarity. We had little criticism, possibly because of the film's undoubted brilliance."

Kramer's gambit to position *Women in Love* as an art film paid off. As the British film director Roy Ward Baker noted, "Trevelyan had that schoolmasterly habit of pigeon-holing people. If you were in the box marked 'art cinema,' you could tackle anything, however controversial: sex, violence, politics, religion—anything. If you were in 'commercial cinema,' you faced obstruction and nit-picking all the way. He chose these categories and allocated everyone according to his estimation of them. He was a sinister, mean hypocrite, treating his favorites with nauseating unctuousness."

Baker had directed low-budget films like *Scars of Dracula* and *The Vampire Lovers*, and possibly it was one of these titles that Trevelyan censured, but he let a couple of seconds of female pubic hair flash by in Michelangelo Antonioni's *Blow-Up*. Trevelyan explained his apparent flip-flop: "I remember that after *Blow-Up* a filmmaker who had sent me an unsavory script of no merit answered my objections by saying, 'I intend to make this film in the style of *Blow-Up*.' I replied that if he could make it as well as Antonioni we would probably pass it, but that I thought this unlikely."

Upon the release of *Women in Love*, the debate among critics focused almost exclusively on the wrestling scene. "Because it was the first studio film to have full-frontal male nudity," said Kramer, "no one paid much attention to the regular, i.e. heterosexual, fuck scenes."

In some countries, the wrestling scene got excised almost completely. In Argentina, for example, the censors edited the scene so that it showed the two men shaking hands before they begin their nude fight, and then it cuts directly to their panting on the rug, lying side by side. "It was known as the great buggery scene," said Ken Russell. "So that's censorship working backwards."

Summer 1969, Revolution

Mourners gathered outside the Frank Campbell Funeral Home on West Seventy-Fifth Street in Manhattan on June 28 for the last rites of their idol Judy Garland. A few days earlier in the *New York Times*, film critic Vincent Canby had eulogized, "The real shock is that she wasn't already dead."

Others were just plain shocked, and after the very private funeral a number of bereaved homosexuals took the Seventh Avenue subway down to Greenwich Village to commiserate at the Stonewall Inn on Christopher Street. While the men drank away their sorrows, the police raided the bar, as they often did, since it was illegal in New York City to serve alcohol to homosexuals. Caught in the paddy-wagon ritual was a lesbian who, when placed in the police vehicle, tried to jump out. A cop grabbed the woman as onlookers quickly began to yell in her defense. Then people threw things at the cops, who finally had no alternative but to retreat into the Stonewall Inn until recruits from their nearby precinct could free them. The siege went on for three days.

In the beginning, the newspapers referred to it as the Sheridan Square Riots. Later, they would be known as the Stonewall Riots, the beginning of the modern-day gay rights movement.

Mart Crowley read about those riots in the *New York Times*. "This unpleasantness in the Village," he recalled. "It was no big deal." He didn't think much about it. Besides, he was otherwise pre-occupied. The film version of *The Boys in the Band* had just gone into production that June, and was shooting a couple dozen blocks away from Sheridan Square, at the CBS studios on West Twenty-Sixth Street in Chelsea. No one discussed the "riots" that day on the set. Not that Crowley recalled. As screenwriter and producer on the film, Crowley had bigger problems: His director, William Friedkin, had just fired his third sound operator, and the brass at CBS Films told Crowley, "You're the producer! Act like one!"

When the cast of *The Boys in the Band* had returned to Manhattan from their London engagement that spring, Crowley took out actor insurance by rejecting all offers from the big studios to turn his play into a movie. Ray Stark, high off his *Funny Girl* success, was typical of the Hollywood need to sanitize. "We will replace the homosexuals of the play with movie stars," said the producer. The original *Boys* troupe of actors laughed at that remark. What movie stars were they going to replace them with? "Rock Hudson? Roddy McDowall?" wondered Laurence Luckinbill. To keep his original cast intact, Crowley signed not with Ray Stark but Cinema Center Films, which was the movie-producing unit of CBS. (Despite that big TV entity behind it, the film's budget came in at $1.6 million on a sixteen-week shoot, of which $250,000 went to Crowley, plus 10 percent of the gross.)

"This cast or no movie" was Crowley's negotiating mantra. "Crowley knew the best way to treat Hollywood was to slap it in the face," explained Luckinbill.

Crowley also insisted on being the film's producer and screen-writer, and keeping Robert Moore as director.

The only battle he lost was his fight to keep Moore, who'd never di-rected a film. The studio insisted on William Friedkin, who had directed three films, including the modest hit *The Night They Raided Minsky's*.

The cast nearly mutinied when they got the Friedkin-instead-of-Moore news. They talked of refusing to do the movie. But a harsh reality confronted them. Despite the play being a big hit in London and Off Broadway, where it continued to run, the actors had received virtually no offers of work onstage, much less in the movies or TV. Luckinbill was dropped from doing True cigarette commercials; he was told, "No fags smoke our fags." Peter White lost a shaving cream ad. He considered suing the ad agency, but when he and his new agent checked into his legal standing they found he had none, since there were no antidiscrimination laws protecting homosexuals in the workplace or, for that matter, laws protecting heterosexuals who played homosexuals onstage.

The *New York Times* published an article on how the actors in *The Boys in the Band* were actually heterosexual, and profiled the cast's two married men, Laurence Luckinbill and Cliff Gorman, and then ran out of space for an analysis of the other eight cast members' respective private lives. Gorman, who played the super-effeminate Emory, took offense.

"There was a lot of crap in the press about my really being a he-man," he said. "This rebound kind of reaction bothered me a lot because whether I was homosexual or not had nothing to do with my performance. I have never stressed the masculine image. . . . At no time have I gone out of my way to prove anything on that score. The people that interviewed me when I was playing Emory picked up on it because the part was so grossly effeminate. That was the basis on which they chose to write about me: 'Holy Mackerel! Big, butch Cliff Gorman is not a homosexual! He doesn't even mince when he walks!' "

If the actors suffered professionally, the play had a relatively easy time of it in New York City and London. Elsewhere, it was rougher. The French critics found it "embarrassing" and "deviant," and likened *The Boys in the Band* to a visit to a "monkey house." And down under in Sydney, Australia, the actors playing Michael and

Emory were charged on four counts of using obscene language in a public place. The actor playing Donald got hit with one count.

Crowley spent his *Boys* largesse by buying Boris Karloff's co-op in the historic Dakota apartment building, which brought him closer to fellow Dakota resident Rex Reed, who'd written a glowing profile of him in the *New York Times* not long after *Boys* opened Off Broadway. Crowley also splurged on a summer house on Fire Island, an overgrown sandbar off the southern coast of Long Island. Since Friedkin was directing a movie about homosexuals, Crowley thought he ought to do some research on the subject, and invited him for a weekend in the homosexual community of the Pines, where the gossip was much less about Judy Garland and the Stonewall Riots than it was Teddy Kennedy, the late Mary Jo Kopechne, and a little bridge on Chappaquiddick Island, Massachusetts.

It must have been a memorable visit to the Pines that summer for the heterosexual director, because he recalled that excursion into "the meat rack in the Pines" in thrilling detail. "It's a gigantic pit with 200 to 300 guys in a daisy chain balling each other in the ass," he said. "One guy started to cruise me. When he got close, though, I retreated." Many years later, in his 2013 memoir, Friedkin remembered the Pines visit with greater poignancy, writing, "As a straight man in a gay world, I got a sense of what it was like to be an outsider."

On the set of *The Boys in the Band*, Friedkin ingratiated himself with cast and crew by wielding a big cigar, which the actors found laughable. Was he gay? Was he straight? There were also comments from him in the press that the cast "had gotten bored" with their roles after doing the play in New York and London, and how he'd made them "go deeper into the characters" and how "we've tried not to make it consciously fag."

The Boys in the Band had only entered its second year Off Broadway, but already a shift in the mind-set of New Yorkers had taken place with regard to the city's homosexual population—a shift due,

in part, to the play's success. While homosexuality had once been a rarely broached subject in the press, the publicity surrounding *The Boys in the Band* movie was "enormous," noted Crowley. Esteemed photographer Irving Penn did portraits of each cast member for *Look* magazine. A feature in *New York* magazine detailed Friedkin's approach to bringing the play to the screen. "I want the faces of the characters to look like the photographs of Marie Cosindas," said the filmmaker, referring to an American photographer best known for her still lifes and portraits. Friedkin wanted the first third of the film to have an "ordered, conventional look," while the final reel would be "hot and kind of cinema verité," he said, "the Walpurgisnacht."

That kind of reverence for the project, however, did not extend to the *New York Times*, which, in one of its recurring anti-homosexual tirades, wondered in print if there was any audience for a film like *The Boys in the Band*. A play is one thing, a movie another. "Is the country ready for 'Boys'? Will they stand in line in Omaha?" wrote *Times* reporter Katie Kelly. "Face it: These are not the all-American boys who made America great. This is not the stuff of which football captains and fraternity boys are made."

Crowley suffered the positive press, as well as the negative questions, as best he could. Regarding the film's chances for success, "Who can predict what the hell is going to happen?" he told the *Times*. He also presaged the criticism that was to come and, in fact, had been there ever since Edward Albee first read and hated the play.

"I've gotten a lot of criticism about not showing homosexuals in their best light or having a happy ending," he said. "I hope there are happy homosexuals—they just don't happen to be at this party."

While the press fretted about *The Boys in the Band* making it to the screen, William Friedkin wrestled with ways to make the movie version even more provocative than the play. His solution came to be known as the Kiss.

Onstage, the play's two characters who are lovers—the macho

basketball player Hank and the promiscuous photographer Larry—leave the birthday party to repair their tattered relationship in a scene played offstage. Friedkin wanted the camera to follow them to the bedroom to show the two actors, Laurence Luckinbill and Keith Prentice, as they embrace and kiss. That bit of graphic play "was the bane of my existence throughout the filming," said Friedkin.

Luckinbill and Prentice resisted. "It was considered to be a career breaker. Both [actors] came to me to talk me out of it," said Friedkin. And it didn't end there. "I got phone calls from agents and lawyers. 'Don't have the kiss!' "

Friedkin thought the kiss would make "a powerful statement about two men." Finally, he compromised: "Let's shoot it and if we think it's not working, we won't use it."

The kiss wasn't rehearsed. Luckinbill told Friedkin, "We'll do it ourselves and improvise." In the end, the two actors kissed in the presence of their director, who operated the camera, and no one else. Not even Mart Crowley was present on set.

Friedkin thought the kiss would give a deeper understanding of the characters' relationship. But there in the editing room, he decided it wasn't necessary—or it was too much for the times. "Today, I'd probably leave it in," he said three decades later. "I don't know how much damage was done to the actors by *The Boys in the Band*. The attitude at the time: You play a gay character, that's how you're going to be perceived by the idiots who run the studios. It was a time when the audience had no idea how many actors playing macho men were gay."

THAT SUMMER, *OH! CALCUTTA!* enjoyed its world premiere in New York City without interference from the police. The California authorities, however, turned prude when the show replicated itself in San Francisco and Los Angeles later that year. Kenneth Tynan's timing couldn't have been worse. In San Francisco, the raid came

a week before election day, and since some city fathers had made pornography-bashing the focus of their reelection campaigns the show closed after a few performances. Farther down the California coast, in Los Angeles, the actors hit a wall of resistance from a public that didn't buy the show's premise of "let it all hang out" in the aftermath of Sharon Tate and four others being murdered in Benedict Canyon at the hands of the Charles Manson "family."

The police were also having none of it. They arrested the *Oh! Calcutta!* actors, then released each of them on $625 bail. The cast could have made the evening curtain but canceled due to "emotional strain," said a spokesman. In both cities, the police claimed that illegal "genital contact" took place, even though a six-inch-by-eight-inch cloth (never used in the New York production) separated the two actors' groins in the Masters and Johnson send-up, "Was It Good for You, Too?"

In Los Angeles, where *Hair* had opened earlier that year, Gerome Ragni and James Rado had already challenged the city's restrictive laws regarding nudity, and while the Los Angeles police didn't raid the *Hair* production, the management did suspend Ragni and Rado from performing in their own musical. The two lovers had traveled west with the show, where it took up residence in the old Earl Carroll Theatre, former home to *The Earl Carroll Vanities*, as well as TV's *Queen for a Day* and *Hullabaloo*. In honor of its new flower-age tenant, the venue was renamed the Aquarius Theatre, and it was there that Ragni and Rado decided to expand on the show's theme of liberation. On more than one occasion, they took to running up and down the aisles naked at the end of act one. Fortunately, the two men possessed a sixth sense that allowed them to detect the presence of the police before they broke the law.

When the two lovers returned to New York City, they fully expected to go back into the Broadway company of *Hair* and incorporate some of their new ideas, engendered not only by their Los Angeles theater stint but their movie debut with French film director Agnès Varda.

Varda had come to the City of Angels and fallen in love with its warm weather and Mediterranean-style hills. She rented a manse there among the bougainvillea and sliding mud, and over a period of a few days and at a cost of $250,000 she improvised a ménage à trois tale involving Rado, Ragni, and Viva, who would end up spending much of their time naked, in bed, and watching TV. When they weren't sleeping together and watching Bobby Kennedy being assassinated on the tube, the trio journeyed out to the backyard, where they turned the bottom of an empty pool into a stage and acted out scenes from Michael McClure's much-banned play *The Beard*, in which Billy the Kid and Jean Harlow perform oral sex on each other. A photograph of Rado, Ragni, and Viva naked in the film, called *Lions Love*, even ended up on the cover of the premiere issue of Andy Warhol's *inter/VIEW*, published that September. The magazine was Warhol's effort to combine the appeal of Jann Wenner's *Rolling Stone* and Al Goldstein's *Screw*, and do for the movies what those two super-successful publications had done for rock 'n' roll and sex, respectively.

Warhol put *Lions Love* on the cover of his first issue, but that didn't mean Varda's movie got a good review on the inside. Taylor Mead was assigned to review. He represented a bit of a conflict, since he'd played Viva's nurse in *Lonesome Cowboys* and counted Rado and Ragni as friends. Nonetheless, he panned *Lions Love*, writing, "They don't even dare show the cocks and balls they cut off and one coy nude shot of the boys is quaintly from the back—real daring shit Agnes—what the fuck are you afraid of—Money??????"

It was a momentous debut issue for other reasons as well. A famous film critic ended up being called a "drag queen" in print, and to avoid a libel lawsuit, Andy Warhol, Paul Morrissey, and a few editorial minions were forced to go through every issue and cross out the word "drag" with a black felt pen. Morrissey vowed, "I will never call him a drag queen again. I will never call him a drag queen again."

That bit of censorship aside, the first issue of *inter/VIEW* (soon to be retitled *Andy Warhol's Interview*) proved revolutionary for Rado and Ragni. When they returned to New York City and the Broadway production of *Hair*, they were more liberated than ever.

"Jerry got totally out of hand and was running up and down the orchestra with a red feather up his ass," said producer Michael Butler. "And Jimmy would just follow Jerry around."

No less an authority than the mayor of New York City put out a warning to Butler. "You've got to do something or we'll have to close you down," John Lindsay threatened.

The producer saw no choice but to fire Rado and Ragni for "deviating from the standard performance in violation of the Equity production contract." They were canned for about two weeks, and while they filed countercharges with the Dramatists Guild, a rapprochement was soon brokered by La MaMa's Ellen Stewart, the doyenne of the Off-Off-Broadway theater. With great fanfare, the two parties settled their differences in a peace meeting held, appropriately enough, in the Sheep Meadow of Central Park. It wasn't quite so easy to keep the show up and running elsewhere, however. *Hair* was officially banned in Boston, and in the years to come, Michael Butler estimated that he kept a dozen lawyers on retainer to keep *Hair* in performance across America.

Autumn 1969, Trauma

he New York Film Festival that September eschewed its usual choice of small-budget foreign-language films, and instead chose to open its sixth-annual confab with a movie from a Hollywood studio. Columbia Pictures even paid for the lavish opening-night dinner at the Footlight Café in Philharmonic Hall. There, 180 guests dined on seafood Newburg and boeuf bourguignon before seeing that night's big movie, *Bob & Carol & Ted & Alice*. Columbia also paid for the fancy after-party on the promenade at the nearby New York State Theater. News of the impending back-to-back fetes unleashed a number of newspaper reports that lambasted the festival, which in its previous five years had opened with films like Jean-Luc Godard's *Alphaville* and Gillo Pontecorvo's *The Battle of Algiers*. There were accusations of the formerly avant-garde festival selling out to the Hollywood establishment.

The director of *Bob & Carol* defended his film. "The directors of the festival knew they had something unique, different," said Paul Mazursky. And festival director Richard Roud explained, somewhat unconvincingly, that "I've always thought we should have a kind of festive or cheerful opening night film."

Cheerful or merely festive, the Columbia execs knew *Bob &*
Carol had something different even before it played the festival.
At producer Mike Frankovich's insistence, they'd screened an ex-
tended scene from the film at the North American Theater Owners
convention. It was Frankovich's favorite moment in the movie, the
one between Ted and Alice, played by Elliott Gould and Dyan
Cannon, where they argue in bed about having or not having sex.
He wants it, she doesn't. Finally, Alice asks, "Would you want me
to do it just like that, with no feeling on my part? Would you, Ted?
Would you, darling?"

"Yeah," says Ted.

Frankovich loved that scene. "This'll give those boys a hard-on
for our movie," he said of the distributors.

The Lincoln Center crowd also liked it. At least that's what the
film's director thought. "The audience went nuts," said Mazursky.

After the festival screening, he and his four stars walked across
the Lincoln Center plaza for a champagne reception on the mezza-
nine promenade of the New York State Theater. Reporters continued
to follow the story of a big studio movie opening the festival. Andrew
Sarris, film critic for the *Village Voice* and a member of the festival
program committee, avoided responding directly to the choice of
Bob & Carol. He instead said, "When you first start picking films
you just look for things you can stay awake through."

Natalie Wood, who wore her hair in a multicolored chignon, kept
telling everyone, "I feel nervous, yes, nervous."

Mazursky wasn't nervous. "Mayor John Lindsay was there. I was
flying. It was a big party," he recalled.

At around 11 P.M., the director took a break from handshaking
and air-kissing when he saw Columbia's publicist Jack Atlas walk
across the vast marble promenade. The flack didn't look happy. Ma-
zursky noticed a rolled-up copy of the *New York Times* under his
arm. "Vincent Canby didn't like it," Atlas told him.

Mazursky wondered how that could be. The audience's reception had been terrific. "I went way down," said Mazursky.

The next morning at the Sherry-Netherland Hotel, Mazursky took time to fully digest Canby's review, which said the film "cops out" by not having the foursome go ahead with their orgy.

The director was in the midst of cursing Canby when the phone rang. He answered it.

"Hello, I'm Pauline Kael," was the reply.

"Oh, I know you," Mazursky blurted into the receiver, even though he'd never met *The New Yorker*'s film critic.

"I just wanted you to know that Vincent Canby is a moron, and you're going to get great reviews," Kael informed him. She went on to name a number of very prominent film critics who liked the film, including herself.

"It made me feel good," said Mazursky, who in the coming months would feel even better when the $2 million–budgeted *Bob & Carol & Ted & Alice* went on to gross $30 million, 10 percent of which went to Natalie Wood, the most she would ever make for appearing in any film.

A FEW DAYS LATER, *Lions Love* screened at the festival, and at film's end Viva accepted the audience's obligatory applause in Alice Tully Hall. Her arms raised to soak in their perfunctory admiration, she then doubled over with laughter. She wanted to tell them, "It's nice to be here this year under such auspicious circumstances—after having been beaten up last year," but she resisted the impulse. She didn't want to embarrass her director, Agnès Varda. The audience's reaction reminded her of how Johnny Carson and his studio audience had mockingly laughed when she mentioned her two upcoming movies, *Midnight Cowboy* and *Lonesome Cowboys*—as if she could only star in movies with the word "cowboy" in the title.

But now the laugh was on Johnny and his company. *Midnight Cowboy* had quickly turned into one of the year's most popular movies.

At the festival, Viva told reporters that her dream role was the one Katharine Hepburn got to play in *The Lion in Winter*. When reporters sneered, she ended the interview, but not before adding that she was tired of appearing nude and having to make up her own lines in Andy Warhol movies. *Fuck*, or *Blue Movie*, had opened earlier that summer at the Garrick Theatre, home to so many Warhol opuses, and if its title weren't controversial enough, Warhol courted more outrage with his opening-night party for *Fuck* at Max's Kansas City, where he acted as father of the bride to Jackie Curtis, who married Stuart Lichtenstein in a mock wedding ceremony.

Variety was one of the few publications to review the movie. "Warhol makes even sex a bore," wrote the newspaper's anonymous critic, who went on to note that thirty-five minutes of *Fuck* was devoted to just that, with the remaining screen time spent on Viva and Louis Waldon as they talked about taxes and Vietnam, among other things. This dialogue, *Variety* opined, was supposed to be "socially redeeming," to inoculate the film from being busted by the cops.

The cops didn't read *Variety*, and seized the *Fuck* print anyway. They also arrested the Garrick's theater manager, projectionist, and ticket seller for possession of obscene materials. The case went all the way to the U.S. Supreme Court, which agreed with the lower courts. *Fuck* was obscene.

Since the film had cost two thousand dollars, Andy hoped he could get some of that money back by releasing the movie as a book, complete with photos and dialogue, by Grove Press, famous for publishing *Lady Chatterley's Lover* and *Tropic of Cancer*, among other long-censored titles.

Not everyone thought the book was such a good idea. When Viva

threatened legal action, Andy gave her two thousand dollars to shut her up. She shut up, except to say, "I was always a cheap date."

Viva never appeared in another Warhol movie.

VIVA, AS IT TURNED out, needed to appear in Andy Warhol movies a lot more than Andy Warhol needed Viva to appear, naked or clothed, in his movies. There was always another superstar lurking around somewhere. There were even a few who weren't Warhol superstars who claimed to be.

During a run in the Off-Off-Broadway play *Heaven Grand in Amber Orbit*, Haroldo Santiago Danhakl found himself perpetually covered in glitter to play a character named Cuckoo the Bird Girl, a moniker that didn't show half the creativity of his own made-up name, Holly Woodlawn. The name Holly came from Truman Capote's Holly Golightly in *Breakfast at Tiffany's*, and since so many female superstars in Warhol's stable hailed from massive family fortunes— Baby Jane Holzer, Edie Sedgwick—the name Woodlawn referenced being heir to the Woodlawn Cemetery in the Bronx.

Neither Paul Morrissey nor Andy Warhol actually saw *Heaven Grand in Amber Orbit*, which played an old funeral parlor on West Forty-Third Street, but they did see a profile of Holly Woodlawn in *Gay*, an underground newspaper, in which the person now known as Holly Woodlawn pontificated rather convincingly about being a Warhol superstar. "Intrigued by my boldness," the actor reported, Morrissey cast her, sight unseen, in *Trash*. It began with his phone call: "Hi, Holly. Listen, we're doing a movie this weekend and I was wondering if you'd like to be in a scene? Can you be at my place this Saturday at one o'clock?"

Casting a transvestite in a lead real role was audacious—and Morrissey's not having met Holly Woodlawn was the least of it. Cross-dressing remained a crime in New York City. Or as Woodlawn put it,

"If you were wearing women's clothes, you were arrested. If you were wearing mascara, they could put you in jail."

Holly Woodlawn soon found herself in the basement of Morrissey's brownstone on East Sixth Street, fucking herself with a beer bottle. The beer bottle was supposed to be a substitute for her boyfriend Joe, played by Joe Dallesandro of *Flesh* fame, who couldn't get it up due to his heroin addiction.

"Morrissey was very anti-drugs," said Dallesandro. "That's why he did the film." Morrissey saw nothing romantic about getting stoned. He hated what drugs did to people, and he hated its glorification in the recently released *Easy Rider* and at that summer's Woodstock festival, which he condemned. " 'Three days of love and peace,' they said. Like hell. It was like the Nuremberg rally, with drugs," he railed.

He also despised the welfare system, something he knew a lot about, having worked as a social worker before he met Warhol. In *Trash*, Holly Woodlawn impersonated a woman who fakes a pregnancy to get on the government dole.

Woodlawn had no idea of Morrissey's moral code. As a director, Morrissey didn't believe in telling actors what to do. He didn't care about giving them motivation. That Woodlawn liked welfare and drugs only made her more believable as the character. Morrissey didn't give much in the way of direction, except to say, "Stop the Method moping—just talk! And whatever you do, don't smile unless you don't mean it!" And besides, he didn't have much time to chat, since *Trash* was being filmed in only six days, strung out over various Saturday and Sunday afternoons.

"We never filmed one day after another," said Woodlawn. "After Paul saw the rushes of an earlier scene, he thought up the following one."

Showing the dailies was an excuse for a party at the Factory. After one such rush party, Sylvia Miles from *Midnight Cowboy* saw

Holly Woodlawn at Max's Kansas City. "Holly!" she called out. "I just saw rushes at the Factory and you are marvelous!"

But then came the rushes with the beer bottle. Woodlawn thought, "Oh, Lord. What have I done to myself? I was so humiliated. There I was with my ass to the wind, having an orgasm with a beer bottle! Just the thought of it made me shrivel, but what made it even more embarrassing was that people actually thought my beer bottle charade was real!"

People at the Factory asked the strangest questions. Like "Didn't it hurt?" and "Weren't you afraid?"

As Woodlawn put it, "If they had paid attention, they would have noticed the shot where my panties show, thus blowing the whole illusion."

The other big illusion was the more obvious: This superstar never possessed a vagina.

WITH HIS NEW MOVIE magazine *Interview*, Andy Warhol dreamed of getting free tickets to screenings and, perhaps, becoming an arbiter of the Hollywood scene, even though he hardly ever visited, much less worked, there. But he heard things—like what his good friend pop artist Roy Lichtenstein was telling him about *Myra Breckinridge* the movie. Lichtenstein, who did for cartoon strips what Andy did for soup cans, had recently worked on the ad campaign for a little British movie called *Joanna*, in which Genevieve Waite changed costumes dozens of times to portray a waif lost in the moral vacuum of swinging London. Pop singer Michael Sarne directed, and the film had turned into a sizable hit, even after Gore Vidal dismissed it as "forty commercials looking for a product" when the powers at Twentieth Century Fox rejected his two—count 'em, two—*Myra Breckinridge* screenplays and hired Sarne to write, as well as direct, the movie version. Over lunch at the Plaza hotel, Vidal let his displeasure

be known not only to Sarne and the film's producer, Robert Fryer, but Fox's top executives David Brown and Richard Zanuck. "I am convinced by what I have read that the next thing I will hear is that Fox is in receivership!" Vidal screamed at his four lunchmates.

Sarne told this story to Lichtenstein, who told it to Warhol, who knew all about the *Myra Breckinridge* movie because his superstar Candy Darling had tested for the lead role and been rejected. Andy told Sarne that the movie looked to be a big disaster. "Oh, just leave it alone," he whined.

Frankly, Sarne wasn't that keen on *Myra Breckinridge*. He didn't think much of the novel. When a friend gave him a well-worn copy, the book automatically opened, he recalled, "in the middle at this well-thumbed page, where this sodomy scene is going on. And I'm reading about this dildo going into the backside of some young guy, and I'm thinking: Are they serious, the William Morris Agency, Twentieth Century Fox . . . ?"

But after *Joanna*, Michael Sarne was hot. And Gore Vidal was suddenly cold, despite the nine hundred thousand dollars Fox had paid him for the rights to film his novel. Vidal's two scripts, in Richard Zanuck's opinion, "lacked that touch of craziness and zaniness that his very idea evoked. It wasn't quite on the page. It had to be told in as outrageous and bizarre a way as the book itself."

In one of its attempts to bang the closet door loudly, *Time* magazine offered another, very speculative analysis of why the original author wasn't up to the movie job: "Perhaps because of his embarrassment over his novel's exquisite self-revelations, Vidal failed in two efforts to bring off a light, witty scenario," the newsweekly prophesied.

Sarne's winning concept, according to Zanuck and Brown and almost nobody else, was to have Myra's sex change be nothing more than Myron's bad dream. Which could also describe the cast that Fox had assembled for the picture.

Mae West, age seventy-six, came out of retirement to play the horny agent Leticia Van Allen. She took the job for a variety of reasons: Her spiritual adviser told her to do it. The film shot on the Paramount lot a few blocks from her home in the Ravenswood Apartments. (She'd recently turned down Federico Fellini's offer to play Nero's mother in *Fellini Satyricon*, since she had no desire to travel to Rome or play a character over the age of twenty-six.) She could write her own lines in *Myra Breckinridge*. The legendary Edith Head would limit her costume palette to black and white. Fox was paying her $350,000. And least of all, "I never could resist an English accent," said Mae West, referring to Sarne's voice.

Mae West's first job as her own screenwriter was to change the name of her character from Leticia to Letitia. It was, she said, "too choice an opportunity to let it get away."

Besides Candy Darling, at least half a dozen other transvestites were tested and rejected, and stars ranging from Elizabeth Taylor to Angela Lansbury to Anne Bancroft passed on the project. Which left it to Raquel Welch to say things like, "I understand Myra thoroughly, I've always identified with her." In addition, the twenty-eight-year-old actress thought that a complex character like Myra Breckinridge represented her best shot at being taken seriously as an actress after posing in a bearskin bikini in 1966's *One Million Years B.C.* and wrestling for screen time with ex–football star Jim Brown in the recent *100 Rifles*. That bit of interracial sex play produced a mildly risqué photo for the "People" page of *Time* magazine, but did little else for the actress's career. Looking back at the end of the 1960s, Welch philosophized, "I was anointed the sex symbol of that era, and I was so socially, politically incorrect. This was the era of girls burning their bras, taking off their makeup. The whole shift in the roles, they were changing."

There could be no bigger change than transsexualism, and without the benefit of twenty-twenty hindsight Raquel Welch

considered Gore Vidal's Myra the perfect send-up of that pesky sex-symbol image of hers. Director Michael Sarne embraced the choice. He opined, "She has a marvelously artificial way of acting. And you could totally believe that she was a sex change in a mad sort of way . . . to me she fitted kind of stylistically into my pop-art gallery. And Mae West fit into that, too: the pose, the walk—'I'm pop art, I'm a Marvel comic.'"

Sarne also approved of director John Huston to play Buck Loner, although, even before production began, he made the mistake of calling the famed director of *The African Queen* and *The Maltese Falcon* an "old hack" in the press. Even more controversial was his and producer Robert Fryer's decision to cast film critic Rex Reed as Myron, because, even though he'd never acted in the movies, Reed did occasionally appear on TV, "camping about, criticizing movies," said Sarne. Those performances were good enough for him.

But Fox ultimately rejected Sarne's script, too, and instead went with one written by David Giler, who would go on to write the *Alien* franchise. Until those sci-fi hits arrived, it didn't really make much difference which script was being used, because Mae West was writing her own lines and Rex Reed had script approval regarding every scene in which he appeared. One of Reed's first chores was to tell everybody that he wasn't playing the following scene: "I was supposed to run naked down Wall Street at midnight, chased by the entire New York police force. When I get to the foot of the Stock Exchange, I look up and, instead of the lady with the scales, there is Raquel with a machete in her hand. She proceeds, of course, to castrate me in front of thousands of people—but instead of blood and genitalia, out come rhinestones, pearls, rubies and sapphires."

Reed let me it be known, "No power on earth could get me to play that scene."

What the film critic agreed to was a kind of Danny Kaye/Walter Mitty–type fantasy movie in which his character "Myron, instead

of undergoing a sex change, would be involved in an accident and dream that he was the alter ego of Myra Breckinridge, giving advice to her. The two of them would be living together at Chateau Marmont and there would be lots of sex between them: I'd be a sort of carnal Jiminy Cricket to Raquel's erotic Pinocchio. I didn't object too strenuously to that," Reed reported. "Under no circumstances was I interested in playing a homosexual who has an operation to make him into a man," he added.

Again, it was *Time* magazine's responsibility to call into question yet another man's masculinity, in this case referring to "the epicene Rex Reed," who "regularly breaks up the crew with his lavender drawl," as if anyone's voice ever spouted color.

Much to his shock, there were limits to Reed's script-approval power. When he refused to play the scene as written—he wakes up in surgery and screams, "Where are my tits?"—David Brown broke out the boxing gloves. "I'll use another actor's voice and have the offending words reverberate throughout the hospital corridors!" Brown ordered.

During the filming, Sarne enjoyed his conversations with Brown and Zanuck, especially those talks that involved Zanuck asking, "How you going to shoot the rape scene? How do you show the dildo?"

Which kind of perturbed Sarne. "It was like a boys' night out, you know, all the time," he recalled.

The women involved, however, weren't so happy, and they weren't happy almost right from the very beginning. Mae West claimed never to have heard of Raquel Welch. When the two stars finally met, Mae reported back to Rex Reed, her confidant on the set, "She's a sweet little thing, but no real women would play this part."

And it didn't bolster Raquel's esteem that Mae got a larger dressing room or that her costumes, by Theodora Van Runkle, were red and blue and never the flashier chiaroscuro of her costar's, or that

Sarne quickly took to calling her "Old Raccoon," or that David Giler told the producer, "She looks like a drag queen." More than her director's direction, Raquel despised Giler's screenplay, which caused her to break down in tears several times. She even asked John Huston for his help in the script department.

"Darling, don't you worry about a thing," he told her. "It's just a movie, it's only a movie."

Finally, the actress took it upon herself to start writing memos to the producer. She thought the rape scene should begin with her wearing a gorilla costume, like Marlene Dietrich in *Blonde Venus*, and the rape should end, she wrote, with "a wild frenzy dance, symbolic of the orgiastic proportions Myra is experiencing at this time." And she added, "We must be cognizant of the fact that today's audiences have already seen *Curious Yellow* and *Sister George* and they are going into this film hoping to see something outrageous, which will satisfy them without being vulgar."

Edith Head was much more worried about the vulgar part than the outrageous part. She'd designed costumes for a few hundred movies during her four-decade career in Hollywood. If the two female stars of *Myra Breckinridge* weren't speaking to each other, their costume designers were. One day, Head asked the other costume designer on the picture, "Thea, do you think we're working on a dirty movie?"

"Yeah, I think we are," replied Van Runkle.

That conversation took place on the day of the orgy. The scene created such a stir on the Fox lot that Welch, who wasn't scheduled to perform, went so far as to cancel her hair appointment so she could watch the shoot. Mae West did more than watch; since she had script approval, she wrote herself an entrance to the orgy: "Oh, this must be what's called letting it all hang out!"

"The set was closed, but it was the hottest thing in Hollywood if you could get onto the Fox set that day," Rex Reed later reported

in *Playboy*. "There was one girl walking around, a suit drawn on her body, with four sequins pasted on for buttons. A man in an Indian hat had pinned an enormous fur contraption over his genitals. A singer named Choo Choo Collins wore nothing but a polka-dot bikini painted on her body. There was a man in a jockstrap with a fingerlike thing hanging down from his crotch. A group of nudes stood around a grand piano singing 'The Star Spangled Banner,' and there was one man in a bra and panties and another in a half-slip."

Since West came armed with her own one-liner, Sarne also let his extras improvise their dialogue for the orgy. "Do you masturbate in the shower?" one girl asked. "Let's burn all the pubic hair off her body with lighter fluid," said another.

Visitors to the set that day included Robert Fryer, who hadn't spoken to Sarne in weeks, telling *Variety*, "We just disagree on everything." Fryer, who tried to have Sarne replaced by *Hair* director Tom O'Horgan, arrived at the orgy with two executives from Fox in tow, and as the three of them looked out over a sea of naked bodies, one of the suits remarked, "Well, it's a today picture."

"Bullshit!" Fryer harrumphed. "*Midnight Cowboy* didn't have pubic hair and filth in it."

DESPITE HIS RESERVATIONS, THE beleaguered producer of *Myra Breckinridge* was in good company that autumn. Just two weeks shy of their first wedding anniversary, Jackie and Aristotle Onassis attended a midafternoon screening of *I Am Curious (Yellow)* at the Cinema 57 Rendezvous on West Fifty-Seventh Street in Manhattan, the same theater where Andy Warhol's *Chelsea Girls* once played. Vilgot Sjöman's film about a very sexually active young woman named Lena had become a cause célèbre when the U.S. Customs Office seized *I Am Curious (Yellow)*, deeming it obscene. If the movie itself didn't appeal to prurient interests, the legal proceedings

did, and Grove Press, the film's distributor, publicized the court case up until the day the Supreme Court found the movie not obscene. Finally, *I Am Curious (Yellow)* was allowed to play in Manhattan, and Mr. and Mrs. Onassis were there on October 5 to buy tickets to watch, among other things, an actress kiss her costar's flaccid penis. Jackie and Aristotle arrived in separate cars, and it wasn't until she left the Rendezvous theater halfway through the movie that photographers, alerted by the theater's management, blinded her with flash-bulbs. Mel Finkelstein, a *Daily News* photographer, tried to take photos of the former first lady inside the lobby. Outside the theater, he continued his quest when, according to Finkelstein, "she grabbed my right wrist . . . put her leg out and flipped me over her thigh."

A Rendezvous doorman told a slightly different story. He said that Finkelstein tripped taking a photograph of Mrs. Onassis, who was wearing a short leather skirt, dark stockings, a ribbed sweater, and a multicolored scarf with zodiac signs tied over her hair. With Finkelstein splayed out at her feet, she walked down the street, turning *I Am Curious (Yellow)* into one of the most successful foreign-language films of 1969.

Aristotle Onassis stayed behind in the theater to watch the entire film undisturbed, leaving an hour after his wife, at which time he was accompanied by two bodyguards. Photographers did not hang around the theater to record his exit.

I AM CURIOUS (YELLOW) was well on its way to grossing $20 million in the United States alone. Russ Meyer's soft-core *Vixen*, made the year before for only $26,500, had already grossed $6 million. That phenomenal forty-to-one return on investment was second only to *Gone with the Wind*'s success, according to the *Wall Street Journal*, and that was good enough for Twentieth Century Fox, which had recently lost millions on such big-budget turkeys as *Dr. Dolittle* and

Hello, Dolly! Whether it was respectable money or not, the studio needed to tap into some of that low-risk lucre.

As the *Myra Breckinridge* shoot wound down in December— "Everyone has quit three or four times," said Richard Zanuck; "I think I've quit once or twice myself as studio chief"—Fox geared up a sequel to its 1966 hit *The Valley of the Dolls.* Since King Leer, otherwise known as Russ Meyer, had performed the box-office miracle of *Vixens,* Zanuck and David Brown thought he could direct *Beyond the Valley of the Dolls.* Its shooting schedule overlapped only slightly with that of *Myra Breckinridge,* but for those two weeks, from December 2 to 18, the air on the Fox lot was redolent with the scent of burning marijuana despite Mae West's contractual decree that no one be allowed to smoke, not even cigarettes, anywhere near the set of her picture.

Hollywood's old-timers were aghast that Twentieth Century Fox, the once-proud studio of *All About Eve* and *The Grapes of Wrath,* had descended to making a Russ Meyer skin flick. Not that Meyer had any intention of turning himself into Joseph Mankiewicz or John Ford the minute he arrived on hallowed studio ground to direct the sequel to *The Valley of the Dolls.* "It seemed to me it presented a good basis for a teenage soap opera," he said of his first studio film.

It wasn't a sequel. *Beyond the Valley of the Dolls* was only a title. As Meyer was quick to point out, "The previous film didn't leave us many characters to deal with. Two of the three leading women appeared to be killed off, though Patty Duke only collapsed on the street."

A chubby twenty-seven-year-old film critic from Chicago had the honor of writing the script to the title, and his one-line synopsis summed up why he got the job. "It's a camp sexploitation horror musical that ends in a quadruple ritual murder and a triple wedding," Roger Ebert told *Time* magazine. It helped that Ebert also shared Meyer's major passion in life, but with a twist.

"I've considered full and pendulous breasts the most appealing

visual of the human anatomy," Ebert revealed. "Russ saw them differently, somehow considering a woman's breasts part of her musculature."

The movie's triple-wedding centerpiece was Ebert's idea, and the quadruple ritual murder was something he ripped from the headlines that summer as soon as he got to Hollywood, the Charles Manson "family" having killed Sharon Tate and others. None of which had anything to do with Jacqueline Susann's *The Valley of the Dolls*, especially after her two attempts at writing a sequel had met with the same success at Fox as Gore Vidal's two *Myra Breckinridge* scripts. But quadruple ritual murder, together with a big wedding, sure sounded like good box office.

Ebert's script boasted no fewer than eleven principal characters and "eighteen couplings," said Meyer. He especially liked the couplings. "20th is letting me film stronger sex stuff for *Beyond the Valley of the Dolls* than I've ever put in my movies," he told reporters. "But I'm covering myself with plenty of cutaway shots on the bed scenes in case they chicken out later."

They didn't.

As the filming progressed, Meyer noticed a "current of confidence" growing among the crew; in his expert opinion, they saw that he knew what he was doing. It helped, too, when Richard Zanuck stopped him on the streets of the back lot to say, "The rushes look damn good." It converted a few Fox executives into believers, even those who didn't considered *Myra Breckinridge* a "today" picture.

Nothing would be more today than the violent rock 'n' roll story that Ebert delivered. Just one week into shooting *Beyond the Valley of the Dolls*, on December 6, the Rolling Stones performed at the Altamont Speedway Free Festival.

. . . .

EVEN AT THE END of a normal week, the Altamont Speedway Free Festival would have been a must for Lance Loud. But it had been a really bad week, and more than ever Lance needed a reason to get out of Santa Barbara. There at the local high school a classmate had told him, in front of a roomful of students, "Why don't you give someone a blowjob behind the bleachers." And in English class, his assignment to interpret a song hadn't gone well. He chose the Velvet Underground's "The Gift," about a man who mails himself to his girlfriend and gets killed when she opens the box with a sheet-metal cutter. Reciting Lou Reed's lyrics, Lance pulled out a knife and stabbed the desk. "You took the performance just a little bit too far," warned his English teacher.

No wonder Lance needed to unwind at the upcoming Altamont rock festival. He left Santa Barbara High School that Friday afternoon with his good friend Kristian Hoffman, son of the heiress to the Knudsen dairy fortune, and rather than a quick stop at their respective homes, they wasted no time, heading up north on Highway 101 to Tracy, a town fifty miles to the east of San Francisco. Actually, they weren't going to Tracy but rather the nearby Altamont Speedway, a race track that had opened three years earlier. The Rolling Stones and the Grateful Dead were hosting a rock concert there that was being touted as Woodstock West, and featured other rock groups as well, among them Jefferson Airplane and Santana.

Looking back at his friendship with Lance, Kristian recalled that he was the one with the car, a green Volkswagen bug. "I was conscripted as his chauffeur for these wonderful adventures," said Kristian. "Lance had this sense of destiny, of being where precisely you were meant to be. Lance took that hunger and turned it into reality. If you were lucky enough to spend part of that quest with him, you didn't question it—his intent and charisma were so powerful that

you were a helpless convert to his belief in that sense of place. He believed there was this moment that was waiting for him, and one had to do anything—one had to abuse your wit, your soul, and any small skill you had—to rise to and grasp that moment."

The moment to be seized that particular Friday night was Altamont.

"Lance and I found this crazy field in the middle of nowhere," said Kristian. "We brought our sleeping bags, and got there the night before. We were by this cyclone fence. They didn't let you in."

Suddenly, amid the rolling, parched hills of a cattle field, Lance and Kristian were engulfed in a stampede of not cows but people as they rushed the fence, breaking through it and running to the stage. Like it or not, Lance and Kristian barely had time to grab their sleeping bags. "Hey, you dropped this!" someone shouted at Kristian. There in the melee, a man had taken the time to retrieve Kristian's wallet with all his money and a gasoline credit card. "It was a very hippie moment for this guy to tell me I'd lost my wallet, and for him to return it to me in the middle of that huge surging crowd," he recalled.

Fortunately, that minor detour in their journey to Altamont did not prevent Lance and Kristian from securing a spot on the ground very near the stage. While the Rolling Stones arrived five hours late, the Hells Angels appeared right on schedule as they proceeded to drive over people with their motorcycles and clobber skulls with pool cues. Concertgoers taking pictures had their cameras opened up and emptied, and at one point in the ensuing riot, Kristian found himself on the ground with his feet in the air as Lance tried to prevent people from stepping on him. "It was a moment like we're in Vietnam," said Kristian. "It was horrifying, scary, adrenaline-pumping—the most transformative event in my life."

Mick Jagger, surrounded onstage by Hells Angels, thought it was pretty intense, too. "Either those cats cool it or we don't play," he

warned the increasingly unruly crowd. An Angel in black leather backed him up: "Do you all want to go home or what?

Jagger mused, "Every time we get to a number, something happens."

What happened is that someone pulled a gun and an Angel stabbed the man in the back and neck, but the man died before a helicopter could airlift him away. Horrified at the violence—in addition to the homicide, there were three accidental deaths and dozens of injuries—the Grateful Dead quickly withdrew from the concert, never to appear at Altamont. Amid the mayhem, Lance and Kristian somehow were able to record a new Stones song.

Back in Santa Barbara, the two teenagers quickly added "Brown Sugar" to the sizable repertoire of songs they'd written for their garage band. People who heard those songs weren't that impressed, Kristian recalled. "But everyone said we really had something with that 'Brown Sugar.'"

IF ANYTHING, THE ALTAMONT homicide made Warner Bros. even more wary of *Performance*—and they pushed the Mick Jagger picture even further back on the shelf, if that were possible. The studio executives were sweating enough over the release of Luchino Visconti's *The Damned*, which the studio found almost as controversial. At least that story, a roman à clef of Germany's once-powerful Krupp family, made dramatic sense, unlike the narrative jumble that was *Performance*. But the movie executives were making demands on Visconti. As the Italian director complained to his star, Dirk Bogarde, "I have bad news. From the Warner Brothers in America. They like very much our film but they wish to make more cuts in it than I agreed. They will butcher me, my work, everything for the dollar. I hate this business: it is always the money. Will the film be understood in Wisconsin?"

Too well, the Warners executives feared.

To depict the Night of the Long Knives, Hitler's 1934 purge of the SA (Sturmabteilung, or "brownshirts"), Visconti staged the prelude to those multiple assassinations by the SS as one long drunken brawl that began with a drag show and a nude frolic in the lake and ended with a gang rape of a beer maid and multiple homosexual assignations—and, of course, lots of naked, blood-splattered male bodies and a slow pan to Dirk Bogarde's smoking gun and angst-ridden face.

Warners ultimately forced Visconti to cut more than five minutes from the extended Knives episode.

But there was plenty more where that came from. Even in its bowdlerized state, *The Damned* offered an operatic brew of incest, transvestism, homosexuality, rape, and child molestation that only a story ripped from the pages of the Bible—or the diaries of some Nazi—could get away with. Visconti even introduced a character that took the kitchen-sink approach to sex. Not only did Helmet Berger's Nazi have sex with a male servant in his family's baronial estate; he also kept a mistress in the city, molested two little girls, raped his mother, and, to tweak his steel-magnate grandfather's moral outrage, dressed up in Marlene Dietrich drag.

At least when it came to Dietrich, Warners didn't pull back. Ready for a Christmas release, they wrapped the film in that *Blue Angel* aura, using the cross-dressing Berger as its poster image together with the tagline: "He was about to become the second most powerful man in Nazi Germany."

Adding to the onscreen sexual frisson was the offscreen romance: The sixty-three-year-old Visconti had taken the twenty-five-year-old Berger as his lover. Theirs was a colorful pairing, especially after the director said of his lover that he visually embodied the "demonic, insane, and sexually perverted."

Visconti left all that perversion intact onscreen, but played the

studio game elsewhere by making a few judicious cuts. According to Bogarde, he had his motives.

"Visconti wondered if he made more cuts to *The Damned* if Warners would agree to let him make *Death in Venice*," the actor wrote in his memoir. Indeed, Warners green-lit *Death in Venice*. Visconti's cuts to *The Damned* had nothing to do with that decision, however, and everything to do with the surprisingly good box office for *The Damned*. In New York City, the film opened right before the year-end holidays. "We were the hit of the season and Visconti put it down to the fact that New York was a predominantly Jewish city (as were many of its critics)," reported Bogarde, "and the film was splendidly anti-German."

Winter 1970, Outrage

Twentieth Century Fox wasn't the only studio going through the dry heaves of near-bankruptcy. Warners' financial straits led it to acquire a new, better-heeled partner. The executives of Kinney National Services, expert in the matters of paper towels and parking lots, were immediately intrigued by the name Mick Jagger, and wanted to see *Performance*, which was buried in a vault and forgotten somewhere in the concrete and asphalt of Burbank. They found the film. They screened it. They liked what they saw. "Doors started opening and money to flow again," said the film's producer, Sandy Lieberson.

Suddenly, *Performance* looked almost mainstream. Almost. Redolent with sex, drugs, rock 'n' roll, and violence, the film now possessed a prescient glow when viewed in the aftermath of the Rolling Stones/Hells Angels/Altamont murder and Charles Manson's mangling of the Beatles' "Helter Skelter" lyrics to reference a racial-war apocalypse. Rock music and violence were a marriage made in tabloid heaven.

A preview screening of *Performance* in New York City signaled a big hit. Young music journalists and film aesthetes, psyched by Hollywood's embrace of edgier fare like *Bonnie and Clyde* and *Easy*

Rider in the previous decade, proved the ideal audience. Too ideal, perhaps, to be an accurate gauge of the film's future success at the box office.

A much older, less rock-savvy crowd three thousand miles away in Santa Monica, California, presaged the film's eventual commercial defeat. "Most of the audience ran screaming out of the theater," said director Donald Cammell. "I don't think you could have a much better reaction than that. I was enjoying it in the back of the theater with my employers, the authorities—the Warner Bros. fuzz."

The film's director didn't mean to be ironic. He reveled in being the trailblazer, the provocateur, the hornet in the studio ointment. Buoyed by the New York response, Cammell dreamed of cult status for his long-gestating baby.

The Warner Bros. fuzz, on the other hand, simply saw a box-office disaster, and it didn't help when the MPAA slapped an X on *Performance*, as much for its violence as its sex. The *Rolling Stone* reviewer pretty much concurred with that ruling, writing: "This is a weird movie, friends. . . . Use Only As Directed. One of the attributes of evil is ugliness and on one level *Performance* is a very ugly film. Hallucinating though it may be, I would not recommend viewing it while tripping."

In 1969, the X didn't hurt *Midnight Cowboy*.

In 1970, the X meant pornography. Even so, Americans saw more than the Brits did when the film opened across the Atlantic, where the censors excised a few minutes. Most of the lost footage had nothing to do with sex and everything to do with the scene in which James Fox and his cohorts torture a gangster's limousine driver. The BBFC's Sir John Trevelyan wrote that the scene was "brilliantly shot by Nicolas Roeg," but violence-wise it was "worse than any that I had seen before. We had to cut it, and, although our cuts were strongly resisted, we insisted on them; even in its modified form the scene was shocking."

If Cammell would remember the disastrous Santa Monica

preview with perverse delight, Roeg had his own guilty pleasure when it came to seeing his work trashed. For several months after the film's release, he carried Richard Schickel's pan review from *Life* magazine in his coat pocket.

Performance turned into an obsession for Schickel and his middle-brow, status-quo-pandering publication. When he reviewed *Gimme Shelter*, the Maysles brothers' documentary on the 1969 Stones tour and the Altamont murder, the clairvoyant Schickel saw Mick Jagger's future, and it didn't include the rocker's footprints in front of Grauman's Chinese Theatre. "Finally, one imagines he will withdraw physically, as he already has psychologically, from his public—just as the character he played in *Performance* did," Schickel wrote of Jagger.

First, James Fox, who continued his Christian missionary work in South America. Now it would be Mick Jagger's turn to retreat from a film career, as evidenced by the one-two blowout of *Performance* and Altamont. The most notable casualty of the rock star's turnabout was Lieberson and Cammell's film adaptation of Michael McClure's *The Beard*, a snippet of which had achieved minor movie immortality in Agnès Varda's *Lions Love*. The play, about a sexual encounter in hell between Billy the Kid and Jean Harlow, had already been busted fifteen times in Los Angeles alone due to its graphic depiction of oral sex. In London, the Royal Court Theatre converted into a private club to be able to stage the show, just as it had done with John Osborne's *A Patriot for Me*.

Cammell savored the challenge of bringing *The Beard* to the screen. "I discovered that I shared one or two fetishes with Michael McClure," revealed the director, who claimed a personal identification with Jean Harlow, as well as Billy the Kid. "It's not necessarily a war," he said of the characters' love-hate relationship. "You can see the consummation of it as being an orgasm. If you look at the whole play as being a fuck, then the seduction at the end of the play corresponds with the orgasm at the end of a sexual encounter."

Cammell couldn't wait to make *The Beard*.

Jagger could. After the twin nightmares of *Performance* and Altamont, he retreated from another brush with filmmaking for the remainder of the decade.

With little fanfare, Paramount Pictures unveiled its utterly incompetent screen adaptation of Henry Miller's *Tropic of Cancer* that February, and despite its being the first major American release to feature the word "cunt" (uttered several times by narrator Rip Torn, and taken verbatim from Henry Miller's much-banned novel) and the pubic hair of Ellen Burstyn (best known heretofore as a showgirl on *The Jackie Gleason Show*) the film played only one week in one theater, according to its godfather, Paramount Pictures' head of production. Robert Evans had made a bet with his old friend Henry Miller, wagered over two games of Ping-Pong, that *Tropic of Cancer* could not be made into a movie. Evans, as well as Paramount, lost that bet.

LIKE SO MANY ONCE-TABOO subjects, blowjobs continued to present sizable problems for filmmakers in 1970.

At Twentieth Century Fox, Michael Sarne was having his own tussle with a scene in which Raquel Welch's Myra had been assigned the improbable task of performing oral sex on Rex Reed's Myron. His solution involved getting the studio to give him the run of its film archives, and it was Sarne's idea to insert a number of classic black-and-white vignettes from old movies into the most colorful action of *Myra Breckinridge*. The inserts, working as comic comment, would lighten the graphicness of certain scenes. At least, that's what he told them at Fox. Of special concern was not only the scene in which Myra penetrates a young man named Rusty with a strap-on dildo, but the moment when Myra miraculously goes down on herself as

a man. Sarne found an old Fox movie in which the young Shirley Temple milks a goat and squirts herself in the face by mistake. He plugged that old gem into the Myra/Myron blowjob scene and nearly laughed himself into a coma.

The scene was also a favorite for the preview audience of three thousand gay men in San Francisco, where Fox chose to test *Myra Breckinridge*. In homage to Mae West and other legendary ladies of the silver screen, a number of moviegoers in attendance that night dressed up as their favorite star of the opposite sex. According to Sarne, the screening was everything he, David Brown, and Richard Zanuck could have hoped for. Then little Shirley milked her goat.

"At that point the fucking theater exploded. It went 'Boom!' like an atom bomb," said Sarne. "Zanuck is holding his sides—he can hardly sit in his seat . . . the gays were loving it—everybody was loving it."

Testing *Myra Breckinridge* with a bunch of gay guys in Frisco was a little like testing *Performance* with a bunch of stoned rock journalists in Manhattan.

Neither demographic is a general moviegoing audience.

A few days later, back in Los Angeles, Zanuck was no longer laughing at Myra, Shirley, and the goat. He called Sarne into his office to tell him that the entire blowjob scene had to go.

Sarne wouldn't hear of it. "Sorry, bubby," he told his boss. "It's staying, it's the best scene in the film, the biggest laugh in the film." He reminded Zanuck, "In San Francisco, you were pissing yourself laughing. I remember, you had to go to the toilet."

According to Sarne, Zanuck revealed that no less a person than the president of the United States, Richard Nixon, had called Zanuck's father, Darryl Zanuck, to complain about the scene. It seemed that little Shirley Temple had grown up to be a delegate to the United Nations. "And that it's got to go," Zanuck demanded.

. . . .

THE OTHER BLOWJOB BALLYHOO that February involved, of all revered organizations, the Academy of Motion Picture Arts & Sciences. The people who gave out the Oscars were petitioning John Schlesinger to cut the Jon Voight/Bob Balaban encounter from *Midnight Cowboy.* Schlesinger's "dirty" picture had been blessed with seven Oscar nominations that winter, including one for best picture, and the Academy did not think it becoming to have one of its nominated films carrying the suddenly sullied X rating. The MPAA announced that it would give *Midnight Cowboy* the less restrictive R rating—if the blowjob scene disappeared.

Schlesinger kept it simple. "No way," he said.

MIDNIGHT COWBOY'S JON VOIGHT and *The Damned*'s Helmut Berger found themselves in competition with each other at the 1970 Golden Globes, for the Most Promising Newcomer Award. The Hollywood Foreign Press Association, which gives out the honors, is an organization of journalists who write about films and otherwise spend their weekends at press junkets held in posh hotels around the world, where they interview movie actors and eat free food and drink free wine provided by the motion picture companies. Although Berger didn't exactly talk about his ongoing relationship with Luchino Visconti, he also didn't exactly hide his sexual orientation when it came to promoting his performance as a Nazi degenerate in *The Damned.*

"I am somewhat of a devil. I can't help it. It's the way I live," he told one journalist. "I must experience everything at least once. It's my curiosity and also my needs. I'm not different from a lot of men, but I admit what and who I am and what and who I need. I now have a very lovely girlfriend, Marisa Berenson. Maybe you saw us on the cover of *Vogue*? She understands me and what love is all about. She

is not shocked because I need a man I love and I also need a woman I love! Does that shock you?"

Berger's admission might have shocked—or perhaps, disgusted —Dr. David Reuben. His how-to manual *Everything You Wanted to Know About Sex (But Were Afraid to Ask)* had recently risen to the top of the bestseller lists. In addition to advising readers on such topics as oral sex and the joys of consecutive rather than simultaneous orgasms, the doctor got very graphic on the subject of homosexual males and the various objects they engorged in their respective anuses; these were acts of self-abuse, wrote the doctor, that often required the aid of emergency-room medics when it came to removing these makeshift dildoes. Unfortunately for Dr. Reuben, no less a personage than Truman Capote took note of the book's strange fixation on homosexuality, and when the bestselling doctor unceremoniously canceled an engagement on *The Dick Cavett Show* to appear instead on the rival *Tonight Show* ("Dr. David Reuben came down with a better engagement," said Dick Cavett), the *Cavett* producers quickly booked Capote, a frequent guest, to fill the empty spot. It didn't take long for Cavett to get his revenge. One of the first questions he asked the author of *In Cold Blood* was if he had learned anything from reading *Everything You Wanted to Know About Sex*. Capote said no, then he attacked, saying the book had "one whole chapter on homosexuality of which not one word is true." The censors at the ABC network went into overdrive and bleeped out most everything else Capote had to say that night, which sent the studio audience into paroxysms of shocked laughter. "Oh, you're ornery tonight!" Cavett said with a smile.

Shocked or just plain ornery, the Golden Globes voters gave their coveted award to Jon Voight, not Helmut Berger.

Spring 1970, Kisses

John Schlesinger decided not to attend either the Golden Globes or the Academy Awards, even though he'd been nominated as best director by both confabs. On the evening of April 7, otherwise known as Oscar night, the director remained in London with boyfriend Michael Childers, who had put his *Oh! Calcutta!* connection to good use and been hired by Kenneth Tynan to be the National Theatre's staff photographer, the first American to hold that position. Schlesinger didn't expect to win the Oscar—he'd already lost the Golden Globe to Charles Jarrott, director of *Anne of the Thousand Days*. And besides, he was too busy to make the brutal twenty-four-hour round-trip flight to Hollywood and back. He was well into production on *Sunday Bloody Sunday*, and for him, it was a very personal project.

As Schlesinger explained it, the film's genesis went back to the early 1960s when he was directing his first play for the Royal Shakespeare Company, which was a one-act play by John Whiting, author of *The Devils*. "I had a very intense affair with one of the actors, a man who was bisexual," Schlesinger recalled. "We had a lot of fun and liked each other enormously, but I was more smitten than he was, and something told me that this might be something that I shouldn't pursue, I don't know why, but I did anyway."

What gave the story a twist suitable for retelling onscreen was that Schlesinger's boyfriend had another lover: an actress. It was a terribly unconventional yet somehow comfortable arrangement. "We laughed so much at the situation together," said Schlesinger. "Then he'd go off the next weekend with his girlfriend," whom the director later cast in one of his films.

Essentially, that was the story of *Sunday Bloody Sunday*—with minor adjustments of poetic license: A fiftyish doctor and a thirtyish career woman share a twentyish bisexual artist. No studio wanted the project, which Schlesinger had been working on since 1966, one full year before Britain's Sexual Offences Act legalized homosexuality between consenting adults. His collaborator on *Sunday Bloody Sunday* was Penelope Gilliatt, who, as film critic for *The New Yorker*, had trashed his first two films, *A Kind of Loving* and *Billy Liar*. The success of *Darling* changed her mind about Schlesinger's considerable talents, and it helped, too, that he liked her novel *A State of Change*, about a ménage à trois. She and he weren't friends, but they were effective working partners, even though he occasionally did refer to Gilliatt as "that cunt."

The film was both easy and difficult to cast. After Larry Kramer showed him a rough cut of *Women in Love*, Schlesinger immediately cast Glenda Jackson. He liked her intensity and thought she'd bring real backbone to his long-suffering Alex, whom he didn't want to come off as a masochist.

Casting the role of the confirmed homosexual Dr. Daniel Hirsh proved the more arduous task. Paul Scofield, who'd recently won an Oscar for portraying Sir Thomas More in *A Man for All Seasons*, was offered the role. Once a saint, never a sinner, Scofield refused. He sent Schlesinger a simple letter of rejection. "I don't suppose you want to know the reasons that I don't want to do this," he wrote.

Schlesinger didn't need to ask.

Alan Bates, whom Schlesinger directed in *A Kind of Loving* and

Far from the Madding Crowd, agreed to play the Hirsh role, then quickly discovered he had other commitments. With production about to commence, Schlesinger finally went with Ian Bannen, an original member of the Royal Shakespeare Company. The results were disastrous. Even the auditions proved a trial for the forty-one-year-old Scottish actor.

Hiram Keller, fresh from *Fellini Satyricon* and *Hair* on Broadway, was one actor who tested to play Bob, the young male bisexual. He tested twice for the role, both times with Bannen. Schlesinger kept telling Keller, "Play it for real love and sympathy."

Keller didn't see it that way. "If I were in that position and I was sleeping with a man and a woman at the same time and I had told them both about it, obviously, I'd be some sort of a little hustler and I'd be playing them both off for sex," said the actor.

Schlesinger definitely didn't see it that way. The auditions proved that Keller wasn't the right actor—nor was Bannen, who had to be well lubricated with gin to play the homosexual love scenes, even when auditioning. Schlesinger had to tell him, "Look, Ian, this is not your test. I've already signed you. This is Hiram's test. Can't you straighten up enough to help Hiram?"

The problem wasn't Bannen's being an uptight heterosexual; rather, he was an uptight homosexual who'd spent a long, distinguished career trying to convince directors, playwrights, producers, and audiences that he could be convincing in heterosexual roles. Suddenly, he was being asked to play a homosexual, and he just couldn't do it.

"Ian wasn't free and out enough to act this part," said Michael Childers. "He just froze up. We thought the studio might cancel the film."

Schlesinger had no choice but to fire the actor, although the report to the press was that Bannen had developed viral pneumonia. Producer Joseph Janni put out a frantic calls to an agent, Olive

Harding, who in turn phoned her client Peter Finch in Rome. "You must fly to London at once, Peter," she ordered. "Joe Janni and John Schlesinger are in a mess. An actor has fallen ill and they want you to come and play Daniel Hirsh in Penelope Gilliatt's *Sunday Bloody Sunday*."

Finch had already read the script and passed on it. Besides, he hated airplanes and didn't want to fly back to London. He also repeated his other major reservation. "I'm not a queer," he told his agent.

"No, dear," said Harding, "but I'd like to see you play one to prove you are an actor."

Back in London, having overcome his fear of flying, Finch met with Schlesinger and Childers at the Sloan Square Hotel. It was a nice tea—until Childers brought out his camera and started taking pictures of Finch. The actor waved away the photographer.

"Dear John," Finch began, "I'm here in front of you. If you think I look too old, just say so. I'm right in front of you."

After just one day of shooting with Finch, Schlesinger could finally relax. "That's exactly what I wanted for the part: a pair of open arms," Schlesinger said of the actor's performance. There was no method about it. "Peter plunged right into his part and there was no time to talk it over with him. He knew the character in some way without, I think, ever having experienced any of it."

Sunday Bloody Sunday filmed at the Bray Studios, where they also made the Hammer horror films. The cast and crew had the place to themselves, and, as Schlesinger recalled, "we became like one big family," with no interference from United Artists despite the long six-month shoot.

If there was any bump in the production, it was "the Kiss," as Schlesinger put it, shared by the doctor and his young lover, Bob. The scene occurs early in the film, right after Bob has momentarily left his girlfriend, Alex, to make an impromptu visit at the doctor's home. In fact, the problem with the Kiss started even before Bannen.

Gilliatt and Schlesinger vehemently disagreed on how the Kiss should be presented. "I didn't think that it should be portrayed with any kind of apology," said Schlesinger. Gilliatt, on the other hand, wanted it done in a long shot, with the two male actors kissing in silhouette. "I wanted the doctor to greet his lover, as if it were the normal thing to do." Schlesinger insisted, "If we start putting it in silhouette and long shot, it's a special pleading and coy."

He was the director. She was the writer. He won.

Gilliatt wasn't the only one with reservations.

"I feel awkward taking this job," said cinematographer Billy Williams. Schlesinger asked him to be more explicit. "Well, it's the subject," he said.

"Look, it's a question of how it's handled," replied Schlesinger.

Unlike his contempt for the *Midnight Cowboy* crew, Schlesinger handpicked the British technicians on *Sunday Bloody Sunday*. He deeply admired and cared about them; he considered them a family. But the Kiss strained those relationships. He wanted it filmed as he would handle any heterosexual kiss—in close-up—and that's just how he planned to shoot it.

After Schlesinger rejected Hiram Keller to play Bob, he went with newcomer Murray Head, whom he'd seen in the London production of *Hair*. Having delved into hippie pansexuality on stage, Head didn't blink at kissing another man for his first major screen role. "The Kiss!" he exclaimed. "To me it was an infinitely simple gesture, which caused eruptions right, left, and center."

On the day of the Kiss, Head was surprised that people treated him with such deference. Grips, costumers, and script girls kept coming up to him, saying, "It's the scene!"

He glanced at his script. "Well, I can't find the dialogue, what scene?" he asked.

"Ah, you know, the Kiss!"

"Oh yeah, yeah it is."

He looked around. Instead of the usual two photographers, there were five men with cameras ready to document the big moment.

"There was a tenseness on the set," Head recalled. "Everybody getting jumpy, and I started to pick up the vibes of uneasiness. I thought, sod them! This is ridiculous to get into this pitch over such a simple gesture of affection."

Schlesinger asked for numerous takes of the Kiss. Finally, the camera operator turned around to ask, "John, is this really necessary?"

"Yes, of course it is!" he snapped.

The tension on the set carried over to the screening room, where the cast and crew viewed rushes of the Kiss. People started coughing and sputtering, lighting up cigarettes, crossing and uncrossing legs. "The more it went on, the more they were embarrassed. I started to worry about it," said Head. And then he had an epiphany amid all the cigarette smoke and bent limbs. "It let the world in for me because it helped me to get myself into perspective. I thought, well, at last as a young person I don't find any trouble accepting this kiss at all. It consolidated my own feelings and the feelings that I knew people my age would have about the scene and the film, as opposed to the older generation that was sitting all around me in the viewing room."

In the weeks that followed, members of the crew sought out the young actor to have tête-à-têtes with him about the film's subject matter. They somehow always got around to asking him, "Of course, you being an actor, I suppose . . . I mean, I don't know, but it's the sort of thing that would worry me. I mean, when you kissed Peter Finch, didn't you feel, well . . . disgusted?"

Head said no. "Well, you know, I really can't help you. I can see it's bugged you, but no, it didn't feel any different from anything else I have to do in the film. I don't feel any problem about it."

For his part, Finch always took the high road when people asked him about the Kiss. "I did it for England," he said. Or when he had

exhausted that retort, he simply said, "I just thought of the Queen Mother."

Schlesinger filmed the Kiss around the time of the Academy Awards. Two weeks before the ceremony, UA's David Picker phoned to tell him, "You're the hot dark horse. We think you have a good chance. We'll pay for shutting down production for three days, and you and Michael come to the Academy Awards."

Schlesinger and Childers talked about it. Childers wanted to make the trip. "We had a huge argument. I thought *Midnight Cowboy* would get one or two awards," he said.

But Schlesinger decided to stay in England, explaining that it would be hard on the crew, "To ask them to work overtime to catch up with the days I'd missed—that would be impossible. I couldn't go for that reason."

The final moments of the four-hour Oscars telecast came at about five o'clock in the morning, London time. Schlesinger and Childers were in bed when they received a phone call from Judy Smith, who'd been one of the director's assistants on *Midnight Cowboy*. Backstage at the Oscar telecast, where she worked as production manager, Smith held up the phone receiver so Schlesinger could hear what was being said onstage at the Dorothy Chandler Pavilion in downtown Los Angeles. He heard the "Everybody's Talkin'" theme song from *Midnight Cowboy*. Waldo Salt had just won for best adapted screenplay. Then Myrna Loy took the stage to announce the best director winner. "John Schlesinger, *Midnight Cowboy*."

"We screamed in our pajamas!" said Childers. Then Elizabeth Taylor appeared onstage to read the titles of the five movies nominated for best picture, her voice noticeably tense, perhaps reflecting her resentment that John Wayne, for his performance in *True Grit*, had beat out her husband, Richard Burton, for *Anne of the Thousand Days*. She read the nominated titles: *Anne of the Thousand*

Days, *Butch Cassidy and the Sundance Kid*, *Hello, Dolly!*, *Midnight Cowboy*, and *Z*.

"And again, we heard the *Midnight Cowboy* theme song," said Childers.

The two men got to Bray Studios at 7 A.M. to find dozens of waiting reporters and photographers. United Artists even splurged on a champagne lunch. "Julie Christie, Alan Bates, Tom Courtenay—all of John's stars came to the set to congratulate him," said Childers.

When he'd finished production, Schlesinger took great satisfaction in screening a rough cut of his film for the camera boys. They brought their wives, and basically were happy with what they saw onscreen. It delighted Schlesinger when the camera operator—who had said of the Kiss, "Is this really necessary?"—told him, "Oh, it's a wonderful film, and I see what you were getting at, and it's not in the least offensive."

But the men with the cameras were not the United Artists executives. If Schlesinger had qualms about showing them *Midnight Cowboy*, he harbored fewer fears about *Sunday Bloody Sunday*. He was, after all, a different director now. An Academy Award–winning director.

So much for the Oscar.

Schlesinger called it one of the more difficult screenings of his career. "We'd filled the little theater with secretaries and assistants and all that kind of thing, because I didn't want it just to be the suits who were watching the movie. And there was a lot of lighting up of cigarettes and wobbling of knee joints, and they were obviously embarrassed. At the end, the reaction was not good," he said.

The head of publicity, who'd loved *Midnight Cowboy*, told him, "Well, you've given us a hard one, John."

The director was accustomed to UA being a friendly place. The doors to the executive offices were always open, with people inviting

him to come in and chat, especially after *Midnight Cowboy* turned into an unexpected box-office hit and then won the Oscar.

"Well, on this occasion, after the screening, a lot of doors were closed," Schlesinger noted. "I should have expected it. They must have known, when they saw it, that they were in the presence of quite a bold film that dared to tread where nobody really had gone in such an overt fashion."

Summer 1970, Retreat

Regarding "overt fashion," John Schlesinger could have been talking about *Myra Breckinridge*, if not for the fact that he hadn't seen *Myra Breckinridge*.

Michael Sarne continued to edit his sex-change opus right up to premiere night, June 24. It was a night that only poured salt in Raquel Welch's wounded ego. With two thousand fans as her witness, Raquel endured being upstaged by a woman fifty years her senior. No sooner did Welch exit her limousine and begin to walk the red carpet into New York's Criterion Theatre than "two men grabbed me by the arms and pushed me through a side door," the actress claimed. What she didn't know is that Mae West had demanded a solo entrance, as well as the evening's last entrance, and her limo had been circling midtown Manhattan for at least an hour to guarantee her that spectacular bow.

At the opening-night party, held at a club appropriately called Iperbole, Mart Crowley saw West sitting alone, except for the company of two musclemen bodyguards. He couldn't miss her, decked out in off-white silk gabardine, white marabou stole and diamonds, the only dollop of color being the many rubies choking her neck. Crowley's *The Boys in the Band* movie had recently opened to pickets in

San Francisco, where the Mattachine Society deemed it offensive to homosexuals. The young gay activists who denounced the movie, a faithful adaptation of the stage play, which was still playing Off Broadway, were part of the "don't trust anyone over thirty" generation, and they forgot for a moment that most of the tormented, repressed characters whom they now objected to in *The Boys in the Band* were over thirty.

Crowley introduced himself to the screen legend. "I wrote *The Boys in the Band*," he told her.

Mae West barely blinked. "I wrote that play forty years ago," she replied. "It was called *Drag*."

Despite being upstaged at the premiere, Raquel Welch played the good girl. The very next afternoon she went on *The Dick Cavett Show* to christen the movie a "head-on smash" even before a full day of movie tickets had been bought.

Mae was a little less diplomatic. When a reporter asked about her two musical numbers in the film, she blamed the "inexperience of the director" for the fact that her singing was interrupted by cutaway shots of Raquel. The seventy-seven-year-old star did, however, know how to stroke her fan base. "The gay boys? It looks like they're taking over," she said, referring to New York City's first gay pride parade and festivities, of which the *Myra Breckinridge* opening was an unofficial event.

Back in Hollywood, *Myra Breckinridge* was the worst kind of embarrassment for Twentieth Century Fox. It wasn't only god-awful. It was a god-awful movie that lost money. Russ Meyer's equally god-awful *Beyond the Valley of the Dolls* also opened that June, but took in $10 million on its $2 million budget.

Still, the one-two punch of *Myra Breckinridge* and *Beyond the Valley of the Dolls* signaled the end for Richard Zanuck and David Brown at Fox. To hasten their demise, the prodigal father, Darryl F. Zanuck, staged a coup in one of the studio's bigger boardrooms, where

he brought up another questionable yet-to-be-filmed acquisition that had been green-lit for production by his son and partner in crime.

Brown recalled the scene: "*Portnoy's Complaint* was derailed in the boardroom when Darryl F. Zanuck, in his quest for damning evidence of our cupidity, extracted every prurient word from the script and intoned them to his God-fearing, aging fellow board members."

The elder Zanuck relished the sound of the script's many dirty epithets: "Motherfucker!" "Cocksucker!" "Shithead!" "Blowjob!"

He even went so far as to count the number of times some of these words appeared in the novel: "cock," sixteen times; "shit," twenty-nine times; "tits," thirteen times. "Shove it in me, big one," Zanuck had to admit, appeared only once. No matter. It was more filth than the Fox bluenoses could handle, especially after the disgrace of *Myra Breckinridge* and *Beyond the Valley of the Dolls*.

Brown also reported, "We expected right there and then a hand on our shoulder and a voice to say, 'You're fired!' "

Both men eventually heard that voice in 1970, if not felt a hand, at which time they took Philip Roth's novel to Warner Bros., where it indeed became a worthy addition to their now-complete X-rated triptych.

PERHAPS IF THE MOVIE versions of *Myra Breckinridge*, *Beyond the Valley of the Dolls*, and *Portnoy's Complaint* had won a few Oscars, the commercial environment in Hollywood might have been more fertile for Terry Southern's long-awaited novel *Blue Movie*, inspired by the writer's 1962 *Esquire* interview with Stanley Kubrick. After that chat, the two men developed an on-again, off-again working relationship that included their cowriting the *Dr. Strangelove* screenplay and their not working on a couple of projects dear to Southern's heart. Southern had optioned Anthony Burgess's novel *A Clockwork Orange* about a gang of young "droogs" who terrorize

a futuristic London. He'd even written a screenplay, which Kubrick wasn't interested in filming.

"Nobody can understand that language," Kubrick told Southern, referring to the invented "nadsat" lingo that Burgess created for his violent antihero Alex, who says things like "droogs," "groodies," and "devotchkas" when, for example, he means "mates," "breasts," and "pretty girls." There was also the little problem of the British film censors, who dismissed Southern's adaptation—or anybody's adaptation, for that matter—with the following condemnation of the Burgess novel: "There's no point in reading this script because it involves youthful defiance of authority and we're not doing that."

Then there was Southern's work-in-progress novel *Blue Movie*. Kubrick was more predisposed to it—or at least he liked one chapter of the novel, which prompted him to write back to Southern, calling it "the definitive blowjob."

Maybe that's why, when the novel was finally published in 1970, the *New York Times* deemed it "pornography without Portnoy," and, as they had done two decades earlier with Gore Vidal's *The City and the Pillar*, the newspaper refused all ads for *Blue Movie*. Southern continued to hope that Stanley Kubrick would turn it into a movie; he even went so far as to dedicate the book to "the great Stanley K." But in the end, Kubrick was no more interested in turning *Blue Movie* into a movie than he was in filming Southern's screenplay of *A Clockwork Orange*. Other movie people were equally uninterested. As Nile Southern explained his father's miscalculation with regard to *Blue Movie*, "The book itself could not have been more of a slap in the face to the Hollywood that fired him." Indeed, there was the novel's plot in which a studio titan, duped into making an X-rated film, has sex with a movie star's corpse. "Terry thought he was telling a good yarn—à la Nathanael West—but others thought he had gone too far," noted Nile Southern.

If nothing else, the novel did manage in its first paragraph to coin

one of Hollywood's most oft-repeated questions, "Listen, who do I have to fuck to get off this picture?!?"

While an erstwhile Hollywood insider like Southern talked about making a movie with unsimulated sex, it was the maverick Melvin Van Peebles who actually took the plunge. Having rejected a three-picture deal at Columbia Pictures, Van Peebles had tired of being mistaken for "a janitor" on the studio lot, even when his *Watermelon Man* turned into a big hit. He didn't want to make another innocuous comedy. He wanted to make his own film, *Sweet Sweetback's Baadasssss Song*, about an African-American man turned fugitive revolutionary who beats up a couple of cops, kills a couple of others, and doesn't end up dead in the final reel.

"Of all the ways we've been exploited by the Man, the most damaging is the way he destroyed our self-image," said the thirty-eight-year-old director-screenwriter. "The message of *Sweetback* is that if you can get it together and stand up to the Man, you can win."

On the first day of his nineteen-day shoot, Van Peebles shot hardcore sex scenes using himself and a few actresses.

"Some of the actresses weren't good. They couldn't fake it. So I had to give them a little of the actuality of it," he explained. In that first scene, set in a brothel, a racially mixed group of customers watch as a bearded, dildo-wielding lesbian has sex with another woman only to be interrupted by a drag queen, dressed as a fairy godmother, who "transforms" one of the lesbians into superstud Sweetback, played by Van Peebles.

More important than the verisimilitude of the sex was the fact that Van Peebles, working on a half-million-dollar budget, couldn't afford a union crew, so he handpicked one that had shot hard-core pornography instead. When union officials came to see his first dailies, "They saw I'm actually doing black porno, which is below the union radar," he recalled. And they left him alone to make his indie movie.

The real sex helped budget-wise in other ways, too. "When I

caught the clap, I filed for workmen's compensation. I got it on the job. It's job related," said Van Peebles.

During the shoot, Van Peebles courted more controversy when he cast his own thirteen-year-old son, Mario, as the young Sweetback, who loses his virginity to one of the brothel's prostitutes. It was to be a graphic depiction of the adolescent's first sexual encounter, and required total nudity of both actors as Van Peebles envisioned it. Mario was concerned.

"Dad, is this going to be an adult movie?" he asked.

"Yes."

"Good, then the kids in class won't see me."

Working with equally controversial material, Terry Southern continued to have much more trouble getting his *Blue Movie* to the screen. And there were worse disappointments that year for Southern.

Stanley Kubrick suddenly took a second look at Burgess's novel about the "droogs" and deemed it his next project, after *2001: A Space Odyssey*. Southern's option on the book had long lapsed, and to add insult to that oversight, Kubrick was writing his own adaptation of *A Clockwork Orange*.

Southern's screenplay wasn't the only one being rejected by Kubrick. Burgess himself had also taken a crack at turning his novel into a screenplay. Burgess took the news of Kubrick's interest in *A Clockwork Orange* with somewhat less pique than Southern. Then again, he wasn't exactly overjoyed, either. He got the news that spring right before he and his wife, Liana, departed for Australia to help open the Adelaide Festival of Arts. Burgess would later remark about the impending film production, "I did not altogether believe this and I did not much care: there would be no money in it for me, since the production company that had originally bought the rights for a few hundred dollars did not consider that I had a claim to part of their profit when they sold those rights to Warner Brothers."

But Burgess did care how Kubrick might translate his novel to the screen. He harbored ambivalent feelings about the novel. It wasn't his favorite. In fact, "It was the most painful thing I've ever written, that damn book," said Burgess. He wrote it to exorcise the memory of what happened to his first wife, who was raped by four American deserters in London during World War II. She was pregnant and lost the child as a result of the attack. *A Clockwork Orange*, by necessity, had to be a very graphic book. "It was the only way I could cope with the violence," said Burgess. "I can't stand violence. I . . . I loathe it. And one feels so responsible putting an act of violence down on paper. If one can put an act of violence down on paper, you've created the act. You might as well have done it. I detest that book now."

Regarding a film adaptation of *A Clockwork Orange*, Burgess had been here before, and not only with Terry Southern but with the Rolling Stones, who briefly toyed with the idea of playing the "droogs" under the direction of Nicolas Roeg. Then Ken Russell was going to direct it, but he started work instead on an adaptation of Aldous Huxley's *The Devils of Loudun*. If Burgess kept track of these things, and he didn't when it involved other people's novels, he would have known that the *Devils* project had also run into deep trouble that year.

Just as Stanley Kubrick readied *A Clockwork Orange* for the cameras, Ken Russell traveled to New York City to help promote *Women in Love*. He chatted up a lot of the local critics and journalists, but what he really wanted to do was talk to the UA executives about progress on his new film about a bunch of crazy nuns. It was not an unknown story. In 1960, John Whiting had adapted Huxley's novel into a play with the more marquee-friendly title *The Devils*, and now Russell wanted a crack at turning this seventeenth-century tale into a movie. It appealed to his macabre sense of the outrageous: A real-life hunchbacked nun, Sister Jeanne, makes false claims of being possessed by Satan as a result of her fantasizing sex with Father Grandier. The nun's exorcism, which extends to include her fellow

sisters, quickly turns into something of a tourists' sideshow to distract the citizens from losing their political independence. Or as Russell would explain the nuns' treatment by the state, "It's as though they'd been exploited to the absolute blasphemy of their religion, which is what the authority wanted and led to the destruction of their city."

Glenda Jackson had starred in Russell's two previous films, *Women in Love* and the yet-to-be-released *Music Lovers*, a biography of Tchaikovsky, and he wanted her for *The Devils*, to play Sister Jeanne. She was intrigued, and especially liked Huxley's epilogue, not included in Whiting's play, which told the story of what happened to Sister Jeanne after Grandier was burned at the stake and the walls of Loudun came tumbling down.

As Russell told it to Jackson, "Sister Jeanne and Sister Agnes went on a jaunt all over France and were hailed with as much fervor as show business personalities and pop stars are received today. . . . She became very friendly with Richelieu, the King and Queen wined and dined her, and she had a grand old time. When she died . . . they cut off her head and put it in a glass casket and stuck it on the altar in her own convent. People came on their knees from miles around to pay her homage."

Alas, Russell's script was too long, and he had no choice but to stick to Whiting's ending. Jackson read the finished screenplay—the one without her head in a box—and informed her director, "That's not the way you told it to me."

Maybe it was the deletion of the epilogue that caused her to say no. Or the thought of making love, again, to the garlic-eating Oliver Reed, whom Russell wanted to cast as Father Grandier. Or, "I was worried about playing another neurotic, sex-starved lady, albeit a nun," Jackson later said. Anyway, she said no.

So, ultimately, did United Artists. There's never a good time for bad news, but the timing could not have been worse. During his New York press chores for *Women in Love*, Russell phoned a friend

at UA. The friend was undergoing a divorce, and between calls to his attorney, he told Russell. "Look, I've got some bad news for you. We're not doing *The Devils* anymore. Excuse me, this is urgent," he said, switching back to his attorney. "See you around."

Russell believed that a higher-up at United Artists, after approving the project, finally got around to reading his script and freaked out at all the sex and violence involving Roman Catholic nuns and priests.

It didn't get any higher up than the UA president, David Picker, who didn't feel there was "a censorship problem" with *The Devils*. Rather, "Because we gave creative control to the filmmakers at UA, I felt *The Devils* material, in the direction Ken was going with the content, it wasn't going to work for us. It was more of a risk than I wanted to take."

When Russell got the rejection over the phone, "I landed on my ass on Broadway," he recalled. He also canceled his remaining *Women in Love* interviews, flew home to England, and started looking for another actress and studio to make *The Devils*.

Kubrick, never having left Old Blighty, was having slightly better luck with his film adaptation. He completed his screenplay of *A Clockwork Orange* that spring after only a few weeks of writing, and while there had been a flurry of telegrams to Anthony Burgess to discuss the project, Kubrick didn't much like collaborating anyway. He saw no reason to meet the novelist. As Kubrick put it, "Whatever Burgess had to say about the story was said in the book." Kubrick had already read Burgess's own screenplay for *A Clockwork Orange* and rejected it, just as he had rejected Terry Southern's adaptation without so much as a phone call to his *Dr. Strangelove* screenwriter. Instead, he had an assistant send a rejection letter to Southern. It read in full: "Mr. Kubrick has decided to try his own hand."

Burgess did not greet the news of Kubrick's screenplay with great joy. As he recalled in his memoir, "I feared, justly as it turned out, that there would be frontal nudity and overt rape." He'd seen

Scandinavian pornography and some of the new American films, which "considered themselves antiquated and reactionary if they did not use 'fuck' and show fucking. I foresaw a dangerous situation for myself and I was right to do so," he wrote.

But it didn't matter what he thought or cared or feared. Burgess had sold his movie rights to *A Clockwork Orange* years ago, and production on the film was set to begin that autumn regardless.

JUNE 24 SAW THE premiere of *Myra Breckinridge* on the East Coast and the premiere of *Catch-22* on the West Coast. It was not a good day for the movies.

Now that Mike Nichols's résumé included the critical and box-office failure of *Catch-22*, critics charged that he suffered from the post-sophomore slump. True or not, he was no longer quite the untarnished success story that he had been when Jules Feiffer first sent him his *Carnal Knowledge* script. Still, "Nothing was a difficult sell," said Nichols. "After *The Graduate*, I could have done the phone book, but had no desire." Besides, his *Graduate* producer, Joseph E. Levine, loved Feiffer's script. "Levine thought it was dirty and he loved that," added Nichols. "He just wanted to make money."

Nichols cast Candice Bergen as the girlfriend who beds both male leads, Jack Nicholson and Art Garfunkel. In the wake of *Catch-22*, the actress didn't read those reviews or the *Variety* box-office charts, and remained a dedicated fan of the director and his new film.

"From the moment it was announced, there was a sense that something special would follow, an eagerness to see what Mike Nichols would do next," she wrote in her memoir. "There was some unspoken honor attached to being part of this film, a feeling of privilege."

The other female lead role went to Ann-Margret, who after a series of *Kitten with a Whip*–style roles had to audition and do a screen test to secure the role of the passive Bobbie, a character who

attempts suicide to help persuade Nicholson's playboy into marrying her. For the audition, the actress played the scene where her Bobby meets Nicholson's Jonathan for the first time. Over the restaurant table, her swooping décolletage upstages her amateur palm-reading.

Nichols had her do the scene four different ways, playing essentially four different characters. After a couple of tries, he suggested, "OK, do it as an airline hostess would do it." The one he liked best was how "a tease" would do it.

But even then the Bobbie role wasn't quite hers.

After the audition, there was a screen test. Nichols visited Ann-Margret's dressing room beforehand. "You know what's required of this part?" he asked.

"Yes, it's frightening," she replied.

But Nichols didn't mean soul-bearing. He had to explain, "You're going to have to reveal yourself—take off your clothing—in the movie. You've read the script. Obviously, nudity is integral to playing Bobbie. Will you be able to do that?"

"If I get the part, yes."

She did, and Nichols promised that her nude scenes would be semiprivate affairs with only himself, Nicholson, a soundman, and a cameraman present.

Nichols thought he had the right cast. Jules Feiffer wasn't so sure. He wasn't sold on Jack Nicholson, because "here was this guy with a kind of hillbilly, Henry Fonda–ish drawl. Jack was good, but I didn't really get the message. I couldn't see him in the part of Jonathan, who I imagined as a Jewish boy from the Bronx."

Nichols told Feiffer, "Believe me when I say he's going to be the most important actor since Brando."

Before filming began in Vancouver, Nichols scheduled two weeks of rehearsals, but left it to Feiffer to help Nicholson with some of the script's slang. A Catholic boy from New Jersey, the actor didn't know how to pronounce the Yiddish word for "penis," which in

popular parlance had come to mean "jerk" but not so long ago had gotten Lenny Bruce arrested on the West Coast "by a Yiddish under-cover agent who had been placed in the club several nights running to determine if my use of Yiddish terms was a cover for profanity," as Feiffer explained.

Nicholson kept saying "smuck" or "schmook."

"I had to give Jack 'schmuck' lessons," noted Feiffer.

Right from the beginning, it was an easy shoot. "We were fin-ished shooting by three or four o'clock in the afternoon and we'd go to a Japanese restaurant and Jack would have some stewardess," said Nichols.

Also filming in Vancouver that September was Robert Altman's *McCabe & Mrs. Miller*, starring Warren Beatty and Julie Christie. The film's producer, David Foster, invited the *Carnal Knowledge* cast for a get-together at the house he'd rented in Vancouver.

"It was this wild party," said Foster. "And it got to be scary. Ev-eryone was stoned out of their minds. It was insane."

Nicholson had never met Beatty, and as the women at the party swarmed around the six-foot-two actor, Nicholson was in awe of this other, taller actor. "Now that's what a movie star is supposed to look like!" he told Feiffer.

Feiffer introduced the two men. In time, they would become close friends; they were already practically neighbors, Nicholson having just rented a house up on Mulholland Drive near Beatty's place. And in time, he would dub Beatty "the pro" for the way he handled not only women but the studio executives.

But that night at the party in Vancouver, it was Beatty who ex-pressed his admiration for his future friend's movie acumen. With *Easy Rider* his only major film credit as an actor, Nicholson had somehow already gotten Columbia Pictures to bankroll his *Drive, He Said*, which he wrote, directed, and produced. At that point in his career, Beatty had only produced one film, *Bonnie and Clyde*.

He hadn't yet directed anything, and while he contributed to the *McCabe & Mrs. Miller* screenplay, Altman made sure he got no credit there. Nicholson's *Drive, He Said* was the kind of film that Beatty wanted to make—one that tapped into the political zeitgeist of the times. Its story of two college students and their problems with the army's draft intrigued a hard-core liberal like Beatty. Nicholson told him that when he wasn't acting in *Carnal Knowledge*, he could be found editing *Drive, He Said* on weekends.

The drug-taking at the Foster party spooked Mike Nichols, who didn't want it to infect his production. Nicholson was well-known for being a major pothead, and his character in *Easy Rider* only advertised that fact. He even bragged, "I was one of the first people in the country to take acid."

In 1970, people openly smoked marijuana in Vancouver; the police there were more concerned about the city's rampant heroin traffic than a little grass dealing. So it was a small thing for Nichols to ask his cast that they all stop smoking the weed. As Nicholson explained, "Mike felt that there would be more vitality, more ability to get with the juvenile factor, especially in the earlier college sequences."

If Nicholson stopped indulging, Ann-Margret started, turning herself into the pill-popping sex object Bobbie. She put on weight— not all of it intentional. "I appeared puffier, fuller. Unable to sleep at night, I took pills to knock me out. I returned from the set, wrapped myself in [a] bathrobe, and didn't leave the hotel room until I was needed on the set. Sometimes that was days," the actress reported.

Her life assumed an eerie parallel to Feiffer's zonked-out character, especially when her Bobbie character complains, "I'm already up to fifteen hours a day [in bed], pretty soon it's gonna be twenty-four." Making *Carnal Knowledge* pushed her into "a depressive stupor fuelled by pills and alcohol," she admitted.

It could have been worse. For her nude scenes, Nicholson also

stripped to keep her company. He'd say, "All right, here comes Steve! Get ready!" and then throw off his robe.

"He would make such a fool of himself that everybody else was cool," said Nichols.

In the end, Nichols kept Ann-Margret's nude scenes and cut Nicholson's. "I'm happy to say," said Nichols, who had a reason for his double standard regarding nudity. "I wanted the film to be entertaining as long as it could be," he explained. "I didn't want the audience to be looking when the trap is sprung. I wanted them to be thinking about something else, Ann-Margret's top, for instance. The more I could get them to look at her, the more they would be complicit in what happens to her."

Nichols never stopped working on the script with Feiffer. After rushes each day, they'd discuss what had just happened, what was going to happen next. Feiffer looked forward to shooting the scene in which Bobbie pleads with Jonathan to marry her. She wants a life, she wants a wedding ring, she wants children. Her demands cause him to explode, and he calls her "a ball-busting, castrating son-of-a-cunt bitch."

Rereading those words, Nichols suddenly had a problem. As Feiffer told it, Nichols thought that Jonathan's conduct was "too repellent for an audience to stomach. They would recoil from the character and never get back into the movie." The language was much stronger than even Nichols's first screen effort, *Who's Afraid of Virginia Woolf?* Most audiences had never heard the words "a ball-busting, castrating son-of-a-cunt bitch" in a movie theater, the word "cunt" being the real showstopper.

It was Feiffer's favorite scene, and he didn't want to see it cut. He recalled a conversation he'd had with his friend Lillian Hellman regarding *Carnal Knowledge.* She wanted to know what it was about, and he told her, "It's a picture about men's hatred of women. All heterosexual men hate women."

"You're talking about homosexuals," Hellman corrected.

"No. Homosexuals love women. And heterosexuals hate women."

Feiffer felt he needed the "ball-busting, castrating son-of-a-cunt bitch" to make his point about straight men's innate dislike of women.

Nichols eventually agreed. "I guess we have to shoot it . . . because that's what would happen," he said.

As the two men debated over the "ball-busting" speech in *Carnal Knowledge*, the National Organization for Women, founded only four years earlier, held the Women's Strike for Equality to protest unequal pay and the lack of abortion rights. Twenty thousand women gathered in New York City and elsewhere, the largest protest of its kind.

Autumn 1970, Arrests

In the late 1890s, Oscar Wilde said that homosexuality was "the love that dare not speak its name." In the late 1960s, Mike Nichols called it "the vice that won't shut up."

Holly Woodlawn fretted over what she'd wear to the October 5 world premiere of *Trash* at Cinema II on Third Avenue in Manhattan. The rushes, especially her scene making love to a beer bottle, had delighted guests at the Factory, and when she went to Max's Kansas City on South Park Avenue and made her way to the back room, with Dan Flavin's huge neon sculpture overhead casting a red inferno glow over the leather booths, Holly Woodlawn was a star. Or, at least, she was a superstar.

"I felt like Elizabeth Taylor!" she reported. "Little did I realize that not only would there be no money but that your star would flicker for two seconds and that was it. But it was worth it, the drugs, the parties, it was fabulous. You live in a hovel, walk up five flights, scraping the rent. And then at night you go to Max's Kansas City where Mick Jagger and Fellini and everyone's there in the back room. And when you walked in that room, you were a star!"

In the meantime, she had to eat, and it wasn't possible to charge every meal at Max's to Andy Warhol. That autumn, a friend of

Holly's was subletting the Park Avenue apartment of Mme. Chardonet, a French diplomat's wife, who made the mistake of not only subletting the apartment to a friend of Holly Woodlawn's but leaving her checkbook and passport in plain sight. Visiting her housesitter friend, Holly had a financial epiphany when she spotted the checkbook and passport: She would impersonate Mme. Chardonet at the local bank. It was easy. Since Holly wore women's clothes better than most women, she had no problem impersonating Mme. Chardonet and draining her bank account by one-third of its contents.

Two weeks later, having spent that $2,000, Holly returned to the bank to take what she should have gotten the first time around, the remaining $4,000. Instead, she was arrested. Bad timing. The *Trash* premiere on October 5 was only five days away and she still had nothing to wear, and now she was also stuck in jail.

Bail was set at one thousand dollars, and while Holly attempted to contact the Factory, those phone calls were not returned. The cops took her to the Women's House of Detention, where a female officer put Holly in a cell with twenty females. "All right, lift your dress and pull down your pants," the officer ordered.

Another inmate told Holly not to worry. "They're just looking for dope."

"Dope?" Holly asked. "In my underwear?"

"Shut up!" the officer ordered. "And pull down your pants."

Holly did as told.

"Get that man out of here!" screamed the officer, to a wild chorus of screams from the female inmates.

"And the next thing I knew I was in a paddy wagon on my way to the Tombs," Holly reported, referring to the men's jail. It was a nightmare. Men hit on her for sex. "I have my period!" she cried.

Then a riot broke out among the homosexual inmates. According

to Holly, the police instigated the uprising. "They used the prisoners like pawns in a chess game," she reported. "What they wanted was more money, more guns, more billy clubs, more helmets, and more police to protect them from all those dangerous prisoners behind the bars. So they cut down on our meals and took away our rock radio station and told us we'd get them back if we began screaming and rioting. Then they gave us hostages—they threw these flunkies into our cells and gave us knives and clubs."

For eight days, the inmates went without being able to shower or, even worse, watch TV. Holly spent most of her time under her bed. "Finally, the police got what they wanted—more police."

Holly Woodlawn, however, remained in jail, unable to join Joe Dallesandro, Andy Warhol, and Paul Morrissey for the premiere of *Trash* at the Garrick Theatre. Joe was especially riding high, his crotch having been photographed for the cover of the Rolling Stones' upcoming album, *Sticky Fingers*. Holly's no-show at the premiere inspired *Variety* to come up with one of its better headlines, "Trash Star Found in Trash Can." And when a journalist from another newspaper inquired into why Andy Warhol didn't pay the thousand-dollars bail so his superstar could attend her own premiere, a Factory apparatchik informed the reporter, "Holly only worked for us for eight days. We're sorry she's in jail, but we're not responsible."

The person answering the phone at the Factory had it only half right. *Trash* took just six days to shoot and Holly Woodlawn had been paid $25 for each of those days for a film that went on to gross $1.5 million on a $25,000 budget. But she was a star now. And not just a superstar. The *New York Times*, fortunately, had added a new film critic to its staff, a would-be poet and playwright named Vincent Canby, who was as liberal and forward-thinking in his reviews as Bosley Crowther had been mired in the Pliocene. Canby not only liked *Trash*; he loved its female lead.

"Holly Woodlawn, especially, is something to behold," he wrote, "a comic-book Mother Courage who fancies herself as Marlene Dietrich, but sounds more like Phil Silvers."

Using feminine pronouns to describe a transvestite, Canby broke a major taboo at the *Times*.

OTHERWISE, IT WAS NOT a good time to be a Warhol superstar.

Lance Loud first noticed the big German shepherd bounding down the beach. Then he saw the dog's owner, a girl in a pixie dress. There were real flowers stuck in her brown hair. Lance had been sunning himself on the sand at Isla Vista, just north of Santa Barbara, and as he watched the girl and her dog, a bunch of college boys who'd been playing catch football also stopped to watch her. It was Edie Sedgwick, although Lance doubted any of the college jocks knew who she was. Lance, on the other hand, had been reading about Edie ever since his father, Bill Loud, had given him an article on Edie Sedgwick and Andy Warhol, written in *Time* magazine years ago.

"Look at this crazy, crazy, crazy guy!" Bill had exclaimed, pointing to a photograph that accompanied the article. There was Edie and Andy with their matching outfits, matching hair, matching expressions of fervent expectation.

"Well, what's wrong with them?" Lance asked.

"Well, this guy has dyed his hair silver and his girlfriend has dyed her hair silver, and she wears these big ball earrings," Bill began. "This guy must be making a million bucks and all he does is silkscreen soup cans and Brillo boxes at a place called the Factory. He's going around with some young girl and they both dyed their hair silver and go around with a group of weirdoes."

There on the beach of Isla Vista, the college boys didn't know who Edie was. They just wanted to fuck her, Lance knew.

He, on the other hand, wanted to meet her. More precisely, he wanted to be her.

Lance had never seen Edie with brown hair, not that he'd ever seen her in person before, even though her family came from Santa Barbara and were these wealthy rancher-philanthropists whose family dated back to the American Revolution. Edith Minturn Sedgwick. That was Edie's real name.

Lance approached her as soon as she and her dog came out of the ocean—unlike the college boys who just stood there gawking. "Dumb," he called them.

Edie's eyes were so sad, he thought. "I've wanted to meet you for the longest time," Lance began.

"Oh, thanks," she said in this baby voice. They kissed, and she asked, "You aren't a fag, are you?"

"Well . . ."

"I'm so tired of fags. That's all I ever knew in New York. Fags. Fags. Fags."

"Really?"

"Yeah, I don't ever want to meet another one in my life. All the boys were so pretty, but they all liked other boys."

The conversation pretty much ended there, after Lance said good-bye.

Later, it was common knowledge in Santa Barbara that Edie Sedgwick had recently spent time drying out from a drug overdose at the city's Cottage Hospital. Friends there told Lance that she had sex with guys all the time. She'd lock the door so the doctors and nurses couldn't get in. Even though she invited Lance to come visit her at the hospital, he never did.

However, his encounter with Edie on the beach got him to thinking. If she knew nothing but fags in New York, maybe that was the place for him.

. . . .

LOOKING BACK AT 1970, Jules Feiffer would remark, "If anyone had said that calling someone a fag was the equivalent of calling someone a nigger, they would have thought you were crazy."

"Fags." It's just one of the words they were using to describe Luchino Visconti's newest project over at Warner Bros.

Surprisingly, there was a bit of a star tussle over who'd get to play the lead.

Burt Lancaster openly petitioned to play a homosexual pedophile in *Death in Venice.* The movie star had worked with Visconti years earlier on *The Leopard,* and he lobbied hard to play the repressed Gustav von Aschenbach in the screen adaptation of Thomas Mann's novel. Visconti, however, never considered anyone but Dirk Bogarde for the role.

In Mann's classic novel, von Aschenbach is a writer. Visconti wanted to be extremely faithful to the story, but he did make one major change—the von Aschenbach of his film would be a composer. "You know it is about Mahler, Gustav Mahler," Visconti told Bogarde. "Thomas Mann told me he met him in a train coming from Venice; this poor man in the corner of the compartment, with make-up weeping . . . because he had fallen in love with beauty. He had found perfect beauty in Venice and must leave it in order to die."

Mann's wife, Katia, placed the story closer to home. In her memoir, she wrote that the idea for *Death in Venice* came during a holiday in Italy's floating city when she and her husband were staying at the Grand Hotel des Bains in the summer of 1911:

"All the details of the story, beginning with the man at the cemetery, are taken from experience. . . . In the dining room, on the very first day, we saw the Polish family . . . and the very charming, beautiful boy of about thirteen was wearing a sailor suit with an open collar and very pretty lacings. He caught my husband's attention

immediately. This boy was tremendously attractive, and my husband was always watching him with his companions on the beach. He didn't pursue him through all of Venice—that he didn't do—but the boy did fascinate him, and he thought of him often. . . . I still remember that my uncle, Privy Counsellor Friedberg, a famous professor of canon law in Leipzig, was outraged: 'What a story! And a married man with a family!'"

Nearly sixty years later, the executives at Warners—men like Ted Ashley and John Calley—weren't exactly outraged, but neither were they very keen to see a movie version of the novel. Despite the success of *The Damned*, they didn't trust Visconti's commercial instincts. Yes, they may have been wrong about homosexual Nazis. But homosexual composers definitely weren't box office. That much they knew for sure. They had a few suggestions for Visconti: one, they wanted a bigger star than Bogarde, and two, how about changing the boy Tadzio to a girl named Tadzia?

Visconti wondered aloud, "But if I change Tadzio to a little girl, and we call her Tadzia, you seriously believe that American audiences would be prepared to accept that?"

The men at Warners seriously did.

"You do not think that in America they mind child molestation?" Visconti asked.

They did not foresee a problem. As one of the executives put it, "We are not as degenerate here as you are in Europe."

Visconti persisted. "This is a search after purity and beauty. Surely people will recognize that? They have been reading the book for many years. Even in America."

Visconti, buoyed by the box-office success of *The Damned*, got to keep his Bogarde and his Tadzio. After all, his movie wasn't about a fiftyish homosexual lusting after a young lad in Venice. "This is a search after purity and beauty," he kept saying.

It was a search that Visconti himself undertook—a monthlong

tour of Scandinavia and Poland, in fact—to find just such purity and beauty among the young males who lived there. Advertisements were placed in the major newspapers of Stockholm, Oslo, Helsinki, Copenhagen, and Warsaw; they kicked off a full-scale talent hunt for beautiful boys between the ages of thirteen and fourteen who were required to possess the requisite blue eyes and blond hair of Mann's dream. It didn't take Visconti long to be smitten. In Stockholm, the first boy to be interviewed—a thirteen-year-old named Björn Andrésen—walked into Visconti's hotel room accompanied by his grandmother. It didn't matter that he spoke with a Swedish accent. Visconti wanted him to remain "enigmatic, mystic, illusion," and gave his character no lines to speak. He just had to be beautiful, blond, blue-eyed.

Perhaps it was sheer duty that led Visconti to keep his appointments to interview dozens of other young boys in Warsaw, Oslo, Helsinki, and Copenhagen. Despite that tour of other cities, Visconti had already decided that Andrésen was Tadzio.

Regarding the other half of his acting equation, Dirk Bogarde arrived in Italy accompanied by Anthony Forwood, whom he introduced as his manager, even though the two men had lived together for almost a decade. That heterosexual charade on the movie set extended to the casting of Visconti's boyfriend's "girlfriend" Marisa Berenson, who played von Aschenbach's wife. Visconti and Helmet Berger continued to be lovers, but since making *The Damned* it had become a strained relationship. When Visconti once complained that younger actors have "everything handed to them," Berger shot back, "You don't think it's hard work having to fuck you every night?"

Still, there were appearances to be maintained, and neither Bogarde nor Visconti wanted the press to report that they were turning the story of a middle-aged man's obsession with a young boy into anything having to do with homosexuality.

Both men took extraordinary precautions to at least certify the young Andrésen's Swedish red-bloodedness. As Bogarde described

him, the teenager possessed a "healthy appetite for bubble gum, rock 'n' roll, fast motorbikes, and the darting-eyed girls whom he met, tightly jeaned, ruby lips, playing the pin-tables in the local Hotel Baron the Lido."

While Visconti asked Bogarde to read the Mann novel sixty times, he asked Andrésen to treat the book as he would any other twentieth-century classic of literature—and avoid it. Andrésen, however, was curious, and during one of his pin-table breaks on the Lido, he took a quick flip through *Death in Venice*. Andrésen promptly reported back to Bogarde, in his best American-ese slang, saying, "Hell, man, now I know who I am, I'm the Angel of Death, right?"

Bogarde nodded yes. He was an angel. Or something like that.

WARNER BROS., UNDER OLD management and new, had this habit of green-lighting movies, like *Performance* and *The Damned* and *Death in Venice* and *The Devils*, that its executives would later, in the harsh darkness of the screening room, find shockingly un-commercial. Of all those films, it is safe to say that Ted Ashley and his Warners gang were most shocked by Ken Russell's *The Devils*.

It was an eventful shoot.

After having to wrestle Alan Bates in the nude, in *Women in Love*, Oliver Reed had it easy in *The Devils*. He did, however, balk at one bit of business—shaving his head as well as his eyebrows for the big auto-da-fé scene. Fighting naked or losing his hair was one thing. But shaving his eyebrows?

"Of course it's important," Russell told him. "They shaved off all of Grandier's bodily hair and then stuck red hot pokers up his arse." Realizing that it could be worse, Reed consented to the full-head shave but demanded a Lloyd's of London contract for half a million pounds to ensure that his luscious brows grew back in toto.

Vanessa Redgrave, taking over for Glenda Jackson, had never

been told about Sister Jeanne's head in a box, and gladly accepted Russell's invitation to play the role as written. His script offered quite enough to activate her theatrical imagination: There was the nun's wet dream in which she imagines herself as Mary Magdalene at the crucifixion, in which Jesus Christ miraculously morphs into Grandier and she gets to not only wipe his feet clean with her long hair but passionately kiss him and roll around on the ground in his tight embrace. Her character is also administered hot, scalding enemas to rid her of the devil, and at the movie's end, instead of her head in a box, she masturbates with Grandier's burnt tibia, a "souvenir," she is told, of his execution at the stake.

"It's a very terrifying sequence," the actress said of the movie's penultimate scene, "a pitiful fact that Sister Jeanne took that bone and was fucking herself with it. I thought it expressed in the most pitiful way the depths of her depravity and her need for humanity."

Unlike Jackson, who always acted at least one scene in the nude in Ken Russell's movies, Redgrave performed the masturbation fully clothed. As David Watkin's camera recorded it, the actress is not shown doing anything with the bone, shaped to look like a blackened cock and balls. Rather, the camera leaves the tibia in her hand to instead rest on the actress's suddenly ecstatic face.

Elsewhere, Russell and Watkin left much less to the imagination. Prior to filming, actresses who signed on to play the movie's many demented nuns were sent photocopies of a book titled *The Dictionary of Witchcraft*, which included descriptions of how the nuns at Loudun really behaved during and after Sister Jeanne's exorcism. Reportedly, it was a very well-publicized event that sent the nuns into a bizarre frenzy, the kind that attracted curiosity seekers from all over France.

Regarding this witches' tome, actress Judith Paris revealed, "It described how they tore off their clothes, how they went screaming into the crowds, how they bent over in hopes of exposing their genitalia." Paris thought to herself, "I can't do this." An obliging

director, Russell kept the actress fully clothed in a nun's habit as she stuck a big candle between her legs and relentlessly stroked it.

Other actresses were less squeamish about appearing naked. They, too, had been warned.

"When we were sent the script, all the nuns were told to read specific scenes, and if they weren't prepared to do what the scenes described quite graphically they shouldn't accept the job," said Imogen Claire, who played an extra in *The Devils*.

In one scene, before the big exorcism, Vanessa Redgrave's character unsuccessfully attempts suicide by hanging herself from a tree. The shoot took place in the rain on the back lot at London's Pinewood Studios, and the actresses playing nuns were directed to run round and round the tree. Ken Russell took a hair dryer and handed it to one of the other actors, Dudley Sutton.

"Warm their tits when they come off," Russell instructed Sutton, who played archvillain Baron de Laubardemont.

"They were grateful," said Sutton.

Sutton, too, was grateful, since Russell had been careful not to cast old or overweight actresses but rather women suitable for a "Sexy Sisters of Loudun" pictorial in *Playboy*.

Blow-dried or hand-toweled, running around a tree in the cold rain was nun's play compared to performing in the scene that came to be known as "The Rape of Christ." Russell's intention was to shoot scenes of Father Grandier at a lake, taking a communion of bread and wine, and intercut those shots of simple holiness with the nuns' "absolute blasphemy of their religion," which included their dismantling a life-sized crucifix and using its nailed feet and hands, among other appendages, to masturbate.

It was a tough shoot. "Some of the younger girls got upset. With all that frenzy . . . some of the men extras got carried away and a couple [of actresses] came out crying," said Lee Fyles, an extra in the scene.

"Girls who were naked didn't enjoy moving amongst the extras.

That wasn't a comfortable thing to do," said actress Selena Gilbert.

Associate producer Roy Baird confirmed that the scene provoked "one or two complaints. But they were fabulous, these girls."

Russell was a bit more sympathetic. "They were very bad in the exterior shots," he said of the male extras, "and in some of the cathedral scenes, they manhandled the naked nuns more than was called for, and one poor girl was even sexually assaulted." According to the director, the extras' union made an effort to correct things "after the fuss on *The Devils*."

But the damage had been done. "It got into the press that there were orgies," said Vernon. Dudley Sutton recalled how crews on other film productions at Pinewood took out their saws and pocket knives to create peepholes in the set of *The Devils*. As a result, there were many leaks to the press about the lurid goings-on at the studio. "I had a dancer friend who came in at the end of the film. She said it was terrible, chaotic. That was Ken's whole point, a community gone berserk," said Vernon.

The Devils had that effect on people, including Russell's own wife, Shirley Russell, who designed the film's costumes. During production, she started taking driving instructions. As Ken Russell described it in his memoir, "These lessons often extended well into the afternoon, as I discovered whenever I sent word for her to join us on the set to discuss one of her bizarre costumes and explain, for instance, which way round it should be worn. Shirley was never to be found and, although there was nothing unusual in this because as the director's wife she was a law unto herself, it nevertheless started me wondering if a little back-seat driving might not be involved."

AUTUMN 1970 EMERGED AS an especially rowdy season for the world's moviemakers: Ken Russell gave enemas to a nun, Mike Nichols

wrestled with a sexist pig, Luchino Visconti lusted for an angel, and Sam Peckinpah fired yet another secretary.

The director of *The Wild Bunch* had already gone through four secretaries in two weeks by the time he met up with Katy Haber, whom he hired on the spot. They started work on a Wednesday afternoon in his London hotel room and worked straight through Sunday, and they didn't quit until Monday at two thirty in the morning. Peckinpah, in a burst of creative energy laced with speed and booze, adapted Gordon M. Williams's novel *The Siege of Trencher's Farm* to the screen. He was calling his script *Straw Dogs*, and in addition to the novel's title, he pretty much ignored the novel's story, too, which he called "shitty," except for those few pages where some drunken thugs attack a professor and his wife in their Cornwall farmhouse.

Beginning that Wednesday afternoon, the first scene Peckinpah gave his brand-new secretary to type was the rape scene. Actually, it was two rape scenes, neither of them in the novel, in which the wife half-wants sex with an old boyfriend and then really, really doesn't want sex with that guy's two cohorts. Haber, who considered herself a "nice Jewish girl from London," wondered about her new boss. "Jesus Christ, who am I working for, Jack the Ripper?" she asked herself.

Peckinpah didn't want to rewrite the script he'd been given but found he had no choice when Harold Pinter, having also passed on Kenneth Tynan's offer to direct *Oh! Calcutta!*, went on a rejection binge and refused to do any work on *The Siege of Trencher's Farm* or whatever it was being called. The playwright, a master of all that goes unspoken, wanted nothing to do with Peckinpah's new movie. He even wrote a letter letting Peckinpah know his displeasure at having to read the rough draft, much less his having to rewrite it: "I can only say I consider it an abomination."

Even before shooting commenced, Peckinpah lost one

cinematographer, Arthur Ibbetson, who, after reading the script, left the project for "religious reasons." Somehow, the script held an allure for Dustin Hoffman, who, as an actor, never wanted to repeat himself onscreen, having quickly gone from the college-grad nerd in *The Graduate* to the burnt-out bum in *Midnight Cowboy* to the peace-loving Native American wannabe in *Little Big Man*. Since he'd never played a revengeful math-professor cuckold before, *Straw Dogs* would be his next film.

As the actor explained, "What appealed to me was the notion, on paper at least, of dealing with a so-called pacifist who was unaware of the feelings and potential for violence inside himself that were the very same feelings he abhorred in society."

In *Straw Dogs*, Hoffman's character would be called upon to kill his movie nemeses in any number of ways: gunfire, acid, bludgeoning by stairway rail, animal trap. Regarding the double rape, he worried about the casting of the comely twenty-one-year-old Susan George, whom he described as "this kind of Lolita-ish girl." Hoffman couldn't understand why his character, an uptight professor, would be married to such a woman. He thought an older actress might be more appropriate, because it would make the rape more convincing. "I thought a woman who was a little older and starting to feel a little out of it in terms of being attractive—had a sensuality but was losing it—might be more ambivalent about being raped."

That bit of pre-feminist thinking aside, it was not an easy shoot for Susan George or anyone else, for that matter. Production shut down for four days when Peckinpah had to be rushed to a London hospital to recover from walking pneumonia, brought on by the Cornwall cold, wet weather, as well as his incipient alcoholism.

Hoffman defended his director. Kind of.

"I do think of Sam as a man out of his time. It's ironic that he's

alive as a gunfighter in an age when we're flying to the moon," said Hoffman, forgetting for a moment that Peckinpah was a director of Westerns and not an actual veteran of the O.K. Corral.

Four days after drying out in London, Peckinpah returned to Cornwall. On the train ride there, Hoffman made his way to Peckinpah's cabin. The hospital visit hadn't done him much good. "He was plastered," said Hoffman. But the booze hadn't dulled his talent.

"I have an idea for this scene," Peckinpah told him.

"What is it?"

"She's getting raped and we cut to you shooting the gun with these guys," Peckinpah began. Hoffman recalled being "transfixed. The way he described it was unbelievable. Film was in his blood, more than alcohol. Talent is talent."

Peckinpah wasn't in great shape when he returned to the wilds of Cornwall, but he was strong enough to scare the shit out of his leading lady. As he put it to one visiting reporter on the set of *Straw Dogs*, "I'm like a good whore. I go where I'm kicked."

BACK IN SAM PECKINPAH'S America, the president of the United States finally released a statement regarding "The Report on the Commission on Obscenity and Pornography." Richard Nixon's condemnation began:

"Several weeks ago, the National Commission on Obscenity and Pornography—appointed in a previous administration—presented its findings. I have evaluated that report and categorically reject its morally bankrupt conclusions and major recommendations.

"So long as I am in the White House, there will be no relaxation of the national effort to control and eliminate smut from our national life. . . .

"The Commission calls for the repeal of laws controlling smut

for adults, while recommending continued restrictions on smut for children. In an open society, this proposal is untenable. If the level of filth rises in the adult community, the young people in our society cannot help but also be inundated by the flood.

"Pornography can corrupt a society and a civilization. The people's elected representatives have the right and obligation to prevent that corruption. . . .

"American morality is not to be trifled with. The Commission on Pornography and Obscenity has performed a disservice, and I totally reject its report."

1971, Fatigue

In addition to calling himself a whore, Sam Peckinpah liked to brandish photographs of dead deer. "I shot that stag in Scotland," he'd brag to reporters. "All my family are hunters, meat-hunters, not for sport. They hunt to kill an animal as quickly as possible. I hunt for meat. I shot that stag and killed it and skinned it and roasted it over a fire, and I ate the meat . . . and it was good."

No, it wasn't easy being a woman—the only woman—on the set of *Straw Dogs*.

The actual shoot began in January, and the Cornwall weather cooperated with Peckinpah's story by being brutally cold and otherwise inhospitable—kind of like the way Peckinpah treated Susan George. In the beginning, Dustin Hoffman behaved much more deferentially to the film's leading lady. "Like a princess," said Daniel Melnick, the film's producer. Hoffman kept his Lolita-ish opinion of George to himself. Peckinpah, on the other hand, "became increasingly cold and hostile to Susan. . . . He got the performance by provoking her into it," said Melnick.

In contract negotiations, Susan George's representatives had approved the rape scene but asked for a body double, a request that was immediately refused. A few weeks into the shoot, as the violent scene

loomed on the production schedule, the actress had severe second thoughts about the rape and the requisite nudity. It didn't help her cause that she expressed her concerns to Melnick about Peckinpah's being an animal. Word of their talk got back to the director, who immediately fired off a memo to Melnick:

"This afternoon when we discussed the rape scene and Susan George's relationship to it, I was stunned." Peckinpah felt betrayed by both Melnick and George. "I have no intention of coming anywhere near anything faintly smelling of pornography. Pussies and penises do not interest me. The emotional havoc that happens to [the character of] Amy is the basis of our story."

Melnick, for his part, thought his actress had reason to be worried. "She didn't trust Sam and a couple of the actors, who were quite primitive in their art, not to really rape her," he said. "I didn't want to devastate her and didn't think it was worth having a huge drama about. But Sam insisted."

Finally, Melnick told George that he would be present for the filming of the rape scene.

Peckinpah balked at that news. "You don't trust me," he told his producer.

"It's not that I don't. She doesn't," Melnick replied. "Between you and me, I think you really would have someone fuck her."

"I'd only do it if it were really necessary," replied Peckinpah.

HOW BADLY WERE HOLLYWOOD movies doing at the box office? For two weeks that spring, Melvin Van Peebles's tiny *Sweet Sweetback's Baadasssss Song* outgrossed Paramount's *Love Story*, starring Ali MacGraw and Ryan O'Neal. That wasn't supposed to happen, because *Sweet Sweetback* wasn't supposed to happen.

Van Peebles, after receiving a fifty-thousand-dollar loan from friend Bill Cosby to finish his film, had little luck securing a

distributor and he finally had to go with Cinemation. Even then, the nearly bankrupt company could book the film into only two theaters: one in Detroit, the other in Atlanta.

"There were only two people at the first screening in Detroit," Van Peebles recalled, "no one at the second, then three or four black guys came to the third. They were Black Panthers and they spread the word, and that evening there were lines around the block. I knew it was a hit when the theater ran out of hot dogs that night."

Eventually, the Black Panthers' Huey P. Newton saw *Sweet Sweetback*, and quickly dashed off a ten-thousand-word paean, devoting an entire issue of the *Black Panther Party* newspaper to the film. Panther member David Hilliard agreed with Newton's high opinion of Van Peebles's work, because in the movie "the [black] community comes to Melvin's defense. We see this as a self-defense movement. The community embraces Melvin and he's a hero."

That year, the Black Panthers had forty-eight chapters. "And every one of our chapters mobilized to see the film," said Hilliard.

Newton's assistant Billy "X" Jennings saw *Sweetback* at his leader's recommendation. "When we arrived at the theater," Jennings recalled, "there were comrades coming out who had just seen it, and they were slapping each other five, saying, 'It's going to be a bad movie; they've got some good shit in there.' And this was the first time you've ever seen sex on-screen, and there were some people saying, 'The young guy getting some!' actually talking to the movie."

Of course, the young guy getting some in the film was Van Peebles's own thirteen-year-old son, Mario, cast as the adolescent Sweetback, a nickname for "a man who could make love," as the director described it.

In his *Black Panther Party* essay, Newton praised the opening scene, wherein the boy loses his virginity at the coaxing of a prostitute. Newton wrote, "Not only is he baptized into his fullness as a man, he gets his name and his identity in this sacred rite. After that,

whenever Sweetback engages in sex with a sister it is always an act of survival and a step towards his liberation."

Newton linked the sex to the violence, and put them both on equal ground in a positive, revolutionary light: "Sweetback grew into a man when he was in bed with that woman and he also grew to be a man when he busted the heads of his oppressors. When he was with the woman it was like a holy union, and when he takes the heads of his oppressors it is like taking the sacrament for the first time." (Tellingly, Newton is one of the few commentators who correctly identified Sweetback as "not a pimp" but an employee of the brothel.)

Others disagreed vehemently with Newton. And they disagreed in publications that far exceeded the readership of the monthly *Black Panther Party* newspaper. The *Los Angeles Times* assigned the Kuumba Workshop of Chicago, a collective of black artists, to write an article to voice its collective opinion: "Van Peebles pictures sexual freakishness as an essential and unmistakable part of black reality and history—a total distortion and gross affront of black people. . . . We don't know what film Huey Newton watched but neither the background spirituals nor the whore's reminder that nobody will take his picture makes the scene 'spiritual.' Van Peebles does not use sex as a spiritual force as Newton argues, but the same as any other pornographer—to arouse and to give his audience a vicarious thrill."

Van Peebles didn't see the big fuss over the scene—or the fact that he had his own thirteen-year-old son strip naked to lie on top of an equally naked adult woman and grind their hips together. "Hell, my father got me a girl. What's the big deal?" he asked critics.

Van Peebles found the film's many graphic sex scenes downright revolutionary. "Up to this point we'd never seen black people with sexuality. We didn't have a Mae West. Only time you have sexuality was [black women] being raped by the Ku Klux Klan."

Nor did he offer excuses for his portrayal of Sweetback as a

superstud, one who proves his sexual prowess in not one but two staged scenes: first, in the brothel, when he performs before paying customers, and second, when the white female leader of a biker gang taunts him into having sex with her in front of the other bikers. "I took a stereotype and stood it on its head," Van Peebles bragged.

The MPAA, true to form, slapped an X rating on the film. Van Peebles called it "cultural genocide" and enlisted the American Civil Liberties Union to take up his cause, which they did.

"They don't have the right to rate a film dealing with the black community," said the ACLU's Eason Monroe. But of course the MPAA did have the right.

In the end, Van Peebles turned even that brouhaha to his advantage by creating a classic T-shirt to help promote the film. It read "Rated X by an all-white jury."

He won in other ways as well. Over at Metro-Goldwyn-Mayer, executives studied the *Sweetback* grosses, then took another look at their *Shaft* script, its lead private-detective character written for a white actor. They promptly cast Richard Roundtree instead.

ONE DAY THAT SPRING, with nothing better to do in America's capital, John Ehrlichman and Bob Haldeman were sitting in the Oval Office, chewing the fat about the Black Panthers and welfare mothers, when their boss just couldn't help but tell them about something he'd seen on the tube the night before. It was this new hit TV show on CBS called *All in the Family*, about this lovable "hard-hat father" and his "hippie son-in-law." In this particular episode, titled "Judging Books by Covers," the hard-hat father, named Archie Bunker, goes to a bar to meet an old friend, an ex–professional linebacker. Archie is shocked to learn that his macho friend is gay.

The president of the United States was equally mortified.

"God, he's handsome, strong, virile, and this and that," said

Richard Nixon, almost swooning over the masculine image he'd seen on the little screen. Then the president couldn't contain himself. "They were glorifying homosexuality!" he yelled at Ehrlichman and Haldeman. "Goddammit, I don't think you should glorify homosexuality on public television. I turned the goddamned thing off. I couldn't listen anymore. What do you think that does to eleven- and twelve-year-old boys? You know what happened to the Greeks? Homosexuality destroyed them. We all know Aristotle was a homo, so was Socrates."

"But they didn't have the influence of television," Ehrlichman chimed in.

Back in the Sodom and Gomorrah of America, otherwise known as Hollywood, the show's producer, Norman Lear, had fought long and hard for that "homo-glorifying" episode of *All in the Family*. Just as he had fought for every "coons" and "Hebes" and "spics" and "Polacks" and "micks" that aired in the show's first episode, on January 21.

Against even stronger objections from the CBS brass, Lear had fought to keep the show's initial story line in which Archie and his wife, Edith, come home from church on Sunday to find their daughter and son-in-law in bed upstairs having sex.

The CBS censors objected, but Lear held firm. He told them, "It's gonna go the way it is or it's not gonna go." Carroll O'Connor, the show's Archie, recalled Lear's telling the executives, "We're going to be getting into a lot of this stuff as the series goes on, and we might as well get the audience used to it." The network buckled and Lear won: The young couple would get to have sex, even if it was Sunday morning.

CBS, fearing a deluge of angry phone calls, posted extra telephone operators on its switchboard the night of January 21. CBS also expected no fewer than "fifty stations to jump off the network!" one executive predicted.

O'Connor feared as much and took out insurance by insisting that his contract guarantee him and his family round-trip tickets back to their home in Italy when the network yanked *All in the Family*.

But no stations fled CBS, few angry viewers phoned to complain, and the O'Connor family had to give up their home in Rome. By season's end, *All in the Family* was the number-one-rated show, having explored such hot topics as Sunday sex, impotence, and Archie Bunker's homosexual friend.

"That was awful!" Nixon said of the latter. "It made a fool out of a good man."

AMID HIS TABOO-BUSTING, Norman Lear never got around to exploring man-boy love in *All in the Family*. He left that to the Italians.

Despite all of Luchino Visconti's talk about purity and beauty and love and angels, the director of *Death in Venice* found that when he visualized Thomas Mann's abstract prose, what he ended up with onscreen was a middle-aged man chasing but never quite getting his hands on a thirteen-year-old boy.

At least that's what the executives at Warners saw when Visconti flew to Hollywood to show them a rough cut of his latest movie starring Dirk Bogarde.

Bogarde referred to those execs as "the American Money." Visconti simply lumped them together as "terrible Los Angeles," even though the studio is located in Burbank.

At first, Visconti was encouraged by the silence in the studio's big screening room when his film ended. "The full house," he reported, made not a sound at the final scene in which the black hair dye runs down Bogarde's makeup-encrusted face and his character, Gustav von Aschenbach, dies on the beach alone. Visconti found the silence encouraging. Had he stunned the executives with the film's absolute brilliance? Then someone in the screening room actually said

something. "Well, I think the music is great. Just great. It's a terrific theme. Terrific! Who was it did our score, Signore Visconti?"

Visconti said the music had been written by Gustav Mahler.

"Just great. I think we should sign him."

How could Visconti tell them that Mahler's Fifth Symphony had been written at the turn of the century and its composer died a few years later? Quiet disgust soon filled the pause in conversation. Eventually, the good family men at Warners deemed *Death in Venice* "un-American," according to Visconti, and told him that if it were released it might be banned in some states. *If it were released?*

Plus, it really needed a new ending. The death scene was just too big a downer.

"How can I give Thomas Mann a happy ending?" Visconti wondered aloud. "It is what he wrote, it is his conception, it is the story, it is sacrosanct."

There was the usual talk of "killing" the movie, writing it off as a total loss. But Visconti wasn't dumb and immediately threatened to create "a great scandal in all the world papers if such a thing should happen."

Instead of watching Warners kill it, Visconti wrapped his movie in a continental aura of prestige and art, and quickly offered *Death in Venice* as part of a London gala to be titled "Venice in Peril," a fund-raiser to help save the sinking city. The Queen of England would attend with Princess Anne, at the Warner Cinema in London, with a berth to follow at the upcoming Cannes Film Festival. Even so, "the American Money" remained unconvinced. And the queen herself wasn't much help in the end.

After the command screening with her highness, Dirk Bogarde heard one of the studio executives remark to a fellow executive, "You know, what I can't understand is how the Queen of England could bring her daughter to see a movie about an old man chasing a kid's ass. . . ."

Two persons who weren't invited to the gala to see *Death in Venice* but should have been were Jan Fudakowski and Wladyslaw Moes, the novel's real-life friends, Jasio and Tadzio. Fudakowski considered buying a ticket but "the ticket prices were rather high, from five to fifty guineas," he reported. Instead, he waited, seeing *Death in Venice* with his movie doppelganger at a local cinema. "Undoubtedly the film is good," he noted, "particularly when considered from the artistic point of view, although to my mind the plot is not very interesting and a bit difficult to follow."

Moes also waited, seeing the film near his home in Paris. According to his sister Maria, he wanted to watch it alone, because "he would not have wanted to show his feelings about it, even to me," she explained.

Visconti knew of Moes and Moes knew of Visconti, but when the Italian director came to Warsaw to audition potential Tadzios, both men kept their distance. They knew it was better not to confuse the fantasy with the reality. Moes said as much in a letter to Fudakowski when he wrote, "It would have been detrimental to have seen an old man with all the signs of ageing when [Visconti's] imagination was concentrated on re-creating the character of a young boy in the style of Thomas Mann."

In the end, *Death in Venice* was no *The Damned*. For once, the Warners executives were right: Gay Nazis easily trumped gay composers at the box office.

THE MOVIES HAD A long tradition of adoring whores with hearts of gold. Think Shirley MacLaine's Irma la Douce. Or better yet, Ona Munson's Belle Watling in *Gone with the Wind*.

The movies, however, had never portrayed anyone quite like Vera de Vries, aka Xaviera Hollander, the happy hooker.

To write the book *The Happy Hooker* was not Hollander's idea. It was her client's idea.

Robin Moore, esteemed author of *The Green Berets* and *The French Connection*, knew there was a bestselling book in this story of a young Jewish secretary from the Netherlands who worked as a secretary at the Dutch consulate in New York City and within a couple of short years became the top madam in the city. Prostitutes had told their stories before, but not without apologies. It's why he—or Hollander's other ghostwriter, Yvonne Dunleavy—wrote the following introduction for the secretary-turned-prostitute:

"Don't think of me as a poor little girl gone astray because of a misguided or underprivileged childhood. The contrary is true. I come from a very good background and grew up in a loving family atmosphere." Plus, she spoke five languages fluently!

Moore might never have met Hollander had a rival madam not gotten pregnant and married, in that order. To seal her retirement, the madam known as Madeleine sold her little black book to Hollander for ten thousand dollars. It was an investment Hollander made back in two months. "While I had come to be regarded as a friendly and witty madam to the Jewish community," she reported, "Madeleine was more or less known as a leading lady to the WASPs, so when I took over her business I became a force for religious brotherhood."

Hollander, who always looked on the bright side of her profession, established this brotherhood by quickly phoning Madeleine's vast list of clients, advising them of the change in locale and management. "Hi, I'm Xaviera Hollander, I'm from Holland. I'm twenty-five years of age, I live in a beautiful three-bedroom apartment in midtown, and I have taken over the management of Madeleine's business because she has retired to have a baby. Why don't you drop over for coffee and a chat with us and see if you like the atmosphere? If you do, we would be glad to have you as a guest occasionally."

When she called a relative of Robin Moore, Moore himself

answered. He wasn't polite. "I'm not into that stuff," he replied. "Do you know who I am?"

"You're Robin Moore. You wrote *The Green Berets* and *The French Connection*," Hollander shot back.

"Oh, so you're a hooker who can read?" he asked.

Hollander took a deep breath. She might be a whore, but she hated being called a hooker.

Much to her surprise, Moore expressed second thoughts about Hollander's initial offer, and arranged to meet at her East Side brothel.

"Robin never took his clothes off," said Hollander. Instead, he asked her to tell him about her adventures as a call girl. In exchange for one hour of taping, he paid her fifty dollars for very graphic talk about orgies, lesbian sex ("It is known that most madams are bisexual, and I am no exception"), the police ("No brothel can operate more than a year in New York without being raided at least once by police"), penis size ("I could take care of the big cocks, any length, any width, because I love it"), a call girl's take ("$500 a week during a good week in January, February, and March"), and race ("We have a saying that going to bed with an Oriental is like washing your hands: clean and simple").

After a few such interviews, however, Hollander became suspicious and asked her lawyer, Paul Sherman, to be present for Moore's next visit. "I don't trust this guy. Let's frisk him," Hollander advised.

Instead, as soon as Sherman and Moore got together, they negotiated the book contract in the living room of Hollander's brothel. "This is the weirdest thing I've ever done," Moore kept saying.

Sherman, who represented a number of authors, also found the situation highly unusual. "I'd never negotiated a book contract in a house of ill-repute before," he said.

With business out of the way, Moore soon introduced Hollander to a surveillance expert, who installed a tape-recorder system in the

brothel's bedrooms in order to get "authenticity" for the book.

"[He] had a sideline: selling information to law enforcement agencies and others. I found out about the hidden bug and [his] sideline only when Knapp Commission investigators called me as a witness many months later. They had in their possession tapes made in my apartment without my knowledge or consent," said Hollander.

A police raid put Hollander on the front page of the city's tabloids, and while headlines like "Midtown Madam" and "Penthouse Prostitutes" caught the public's attention, it was Xaviera Hollander's risqué quotes that forced them to read on. She was proud, defiant, and extremely articulate. "And she was blatant," said Yvonne Dunleavy. She was also read by a top editor at Dell Publishing.

"Bob Abel wanted it because the story was headlines," said Dunleavy, "and there was an upscale element to it," thanks to all that East Side Manhattan sex.

For its part, Dell "crashed" the book, bringing it out in paperback within six weeks of purchasing the completed manuscript. Despite his *Green Berets* and *French Connection* credentials, Moore really wasn't much of a writer, which is why he brought Dunleavy to the project. "Robin wrote one chapter, it was awful," said Hollander. "He was a Jerzy Kosinski," said Dunleavy. In other words, Moore could package and edit a book; he just couldn't write a book.

Later that year, when Hollander testified before Mayor John Lindsay's crime commission, formally titled the Commission to Investigate Alleged Police Corruption, it ended her brief stay in America. But it also sent *The Happy Hooker* to the top of the bestseller lists, where it would eventually sell more than fourteen million copies.

"It brought sex out of a plain brown wrapper," said Dunleavy. "You saw people reading *The Happy Hooker* on subways and in laundromats everywhere. That hadn't happened before." Readers were intrigued not only by the graphic sex talk but the blind items

that included such notable clients as Frank Sinatra, Alfred Hitch-cock, and *Oh! Calcutta!* producer Hilly Elkins.

Hollander never offered any apologies for her work—"To tell you the truth, I am very happy in the business"—but she did harbor one regret. "I wanted to call the book *Come and Go*, but Robin insisted on calling it *The Happy Hooker*." She had to admit the seemingly oxymoronic moniker Happy Hooker made for the better title, even if she hated being called a hooker.

Shortly after the publication of *The Happy Hooker*, Hollywood offered yet another portrait of prostitution, in this case the very contrite Bree Daniels, as embodied by Jane Fonda in *Klute*. It was a rough-edge portrayal, but in the end Bree Daniels was as repentant and emotionally troubled as Xaviera Hollander was defiant and carefree.

HOLLYWOOD'S MOST FAMOUS GAY director, George Cukor, all but came out of the closet with his Oscar campaign to get Holly Wood-lawn nominated for best supporting actress that winter. The legendary helmer of *The Philadelphia Story* and *My Fair Lady* had absolutely fallen in love with *Trash*, and his admiration included trying to make Hollywood believe that a drag queen is a woman. He thought Paul Morrissey's male Galatea sported a great pair of pecs, and who knew he could act? "Joe Dallesandro does some enormously difficult things," Cukor observed, like "walking around in the nude in a completely unselfconscious way."

Dallesandro found inspiration in being naked, in *Flesh* and now in *Trash*, although in the latter he never exposed his erection, for the simple fact that his heroin-addict character is incapable of getting one. "If you watch closely, you'll see that my best performing comes when I have my clothes off," observed the actor. "When I'm dressed, I really don't give very good performances."

Cukor, however, didn't put his muscle behind trying to nab an Oscar nomination for Dallesandro. He knew full well that the academy had a long tradition of honoring the most acting rather than the best acting, and Dallesandro had given a very understated performance as the strung-out Joe.

Holly Woodlawn, on the other hand, displayed enough acting in *Trash* to sink a ton of garbage in the Hudson River, and Cukor took note. He went so far as to have big orange buttons made, declaring "Holly Woodlawn for Best Supporting Actress." He even got Ben Gazzara and Joanne Woodward to join him in signing a petition to the academy. But to no avail. Like Andy Warhol, who was entering a new phase of filmmaking, the Oscars weren't having anything to do with "chicks with dicks," as the king of pop art now called them.

PRINCIPAL PHOTOGRAPHY FOR *STRAW DOGS* ended the last week of April, which is when Sam Peckinpah began his editing chores. He had particular trouble working on the final reel, but after a few sleepless days in the editing room he was able to say, "I think I've made my statement on violence."

The first cut of the siege and rape clocked in at one hundred minutes. When cut down to eighteen minutes, "it became a very different animal," said Roger Spottiswoode, one of the film's editors. "It turned from an exciting but standard battle into this strange, otherworldly scene."

Producer Daniel Melnick anticipated trouble from the censors, less for the blood than for the back-to-back rapes. In the United States, he cut a few seconds from the second rape to get an R, rather than an X, from the MPAA.

The Brits were tougher, and he feared he might lose the entire second rape—the one that the wife really, really doesn't want. At the censor's office, Melnick sat in front of a Moviola with "this

venerable member of the aristocracy, explaining to him by looking at the rape scene that what was going on was rear entry, not sodomy," said the producer. "By British standards, rear entry was acceptable but sodomy was not."

The American/British divide was even greater when it came to the film reviews. No fewer than thirteen prominent British critics wrote to condemn the censor's passage of *Straw Dogs*. Theirs was a joint letter in the *Times* of London, calling Peckinpah's film "dubious in its intention, excessive in its effect." One of those critics actually threatened a lawsuit over copyright infringement—and won!—when a London cinema used his pan review in its advertisements to entice theatergoers to buy tickets. According to Sir John Trevelyan, the outraged notice "immediately doubled the queues" outside the theater.

Stateside, pre-release test screenings brought out the worst in American audiences. Melnick recalled, "I hoped people would be devastated and shocked and horrified by the siege. Suddenly, I heard six hundred people shout, 'Kill him, get him!' I thought, My God, what have we unleashed?" And there were reports of little old ladies watching the film and cheering Dustin Hoffman to kill the thugs who had raped his wife.

After one such screening, a man asked who was responsible for the film. Peckinpah immediately pointed at Melnick. The man screamed at the producer, "That's the most disgusting thing I've ever seen. I'm a pacifist and I'll kill you for making it!"

As a result, *Straw Dogs* turned out to be a bigger box-office hit than Peckinpah's previous blood-fest, *The Wild Bunch*. The American critics, however, were divided. Reviewers for *Newsweek*, *Time*, and *Saturday Review* loved it. Richard Schickel in *Life* and Pauline Kael in *The New Yorker* disliked it intensely, and even got personal in their attacks.

"*Straw Dogs* is literally sophomoric," wrote Schickel. "Unable

to question either Peckinpah's craft or the insincerity of his motives, one must question his intelligence and perception."

Kael wrote, "Peckinpah's view of human experience seems to be no more than the sort of anecdote that drunks tell in bars." She went on to call *Straw Dogs* "a fascist work of art."

For some reason, the word "fascist" struck a nerve in Peckinpah's otherwise thick, deer-hunter hide. He fired off a letter to Kael, scolding her: "Shall I discuss this with my lawyer or are you prepared to print in public the definition of the film? Simply I think the term is in incredible bad taste and I intend to take issue with it."

He also fired off a missive to Schickel: "If I am at fault, part of it is because I expected too much, my vision of morality is certainly not yours, but I damn you for having the bad taste to speak of me as you did of my life in conjunction with my film."

Peckinpah deliberately blurred those lines between life and film by embracing not only the violent mantle but the male-chauvinistic-pig mantle. "There are two kinds of women," he told *Playboy*. "There are women and then there's pussy. . . . I ignore women's lib. I'm for most of what they're for, but I can't see why they have to make such assholes of themselves over the issue. I consider myself one of the foremost male lesbians in the world."

What didn't help the *Straw Dogs* cause was the nearly concurrent release of Stanley Kubrick's *A Clockwork Orange* and Ralph Bakshi's *Fritz the Cat*, two films laden with sex and violence.

Bakshi's animated feature, based on the famed Robert Crumb comic collection, had the distinction of featuring anthropomorphic animals who, in some cases, were anatomically correct, depending on what the viewer saw them as—animal or human. "They were animals fucking. And that, to me, was like the best of Terrytoons and the best of what I wanted to do," said Bakshi. Actually, the characters were often male animals fucking female humans with tails and floppy ears, all of which gave a definite tinge of bestiality to the

project. Which was the least of it for a few animators. "Sometimes I'd have to lean on some guy who's been doing animation for Disney or somebody for thirty years and tell him to pinch a chick's tit a little harder," said Bakshi, a former Paramount Pictures animator. "And some of them would just throw their hands in the air and walk out."

Kubrick, also, had considerably sexed up his movie's original source material, Anthony Burgess's novel *A Clockwork Orange*. He did his eroticizing less with dialogue than with his visuals. For example, the Korova Milk Bar, barely described in the novel, got the full Kubrick treatment: The director had admired the nude sculptures of Michel Climent, but when Climent demanded to be paid for his work, the parsimonious Kubrick hired another designer (Liz Moore, who had created the Star Child for *2001: A Space Odyssey*) to make tables and drinking fountains from naked female mannequins, complete with fluorescent wigs and matching pubic hair. Elsewhere in the film, girls in a record shop suck on phallic lollipops. And one victim, the Cat Lady, received a major makeover, as did her abode, the walls of which were now replete with erotic art. In a production memo, Kubrick detailed many of his original touches, including the Cat Lady's death by dildo when she is bludgeoned by a huge penis-like work of art.

During production of *A Clockwork Orange*, the movie's Alex, Malcolm McDowell, inquired if Kubrick had ever met with Burgess to discuss the project.

"Oh, good God, no!" exclaimed Kubrick. "Why would I want to do that?"

Or, as McDowell surmised, "Kubrick didn't want interference from the author, who probably didn't know the first thing about making a movie."

McDowell turned out to be the perfect Alex. He conveyed the requisite antic anarchy, and had no qualms about appearing naked on camera either alone or with an equally naked actress—a fact

Kubrick well knew from viewing McDowell's first major stint in front of the camera, Lindsay Anderson's *If . . .* , about a revolution in an English boarding school. In that film, McDowell and actress Christine Noonan got so carried away filming their nude tussle that an assistant director quit the production in a fit of moral pique.

Burgess was equally squeamish. He harbored his doubts about Kubrick's making an acceptable screen version of his novel. Despite having much admired the director's *Paths of Glory*, *Dr. Strangelove*, and *2001: A Space Odyssey*, Burgess was not a fan of Kubrick's *Lolita*, and he feared what would happen to his *A Clockwork Orange* when all the sex and violence had to be visualized onscreen. "*Lolita* could not work well," Burgess wrote, "because Kubrick had found no cinematic equivalent to Nabokov's literary extravagance. Nabokov's script, I knew, had been rejected; all the scripts for *A Clockwork Orange*, above all my own, had been rejected too, and I feared that the cutting to the narrative bone which harmed the filmed *Lolita* would turn the filmed *A Clockwork Orange* into a complimentary pornograph."

Initially, Burgess liked what he saw—or, at least, he said he liked what he saw—when Kubrick eventually deigned to meet and give him a private screening of the complete film. Burgess didn't hold it against the film version of *A Clockwork Orange* when his wife, repulsed by its choreographed sex and violence, asked to leave that screening after a mere ten minutes. After seeing the movie, Burgess initially told the press, "This is one of the great books that has been made into a great film."

Maybe he meant what he said. Or maybe he simply wanted to persuade Kubrick to direct his screenplay "Napoleon Symphony." In the following weeks, as well as years, Burgess would radically reassess his opinion of *A Clockwork Orange* the movie.

. . . .

THE SEX-AND-VIOLENCE CONTROVERSIES REGARDING *Straw Dogs* and *A Clockwork Orange* were to play out on such a grand stage that a little X-rated film could come and go with scant notice that year— even one directed by a movie star.

At the 1971 Cannes Film Festival, Jack Nicholson put aside his actor's hat to watch for the umpteenth time the film he'd produced, directed, and cowritten. As soon as the end credits started to roll on *Drive, He Said*, there were screams of approval from the gala audience. "I thought I was Stravinsky for a moment," said Nicholson. For a moment. Then the boos and catcalls began. To Nicholson's eyes and ears it looked like "a riot," and one that was not going to help his picture. "It was a disaster and I knew it was going to set me back," he said.

Drive, He Said got hit with an X rating from the MPAA, the Catholic Legion of Decency condemned it, the Canadian censors asked for forty-five cuts, and the British censors rejected it outright. Columbia Pictures, which released the movie, stood by their star director and refused to make any cuts. The studio even went so far as to obtain a few hundred affidavits from psychiatrists who declared it a morally fit film, which was enough to convince the MPAA to reconsider and give it an R rating.

Nicholson had a theory for why his film inspired all the censorship woes, and it had everything to do with a scene, early in the movie, where actor William Tepper simulates sex with Karen Black as she is slumped over the steering wheel of a car. "I felt it was because they didn't have orgasms in American films up until now," argued Nicholson. Plus, "The orgasm is audible, not visible. The person says, 'I'm coming.'" He explained, "You can have everybody moaning and saying, 'It feels good' and 'Screw me,' but you can't have someone saying, 'I'm coming!'"

One reporter at Cannes found the front-seat sex scene unattractive and especially demeaning to women. Nicholson challenged the journalist, telling him that he'd had intercourse in the front seat of a car many times and the man-behind-woman position is the only one that works. And as for being "unattractive," Nicholson wanted to know, "Well, is it only beautiful people who are allowed to enjoy sex?"

Others charged the film with being racist, since its locker-room sequences featured full-frontal nudity of only the African-American actor-athletes; it was an accusation that ignored the fact that Caucasian costar Michael Margotta, playing a draft dodger, is featured streaking full-frontally across a college campus for a good sixty seconds of screen time.

Despite the controversy, *Drive, He Said* sunk like reinforced concrete in the public consciousness, garnering both bad reviews and box office.

Being a Mike Nichols film, *Carnal Knowledge* had no such place to hide. Jules Feiffer thought he sat on an unqualified hit, both with the critics and the moviegoing public. Then a few weeks before the film's official June release, he and Nichols attended a Directors Guild of America screening in Los Angeles. They stood in the theater's foyer as their illustrious colleagues in the movie business made their collective exit.

"Uncompromising," said William Wyler, director of *The Best Years of Our Lives*.

"It was like open-heart surgery," said John Frankenheimer, director of *The Manchurian Candidate*.

Feiffer turned to Nichols. "We're dead," he said.

It seemed to Feiffer that the Hollywood establishment hated his movie. "It was too raw, too revealing, it stuck in their craw," he would later write in his memoir. And there were other problems, ones that had nothing to do with Hollywood's snub (only Ann-Margret would receive an Oscar nomination). On the right, the state

of Georgia banned *Carnal Knowledge*. On the left, feminists hated *Carnal Knowledge*. "It was assaulted by some women writers as sexist and exalted by other women writers as the first film conceived by men to show what we're really like: creeps," wrote Feiffer.

There were a few good reviews—like Vincent Canby's in the *New York Times*, a review that managed the print legerdemain of offering a long dissertation on the history of the word "cunt"—it goes back to Chaucer—without actually printing the word "cunt."

And there were bad reviews. And not just bad reviews, but damning reviews. In *The New Yorker*, Pauline Kael wrote, "This movie doesn't just raise a problem, it's part of it."

In the *Chicago Sun-Times*, Roger Ebert saw *Carnal Knowledge* as a film that succeeded commercially because of that rarest of phenomena: "bad word-of-mouth. The more people hear that *Carnal Knowledge* is only about sex, or that its characters seem obsessed by sex and lack three dimensions, etc., the more people want to go so that they, too, can agree about the movie's lamentable shortcomings."

In that regard, feminist writers definitely led the charge. In the *New York Times*, Rosalyn Drexler railed against *Carnal Knowledge*: "But what do we learn of the flesh that any self-respecting carnivore does not already know? Only that if you are a male, it can lie there like a lump of pasta until woman, as magical fork, lifts it up again. Sexual attitudes and activities are the meat of this picture, but there are maggots in the meat . . . dead meat . . . meat laid out, not laid!"

Jack Nicholson didn't help matters. He threw a lot of combustible bad language into the feminists' bonfire when he told a *Newsweek* interviewer, "I've balled all the women, I've done all the drugs, I've drunk every drink."

To help publicize the movie, his interview in *Playboy* further stoked the flames, especially when he sang the praises of cocaine and why "chicks dig it sexually. . . . While it numbs some areas, it inflames the mucous membranes such as those in a lady's genital

region. That's the real attraction of it." Or when he said, "Within three days in a new town, you are thinking, Why can't I find a beaver in a bar?" Or that his word for unattainable women was "skunks."

At moments like these—and there were a lot of them—Nicholson sounded just like that sex-crazed Jonathan cad from *Carnal Knowledge*.

"I can't go around picking up stray pussy anymore," Nicholson complained, blaming his predicament on the high-profile *Carnal Knowledge*. "The Jonathan role turned off a lot of chicks. In a casual conversation with me, you could have a certain difficulty in separating my sexual stance from Jonathan's. You can imagine what that does to a chick who sees the film, then meets me. For her, I become that character, the negativity she saw in the film. And she doesn't want to be in a pussy parade. I mean, no chick wants to be part of some band of cunts. And I certainly don't blame 'em for that."

Feiffer weathered the *Carnal Knowledge* firestorm with feminists, owning up to what he'd written. "Men don't like girls," he said. He also didn't write another screenplay for ten years.

Mike Nichols had the better cover. "I was going with Gloria Steinem at the time," he said.

Jack Nicholson, however, immediately took his place on the feminist hit list, somewhere between Hugh Hefner and Norman Mailer, as one of the most reviled men in America.

Mailer made the list with his recently published *Prisoner of Sex*, written in response to Kate Millett's *Sexual Politics*, which didn't have much good to say about Mailer's—or D. H. Lawrence's or Henry Miller's—attitude toward women. Mailer resented Millett's attack on his novels, especially her opinion that his novel *An American Dream* is an exercise in how to kill your wife and be happy ever after." He retaliated in the book *Prisoner of Sex*, pointing out that "some of the women were writing like very tough faggots."

To promote *Prisoner of Sex*, Mailer appeared at Town Hall in

U.S. Customs seized
I Am Curious (Yellow)
(1967) over objections
to nude scenes
involving Lena Nyman
and Börje Ahlstedt.
Photofest

In 1969, Jacqueline
Onassis is caught by a
paparazzo as she leaves
the Manhattan theater
that is screening the
suddenly notorious
I Am Curious (Yellow).
New York Daily News

Holly Woodlawn's
welfare queen finds
solace with a beer
bottle while Joe
Dallesandro's drug
addict takes a heroin-
induced nap in *Trash*
(1970). *Photofest*

Andy Warhol says of his oft-naked leading man in *Trash*, "Everybody loves Joe." *Photofest*

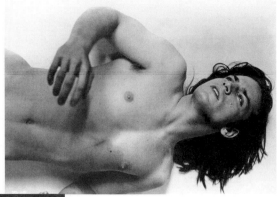

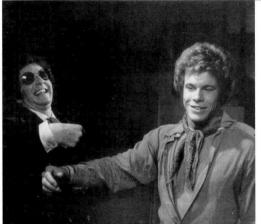

Leonard Frey's birthday boy receives the gift of Robert La Tourneaux's hustler in the movie version of *The Boys in the Band* (1970). *Photofest*

Raquel Welch drops trou to expose her character's transsexuality to a boardroom full of shocked execs in *Myra Breckinridge* (1970). *Photofest*

Mae West arrives for the world premiere of *Myra Breckinridge* in New York City, then trashes the film to reporters. *Photofest*

Viva forms a ménage à trois with James Rado and Gerome Ragni in *Lions Love* (1970); the movie still goes on to grace the first cover of Andy Warhol's *Interview* magazine. *Photofest*

One movie executive charges that "even the bath water is dirty" when Mick Jagger, Michèle Breton, and Anita Pallenberg get in a tub together in *Performance* (1970). *Photofest*

James Fox and Mick Jagger indulge in a bit of cross-dressing for their gender-bending roles in *Performance*. *Photofest*

Melvin Van Peebles lowers production costs by convincing union officials that he's shooting a triple-X movie, *Sweet Sweetback's Baadasssss Song* (1971). *Photofest*

Jack Nicholson is dubbed a male chauvinist, thanks to a *Playboy* interview and his role in *Carnal Knowledge* (1971), which costars Ann-Margret. *Photofest*

Björn Andrésen finds himself pursued by an older man, Dirk Bogarde, in *Death in Venice* (1971), adapted from the Thomas Mann novella. *Photofest*

John Schlesinger follows a close-up kiss between Peter Finch and Murray Head with a same-sex bedroom scene in *Sunday Bloody Sunday* (1971). *Photofest*

Censors cut the rape of Christ sequence from *The Devils* (1971), the footage later found and reinserted into Ken Russell's film. *Photofest*

Vanessa Redgrave's nun
fantasizes having sex
with Oliver Reed's Christ
figure in *The Devils*.
Photofest

Straw Dogs (1971) features a
controversial double rape, enacted
by Del Henney, Susan George, and
Ken Hutchison. *Photofest*

Malcolm McDowell's thug, using
phallic artwork as a murder weapon,
kills the Cat Lady in *A Clockwork
Orange* (1971). *Photofest*

Nude mannequins
supply the libations
to the "droogs"
in the Milk Bar
sequence from *A
Clockwork Orange*.
Photofest

Stanley Kubrick
directs the rape scene
in *A Clockwork
Orange*, with
Malcolm McDowell
and Adrienne Corri.
Photofest

The Motion Picture
Association of America
gave an X-rating to
Fritz the Cat (1972),
the first animated
feature to be deemed
suitable only for
adults. *Photofest*

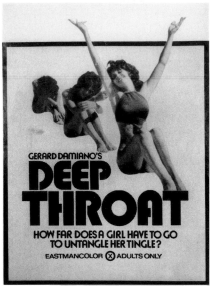

The *New York Times* identified *Deep Throat* (1972) as a major attraction in the burgeoning "porno chic" movement. *Photofest*

Marlon Brando and Maria Schneider are acquitted of obscenity charges in Italy, where *Last Tango in Paris* (1972) runs into trouble with the law. *Photofest*

Lance Loud, upper left, doesn't hide his homosexuality in *An American Family* (1973); he poses here with his siblings and his parents, Pat and Bill Loud. *Everett Collection*

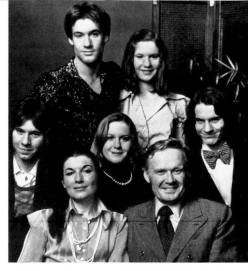

New York City to debate the feminists. Millett declined the invitation to speak, but Germaine Greer, ready to promote her *Female Eunuch* book, accepted, as did Jill Johnston, who wrote about being a militant lesbian on a weekly basis for the *Village Voice*. The Town Hall debates were mud-wrestling for the intelligentsia or, as Jules Feiffer put it, "ego-tripping at a very high level."

Sometime after Johnston and Greer spoke that night at Town Hall, two women in dungarees emerged from the audience and walked onstage to embrace Johnston. The three of them then began to kiss and hug but quickly lost their collective balance and fell off the stage.

Mailer was outraged. "C'mon," he ordered. "You can get as much prick and cunt as you want around the corner on Forty-Second Street for two dollars and fifty cents. We don't need it here."

The crowd at the Town Hall applauded that reprimand, but booed when Mailer later called fellow feminist Betty Friedan "a lady."

VANESSA REDGRAVE UTTERING THE word "cunt" was not the biggest problem Ken Russell confronted in getting *The Devils* approved by the British censors. That spring, Sir John Trevelyan met with the director to give him the bad news. "I'm afraid I'm going to cut your best scene," he said. "Don't hold it against me. That's my job, lad."

In truth, Trevelyan wasn't talking specifically about the "cunt" scene. He was talking about "The Rape of Christ" scene, as Russell well expected.

Russell affectionately called Trevelyan a "garrulous" old character, and he thought he "worked wonders" in getting the BBFC to approve as much controversial material as the board did over the years, namely the nude wrestling match in his *Women in Love*.

But the director had no such luck getting Trevelyan to approve either "The Rape of Christ" or the scene near the end of the film

where Redgrave's Sister Jeanne masturbates with a burnt fragment of Grandier's shinbone. Also, there was that language problem.

"I'm afraid we can't have Vanessa saying 'cunt,'" Trevelyan told Russell. "It's taken me ten years of fighting just to get 'fuck' accepted. I'm afraid the British public isn't ready yet for 'cunt.'"

Trevelyan also cut seconds of footage here and there, most of them having to do with scenes of torture, as Russell recalled, "such as the skewering of Grandier's tongue with needles, or the breaking of his knees—all Trevelyan did was to tone down or reduce the scenes as I had cut them."

It could have been much worse for *The Devils*—if someone other than Trevelyan had headed up the censorship board.

"Trevelyan admired the film greatly and prevented them from cutting it further," said BBFC member James Ferman. "Many members of the board thought [*The Devils*] was shameful . . . and needed to be censored heavily."

Trevelyan retired shortly after the release of Russell's film about a philandering priest and sexually obsessed nuns. Many critics were glad to see him go, and thought he shouldn't have approved *The Devils* under any circumstance. Russell, for one, understood the uproar. "There's nothing too subtle with a naked nun waggling her breasts in front of the camera," he quipped. In truth, there were lots of naked nuns waggling their breasts, as well as their bums. This much female nudity had never been seen in a mainstream movie—and that the women were young, voluptuous actresses playing nuns only compounded the problem in some critics' eyes.

The *Evening Standard* film reviewer Alexander Walker called it "the masturbation fantasies of a Roman Catholic boyhood," and went on in his review to imagine a scene in which Oliver Reed's character has his penis cut off. Since the scene was never shot, much less put in the movie, Russell whacked the critic over the head with a rolled-up copy of the *Evening Standard* in a BBC encounter and,

even worse for his cause, Russell uttered the word "fuck" on-air, which only further incensed the organizers of the Festival of Light, led by that sixty-one-year tower of self-appointed puritanism, Mary Whitehouse. Together with the festival, Whitehouse's letter-writing campaign forced seventeen British municipalities to ignore the BBFC ruling and ban *The Devil* outright in those townships.

Other high-profile critics of the film included no less a personage than the future Pope John Paul II, then the Patriarch of Venice, who called out "excesses never seen before" when *The Devils* screened at the Venice Film Festival that summer.

More problematic than the future pope were the current executives at Warner Bros. They'd read and approved Russell's script (the same script that UA's David Picker had read and rejected), and voiced no preliminary objections. But there was a difference between reading directions like "they give Sister Jeanne an enema of boiling water" and seeing it depicted onscreen. There's even a difference between those visuals and how Aldous Huxley in his novel described it: "The purging of Sister Jeanne was the equivalent of a rape in a public lavatory."

Russell offered a defense of his script, which was really a defense of the film medium or, at least, an explanation of its powers as well as its limitations. "When one reads these events in Huxley's account, one can sift the words through one's imagination and filter out as much of the unpleasantness as one cares to," he maintained. "You can't do this when you are looking at a film."

Maybe Warners chief Ted Ashley never actually read the screenplay—that's what he paid readers to do—but he most certainly didn't see what he expected to see when he and a few other studio "henchmen," as Russell called them, first saw *The Devils* in a London screening room. Russell showed them the version that had already been cut and approved by the BBFC. Even without witnessing "The Rape of Christ" scene, "they walked out stunned," said Russell.

A Warners vice president told him, "Better come and see us in our suite at the Dorchester in an hour."

An hour later, Ashley and the others let him have it. "That's the biggest load of shit I've ever seen," Ashley told Russell. "I've never seen the likes of this disgusting shit."

Russell said something about their having seen the script; he'd shot it as written. "But the fact is they weren't very visual people," despite their exalted jobs at a movie studio, he said.

Overall, the British censors didn't have a problem with the nudity in *The Devils*. The American executives, however, were another story. According to the director, "Ashley cut *The Devils* to pieces because of an apparent fear of pubic hair." And there was a lot of pubic hair to be cut. "They took the film and got my editor to cut out all the shots which they wanted removed, which basically consisted of all the shots in which there was graphic nudity. This adversely affected the story, to the point where in American the film is disjointed and incomprehensible," said Russell.

JOHN SCHLESINGER'S *SUNDAY BLOODY SUNDAY* made it to premiere night without any cuts from the censors or its studio. Schlesinger, on the other hand, did a lot of editing when it came to publicly discussing his love life. The subject matter of the film made that veil of privacy difficult to maintain, especially on opening night, when reporters asked if he identified with the gay characters in *Sunday Bloody Sunday* or if the film's plot in any way resembled his own life story.

"I make no personal statement about my private life," Schlesinger replied. "My private life is my private life. Actually, I identify with all three characters in *Sunday Bloody Sunday*."

Regardless of such noncommittal statements, his date that night was boyfriend Michael Childers.

The executives of United Artists thought they had a real

box-office dud with *Sunday Bloody Sunday*, but they also knew it was Schlesinger's follow-up to his Oscar-winning picture, *Midnight Cowboy*, and they treated it accordingly. So did some of London's most famous residents. Elizabeth Taylor and Richard Burton attended, as did Sir Laurence and Lady Olivier and Lord Snowdon and Princess Margaret, who turned out not to be a fan of the movie. At the reception afterward, within earshot of Schlesinger and Childers, the queen's sister, sloshed on too much gin, let out with her critique, "I thought it was horrific. Men in bed kissing!"

"Oh Margaret, shut up!" said Tony Snowdon.

The reviews were kinder; in fact, they were arguably the best of Schlesinger's career and relatively free of homophobia. *Sunday Bloody Sunday* would go on to receive five Oscar nominations, including one for best picture, but there were no wins. And it did not perform well at the box office, as they say in the trades. Gore Vidal, an admirer of the film, expressed his opinion on why it didn't succeed with the moviegoing public. "Americans are taught that either you're a faggot, and dress up in women's clothes and get fucked, or you're a 'real man' and would die if another man puts his hand on you," he said. "So, as a result, the Americans believe there is no such thing as bisexuality. What fascinated me about the movie was it takes for granted the bisexuality of the boy, and makes no point of it. I've known so many situations like that one. But it all came down to that one core: 'How could a nice, manly, Jewish doctor have an affair with a boy who doesn't seem to be wearing women's clothes.' They just couldn't get it."

LANCE LOUD WAS ALSO not wearing women's clothes when he fulfilled his fantasy to live in the hotel of *Chelsea Girls* fame. He and his friend Kristian Hoffman had traveled east after high school graduation, and when the money from home had run out and they were

evicted from an apartment on Seventh Avenue and Fifteenth Street, Hoffman returned to Santa Barbara. His more adventurous and resourceful friend remained behind in New York City.

"Lance had this sense of destiny, of being where you were meant to be," said Hoffman. "Lance took that hunger and turned it into reality. He believed there was this moment that was waiting for him, and to be clever and rise to that moment."

What was waiting for Lance was a man at least ten years his senior named Soren Agenoux, who lived at the Chelsea Hotel and worked as managing editor of *Andy Warhol's Interview*. If Soren wasn't love for Lance, he was destiny.

That year, Lance Loud's life would change even more, and that change had nothing to do with the Chelsea Hotel or Andy Warhol or, for that matter, Soren Agenoux.

Back in Santa Barbara, the half dozen other Louds were meeting with Mary Every, an editor for the town's *News Press*. Every knew producer Craig Gilbert, who had a deal with the PBS affiliate WNET to do documentary-style programs on five American families. Gilbert wanted upper-middle-class families like the ones that once populated 1950s sitcoms *Leave It to Beaver*, *Father Knows Best*, *The Donna Reed Show*, and *The Adventures of Ozzie and Harriet*. The happy family genre hadn't entirely disappeared from the tube, *The Brady Brunch* being the most notable survivor in 1971. But Gilbert wasn't looking for a sugarcoated family to be played for laughs in his documentaries. He wanted real families, with real houses, with real problems. Gilbert had already done some interviewing in Palo Alto and Los Angeles, but hadn't even found one family when he decided to visit Santa Barbara.

Every thought she knew just the family he wanted, and one evening in May she took Gilbert to the William C. Loud residence at 35 Wood Dale Drive in Santa Barbara. It was there at the Louds' eight-room stucco ranch house that he met Bill and his wife, Pat, as

well as four of their five children. Gilbert described what he wanted to do: A film and sound crew would tape their day-to-day lives for four weeks and then edit it down to a one-hour program, with each of the five families getting their own one-hour special.

According to Pat Loud, everybody in the family thought it would be "fun." Pat also had a couple of other reasons for wanting to be on TV, reasons that she kept to herself: She hoped that doing the documentary would keep her husband, who owned a mining equipment company, home in Santa Barbara more, and most important, she couldn't helping thinking of all the people who would see the show and read about them, "and the first ones I thought of were all Bill's women . . . they would turn on their televisions to look at the Louds, and they would weep. There we'd be, all seven of us, a portrait of family solidarity, all interwoven by blood and love and time and mutual need and a thousand other ties those poor things couldn't even comprehend," she would later write in her memoir.

And she also thought, "This documentary will never air."

Pat Loud wasn't the only one who had severe doubts about Craig Gilbert's project, to be called *An American Family*. Jacqueline Donnet, coordinating producer of the PBS show, recalled that back in the early 1970s "no one ever looked at public television. We thought that we were working on a little series like *The Working Musician*. Of course, there was an audience out there, but we didn't think the family was going to make the cover of *Newsweek*."

In Pat Loud's first few talks with Gilbert, she didn't mention her husband's infidelities. She and Bill had already discussed getting a divorce; perhaps they would wait until their youngest child, thirteen-year-old Michelle, was out of high school before they made the big break. For all Gilbert knew, the Louds were the perfect, average American family. Pat also didn't say much about her oldest son, Lance. Regardless, Gilbert found himself so impressed with the Louds that he decided to abandon his search for the other

four families and devote all five hours to just this one. (The series eventually ran twelve hours.) Pat recalled, "That was flattering, to say the least."

There were a few ground rules. Gilbert told the Louds that they would be filmed on a daily basis from 8 A.M. to 10 P.M. "They were to live their lives as if there were no camera present," he said. "They were to do nothing differently than they would ordinarily."

Pat mentioned her upcoming visit to New York City to see Lance, and Gilbert decided that her trip east might be an excellent time to start taping. He asked where Lance was staying, she said the Chelsea Hotel, and his eyes widened. It hadn't really occurred to Pat that the Chelsea Hotel was the hotel of Andy Warhol's *Chelsea Girls*, the film that her son so adored. She imagined a hotel called Chelsea being "a nice, quaint middle-class hostelry where a white-haired grandma type with a big bunch of keys at her waist clucked over boys far from home and brought them hot toddies and did their laundry."

Gilbert lived near the Chelsea Hotel. He knew its tenants. He knew its outré reputation. He knew he'd struck TV gold. Or as Pat put it, "He got the idea before I did that the life Lance was leading wasn't that of just any normal healthy twenty-year-old loose in the big city."

It was there, at 222 West Twenty-Third Street in Manhattan, that Pat Loud stepped from a taxicab to meet for the first time the *American Family* crew, all two of them: Alan Raymond, the cinematographer, was receiving $1,000 a week for his efforts; wife Susan Raymond, the sound person, got $900. There was no introduction as the Raymonds started to film Pat making her way across the sidewalk and into the Chelsea Hotel. They instructed her to "just ignore us, like we're not here."

"I was like a deer in headlights," Pat recalled.

The Chelsea Hotel.

While Lance adored the Chelsea—"I love it. All these little identical cells of people, and they're all famous and exciting and know what to do," he believed—Pat found it to be a seedy rip-off, its rent exorbitant, and its general air redolent of mildew and marijuana.

It was at the Chelsea that Pat met Lance's new boyfriend, Soren Agenoux, and Lance's new friend Holly Woodlawn of *Trash* fame. That first day, Lance took his mother to La MaMa, where *Hair*'s Tom O'Horgan came to fame, and where Pat was to see her first drag show, *Vain Victory*, starring those Warhol superstars Jackie Curtis and Candy Darling who'd romped together briefly in *Flesh*. Thanks to her Warhol-fixated son, Pat Loud was perhaps the only homemaker in Santa Barbara who'd heard of this transvestite triumvirate—Woodlawn, Curtis, and Darling.

After the show, over late-night coffee in a greasy spoon, Pat said she was alternatively shocked and bored by *Vain Victory*, Soren said he didn't understand it and sort of apologized to his boyfriend's mother, and Lance said it was thrilling. After all, future movie stars like Robert De Niro, Al Pacino, and Jill Clayburgh had preceded them to see *Vain Victory* at La MaMa.

The next day, mother and son had a heart-to-heart talk in Central Park in which he revealed how much he'd wished that the family had tried to "understand me."

Before Pat Loud left New York City, Gilbert met with her at a restaurant in Grand Central Terminal for a brief chat. Showing an openly homosexual person on television had never been done before. Gilbert loved the challenge but feared the repercussions. "Patty, what do you really feel about Lance?" he asked.

She told him, "I believe in teaching kids responsibility for their own actions. He's been wanting to come here for a long, long time. Lance is . . . well, gotten himself into a pretty weird scene. I can't keep bailing him out. I encourage him to stick it out so he can see

I'm not going to swoop in and carry him back to the sterile and safe family hearth. I want him to grow up, and that's a job he's got to do on his own."

What Pat Loud did not do was criticize Lance for being homosexual or living openly with his boyfriend. "If Lance seems not to care what others think of him it's not a cover-up," she told Gilbert. "His attitude is 'Here I am the way I am,' and he means it."

What she also knew is that "Lance would be all right. I knew that after visiting him."

Back home in Santa Barbara, Pat found Bill recovering from a bad sunburn, which he'd gotten "lolling around a pool," as he put it. No one working on the *American Family* series asked about Bill's affairs with other women, but there was, in Pat's words, a "thickening of the atmosphere around the house as the filming went on."

That atmosphere exploded on camera when Pat called Bill "a goddamned asshole," and a couple of episodes later she revealed to her brother and sister-in-law why she was getting a divorce. "If we had any sex life, that could be kind of nice. But it is kind of a courtesy thank-you-ma'am thing. I'm too young for that, too old for women's lib, but I'm too young for that. We don't have any rapport anymore. And everything's more obvious now—lipstick, powder, and gunk on his shirt. It has turned into a game."

Viewers had never heard such sexually explicit dialogue on television, and that such intimate details of an unraveling marriage came from not a fictional character but a real person would only compound the shock value.

In the following episode of *An American Family*, Pat asked Bill for a divorce. Actually, she simply informed him she'd hired a lawyer, gave him the lawyer's card, and said it was time for him to move out of the house. "At least I don't have to unpack my bags," replied Bill, just back from a business trip—or was it a pleasure trip? They could

have ended the taping right there—except Pat came down with a bad guilt attack, typical for good Catholic girls. "Almost a million dollars had been poured into filming the Louds," she explained. "I felt an obligation to live up to our part of the bargain. . . ."

Meanwhile, Craig Gilbert dispatched another film crew to Europe to record Lance's journeys there. Ensconced in Paris, he imagined himself Edith Piaf in an apartment overlooking the Seine and sang atop an upright piano. Lance would be the only family member to speak directly into the camera, very much the way the actors did in *Chelsea Girls*. In one such interview, he looked into the camera to say, "New York has so many things that really do interest me or that could interest me that for . . . for my own good, I think I'll just have to stay. Even if I really don't want to. In fact, I guess I really don't. It is so much easier just to go home. I could get a little job and make everyone happy on a day-to-day type basis and get a little money and live by myself in my own apartment or something."

Later, once he decided to leave New York City and return to Santa Barbara, he donned a floppy picture hat and flowing scarf, and made sure to be the very last passenger off the airplane to greet family and camera on the tarmac. He was now sporting blue eyeliner and lipstick, and back at 35 Wood Dale Drive he showed his sisters, Michelle and Delilah, how to apply such extreme makeup. Delilah told him he looked great.

During the taping, his four siblings never called him a fag or fairy or queer, and there was no eyeball-rolling at his theatrics. "I was so influenced by him, in the idea of being outrageous," Lance said of Andy Warhol. "When the cameras were on me I was really thinking, you know, *Chelsea Girls* and *Bike Boy* and stuff like that when they were filming. I was just so taken with it. I felt like I was in *Chelsea Girls II*, the sequel."

Off camera, the Raymonds broke the cardinal rule of cinéma

vérité. While the Loud family let Lance go his way, Alan and Susan Raymond told him to tone it down—he was coming off too flamboyant, too outrageous, too gay.

Lance didn't see it that way. He thought he was being "terribly avant-garde" and not trying "to dress like a woman or femmy." Only later, when he saw the twelve-hour documentary, with each sequence laid out one after the other, would he then realize, "I came off like a big fag."

One day, the Raymonds followed Lance to a fashion show at the Santa Barbara Museum. He arrived with his friend Jackie Horner, and they were both wearing makeup—Horner, swathed in a blue feather boa, had put black dots around his eyes, while Lance stuck to his basic blue mascara and lipstick. Even though both of them had tickets in hand, the museum guards wouldn't let them through the front door because of the way they looked. The Raymonds' camera and sound equipment was also a bit much. Finally, Jack Baker, the fashion show director, intervened. "The museum director wanted me to guarantee that they would behave," said Baker, who had been Lance's and Jackie's art instructor in high school.

"The Santa Barbara matrons thought we were monsters. That scared me," said Lance. But then, amazingly, Edie Sedgwick materialized, like a calming tonic. She introduced herself. "I haven't seen you for eons!" she told Lance, giving him a kiss. It was true—not since that day at the beach with her dog and the college boys playing football and her tirade about all those fags in New York City. How could he forget?

Lance asked where she'd been.

"I've been put away for a while!" she said.

A Santa Barbara matron, intrigued by the cameras, asked Edie who she was. "Edie Sedgwick Post . . . temporarily," she replied.

Lance knew what the erstwhile Andy Warhol superstar really

wanted. She didn't care about him, but rather was "drawn like a moth to flames by those cameras." She looked frail, sickly, horrible, and Lance believed "that I was standing there with a ghost of myself in the future. It would seem like 'Oh, look, there's Lance, and that's what's going to happen to him.'"

Lance and his friend drove Edie home. There in the foyer of the Sedgwick manse were dozens of bottles of pills, displayed openly like so much candy for the kids. They said good-bye.

The next day, a week before Thanksgiving, Lance received a phone call from Jackie Horner, who told him, "Edie Sedgwick is dead of an overdose."

1972, Frenzy

Buoyed with his initial opinion that "this is one of the great books that has been made into a great film," Anthony Burgess consented to join Malcolm McDowell for a one-week publicity tour of New York City to promote *A Clockwork Orange*. The travel-phobic Kubrick remained behind in England that January, "controlling everything," said McDowell. The two men's press day began with a limousine pickup, which invariably kicked off with Burgess asking McDowell, "Have you shit today?" McDowell told him yes, at which Burgess launched into a scatological dissertation until their first interview of the morning. That was Monday.

By Wednesday, however, McDowell noticed a distinct change in his publicity date's attitude toward Kubrick and his film. "Burgess realized he'd been cheated because he wasn't paid anything for *A Clockwork Orange*," said the actor. Years earlier, Burgess had sold the film rights "for a few hundred dollars," he groused. Regardless of how the film version performed at the box office, Burgess would see no profit points. Worse, "Kubrick went on paring his nails in Borehamwood," complained Burgess, leaving the publicity chores to McDowell and the novelist, who was even called upon to attend the New York Film Critics' Circle Awards on Kubrick's behalf. There

at Sardi's restaurant, Burgess got his revenge, since he quickly won the hearts and laughter of the assembled film reviewers when he shouted out, "I have been sent by God—Stanley Kubrick—to accept his award!"

It had been, by all accounts, a very rough few days of interviews for Burgess and McDowell.

On the *Today* show, Barbara Walters attacked the film's graphic sex and violence. Four teenagers had recently raped a nun in Poughkeepsie, New York, and it was inaccurately reported that they were dressed à la the droogs. Perhaps Walters had not yet seen *Fritz the Cat* (released by little Cinemation, flush with cash from its recent *Sweet Sweetback's Baadasssss Song* bonanza), in which a female donkey is chain-whipped and gang-raped by her rabbit-biker-boyfriend and two other characters of indeterminate species. (Robert Crumb called the film an "embarrassment for the rest of my life," and promptly killed off Fritz in a subsequent cartoon by having a female ostrich plant an ice pick in the back of his cat skull.)

As it turned out, the Poughkeepsie culprits hadn't seen *A Clockwork Orange*. Burgess recalled, "I was not quite sure what I was defending—the book that had been called 'a nasty little shock' or the film about which Kubrick remained silent. I realized, not for the first time, how little impact even a shocking book can make in comparison with a film. Kubrick's achievement swallowed mine, whole, and yet I was responsible for what some called its malign influence on the young."

During his press chores, Burgess took time to attend a screening of *A Clockwork Orange* with a paying audience. He wanted to see what all the fuss was about. He wanted to see how Americans were responding, and found that "the theology passed over their coiffures." He was especially dismayed by "the blacks" in the audience who shouted, "Right on!" at the thug-hero Alex.

Even so, he defended the film, the novel, and himself. In between

interviews, he wrote a defense of the film: "Neither cinema nor literature can be blamed for original sin. A man who kills his uncle cannot justifiably blame a performance of *Hamlet*. On the other hand, if literature is to be held responsible for mayhem and murder, then the most damnable book of them all is the Bible, the most vindictive piece of literature in existence."

From England, Kubrick said pretty much the same thing when the MPAA and the BBFC gave the film their respective X ratings, which in America had provoked a boycott. The one-two punch of *A Clockwork Orange* and *Straw Dogs*, which later cut a few seconds of footage to be reclassified R, alarmed several newspaper editors and publishers, who instituted a policy of refusing to carry advertisements for X-rated films. Of these newspapers, the *Detroit News* boasted the most readers, and its editorial page declared, "In our view, a sick motion picture industry is using pornography and an appeal to prurience to bolster theater attendance: quite simply, we do not want to assist them in the process."

The editorial didn't mention Kubrick, but that didn't stop him from attacking the editors of the *Detroit News*. His letter to the newspaper referenced Adolf Hitler's response to a Munich art exhibition in 1937: "Works of art which cannot be understood and need a set of instructions to justify their existence, and which find their way to neurotics receptive to such harmful rubbish, will no longer reach the public. Let us have no illusions: we have set out to rid the nation and our people of all those influences threatening its existence and character."

Kubrick went on to condemn the newspaper's policy: "In this day and age, the *Detroit News* censors may feel better equipped to make such fine distinctions—though I do not envy them their task. But what they are doing is, in essence, the same."

The Bible and Adolf Hitler. Burgess and Kubrick weren't afraid of going after the big guns.

. . . .

IT WASN'T THE BIBLE and it wasn't Hitler. It was something much more popular: *The Tonight Show.*

Johnny Carson's guests that January night were Burt Reynolds, the burly beefcake star of such forgettable testosterone epics as *Skullduggery* and *Sam Whiskey*, and Helen Gurley Brown, libido-driven editor of *Cosmopolitan* and bestselling author of *Sex and the Single Girl*. There on the *Tonight Show* couch, Helen was laughing at Burt for saying that men read *Playboy* for the articles, and he was laughing at her for putting out such an editorially lowbrow magazine.

"Are you a sexist?" she asked.

"I bet in ten years that word will be very tired and so dated that you'll sound like a dipshit to ask," he replied. Helen Gurley Brown called him, essentially, a Neanderthal. To which Reynolds remarked, "You know what? I want to go back to fighting my way through crinolines in the backseat of a car. It was a hell of a lot sexier. Painful, but sexier."

Somehow, in the midst of that heated exchange, the *Cosmo* editor knew she'd found her man. She'd been on a months-long search for just the right male specimen, when she put it to Reynolds on-air, "I want you to be the first male nude centerfold in *Cosmo!*"

Reynolds thought fast. He joked that *Cosmo* could show his left arm in the May issue and his right leg in June. But Brown wasn't letting him go. "You're the only one who could do it with a twinkle in your eye," she said.

In truth, he was about the only one who wanted to do it. A slew of major stars had turned Brown down. Reynolds, in his pre-*Deliverance* days, wasn't really much of a star at all, but he and his publicist, David Gershenson, could only pray that he would one day be a star—and in Hollywood, there are all kinds of ways to find God.

Burt Reynolds found his religion by downing a fifth of vodka

and starting on another bottle when famed photographer Francesco Scavullo asked him to get naked and lie down on a bearskin rug. Scavullo shot all the *Cosmo* covers, but this session was particularly arduous because Scavullo knew he couldn't airbrush Reynolds's hairy body into the plastic perfection that had become his trademark with so many female models' bosoms. He had to get the focus just right. Perhaps that's why "the session lasted several hours," Reynolds noted. In addition to the "Arctic" temperature in the studio, Reynolds had to contend with the photographers' two male assistants.

"Each one seemed so gay his hair was on fire," Reynolds revealed in his memoir. Maybe it was his naïveté or inebriation, but the actor never questioned why Scavullo always wore those silly little Carnaby Street caps.

Regardless, the April issue of *Cosmopolitan*, with the first male nude centerfold not counting the thousands of male nude centerfolds in hundreds of specialty "athletic" magazines, sold out its 1.5 million print run within two days of publication. The actor would contend that it was that year's release of *Deliverance* that made him a star. Others thought it was his spread in *Cosmo*.

Shortly after that issue appeared and quickly disappeared from newsstands, Reynolds was enjoying dinner with his current girlfriend, Dinah Shore, in a fancy Manhattan restaurant. A small combo played, and during a break the violinist approached the actor to say, "You wouldn't be anything if it hadn't been for that magazine picture."

Reynolds just smiled. "You ought to pose for one and then you could be playing at Carnegie Hall," he shot back.

BURT REYNOLDS WASN'T THE only one battling the cold that January. Marlon Brando's first nude scene in *Last Tango in Paris* also hit a nearly freezing wall of resistance. When director Bernardo Bertolucci

told him to take off his clothes, Brando took off his clothes. "But it was such a cold day that my penis shrank to the size of a peanut," the actor reported. "It simply withered."

Instead of turning up the thermostat, Bertolucci let his star suffer. "Because of the cold, my body went into full retreat, and the tension, embarrassment, and stress made it recede even more," Brando wrote in his memoir. "I realized I couldn't play the scene this way, so I paced back and forth around the apartment stark naked, hoping for magic. I've always had a strong belief in the power of mind over matter, so I concentrated on my private parts, trying to will my penis and testicles to grow; I even spoke to them. But my mind failed me. I was humiliated, but not ready to surrender yet. I asked Bernardo to be patient and told the crew that I wasn't giving up. But after an hour I could tell from their faces that they had given up on me."

The Godfather was a good two months away from being released, and Marlon Brando, naked or clothed, remained the very compromised, unbankable star of *The Nightcomers*, *Burn!*, *The Night of the Following Day*, and, yes, *Candy*. But he was still Marlon Brando, naked or clothed, and as *Last Tango* producer Alberto Grimaldi explained, "Brando had the personality and charisma which could allow for an easier public absorption and reception of the considerable shock which such a film would provoke." The graphic sex scenes in *Last Tango* demanded a star, even one of questionable box office reliability.

In describing his film to Brando, Bertolucci talked about his fantasy of being trapped with a woman in a room. He also spoke of his deep love for Francis Bacon paintings—"In Bacon, you see people throwing up their guts and then doing a makeup job with their own vomit"—and the short stories of Georges Bataille, whose characters "breathe in their farts and breathe in their come . . . that is what I want *Tango* to suggest," he said. And Bertolucci added, "Let's talk about ourselves, about our lives, our loves, about sex. That's what the film is going to be about."

"He wanted me to play myself," Brando said of Bertolucci's sales pitch, "as if [the character of] Paul were an autobiographical mirror of me."

Grimaldi had initially gone to Paramount Pictures to find a home for *Tango*, and yet despite *The Godfather* being in the studio's can, the executives there didn't see the potential in another Brando film, at least, not this Brando film. "No one was willing to take the risk, especially with such a film. . . . But finally, despite their fear that it might stain or throw a shadow over their image, United Artists, after much reluctance, agreed to a coproduction with me." (The final film cost $1,430,000, of which UA put in $800,000.)

United Artists knew what it was getting. Bertolucci made sure of that.

"Films like *Midnight Cowboy* and *Sunday Bloody Sunday* would not have been made by any other studio," said UA's David Picker. "*Last Tango* would have been made by another studio." It was a secret that Picker made sure to keep from Grimaldi.

Bertolucci, for his part, withheld nothing. "The sexual scenes as Bertolucci described them were even more candid than in the actual film," said David Chasman, head of UA in London. "He didn't talk about butt-fucking, but he conveyed that it would be very explicit. From what he said, I thought we were going to get a look at Brando's balls."

If Bertolucci had his way, the world would have gotten much more than a tour of Brando's crotch. The director's original vision was to have his two actors perform, not simulate, sexual intercourse. "Bernardo wanted me to fuck Maria," Brando said of his leading lady, Maria Schneider. "But I told him that was impossible. If that happens, our sex organs become the centerpiece of the film. He didn't agree with me."

Bertolucci had auditioned more than two hundred actresses, a process that quickly devolved into an exercise of instant déjà vu. "It

was like seeing the same one, because they were all exactly alike. All absolutely the same—same makeup, same hairdress," he said of nearly all the female contenders.

Fortunately, one eighteen-year-old novice was different. When Bertolucci asked Schneider to take off her clothes for the audition, she stripped without stopping to blink. "She was a little Lolita, only more perverse," he said of the edgy girl with the corkscrew curls. Later, he surmised, "Undressed, she became much more natural."

It's what George Cukor said of Joe Dallesandro's appeal. Careers have been made on less.

If Schneider was relaxed with her nudity, Brando was not. Where she walked around naked almost from day one, Brando demurred. "We have to wait a bit longer," he kept saying. "I'm not thin enough yet."

Finally, Bertolucci had waited long enough and insisted that his male lead get naked for the camera. Traumatized, Brando confided his nudity phobia to his longtime secretary. Alice Marchak gave him a very sympathetic ear; she deplored the sexual explicitness of the *Last Tango* script and advised her boss to leave the project. "I can't," Brando replied. "The picture is half-done. They'll sue for millions."

Initially, Bertolucci wanted a full frontal shot of the star, but he never got it.

Later, when Bertolucci was asked why Schneider's groin was exposed in the film and Brando's wasn't, he defended his male star, saying that scenes with a fully naked Brando were cut "for structural reasons, to shorten the film." He made up other reasons as well. Like, "I wanted to show it as essentially an oedipal relationship," he said. "Her nakedness makes her more childlike, his clothes make him more fatherly."

Schneider gave a simpler reason for the disparity in their respective wardrobes. "It was just his complex about his body," she said of Brando.

Even with his body only partially exposed, Brando did have to get naked on occasion. During one such scene, Bertolucci offered his star some unusual direction, motivation, therapy, or just plain blather. "You are the embodiment of *my* prick. You are its symbol," he said. Brando later said he didn't know what the hell Bertolucci was talking about.

Schneider could only laugh at Brando's reluctance to expose his body, and she often rolled her eyes at his habit of having to disrobe behind drawn curtains. "I'm much more free sexually than Bernardo or Brando," she bragged. She also said that making love to one of the screen's great leading men was no turn-on. "It was a very paternalistic thing, and a good friendship. I wasn't excited by him, although my friends told me I should be, and I don't think he was excited by me. He's old, almost fifty, you know, and he's flabby, and he has a big . . . ," she said, gesturing over her own tight abdomen.

Despite Schneider's seeming nonchalance on the set, her confidence was tested for the soon-to-be infamous sodomy scene. It was not in the original script. Brando conceived it over café au laits with Bertolucci when the two men were having a script consultation at a café near the Arc de Triomphe. The director embellished on the idea, giving it a novel twist: The lubricant would be a stick of butter that Brando grabs just before entry.

"Maria and I simulated a lot of things, including one scene of buggering in which I used butter, but it was all ersatz sex," said Brando. He respected his inexperienced leading lady, who tried to adopt his improvisational/autobiographical approach to her own role. As he put it, "We lived out our characters entirely. The complicity between us was the complicity of two ghosts to whom we had lent our bodies."

Perhaps Schneider's ghost was a little less complicit, because the actress claimed not to have been told about the buttery sodomy scene—until they shot it. "And I was so angry," she later said. "I

should have called my agent or had my lawyer come to the set because you can't force somebody to do something that isn't in the script, but at the time, I didn't know that."

At the time, what Brando did try to do was calm her. "Maria, don't worry, it's just a movie,' he said.

But during the scene, even though Brando wasn't really sodomizing her, "I was crying real tears," said Schneider. "I felt humiliated and to be honest, I felt a little raped, both by Brando and by Bertolucci. After the scene, Marlon didn't console me or apologize. Thankfully, there was just one take."

Near the end of the production's twelve-and-a-half-week shoot, Bertolucci staged the titular dance scene, shot at the Salle Wagram. It didn't go well. After several takes, Bertolucci asked Brando, who turned forty-eight that day, "I want you to do something outlandish!" He didn't ask Brando to tell him what he was going to do. "Just something outlandish."

Brando's concept of outlandish was to finish the dance by dropping his trousers and mooning one of the extras. "Kiss this, Kiss this!" he shouted at an old woman. "Farewell, my peach blossom!" and then, grabbing his trousers, he ran out of the dance hall with Schneider in hand.

The production ended on that fairly upbeat note. But perhaps Brando shared more of Schneider's reluctance with regard to all the sex and soul-searching than even he knew at the time. Years later, in his memoir, he wrote, "I felt I had violated my innermost self and didn't want to suffer like that anymore."

THE YEAR'S OTHER MOST controversial film began shooting almost to the day that production started on *Last Tango in Paris*. But it was an ocean away, in America, and no one in Hollywood had heard of its director, Gerard Damiano, or its star, Linda Boreman, the

twenty-one-year-old daughter of a Yonkers, New York, policeman. The movie began, unlike most movie productions, as the result of a love affair. And a twisted one at that.

What first attracted Linda Boreman to Chuck Traynor was his burgundy Jaguar XKE. What attracted Traynor to Boreman was her willingness to overcome the gag reflex when it came to giving him a blowjob. Hers was a bored life, even for a twenty-one-year-old living in Yonkers. She worked in a boutique, trying to save enough money to buy her own shop, when a near-fatal car accident ended that modest fantasy. That's when Traynor pulled up in his burgundy Jaguar XKE, and even though he came off like a gas station flunky, he offered to take care of her. He could afford it, having been a pimp and a drug smuggler, and he certainly had the money to give Linda Boreman a better place to live than her cop-father could.

Years later, Boreman would reveal, "There was no love, no affection, no normal sex with anyone from the day I met Chuck Traynor until the day I finally got away. I did not have a single orgasm for six or seven years. I never had any enjoyment from any of it at all."

There were, however, benefits to living with Traynor. Through hypnosis, Traynor got his girlfriend to give up smoking cigarettes. What else he hypnotized her into doing, she never knew. He might have hypnotized her into being one of his prostitutes, making a few porno movies, and meeting with the porn director Gerard Damiano, who was immediately taken with what Boreman called her "sword-swallowing or deep-throat trick."

Damiano liked to believe that his old job of cutting women's hair in New Jersey made him the ideal pornmeister, because "I could relate to women," he said. "Most of them were unhappy in their relationships." He got the idea for his "biggest movie yet" just a few days after meeting Boreman and Traynor in his Manhattan office. He told them, "I was driving over the bridge when it hit me.

We're going to do a whole film and I mean a feature, thirty-five millimeter—about a girl who has her clit in her throat."

"Hey, that's cool!" said Traynor.

"I've even got a title. *Deep Throat*. It came to me all at once," said Damiano.

He also had another idea. He thought movie stars needed alliterative names, like Marilyn Monroe and Rin Tin Tin, so he decided to give Boreman the screen name Linda Lovelace. Even though she wasn't voluptuous like most porn actresses, Damiano liked that Boreman looked "sweet and innocent" in an emaciated sort of way. The film's moneyman, who put up the entire twenty-five thousand dollars, wasn't so impressed. Lou Periano, aka Lou Perry, wanted a blonde and he wanted a blonde with big tits. Periano didn't even know if Boreman could talk. When he demanded a screen test, Damiano had his brunette, small-breasted discovery read aloud the nursery rhyme "Mary Had a Little Lamb." She read it. Periano remained unimpressed, but Damiano gave her the job anyway.

Periano's doubts about Boreman, however, concerned Traynor, and at his insistence she performed her "deep-throat trick" on the producer every day during the twelve-day shoot to help ensure her and Traynor's $2,400 gig. She wondered, "I knew that some starlets would take care of movie producers sexually, but that was before they got the role, not afterwards."

The *Deep Throat* production established its headquarters at the Voyager Inn in Biscayne, Florida, and as Boreman remembered it, the film took up a week and a half of her life. "Six before the cameras, six waiting around for the sun to come out," she said. When she wasn't swimming in the motel pool to "get rid of the flab," as Traynor called it, her boyfriend was either beating her blue, which posed a problem for the film's makeup guy, or threatening her with his arsenal of weaponry, which included a .45-caliber Walther pistol, an eight-shot automatic, and a semi-automatic machine gun. Her

only friend, it seemed, was her cat, which she named Adolf Hitler in honor of the pet's mustache-like markings on his head.

Herbert Streicher, Boreman's costar in the film, began work as a production assistant on *Deep Throat*, but around day two of the shoot Damiano promoted him to the role of onscreen doctor when another actor couldn't get it up on cue. It's the character of Dr. Young who discovers the clitoris in the throat of Linda Lovelace, which is what they called Boreman's character. Damiano did not give Streicher the screen name Dr. Young; he called him Harry Reems.

Depending on who does the talking, it was or wasn't a happy set.

"Chuck was an asshole," said Streicher, "but he was hardly around for the filming. Damiano sent him away because he would get jealous of how much she was enjoying the sex. She was really into it."

Damiano agreed with Streicher that, contrary to what she said later, Boreman enjoyed her job in the Florida sun. "Linda needed someone to tell her what to do," he surmised. "She was happy making the movie. Afterwards, someone told her she was unhappy making the movie. So she was unhappy making the movie. Which was not true."

Boreman rejected that willing-victim status. As she explained her seeming complicity, "Because it's kind of hard to get away when there's a gun pointed at your head. There was always a gun pointed at my head. Even when no gun could be seen, there was a gun pointed at my head."

And besides, as much as she may or may not have enjoyed the sex with Streicher and a few other men, life on the set of *Deep Throat* was an improvement of sorts. "Two weeks of making a movie, even a pornographic movie, was better than two weeks of being a hooker. And being with other people, just listening to others talk, that was nice," she noted.

Streicher found it "courageous," not to mention a public service,

that someone was daring and liberated enough to make a film about oral sex. Damiano agreed: "People didn't realize that a woman could ever have as much pleasure as a man. That why I wanted to show it." But it was a challenge. When a man has an orgasm, there's the proof of semen. But a woman? "That's why I inserted the rocket footage to embellish the footage of Lovelace going down on Reems, to show the power of her orgasm," said Damiano.

Years later, Boreman would reject the idea that *Deep Throat* showed a woman's sexual pleasure. "Suppose your balls were in your ears?" she asked an inquiring reporter.

ON JUNE 12, LESS than six months after principal photography had completed, *Deep Throat* opened in Times Square at the New World. The theater took in thirty-three thousand dollars in the movie's first week. The theater's twenty-six-year-old manager, Bob Sumner, thought he could improve those phenomenal grosses by charging three dollars instead of five, but he soon learned that aficionados of hard-core think they're getting soft-core if the admission isn't at least twice that of a normal movie. He quickly raised admission back to five dollars, the going rate for hard-core, and the box office bonanza continued.

Pornmeisters sensed the competition. "I'm really offended that films like *Deep Throat* are available in this city," said Bob Guccione, whose new skin magazine, *Penthouse*, had just begun to make deep inroads into *Playboy*'s circulation of five million copies a month. Quotes like "I'm really offended," coming from Guccione, helped keep the dew on the scandal. And soon gossip columnists were giving almost daily tallies of the many celebrities who came to Times Square to see *Deep Throat*, whether it be Johnny Carson, Sandy Dennis, Ben Gazzara, or Jack Nicholson. "Mike Nichols told

me I just had to see it!" said Truman Capote, who deemed Linda Lovelace "charming."

Even housewives from the boroughs started making the Wednesday matinee trek to the New World. "Once it broke in the society columns, it was OK to go," said *Variety*'s film critic Addison Verrill.

Pauline Kael wanted to review *Deep Throat* for *The New Yorker*. She'd paid to see the film with her friend Charles Simmons, an editor at the *New York Times Book Review*, who told her he'd never seen a porn film before. "You lost your cherry on a good one," Kael told him. Her good opinion of *Deep Throat*, however, never made it into print. Kael's editor at *The New Yorker*, the prudish William Shawn, refused to have pornography reviewed in his magazine.

Overall, female moviegoers were not pleased—at least those who wrote for major publications. Ellen Willis of the *New York Review of Books* called *Deep Throat* "as erotic as a tonsillectomy." Nora Ephron in *Esquire* called it "one of the most unpleasant, disturbing films I have ever seen. It is not just anti-female, but anti-sex as well." She went on to wonder if she was "a puritanical feminist who had lost her sense of humor at a skin flick." Or as famed attorney Alan Dershowitz explained it, "In the 1970s, the worst censors in the country suddenly became the feminists."

The media did their best to promote that truism. The feminist war on pornography made good copy; reports on reproductive rights, equal pay, and day-care access did not and were essentially ignored.

As soon as *Deep Throat* looked to be a runaway hit, Damiano sold out his share for only twenty thousand dollars to Lou Periano, the original moneyman. On why he decided to sell out for such a lowball figure just when the film's weekly grosses were skyrocketing, Damiano explained, "Look, you want me to get both my legs broken?"

Periano would later claim there was nothing shady going on. "My father may have been in the mob. My uncle may have been. But even

the government says that I wasn't. They called me 'an associate,' "
he said.

Yes, the government. "The government became the driving force behind the [film's] public relations," said Alan Dershowitz.

The NYPD, at the instigation of the Times Square Development Council, raided *Deep Throat* during its premiere summer run in Times Square, and Criminal Court Judge Ernst Rosenberger had the film seized on August 18. It was all part of Mayor John Lindsay's "Clean Up Times Square" campaign. Periano and the New World theater hired as their defense attorney Herbert Kassner, who volleyed back, "If it was pornography, they could prosecute in a diligent manner. They wouldn't have to come around in hordes of fifty and take signs out of windows and act like the Gestapo of old."

Gestapo of old or new, it didn't matter. At least that first summer. Since the good judge failed to give the theater owner a hearing, *Deep Throat* quickly returned home to the New World, where its fame only grew, fueled by reports like the one in *New York* magazine, which held forth that "the whole issue is now before the United States Supreme Court, which must decide whether a judge alone can see a film and decide it is obscene without giving the theater owner a hearing."

No, said the Supreme Court, giving thousands of other moviegoers time to jam the New World to make up their own mind.

While *Deep Throat* was subsequently banned in twenty-three states, it continued to open elsewhere and prosper, as did a new and equally graphic how-to sex manual. Since he'd studied medicine and anatomy back in London, Dr. Alex Comfort already knew that the clitoris did not call the throat its home. But there among the chaparral and hot tubs of the Sandstone retreat in Topanga Canyon, California, Comfort did learn a few new things regarding group sex and bondage, and he put these teachings into *The Joy of Sex: A Gourmet Guide*. Just as sales for *Everything You Wanted to*

Know about Sex began to recede, Comfort's manual took its place, spending no fewer than seventy weeks on the *New York Times* bestseller list.

CANDY DARLING AND HOLLY WOODLAWN walked off Park Avenue South and into Max's Kansas City, bummed that neither Paul Morrissey nor Andy Warhol had the decency to invite them to the premiere of their new film, *Heat*, about a former child actor who beds an old Hollywood star, played by Sylvia Miles, to jump-start his movie career. As usual, the movie starred Joe Dallesandro, and as usual he played a hustler.

Word had gotten back to Holly and Candy that Andy was no longer into chicks with dicks, which made them wonder why Morrissey had cast Andrea Feldman, aka Andy Feldman, to play Sylvia Miles's daughter in the film.

Feldman also didn't get invited to the *Heat* premiere. But no one could hold that snub against the movie's makers. Two months earlier, Andrea asked a few ex-boyfriends to her parents' apartment on Fifth Avenue. And with a Bible in one hand and a crucifix in the other, she told the assemblage that this was her "final starring role" and jumped out the window.

Maybe that's why Andy wasn't into chicks with dicks. Or maybe he just wasn't into chicks, period, after the Valerie Solanas episode.

Despite their *Heat* disappointment, Candy and Holly had good news nonetheless that autumn day when they walked into the back room at Max's and saw friends. "Lou Reed wrote a song about me!" Candy bragged.

"Pig's eye, Lou Reed wrote a song about you," replied a friend.

"Okay, Mr. Wiseguy, I'll show you," said Candy. She asked for a quarter. She never had any money. Someone gave her a quarter, and Candy walked over to the jukebox, put in the money, and hit some

keys. The music came on. It sure sounded like Lou Reed singing, "Hey Babe, take a walk on the wild side."

Candy Darling could not have been happier, even if she did have to share the song with Holly Woodlawn and Joe Dallesandro, who'd also been immortalized by Lou Reed. Candy's fame from the song, however, proved the most ephemeral. When RCA released the "Walk on the Wild Side" single from Reed's album *Transformer*, the label cut the Candy Darling reference due to its implications of oral sex: "But she never lost her head / Even when she was giving head."

Coincidentally, *Heat* was also much less bold than Paul Morrissey's previous movies. He didn't show Joe Dallesandro's penis this time around, as he'd done in *Flesh* and *Trash*.

"I was naked enough in *Heat*," Dallesandro surmised, especially with regard to his costars Sylvia Miles and Pat Ast. "They're not the kind of women you want to get naked with in bed," he explained.

Neither was he terribly impressed with the Lou Reed song. "Paul Morrissey asked him to write it," said Dallesandro. "Lou Reed didn't know me. He watched some movies and wrote about the characters that Candy, Holly, and I played, that's all."

Morrissey, again, deserved full credit. And the *New York Times* agreed, reporting, "He did more than anyone to create the image of the Warhol world as a nonstop festival of sleaze, drugs and moral squalor."

Morrissey, for his part, was in full agreement.

"I did those films one hundred percent myself," Morrissey said years later. "Andy Warhol was a total vacuum. He just stood there like an even bigger idiot than he was. I put his name on [the films] as a presenter. That's all he wanted was to have his name in the paper. He couldn't read anything. He just saw his name. I made the mistake of putting his name on them. Everything was done by me."

Not that it was a mistake. "Paul thought those films would be shown in museums forever," said Dallesandro, "because Warhol was an artist."

. . . .

THAT OCTOBER, THE CONTINUING notoriety of *Deep Throat* played into United Artists' unusual release of its new sex-saturated film. As the *Village Voice* film critic Andrew Sarris observed, "Adding to the [*Deep Throat*] ferment was the almost simultaneous furor around Bernardo Bertolucci's *Last Tango in Paris*, in which Marlon Brando simulated forcing a buttery substance down the anus of the writhing and nude Maria Schneider."

United Artists' David Picker knew he couldn't open a film like *Last Tango* in Italy, Bertolucci's home country, where it would almost certainly run into censorship problems. Instead, the studio decided to brand *Last Tango* as an "art film" by holding just one screening at a prestigious film festival. Cannes was nearly a year away, in May 1973. The closest major event was the New York Film Festival. United Artists would debut the film there on October 14.

It was the hottest ticket in town, and Picker and Bertolucci could not have been more pleased at the reception in Lincoln Center's Alice Tully Hall. Andrew Sarris sat a few rows back from *The New Yorker*'s Pauline Kael. "I could hear her gasping—in shock or ecstasy. I couldn't tell," he reported. Bertolucci fans yelled bravo, prudes simply left in a huff, and Kael let everyone within earshot know that she'd just witnessed a movie "breakthrough."

A few days later, in *The New Yorker*, she reported on what she'd seen on October 14, 1972:

"That date should become a landmark in movie history— comparable to May 29, 1913—the night *Le sacre du printemps* was first performed—in music history." She went on to explain, "This must be the most powerfully erotic movie ever made, and it may turn out to be the most liberating. . . . Brando and Bertolucci have altered the face of an art form."

Detractors of Kael, and she had many in the New York film critics community, gossiped that Kael's review was an act of politics, that she had always been a major supporter of Bertolucci, and had set out to write a review that would prevent any censor from tampering with it. Kael always denied the political aspects of her review. But there was no denying her review's impact. "She single-handedly rescued the film from any dismissive puritanical condemnation," said Sarris.

The Italians didn't get that memo.

Last Tango in Paris was an immediate box-office sensation in Bertolucci's native country, especially in Rome. But up north in Bologna, it created the kind of sensation that moviemakers generally try to avoid.

The Bologna lawmakers slapped *Last Tango* with an obscenity charge that claimed the movie was "permeated by scurrilous language—with crude, repulsive, naturalistic and even unnatural representation of carnal union, with continued and complacent scenes, descriptions and exhibitions of masturbation, libidinous acts and lewd nudity."

Bertolucci replied in kind. "The text of the court accusation is a pornographic document," he said.

Bertolucci, Brando, and Schneider were each threatened with an eight-month prison sentence, and United Artists immediately withdrew the film from distribution throughout Italy.

Paris was a different story. There, the film continued to do gangbuster business.

PAT LOUD MADE A few visits to New York City to see the edited version of *An American Family.* Her estranged husband, Bill, made just one trip—to check out episode nine, in which Pat tells him to find another place to spend the night, as well as the rest of his life. Bill

asked Craig Gilbert if a couple of lines could be cut. Gilbert agreed. But it was clear to both Pat and Bill: They didn't have final approval of the edit. Their visits were courtesy calls at best, because when Pat had a major problem—like she did with the title sequence—she didn't get her way.

Pat hated how the title words *An American Family* developed spidery cracks, as if they were ready to shatter into pieces. Or, as she described it, "cracked, like china breaking." She felt it was too strong an editorial comment. And besides, the Louds were still a family. She objected to the graphics not once but twice. On her second visit to New York City, Gilbert didn't verbally respond to her objections. He simply put his hand over her eyes when the logo splintered onscreen. In other words, she came, she saw, she lost.

That autumn, the Louds didn't hear much about the series or think much about it, except for the family's seventeen-year-old son, Grant, who hoped that the show would help launch his new rock band, which the documentary showcased in a couple of episodes.

In December, WNET invited Lance Loud to represent his family at the premiere screening of *An American Family*. It took place at no less a prestigious venue than the Museum of Modern Art, and Lance dressed to impress in his best David Bowie/Ziggie Stardust gender-bending attire. He had been hired by Gilbert to help with the editing and do some voice-over narration, and so he thought he knew what to expect. There would be no surprises, he thought.

At the museum, a publicist's flunky handed him the glossy press kit. Lance immediately recognized the cover image as a recent portrait of the Loud family, one that they had used for a Christmas card—only it was different. The family photograph no longer looked so festive, because the image had been scorched at the edges and there were big cracks drawn on it to separate each of the seven Louds.

Lance phoned his mother as soon as he returned home from MoMA that night. "You won't believe it!" he began. He not only

described the doctored family portrait; he read the entire press release, which contained profiles of each of the twelve episodes. The family had trusted Craig Gilbert and WNET. This was public television—no commercials, no promos, no hype. Lance began reading from the press release: "The breakdown of communications so striking in the Loud family is perhaps a typically American disease, the result of disproportionate emphasis on maintaining surfaces, keeping cool. These people touch without meeting, meet without touching."

By the time he finished reading, Pat wanted to kill Craig Gilbert and the whole cabal at WNET. "I knew that everybody in the business who hadn't seen the series would simply lift things from that piece and use them as their own," she believed.

Pat begged that the press kit not be given out at the upcoming Los Angeles screening, to which the Louds had all been invited. Instead, WNET mailed the press kit to editors and reporters. Pat wondered, "This is educational television?"

Winter 1973, Backlash

The initial advertisement for *An American Family* in the *New York Times* looked like something put together by ABC or NBC or CBS for one of its afternoon soap operas. Coming from WNET, it shocked the Louds. "Are You Ready for an American Family?" the ad asked provocatively, referring to their house not as a home but as the "headquarters" and the "message center."

The second ad, promoting the episode devoted to Lance and Pat Loud in New York City, was even more inflammatory. It proclaimed, "He Dyed His Hair Silver!" The ad featured a portrait of Lance, torn out of a family photo, as if he had been disowned by the six other Louds, and the copy wondered if he'd "dyed his clothes purple as a personal expression of . . . something . . . something he wasn't fully aware of at the time."

Which was strange. Lance had never hidden his sexual orientation from his family or the filmmakers. He didn't "come out on camera," as many reviewers would soon report. "The sexual preference has always been there," Lance told interviewers. "When I went through puberty, I wanted to have sex with boys."

Despite Lance's frankness, WNET used code words to describe him. A press kit photo of a leather-jacketed Lance carried the caption:

"This is Lance Loud, public television's flamboyant 21-year-old member of 'An American Family.'"

Two years earlier, *All in the Family* introduced TV's first openly gay character—the macho athlete whom Archie Bunker mistook for being straight. Lance Loud was also gay but he was also different. Not only was he a real person; he was the first openly homosexual "character" on television to have a story line that carried out over multiple episodes.

Anne Roiphe, author of the feminist bestselling novel *Up the Sandbox*, had coffee with Pat and Bill Loud at the Carnegie Deli in New York City that January, right after the series began airing. Their interview was to be the centerpiece of her upcoming article on *An American Family* for the *New York Times Magazine*. She didn't speak with Lance, but that didn't prevent her from turning the nine-page article, awkwardly titled "Things Are Keen but Could Be Keener," into what was first and foremost an attack on him.

In that article, before Roiphe got around to detailing the show's various highlights—the breakup of the Louds' marriage, a fire that almost destroyed their home, a car accident, Bill Loud's business problems—she took space to describe "the flamboyant, leechlike homosexuality of their oldest son, Lance."

She quoted Shana Alexander's essay in *Newsweek*, which preceded Roiphe's article by a few weeks: "The silence of the Louds is also a scream, a scream that people matter, that they matter and we matter. I think it is a scream whose echoes will shake up all America."

What appeared to bother writers like Alexander and Roiphe, but none more than Roiphe, was that the Louds—Bill, Pat, Delilah, Michelle, Grant, and Kevin—did not openly criticize Lance for being homosexual. Certainly both parents devoted several minutes of the twelve-hour series to criticizing Lance's lack of initiative in getting a job. Totally missing, however, were those chats about his making a

sincere effort to become a heterosexual. Also absent were any anti-gay taunts from Lance's four siblings. It was the family's implicit acceptance of Lance's sexual orientation that outraged journalists like Roiphe, who wrote in her *Times* article, "Lance Loud, the evil flower of the Loud family, dominates the drama—the devil always has the best lines . . . he is beyond understanding in a wonderland of city cats whose morality and values, whose actions and reactions can only mock those of us on the other side of the mirror."

Regarding Pat's reaction to Lance, Roiphe wrote, "I shared her unacknowledged sadness for a son whose childishness runs wild, whose ability to survive is in question."

Roiphe's surmise of Bill's reaction to his oldest child is even more inflammatory: "[Bill] tries to go along with jokes he doesn't quite get, to admit to no one, not the camera, not his son, not himself, the disappointment, puzzlement, haunting shadow such a son as Lance must be to a man whose business is to sell parts for strip mining machines, whose life work takes him out among the hard hats, the dump trucks, the huge grinding steel teeth of the steam shovels. A world where, I was reminded as I saw it on the camera, men seem strong and decent, large and dependable."

Roiphe wondered, "Is Lance the true American son?"

Then she compared him to a fish: "I suspect getting close to Lance must always have been like swimming alongside an electric eel."

She also pinpointed Lance's homosexuality as the reason why Bill cheated on Pat: "Why the infidelities? The camera doesn't tell us, but we can guess. Bill reached his early 40's and his first son was not going to be a man; his sense of himself could have been badly shaken by that unacknowledged discovery. The disappointment may have driven him to prove himself with others."

After reading the *Times* article, Pat Loud placed a middle-of-the-night call to Craig Gilbert, who had set up the interview with Roiphe.

"Pat was screaming," said the filmmaker. "She'd taken a below-the-belt hit, and it hurt. That, right there, was the beginning of my own confusion. What have I done? What do I do?"

What the Louds did that February was try to defend themselves on *The Dick Cavett Show*. Regarding the hot-button topic of Lance's homosexuality, brother Kevin challenged their famous interviewer. "We don't say 'homo,'" he told Dick Cavett. "That's what the newspapers say. We don't say it."

The Loud family's appearance that February evening doubled the talk show's ratings.

BERNARDO BERTOLUCCI HAD TO defend himself and his actors in the Bologna court. "I can confirm that neither the performers nor myself ever contemplated for a moment commercial benefits or entertainment devices," he said. "We were interested in the question of possession of a component of a relationship, a self-destructive one prevalent in today's society."

The three judges hearing the case agreed and all three defendants—Bertolucci, Marlon Brando, and Maria Schneider—were acquitted.

The Italian court case delayed the official New York City opening of *Last Tango in Paris* until February 1, giving the box office at the TransLux East adequate time to promote the controversy and rack up more than $100,000 in advance ticket sales at the small movie theater.

After testifying in Italy, Bertolucci flew directly to New York City for his film's premiere. Jet-lagged, he picked up a newspaper to read about what he'd just experienced six thousand miles away, and glancing at the paper's photo he remarked, "I look like a criminal the moment he goes before the judge."

After Pauline Kael went orgasmic in *The New Yorker*, everyone

in New York suddenly had an opinion about *Last Tango*, including people like William F. Buckley Jr. and ABC commentator Harry Reasoner, both of whom condemned the film as being pornography without their having actually seen it. Others, like Norman Mailer, thought the film didn't go far enough, offering, "Brando's cock up Schneider's real vagina would have brought the history of cinema one huge march closer to the ultimate experience it has promised since its inception—that is, to embody life."

Prior to the film's commercial release, Bertolucci had kept his analysis of *Last Tango* simple. "Can a man and a woman still live together today without destroying each other?" he asked.

Now, with Kael's review in hand and the film about to open, Bertolucci felt compelled to pontificate. "Women are the only ones who really understand the film," he believed. "Because it's a film that's built on the concept of the inside of the uterus. Not just the room. Marlon, in fact, makes a voyage back to the uterus so that at the end he's a fetus. The colors in the film are uterine colors."

Women, of course, didn't all love it. Many of them hated it, women like feminist Grace Glueck, who called *Last Tango* "the perfect macho soap opera," and went on to write, "Brando's and Bertolucci's dislike of women is intense."

When reporters asked Bertolucci about quotes like Glueck's, he shot back, "I consider myself a member of women's lib, but I don't want to talk with women who believe my film is misogynistic. That is too narrow a vision . . . because they make this equation: Marlon brutalizes Maria, therefore the film is against women. It's a very simplistic interpretation. . . ."

It had been a long haul for Bertolucci, and sitting there in a Manhattan hotel room trying to defend/promote/explain his movie, he admitted, "I'm more than bored. I've been taking all this as a game, and now I'm tired of playing the game."

Much newer to the game, Maria Schneider wasn't bored in the least, and neither were the reporters who sat down to interview her. Only seven years earlier, Julie Christie had shocked reporters by telling them that she lived openly with her boyfriend Don Bessant without the benefit of marriage, an admission that linked the actress to her party-girl character in *Darling*.

Likewise, Schneider became Jeanne from *Last Tango*, especially after her unexpected, open admission to the *New York Times*, "I'm bisexual completely, and I've had quite a few lovers for my age. More men than women. Probably fifty men and twenty women. I'm incapable of fidelity; I have a need for a million experiences."

And she didn't stop there. She and Brando got along so well "because we're both bisexual," she insisted, and regarding the making of *Last Tango* she revealed that "Bertolucci was in love with Marlon Brando, and that's what the movie was about. We were acting out Bernardo's sex problems, in effect trying to transfer them to the film."

Bertolucci stoked the rumors of his being infatuated with Brando, declaring, "He was so wonderful. I always fall in love with my actors and actresses, but especially with Marlon." He even went so far as to kiss a photograph of Brando. "Isn't he beautiful?" he asked a reporter. "Just look at that face. Oh, Marlon, you are good enough to eat."

The rumors were already circulating that Bertolucci had originally conceived the film as the love story of two men, and no less a movie personage than Ingmar Bergman gave those stories oxygen, if not validity, when he speculated that Bertolucci "got worried about taboos" and so turned *Last Tango* into a heterosexual love story. "There is much hatred of women in this film, but if you see it as being about a man who loves a boy, you can understand it," said Bergman.

Same sex or different sex, *Last Tango in Paris* did very well for its participants. It cost $1.4 million and grossed more than $45 million, with Brando's take being about $4 million.

FINALLY, *DEEP THROAT* ALSO got its day—ten days, to be exact—in court that winter.

The prosecutor, William Purcell, argued that the film had no social redeeming value.

The defense, Herbert Kassner, argued, "It indicates that women have the right to a sex life."

On the contrary, Purcell countered: *Deep Throat* could be injurious to a person's health, especially if that person happened to be female. "A woman seeing this film may think that it is perfectly healthy, perfectly moral to have a clitoral orgasm that is all she needs. She is wrong. She is wrong. And this film will strengthen her in her ignorance," he said with a straight face.

The words "clitoral orgasm" baffled the judge for the simple reason that the Honorable Joel J. Tyler had never heard of such a thing. Not a good sign for the defense.

As the trial progressed, Norman Mailer threw a fiftieth-birthday party for himself at the Four Seasons restaurant. Mailer used the occasion to launch something he was calling the Fifth Estate, a group to monitor the CIA. To kick off the party, Mailer told his assembled guests an anecdote about "an Oriental cunt."

No one at the Four Seasons laughed. But they did talk about Mailer being drunk, being a joke, and their having to pay fifty dollars a ticket to attend his stupid birthday party. After his "cunt" comment, the conversation elevated a bit as guests switched to discuss the two major cultural events in New York City that winter: *Last Tango in Paris*, which had just opened officially, and *Deep*

Throat, which the *New York Times Magazine* called "Porno Chic" in a recent cover story. Andrew Sarris didn't know Mailer and never got around to meeting him that day, but the critic's film credentials from the *Village Voice* made him more of an authority on *Last Tango* and *Deep Throat* than most people at the fete. Sarris told anyone who'd listen that Bernardo Bertolucci's film "wasn't that good." He had a reason not to like *Last Tango*, especially after Pauline Kael had made it her cause célèbre. Kael and Sarris could never agree on anything after she had panned his beloved "auteur theory" in print years ago, and had offended him once by suggesting he bring his "partner," that is, male lover, to lunch one day, even though Sarris was straight and now married to fellow film critic Molly Haskell. Sarris had less reason to dislike *Deep Throat*, saying it "certainly didn't invent oral sex, but it may well have been the first porno film to exploit it."

Last Tango and *Deep Throat*. It's all anybody talked about.

Bertolucci didn't make it to Mailer's birthday party to defend his film, but Harry Reems did, although Sarris somehow missed seeing or speaking to the porn actor. Instead, the rather owlish-looking movie critic held forth in a sizable circle of listeners on "how ridiculous it was for Mailer to make such a fuss over the lack of full-frontal male nudity in Brando's *Last Tango* performance when, only a few years before, Alan Bates and Oliver Reed had bared all when they wrestled nude in Ken Russell's *Women in Love*."

Sarris laughed as he went on and on about Bates and Reed and Brando and Bertolucci when, suddenly, he looked up and there was Alan Bates staring at him across the Four Seasons restaurant, listening to his every word. The actor was in New York to perform on Broadway in the play *Butley*. It was a terribly embarrassing moment for Sarris, who just stood there wanting to evaporate. Bates then did something "remarkable," according to Sarris, something that made

him relax and know that everything was all right. "He simply winked at me with a friendly, conspiratorial expression," said the critic.

After a ten-day nonjury trial, Judge Tyler mulled over more than one thousand pages of expert testimony regarding *Deep Throat*. Then he ruled, "This is one throat that deserves to be cut."

The next day, the New World theater, fined for $3 million, put up a few new letters on its marquee: "Judge Cuts Throat, World Mourns."

Spring 1973 and Beyond, Finales

By the time PBS finished airing all twelve episodes of *An American Family*, drawing more than ten million viewers per week, Lance Loud had already received three Bibles in the mail. Also, "I got a lot of letters from gay guys, gay suburban kids, who thanked me for being a voice of outrage in a bland fucking normal middle-class world," said Lance, who went on to call himself, with rueful accuracy, "the homo of the year."

His major nemesis, the *New York Times*'s Anne Roiphe, went on to write more articles about television for the newspaper, including one praising the CBS series *The Waltons*, which featured, she felt, a good and hardworking American family from the Depression that was everything the Louds were not.

Roiphe did not mention Lance or the other Louds in her *Waltons* critique, nor was he mentioned, despite his self-proclamation as "the homo of the year," in the *Times*'s less-than-celebratory article "Doctors Rule Homosexuals Not Abnormal," which reported on the American Psychiatric Association's decision to delete homosexuality from its official list of mental disorders. Nineteen seventy-three was definitely a good year for sexual liberation, bracketed by the APA decision in December and the Supreme Court's *Roe v. Wade*

ruling in January, which made abortion a fundamental right under the U.S. Constitution. The court's abortion ruling and the APA decision were applauded by liberals; those twin edicts, however, also functioned to galvanize conservatives, uniting them around causes to stop reproductive rights, stop gay rights, stop pornography, stop whatever else they thought contributed to a permissive society. And people are always more willing to fight battles they think they've just lost than defend those they think they've just won.

As the pop culture scene in America grew much less New York City–centric, the sexual taboos continued to fall but at a much slower pace than in the Sexplosion years. The daring subject matter and language of the Broadway stage had already been co-opted by the movies. And the Manhattan world of book publishing would never again enjoy the sexual halcyon of *Myra Breckinridge, Couples*, and *Portnoy's Complaint*: three smart novels by East Coast intellectuals that dominated the bestseller lists.

Pop culture would also become much less man-made.

This tale of pop rebels has been, essentially, a male tale. A few women have made appearances, as actresses. But performers, especially in the late 1960s and early 1970s, were rarely instrumental in making a project happen (Jane Fonda and Natalie Wood being the possible exceptions), and there were no female executives, producers, or directors to help in those groundbreaking endeavors. Only one major female writer was a significant force, Penelope Gilliatt, and even her screenplay for *Sunday Bloody Sunday* was not her story but rather John Schlesinger's, conceived by him and based loosely on an incident in his life. The choreographers Margo Sappington and Julie Arenal made significant contributions to the stage shows *Oh! Calcutta!* and *Hair*, respectively, but they would be the first to admit that those projects did not tell their stories or necessarily reflect their worldview.

After the sagas of *An American Family, Last Tango in Paris*, and *Deep Throat* played out in early 1973, the marketplace began

to open for female artists, with book publishers providing the most inviting platform. Nancy Friday's *My Secret Garden*, the first published compilation of women's sexual fantasies, went on to become a bestseller, as did Erica Jong's novel *Fear of Flying*, published later that year. Tellingly, both books were late bloomers, doing only respectable business in their hardcover editions in 1973 but selling millions in paperback in 1974 and beyond as the culture became more accepting of female provocateurs.

Friday had tried in the late 1960s to write a novel in which she devoted "one entire chapter in the book to a long idyllic reverie of the heroine's sexual fantasies," as she described it. But her editor, a man, balked. "If she's so crazy about this guy she's with, if he's such a great fuck, then why's she thinking about all these other crazy things . . . why isn't she thinking about him?" he asked.

Sensing a hostile environment, Friday chose not to finish her novel. Instead, she took out ads in newspapers and magazines to begin work on a nonfiction book. The ad for this project read: "Female Sexual Fantasies wanted by serious female research. Anonymity guaranteed," and she solicited women to write and submit their stories.

Friday's first sexual fantasy entry in *My Secret Garden* is her own fantasy, one in which she dreams about sharing an orgasm with a man under the cover of a wool blanket at a Baltimore Colts–Minnesota Vikings game as Johnny Unitas scores a touchdown. Dozens of other sex stories follow in the book. A new magazine, *Ms.*, founded by Gloria Steinem and other feminists, was not pleased, and its editors had little time for the subject matter of *My Secret Garden*—or its author. "This woman is not a feminist," proclaimed the *Ms.* review of Friday's book. The author took solace in "the millions of women who went on to buy *My Secret Garden*," she said.

Erica Jong had better luck with *Ms.*, having developed a few years of feminist credibility with her published poetry. No matter

that "cunt," the new N-word for female, appeared multiple times in *Fear of Flying*, her first novel, about a woman who engages in quickie sex with total strangers—or, as Jong famously coined it, "the zipless fuck."

"New American Library saw my book as the first breakthrough novel about female sexual fantasies," said Jong.

Fear of Flying owed its success, in part, to two principal players from the Sexplosion years.

"Oh, I loved that book," Jong said of Philip Roth's *Portnoy's Complaint.* "I think I learned something from it: the switching back and forth between past and present. I reread *Portnoy's Complaint* many times and I realized that one need not worry about leaping back and forth, that it could be very readable. His books were proof to me that it could be done." While Jong credited Roth's writing style, it could not be denied that the sexual derring-do of his novel helped to develop a readership for a funny book about anonymous sex, even one written by a woman.

Equally important, John Updike wrote a rave review of Jong's book in *The New Yorker*, in which he called *Fear of Flying* a "lovable, delicious novel (each chapter garnished with epigraphs)," which brought the book to the attention of other notable critics, who treated it as a serious work of fiction and not a potboiler like Grace Metalious's *Peyton Place* or Jacqueline Susann's *The Valley of the Dolls*.

Erica Jong and Nancy Friday, however, were in the minority. During the Sexplosion years, men were most likely the storytellers and women, if they had any status at all, were their critics—critics who would increasingly be heard objecting to certain taboos, especially those dealing with sex and violence.

In 1974, Stanley Kubrick took *A Clockwork Orange* out of circulation in the United Kingdom due to accusations that the film inspired copycat rapes and other violent acts. As his wife, Christiane Kubrick, recalled, "When it was released in England, it was blamed

unfairly for the increase in crime and there were cries to ban it. We received hate mail and death threats."

Anthony Burgess was one of those who grew to hate the film, so much so that he eventually turned his novel into a play, which included the stage direction: "A man bearded like Stanley Kubrick comes on playing, in exquisite counterpoint, 'Singin' in the Rain' on a trumpet. He is kicked off the stage."

While Kubrick's film came under attack in England, the Supreme Court of Georgia ruled that Mike Nichols's film *Carnal Knowledge* was obscene, and banned it. For a moment in 1974, sexual expression in pop culture got a reprise when the U.S. Supreme Court overturned that decision, ruling that the film did not "depict sexual conduct in a patently offensive way."

" 'Carnal Knowledge' Not Porn," blared the *Variety* headline. But no sooner did Hollywood's bible publish its page-one story about Nichols's film than FBI agents in New York City arrested *Deep Throat* star Harry Reems, who was later hit with an indictment in Memphis, Tennessee, on federal charges of conspiracy to distribute obscenity across state lines.

Hollywood stars, from Warren Beatty to Jack Nicholson, held parties to help pay Reems's legal fees. Who knew? Any actor could be the next if he or she appeared naked or simulated sex or simply said "fuck" in a movie or onstage. And Mike Nichols, still smarting from his own legal mess, recalled, "I found myself at all these fund-raisers with that actor with the big dick."

Several sex-themed movies suddenly didn't look so lucratively attractive. One of those was *Blue Movie*.

In 1975, Ringo Starr, having forgotten his bad acting experience in the movie *Candy*, held the option to Terry Southern's novel *Blue Movie* and thought he had Mike Nichols on board to direct at Warner Bros. Then the deal unraveled. Southern wrote to studio head John Calley, pleading that they not miss this opportunity to make "the

porn to end all porn." It didn't depend on Nichols, in Southern's opinion. "What about Stanley? Or Coppola?" he wanted to know. But Kubrick and Coppola were also suddenly not interested—and never would be. What did it matter that Harry Reems eventually got his *Deep Throat* conviction overturned? No one saw the advantage of being the next sex martyr.

Except for Gore Vidal.

Undaunted by the memory of having his *Myra Breckinridge* ruined by Hollywood, Vidal continued to believe in this long-gestating screenplay he'd written—one that mused on the anarchic politics, insane extravagances, and sexual perversities of an ancient Roman ruler named Caligula. Since no motion picture studio—major or minor—would touch it, Vidal found a complete film novice to produce it: Bob Guccione, publisher and editor in chief of *Penthouse*.

Gore Vidal's Caligula, as it was originally titled before the author had his name removed in exchange for giving up his profit points, delivered what Southern's *Blue Movie* novel had envisioned almost a decade earlier: graphic sex in a big-budget X-rated movie featuring major stars. With one caveat: *Caligula*'s famous cast—Malcolm McDowell, Peter O'Toole, John Gielgud, and Helen Mirren—left the full-penetration and ejaculation shots to anonymous extras. But it was porn nonetheless and very expensive and a total embarrassment, and the perception that graphic sex and art could successfully coexist at the movies was given its burial.

Larry Kramer and William Friedkin were other major figures from the Sexplosion years who returned to challenge the sexual status quo only to do battle with another foe. Political correctness had been born of the feminist and black civil rights movements of the late 1960s, and as Kramer and Friedkin were to learn when it came to homosexual subject matter, there was probably a reason that Malcolm X never wrote a book called *Niggers* or Gloria Steinem never wrote one called *Cunts*.

In 1978, Kramer wrote *Faggots*, a novel about homosexual promiscuity. It caused such consternation in the gay community that the Oscar Wilde Book Store in Greenwich Village refused to stock the novel. "The straight world thought I was repulsive, and the gay world treated me like a traitor. People would literally turn their back when I walked by," recalled Kramer.

After directing the *Boys in the Band* movie, Friedkin returned to the Greenwich Village scene in the late 1970s to shoot *Cruising*, in which Al Pacino played an undercover cop investigating murders in the world of gay S&M. Activists protested and Vincent Canby in the *New York Times* agreed with them, calling the film a "homosexual nightmare." Suddenly, the old Production Code didn't look so bad to certain niche audiences: No-depiction of homosexuals had to be better than this depiction of homosexuals.

Kramer more than redeemed himself in the following decade with *The Normal Heart*, a play about the onset of AIDS that advocated, among other things, that gays stop having sex and start watching porn on that new medium: video. Ronald Reagan may never have gotten around to "cleaning up the mess in Berkeley" when he was governor of California, but as president of the United States he did see that the federal government in the 1980s stayed away from AIDS research and that foreigners with the HIV virus were prevented from entering the country. Weeks after Rock Hudson died from AIDS in 1987, the long-running gay-themed musical *La Cage aux Folles* suddenly closed on Broadway; and even heterosexual themed material was not immune. In that year's James Bond installment, *License to Kill*, the spy suddenly had to make do with just one female sex partner.

The "porno chic" of the early 1970s, once trumpeted on the front page of the Sunday *New York Times Magazine*, had devolved into Linda Boreman of *Deep Throat* writing no fewer than two antipornography exposés in the 1980s, *Ordeal* and *Out of Bondage*, which featured a foreword by Gloria Steinem.

No taboo was more firmly reestablished at this time than sex with a minor. While Stanley Kubrick's 1962 screen version of Vladimir Nabokov's novel *Lolita* had achieved classic status, critics lambasted (and audiences avoided) Edward Albee's 1981 stage adaptation and Adrian Lyne's 1997 screen adaption of *Lolita*, due in part to the subject matter of an adult man having sex with a twelve-year-old girl.

In 1981, nearly a decade after the release of *Sweet Sweetback's Baadasssss Song*, the Adelaide Film Festival banned Melvin Van Peebles's breakthrough film when South Australia's attorney general, Trevor Griffin, objected to "the first four minutes of the film [in which] there is an explicit sequence of a young Negro boy in a position of gross indecency with a Negro woman. I don't think I'd spend my time going to watch it." And even more significant, when Mario Van Peebles wrote, directed, and produced *Baadasssss!*, his 2003 movie about the making of his father's *Sweet Sweetback Baadasssss Song*, the one scene he did not faithfully re-create was his own deflowering at age thirteen in the arms of a prostitute. Graphic sex with a minor proved too controversial even for the director of a movie called *Baadasssss!*

Pornography didn't go underground; it instead entered the front door of millions of homes with the advent of video technology that greatly expanded its reach. Taken off theater marquees and newsstands, it no longer stirred much controversy or heated debate, even among archfeminists who had bought *Ordeal* and *Out of Bondage*. For her part, Linda Boreman returned to the world she knew best, and using her old nom de porn Linda Lovelace, she posed for a pictorial in the soft-core *Leg Show* magazine. Porn wasn't chic. It was now ordinary and everywhere.

Around the turn of the millennium, after an exhaustive search of British film vaults, British critic Mark Kermode found the "Rape of Christ" sequence, as well as other scenes cut from *The Devils*. His discovery led to the making of Paul Joyce's documentary *Hell*

on Earth: The Desecration and Resurrection of Ken Russell's The Devils, narrated by Kermode and released in 2004. It spurred screenings of the uncut version of *The Devils* at film festivals throughout the world, and the film is oft cited as Russell's very best. It is also a reminder of what groundbreaking work the major Hollywood studios once produced on a regular basis in the Sexplosion years—and how diminished that output has been since then.

Warner Bros. had long abandoned producing any film like *The Devils*—or, for that matter, *The Damned, Death in Venice*, or *Performance*—and instead concentrated on mega-profit-making franchises like the Batman and Harry Potter movies. United Artists, home of *Midnight Cowboy, Women in Love, Sunday Bloody Sunday*, and *Last Tango in Paris*, languished as a major force in Hollywood, and was eventually bought by Tom Cruise to make his Nazi action picture *Valkyrie*, released in 2008. Sex-themed movies—movies like David Cronenberg's *Crash*, about car accident fetishists; or Todd Field's *Little Children*, about suburban infidelity; or *Brokeback Mountain*, about gay cowboy lovers; or *Shame*, about sex addiction—were left to the small independent studios. These films sometimes played to more limited or niche audiences, but the stories were told and often without compromise. The impact on the culture has been undeniable.

Where President Richard Nixon once fulminated in the Oval Office over the appearance of a gay character in *All in the Family*, President Barack Obama embraced "out" TV star Jesse Tyler Ferguson at a reelection fund-raiser in West Hollywood, and complimented him on his portrayal of a homosexual father on *Modern Family*. "Michelle and my daughters love that show," gushed the president of the United States.

The first lady also waded into formerly forbidden territory when she commented on E. L. James's S&M-themed bestseller *Fifty Shades of Grey*. While Michelle Obama admitted to not having read

the novel, she did give it her tacit approval, noting, "But it's obviously tacked into something, and giving people permission to explore parts of themselves that maybe felt a bit taboo."

Even before the Obamas took up residence in the White House, the *New York Times* editor A. M. Rosenthal had been dead a couple of years, not that his gay-baiting ended with his death at age eighty-four. His tombstone in Westchester Hills, New York, carries the epitaph "He kept the paper straight." Otherwise, his legacy did not live on at the *Times*, which employed several openly gay staffers, including its chief theater critic. Ben Brantley has presided over a wildly more liberal, if marginalized, Broadway than in Rosenthal's era. Where the *Hair* creators James Rado and Gerome Ragni chose to hide their romance during the musical's long run, gay and lesbian couples were now married on the stage of the musical's revival at the St. James Theatre shortly after same-sex marriage was legalized in New York State.

Four decades after its first unveiling, the big nude scene in *Hair* looked quaint in its stasis and shadows, and naked actors were no longer easy roadkill for judges, politicians, or other censors. Back in the Sexplosion years, those bluenose decisions sometimes came from notables who were otherwise liberal: In 1973, Nicolas Roeg followed his *Performance* directorial debut with *Don't Look Now*, a film that Warren Beatty personally took upon himself to censor when he complained to executives at Paramount that "you can see her pussy." The anatomy in question belonged to Beatty's ex-girlfriend Julie Christie, who'd apparently gotten carried away in her big love scene with Donald Sutherland, whom Beatty saw as a rival, albeit in retrospect. Regarding deep frontal nudity, nearly two decades passed until Sharon Stone's self-proclaimed "leg-crossing" scene in *Basic Instinct* made the journeyman actress, at age thirty-two, a star. Since then, incensed outrage over nudity has been replaced by mild amusement. At the 2012 Golden Globes, George Clooney joked

from the podium about the size of Michael Fassbender's oft-exposed penis in *Shame*. And when Helen Hunt played a sex surrogate, a role that required her to be totally naked for most of her screen time in *The Sessions*, she commented about reporters' overuse of the word "brave" to describe her performance. " 'Brave' is 'naked,' right?" she quipped, and went on to receive an Academy Award nomination for her effort.

Today, full frontal nudity is more common on cable TV than cigarette smoking is in office buildings, and the MPAA has tolerated one "fuck" per PG movie since the 1990s.

Even Lance Loud ultimately proved victorious over the reactionaries who once condemned him in *Newsweek*, the *New York Times*, and elsewhere. A decade after his death at age fifty, HBO aired the film *Cinema Verite*, a behind-the-scenes look at the making of *An American Family*. Of all the Andy Warhol superstars, only Edie Sedgwick achieved what Lance Loud did. Someone had cared enough to make a movie about him.

Acknowledgments

I am pleased and very proud to pay taxes to support the public libraries that make a book like this possible. Those libraries include the Beverly Hills Public Library, Library for the Performing Arts at Lincoln Center, Los Angeles Public Library, New York City Public Library, and West Hollywood Public Library. Also essential to my research were such private institutions as the Margaret Herrick Library at the Academy of Motion Picture Arts & Sciences and the One Institute at the University of Southern California. Their librarians are my saviors.

I'm indebted to all the people whom I interviewed for this book, especially Michael Childers, who shared not only his memories but his magnificent photographs.

Peter Bloch, Holly Millea, and Stephen M. Silverman were early supporters who made invaluable suggestions regarding what I wrote. And Denise Smaldino designed a mock-up book cover that aided immensely in helping to find a publisher.

Above all, this book would not be a book without my agent, Eric Myers at the Spieler Agency; my editors, Cal Morgan and Denise Oswald at HarperCollins; and my photo guru, Howard Mandelbaum at Photofest.

Bibliography

Adair, Gilbert. *The Real Tadzio: Thomas Mann's* Death in Venice *and the Boy Who Inspired It*. New York: Carroll & Graf, 2003.

Aldgate, Anthony, and James C. Robertson. *Censorship in Theatre and Cinema*. Edinburgh: Edinburgh University Press, 2005.

Amburn, Ellis. *The Sexiest Man Alive: A Biography of Warren Beatty*. New York: Harper Entertainment, 2002.

Andersen, Christopher. *Citizen Jane: The Turbulent Life of Jane Fonda*. New York: Henry Holt, 1990.

Ann-Margret, with Todd Gold. *Ann-Margret: My Story*. New York: Putnam, 1994.

Bailey, David, and Peter Evans. *Goodbye Baby & Amen*. New York: Coward-McCann, 1969.

Baker, Roy Ward. *The Director's Cut: A Memoir of 60 Years in Film and Television*. London: Reynolds & Hearn, 2000.

Barrett, Raina. *First Your Money, Then Your Clothes: My Life and* Oh! Calcutta! New York: Signet /New American Library, 1973.

Bart, Peter. *Infamous Players: A Tale of Movies, the Mob (and Sex)*. New York: Weinstein Books, 2011.

Baxter, John. *An Appalling Talent/Ken Russell*. London: Michael Joseph, 1973.
———. *Glenda Jackson*. London: Michael Joseph, 1973.

Bergen, Candice. *Knock Wood*. New York: Linden Press/Simon & Schuster, 1984.

Bisbort, Alan. *Media Scandals: Scandals in American History*. Westport, CT: Greenwood Press, 2009.

Biskind, Peter. *Star: How Warren Beatty Seduced America*. New York: Simon & Schuster, 2011.

Biswell, Anthony. *The Real Life of Anthony Burgess*. London: Macmillan UK, 2007.

Bloom, Claire. *Leaving a Doll's House: A Memoir*. New York: Little, Brown, 1996.

Bloom, Harold, ed. *Philip Roth's* Portnoy's Complaint. Philadelphia: Chelsea House, 2004.

Bockris, Victor. *The Life and Death of Andy Warhol*. New York: Bantam Books, 1998.

———. *Warhol*. Boston: Da Capo Press, 2003.

Bogarde, Dirk. *An Orderly Man*. London: Chatto & Windus, 1983.

———. *Snakes & Ladders*. London: Chatto & Windus, 1991.

Bosworth, Patricia. *Jane Fonda: The Private Life of a Public Woman*. New York: Houghton Mifflin Harcourt, 2011.

———. *Marlon Brando*. New York: Lipper/Viking, 2001.

Brando, Marlon, with Robert Lindsey. *Brando: Songs My Mother Taught Me*. New York: Random House, 1997.

Brode, Douglas. *The Films of Jack Nicholson*. New York: Citadel Press, 1996.

Broer, Lawrence R., ed. *Rabbit Tales: Poetry and Politics in John Updike's Rabbit Novels*. Tuscaloosa: University of Alabama Press, 1998.

Brown, David. *Let Me Entertain You*. New York: William Morrow, 1990.

Bruce, Lenny. *How to Talk Dirty and Influence People: An Autobiography*. New York: Fireside, 1992.

Burgess, Anthony. *You've Had Your Time*. New York: Grove Press, 1991.

Buruma, Ian. *Conversations with John Schlesinger*. New York: Random House, 2005.

Capsuto, Steven. *Alternate Channels: The Uncensored Story of Gay and Lesbian Images on Radio and Television*. New York: Ballantine Books, 2000.

Carey, Gary. *Marlon Brando: The Only Contender*. New York: St. Martin's Press, 1986.

Cassell, Erik. *Lindsay Anderson: Maverick Film-Maker*. London: Cassell, 1998.

Castle, Alison, ed., Jan Harlan, Christian Kubrick, and Stanley Kubrick. *The Stanley Kubrick Archives*. Cologne: Taschen, 2008.

Chandler, Charlotte. *She Always Knew How: Mae West*. New York: Simon & Schuster, 2009.

Childers, Michael, and Christine Gildes. *Icons and Legends: The Photography of Michael Childers*. Palm Springs, CA: Palm Springs Desert Museum, 2004.

Chunovic, Louis. *One Foot on the Floor: The Curious Evolution of Sex on Television from* I Love Lucy *to* South Park. New York: TV Books, 2000.

Colacello, Bob. *Holy Terror: Andy Warhol Close Up*. New York: HarperCollins, 1980.

Coldstream, John. *Dirk Bogarde: The Authorised Biography*. London: Orion, 2004.

Crane, Robert David, and Christopher Fryer. *Jack Nicholson: Face to Face.* New York: M. Evans, 1975.

Crimp, Douglas. *"Our Kind of Movie": The Films of Andy Warhol.* Cambridge, MA: MIT Press, 2012.

Davis, Lorrie, and Rachel Gallagher. *Letting Down My Hair: Two Years with the Love Rock Tribe—from Dawning to Downing of Aquarius.* New York: A. Fields Books, 1973.

Dearborn, Mary V. *The Happiest Man Alive: A Biography of Henry Miller.* New York: Touchstone, 1992.

Dundy, Elaine. *Finch, Bloody Finch: A Life of Peter Finch.* New York: Holt, Rinehart & Winston, 1980.

Ebert, Roger. *Life Itself: A Memoir.* New York: Grand Central, 2011.

Epstein, Helen. *Joe Papp: An American Life.* New York: Little, Brown, 1995.

Evans, Robert. *The Kid Stays in the Picture.* New York: Hyperion, 1994.

Faulkner, Trader. *Peter Finch.* New York: Taplinger, 1979.

Feiffer, Jules. *Backing into Forward.* New York: Nan A. Talese/Doubleday, 2010.

Ferguson, Michael. *Little Joe, Superstar: The Films of Joe Dallesandro.* Laguna Hills, CA: Companion Press, 1998.

Ferguson, Robert. *Henry Miller: A Life.* New York: Norton, 1993.

Fine, Marshall. *Bloody Sam: The Life and Films of Sam Peckinpah.* New York: Hyperion, 2007.

Finkelstein, Nat. *Andy Warhol: The Factory Years 1964–1967.* New York: Powerhouse Books, 2010.

Finstad, Suzanne. *Natasha: The Biography of Natalie Wood.* New York: Harmony Books, 2002.

———. *Warren Beatty: A Private Man.* New York: Harmony Books, 2005.

Fonda, Jane. *My Life So Far.* New York: Random House, 2005.

Freedland, Michael. *Jane Fonda: A Biography.* New York: St. Martin's Press, 1988.

Friday, Nancy. *My Secret Garden.* New York: Pocket Books, 1998.

Friedkin, William. *The Friedkin Connection: A Memoir.* New York: HarperCollins, 2013.

Gardner, Gerald. *The Censorship Papers: Movie Censorship Letters from the Hays Office, 1934 to 1968.* New York: Dodd, Mead, 1994.

Gerard, Fabien S., T. Jefferson Klin, and Bruce Sklarew, eds. *Bernardo Bertolucci: Interviews.* Jackson: University Press of Mississippi, 2000.

Gerber, Gail, with Tom Lisanti. *Trippin' with Terry Southern: What I Think I Remember.* Jefferson, NC: McFarland, 2009.

Gibson, Jon M., and Chris McDonnell. *Unfiltered: The Complete Ralph Bakshi.* New York: Universe, 2008.

Gomez, Joseph A. *Ken Russell: The Adaptor as Creator.* London: Frederick Muller, 1976.

Goodwin, Cliff. *Evil Spirits: The Life of Oliver Reed*. London: Virgin Books, 2001.

Greenberg, Jan, and Sandra Jordan. *Andy Warhol: Prince of Pop*. New York: Delacorte Press, 2004.

Grode, Eric. *Hair: The Story of the Show That Defined a Generation*. Philadelphia: Running Press, 2010.

Guiles, Fred Lawrence. *Jane Fonda: The Actress in Her Time*. New York: Doubleday, 1982.

Gussow, Mel. *Edward Albee: A Singular Journey*. New York: Applause, 2001.

Hayes, Kevin J., ed. *Sam Peckinpah: Interviews*. Jackson: University Press of Mississippi, 2008.

Herman, Gary. *Rock 'n' Roll Babylon*. London: Plexus, 1982.

Higham, Charles. *Brando: The Unauthorized Biography*. New York: New American Library, 1988.

Highberger, Craig B. *Superstar in a Housedress: The Life and Legend of Jackie Curtis*. New York: Chamberlain Bros., 2005.

Hill, Lee. *A Grand Guy: The Art and Life of Terry Southern*. New York: HarperCollins, 2001.

Hollander, Xaviera, with Robin Moore and Yvonne Dunleavy. *The Happy Hooker: My Own Story*. New York: Dell, 1972.

Hurwood, Bernhardt J. *Burt Reynolds*. New York: Quick Fox, 1979.

Johnson, Jonathon. *Good Hair Days: A Personal Journey with the American Tribal Love-Rock Musical Hair*. New York: iUniverse, 2004.

Johnson, Paul. *Intellectuals*. London: Weidenfeld & Nicolson, 1988.

Kael, Pauline. *For Keeps: 30 Years at the Movies*. New York: Plume, 1996.

Kaplan, Fred. *Gore Vidal: A Biography*. New York: Doubleday, 1999.

Kellow, Brian. *Pauline Kael: A Life in the Dark*. New York: Viking, 2011.

Koestenbaum, Wayne. *Andy Warhol*. New York: Lipper/Viking, 2001.

Kramer, Larry. Women in Love *and Other Dramatic Writings*. New York: Grove Press, 2002.

Lahr, John, ed. *The Diaries of Kenneth Tynan*. London: Bloomsbury, 2001.

Lambert, Gavin. *Natalie Wood: A Life*. New York: Knopf, 2004.

Lanza, Joseph. *Fragile Geometry: The Films, Philosophy and Misadventures of Nicolas Roeg*. New York: PAJ, 1989.

Lewis, John. *Hollywood v. Hard Core: How the Struggle over Censorship Saved the Modern Film Industry*. New York: New York University Press, 2000.

Lewis, Roger. *Anthony Burgess*. London: Faber & Faber, 2003.

LoBrutto, Vincent. *Stanley Kubrick: A Biography*. New York: Donald I. Fine Books, 1997.

Loud, Pat, with Nora Johnson. *Pat Loud: A Woman's Story*. New York: Coward, McCann & Geoghegan, 1974.

Lovelace, Linda. *Inside Linda Lovelace*. New York: Pinnacle Books, 1973.

Lovelace, Linda, with Mike McGrady. *Ordeal: The Truth Behind* Deep Throat. New York: Citadel Press, 1980.

McDonough, Jimmy. *Big Breasts and Square Jaws: The Biography of Russ Meyer, King of the Sex Film.* New York: Three Rivers Press, 2006.

McDouglas, Dennis. *Five Easy Decades: How Jack Nicholson Became the Biggest Movie Star in Modern Times.* New York: Wiley, 2008.

McGilligan, Patrick. *Jack's Life: A Biography of Jack Nicholson.* New York: Norton, 1996.

Mailer, Norman. *The Prisoner of Sex.* Boston: Little, Brown, 1971.

Mann, Katia. *Unwritten Memories.* New York: HarperCollins, 1976.

Mann, William J. *Edge of Midnight: The Life of John Schlesinger.* New York: Billboard Books, 2005.

Manso, Peter. *Brando.* New York: Hyperion Books, 1995.

———. *Mailer: His Life and Times.* New York: Washington Square Press, 2008.

Marc, David, and Robert J. Thompson. *Prime Time, Prime Movers: From* I Love Lucy *to* L.A. Law—*America's Greatest TV Shows and the People Who Created Them.* Boston: Little, Brown, 1992.

Mazursky, Paul. *Show Me the Magic.* New York: Simon & Schuster, 1999.

Mitzel, John, and Steven Abbott. *Myra & Gore: A Book for Vidalophiles.* New York: Manifest Destiny Book, 1976.

Offen, Ron. *Brando.* Chicago: Henry Regnery, 1973.

Parker, John. *The Joker's Wild: The Biography of Jack Nicholson.* London: Anaya, 1991.

———. *Warren Beatty: The Last Great Lover of Hollywood.* New York: Carroll & Graf, 1993.

Pennington, Jody W. *The History of Sex in American Film.* New York: Praeger, 2007.

Phillips, Gene D. *John Schlesinger.* Boston: Twayne, 1981.

———. *Ken Russell.* Boston: Twayne, 1979.

Resnick, Sylvia Safran. *Burt Reynolds: An Unauthorized Biography.* New York: St. Martin's Press, 1983.

Reynolds, Burt. *My Life.* New York: Hyperion, 1994.

Richards, Keith, with James Fox. *Life.* New York: Little, Brown, 2010.

Rollyson, Carl E. *The Lives of Norman Mailer: A Biography.* St. Paul, Minn.: Paragon House, 1991.

Roth, Philip. *The Facts: A Novelist's Autobiography.* New York: Vintage Books, 1998.

———. *Reading Myself and Others.* New York: Vintage International, 1974.

Russell, Ken. *Altered States: The Autobiography of Ken Russell.* New York: Bantam Books, 1991.

Salwolke, Scott. *Nicolas Roeg: Film by Film.* Jefferson, NC: McFarland, 1993.

Scherman, Tony, and David Dalton: *Pop: The Genius of Andy Warhol*. New York: Harper, 2009.

Shellard, Dominic. *Kenneth Tynan: A Life*. New Haven, CT: Yale University Press, 2003.

Siegel, Barbara, and Scott Siegel. *Jack Nicholson: The Unauthorized Biography*. New York: Avon Books, 1991.

Simmons, Garner. *Peckinpah: A Portrait in Montage*. New York: Limelight Editions, 1998.

Spoto, James. *Otherwise Engaged: The Life of Alan Bates*. New York: Random House, 2007.

Southern, Nile. *The Candy Men: The Rollicking Life and Times of the Notorious Novel* Candy. New York: Arcade, 2004.

Staiger, Janet. *Blockbuster TV: Must-See Sitcoms in the Network Era*. New York: New York University Press, 2000.

Stein, Jean, ed., with George Plimpton. *Edie: An American Biography*. New York: Knopf, 1989.

Streitmatter, Rodger. *From "Perverts" to "Fab Five": The Media's Changing Depiction of Gay Men and Lesbians*. New York: Routledge, 2009.

———. *Sex Sells! The Media's Journey from Repression to Obsession*. New York: Westview Press, 2005.

Thomas, Bob. *Brando*. New York: W. H. Allen, 1973.

Thompson, Peter. *Jack Nicholson: The Life and Times of an Actor on the Edge*. New York: Birch Lane Press, 1997.

Trevelyan, John. *What the Censor Saw*. London: Michael Joseph, 1973.

Turan, Kenneth, and Joseph Papp. *Free for All: Joe Papp, the Public, and the Greatest Theater Story Ever Told*. New York: Doubleday, 2009.

Tynan, Kathleen. *The Life of Kenneth Tynan*. New York: William Morrow, 1988.

Tytell, John. *The Living Theatre: Art, Exile, and Outrage*. New York: Gross Press, 1995.

Umland, Rebecca, and Sam Umland. *Donald Cammell: A Life on the Wild Side*. London: FAB, 2006.

Van Peebles, Melvin. Sweet Sweetback's Baadasssss Song: *A Guerilla Filmmaking Manifesto*. New York: Thunder's Mouth Press, 2004.

Vidal, Gore. *Palimpsest: A Memoir*. New York: Penguin Books, 2007

———. *Point to Point Navigation: A Memoir, 1964 to 2006*. New York: Doubleday, 2008.

Walker, Alexander. *Hollywood U.K.* Briarcliff Manor, NY: Stein & Day, 1974.

Warhol, Andy, and Pat Hackett. *POPism: The Warhol Sixties*. New York: Mariner Books, 1990.

Watson, Steven. *Factory Made: Warhol and the Sixties*. New York: Pantheon, 2003.

Wolf, Reva. *Andy Warhol, Poetry, and Gossip in the 1960s.* Chicago: University of Chicago Press, 1998.

Wollman, Elizabeth. *The Theater Will Rock: A History of the Rock Musical, from* Hair *to* Hedwig. Ann Arbor: University of Michigan Press, 2006.

Woodlawn, Holly, with Jeffrey Copeland. *The Holly Woodlawn Story: A Low Life in High Heels.* New York: St. Martin's Press, 1991.

Yacowar, Maurice. *The Films of Paul Morrissey.* Cambridge: Cambridge University Press, 1993.

Notes

Introduction: 1966 and 1967, Caution

xiv "No American films": Rex Reed, "After the 'Blow-Up,' a Close-Up," *New York Times*, Jan. 1, 1967, D-7

xv "It was all right": Bosley Crowther, "The Underground Overflows," *New York Times*, Dec. 11, 1966.

xv Chelsea Hotel's manager: Crimp, *"Our Kind of Movie,"* 102.

xvi "it was in someone's bedroom": Brigid Berlin, "Brigid Berlin Talks to Factory Co-Worker Paul Morrissey," *Interview*, February 1989, 57.

xvii "I can't believe": Steven Watson, *Factory Made*, 308.

xix "golden age for creative": "No Limits," *Newsweek*, June 22, 1964.

Chapter One: Winter 1968, Guts

2 "I had this idea": Yacowar, *The Films of Paul Morrissey*, 21.

3 Viva Paper Towels: Guy Flatley, "How to Be Very Viva," *New York Times*, Nov. 9, 1969, 17.

3 "They felt they were": Dallesandro to author, Sept. 29, 2012.

3 *The Glory of the Fuck*: Wayne Koestenbaum, *Andy Warhol*, 146.

3–4 "The story is"/"Jackie Kennedy"/"Save it": Sally Kempton, "Viva of the Visions," *Village Voice*, Feb. 22, 1968, 51.

4 "There were planes": Dallesandro to author, Sept. 29, 2012.

4 "All of the males": Margia Kramer, "The Warhol File," *Village Voice*, May 17, 1988.

5 "sick sex": Robert Wilonsky, "Southern Comfort," *New Times Los Angeles*, Feb. 11–17, 1999, 4.

5 "pornographer": Southern, *The Candy Men*, 262.

5 "not a suitable vehicle": Ibid., 263.

6 atoll of Tetiaroa: Manso, *Brando*, 634.

6 "I have nothing": Southern, *The Candy Men*, 311.

7 "1960s movie"/"wonderful ass": Manso, *Brando*, 636.

8 "Soon, rumors reached": Southern, *The Candy Men*, 313.

7–8 "every one conceivable"/"We're keeping it a secret": Offen, *Brando*, 181.

8 "This movie makes": Bosworth, *Marlon Brando*, 157.

8 one thousand British pounds: Kaplan, *Gore Vidal*, 577.

9 "madly in love": Gerald Clarke, "Petronius Americanus," *Atlantic*, March 1972, 51.

9 "To cane a woman": Johnson, *Intellectuals*, 326.

9 "I love prostitution": "More of Gore," *Screw*, Nov. 23, 1970, 6.

10 "a skit, a song": Lewis Funke, "Tynan Plans a Stage Tribute to Eros," *New York Times*, April 9, 1969, 54.

10 word "fuck" on TV: Lahr, *The Diaries of Kenneth Tynan*, 15.

10 "So that's my obit?": Tynan, *The Life of Kenneth Tynan*, 311.

10 "It's to be an erotic evening": Kaplan, *Gore Vidal*, 577.

11 "co-devising and co-directing": Ibid.

11 White recalled meeting: White to author, Jan. 21, 2012.

11 "organization of an orgy": Kaplan, *Gore Vidal*, 577.

11 "four fellows wanking": Tynan, *The Life of Kenneth Tynan*, 351.

11 "non-queers": Ibid., 362.

11 "There's been enough": Lewis Funke, "Tynan Plans a Stage Tribute to Eros," *New York Times*, April 9, 1969, 54.

11 "gentle stimulation": "Waiting for Calcutta," *Newsweek*, June 16, 1969, 107.

12 "something far out": Kaplan, *Gore Vidal*, 577.

12 "I seldom start": Vidal, *Point to Point Navigation*, 142.

12 "Absolutely like Joan of Arc": Russell Halley, "The Complete Works of Gore Vidal," *Atlantic*, March 1975, 19.

12 "It got more interesting": Kaplan, *Gore Vidal*, 577.

13 "yellow legal pads": Vidal, *Point to Point Navigation*, 140.

13 "Myra had been a male": Ibid., 142.

13 "fragile white race": Ibid., 151.

14 "cold, clinical sex": Laura Bergquist, "Gore Vidal," *Look*, July 29, 1979, 74.

14 "le maitre Tyler": John Calendo, "Parker Tyler," *Andy Warhol's Interview*, March 1973, 44.

14 "hot stuff": Vidal, *Palimpsest*, 106.

14 "Anaïs in all the flowing": Ibid., 107.

15 "Oh God, to wake up": Hollis Alpert, "Dialogue on Film," *American Film*, April 1977, 38.

15 "just a big queen": Mitzel and Abbott, *Myra & Gore*, 80.

16 "Bunny Breckinridge was": Kaplan, *Gore Vidal*, 579.

16 "part castle, part dungeon": Fonda, *Jane Fonda*, 176.

16 an owl dropped: Ibid.

16 "Can I have": Bosworth, *Jane Fonda*, 254.

16 female lead in *Bonnie and Clyde*: Andersen, *Citizen Jane*, 136.

17 "Vadim promised": Fonda, *Jane Fonda*, 177.

17 started popping Dexedrine, while her director/husband: Ibid, 180.

17 "Brigitte Bardot type": Freedland, *Jane Fonda*, 99.

17 even if Vadim also wanted: Bosworth, *Jane Fonda*, 254.

17 "I don't think I know": "Gore's Myra," *Time*, Feb. 16, 1968, 69.

17 "very best satirical work": Kaplan, *Gore Vidal*, 584.

18 "right-wing circles": Andrew Solomon, "Gore Vidal Receives a Visitor," *New York Times Magazine*, Oct. 15, 1995, 40.

18 "*New York Times* would not advertise": Vidal, *Palimpsest*, 102.

19 "Gore has slipped": Laura Bergquist, "Gore Vidal," *Look*, July 29, 1969, 74.

19 "You know, Hemingway's problem": Mitzel and Abbott, *Myra & Gore*, 76.

19 took time to have lunch: Hellman to author; Oct. 16, 2011.

20 "I hoped that Ned": Vidal, *Point to Point Navigation*, 151.

20 masturbation session: Kaplan, *Gore Vidal*, 583.

20–21 Vidal sign a release/Heinemann/Anthony Blond: Ibid., 588.

21 "coquettishly"/"sexual problems": "Myra the Messiah," *Time*, Feb. 16, 1968.

21 "Myra favors anything": "*Playboy* Interview: Gore Vidal," *Playboy*, June 1969, 94.

22 "high camp": Sandra Shevey, "Just Beginning," *After Dark*, Feb. 1969, 53.

22 "Most of us worry": Laura Bergquist, "Gore Vidal," *Look*, July 29, 1969, 74.

22 "Everyone below Rosenthal": Larry Gross, "Abe Rosenthal's Reign of Homophobia," *Truthdig*, May 16, 2006.

23 Lenny Bruce/"schmuck": Scherman, *Pop*, 218.

23 Dr. Donald Kaplan/*Tulane Drama Review*: Bram, *Eminent Outlaws*, 81.

23 "Short people can't": *Making the Boys* documentary, 2011.

24 "Why not me?": Crowley to author, Dec. 1, 2010.

24 "Well, life is": Rex Reed, "Breakthough by 'The Boys in the Band'," *New York Times*, May 12, 1968.

24 "I had to sublet": Crowley to author, Dec. 1, 2010.

24 "Too many dykeisms": Andy Humm, " 'Boys in the Band' Hits 40," *Gay City News*, June 26, 2008, 64.

25 "I'm worried about you": Crowley to author, Dec. 1, 2010.

26 "a changed woman": Wendell Rickeets, "Talking Truth," *Bay Area Reporter*, Feb. 8, 1990, 35.

26 "I don't know anyone": Crowley to author, Dec. 1, 2010; also, *Making the Boys* documentary, 2011.

26 "Not a weekend": Richard Kramer, "A Play of Words About a Play," *New York Times*, Oct. 31, 1993, 8.

27 "Anyone who had": Peter Filichia, "Stagestruck," *TheaterWeek*, June 17, 1996, 10.

27 "Edward didn't"/Barr exchange: Crowley to author, Dec. 1, 2010.

28 "I'm only directing": Rondo to author; Dec. 10, 2010.

29 "Don't get involved": *Making the Boys* documentary, 2011.

29 "I read the play": Ibid.

29 "There's nothing in *The Knack*": Alfred Zelcer, "Cliff Gorman—Coitus Interrupted," *After Dark*, Dec. 1971, 22.

30 "You're so Hollywood": Crowley to author, Dec. 1, 2010.

30 Although he studied: Andy Humm, " 'Boys in the Band' Hits 40," *Gay City News*, June 26, 2008, 64.

30 "Make up whatever": Ibid., 82.

30 "Do you think"/"Aristophanes": Mary Talbot, "How One Man's 'Band' Changed Theater," *Daily News*, June 19, 1996, 37.

30–31 "word somehow got out"/"*Our Town*": Crowley to author, Dec. 1, 2010.

31 "I found it highly skillful": *Making the Boys* documentary, 2011.

31 "It was 1968": Crowley to author, Dec. 1, 2010.

31 "Clinton Wilder": Crowley to author, Dec. 1, 2010.

31 "Here it is": Gussow, *Edward Albee*, 164.

31 "I'll take one": Ibid., 165.

32 "So there was": Alfred Zelcer, "Cliff Gorman—Coitus Interrupted," *After Dark*, Dec. 1971, 22.

32 word "shit"/"infinitely more vulgar": Feiffer, *Backing into Forward*, 373, 377.

32 "I'm sure everyone": *Making the Boys* documentary, 2011.

Chapter Two: Spring 1968, Partners

33 "Even in college": Crowley to author, Dec. 1, 2010.

33 "We thought people": Rado to author; June 16, 2010.

33 " 'Sodomy' was not": MacDermot to author; June 15, 2010.

34 "Who's Rado and Ragni": Rado to author, June 16, 2010.

34 director of choice, Gerald Freedman: Rado to author, June 16, 2010.

34 obvious one for Michael Butler: Butler to author; Dec. 4, 2010.

35 "I wanted Jim": Butler to author, Dec. 4, 2010.

35 "We were looking": Wollman, *The Theater Will Rock*, 48.

35 "environmental theater piece": Cohen to author; Aug. 17, 2011.

36 "These two guys": Rado to author, June 16, 2010.

36 "Galt MacDermot didn't fit": Butler to author, Dec. 4, 2010.

36 "I didn't find them"/narc: MacDermot to author, June 15, 2010.

37 "pansexuality"/"omnisexual": Sheela Lambert, "The Man Behind the Hair," *The Advocate*, March 12, 2009.

37 "idea of close friendship": Rado to author, June 16, 2010.

37–38 "very guy situation"/"like any couple": Arenal to author; Dec. 12, 2010.

38 "Tom was very secretive": Cohen to author, Aug. 17, 2011.

38 "They were lovers": Butler to author, Dec. 4, 2010.

38–39 "Why aren't the girls"/choreography credit: Arenal to author, Dec. 12, 2010.

39 "It was crazy backstage"/"spaced out": Arenal to author, Dec. 12, 2010.

39 "You tasted the Vitamin": Grode, *Hair*, 125.

39 "The stagehands hated": Arenal to author, Dec. 12, 2010.

39 body stockings: Davis, *Letting Down My Hair*, 59.

40 "Only a few": MacDermot to author, June 15, 2010.

40 "totally artistic decision": Grode, *Hair*, 70.

40 "[e]veryone was momentarily": Davis, *Letting Down My Hair*, 76.

40 "The shots 'shrivelled'": Ibid.

41 "Many of the girls": Ibid., 234.

41 bogus "raid": Grode, *Hair*, 70.

41 "There was a time": Davis, *Letting Down My Hair*, 118.

41 The League denied/"I have to thank": Butler to author, Dec. 4, 2010.

41 John Schlesinger: Childers to author, June 12, 2010.

42 Groucho Marx/peephole: Crowley to author, Dec. 1, 2010.

42 "I saw straights": *Making the Boys* documentary, 2011.

42 "a funny, frank": "New Plays," *Time*, April 26, 1968, 97.

43 "calls a fag": Wilfred Sheed, "Gay Life Gets a Sharp Going Over," *Life*, May 10, 1968.

43 "party of bitchy fags"/"Probably most homosexuals": Frances Herridge, "'The Boys in the Band' Alters Author's Life," *New York Post*, April 22, 1968.

43 "A couple of years": Clive Barnes, "'Boys in the Band,'" *New York Times*, April 15, 1968, 48.

44 "People like Tynan": Crowley to author, Dec. 1, 2010.

44 Philip Roth declined: Feiffer to author; Dec. 7, 2010.

44 *Playboy*/Drs. William Masters: Maier, *Masters of Sex*, 203.

45 "studs and cartoonists": Feiffer to author, Dec. 7, 2010.

45 When he'd polished the play: Feiffer to author; also, Feiffer, *Backing into Forward*, 398.

46 "The Jewish women": Roth, *Reading Myself and Others*, 34.

47 slide show/"L.B.J.'s testicles": Ibid., 31-32.

48 "The issue seems": Sam Tanenhaus, "John Updike's Archive," *New York Times*, June 20, 2010, C1.

49 "sort of a crusader": Dick Cavett, "John Updike Interview," *Conversations with John Updike*, 230.

49 Wolper Company: "View from the Catacombs," *Time*, April 26, 1968, 66.

49 "kind of a mess": John Updike, "Bech Meets Me," *New York Times Book Review*, Nov. 14, 1971, 3.

49 "My observation about American": Elinor Stout, *Converations with John Updike*, 79.

50 late-blooming sexual awareness: Updike, *Self-Consciousness*, 135.

50 17th Century Day pageants: Charles Thomas Samuels, "The Art of Fiction XLIII: John Updike," *Paris Review*, Winter 1968.

50 "surge of belonging": Updike, *Self-Consciousness*, 51.

50 "Updikes are the ringleaders": "View from the Catacombs," *Time*, April 26, 1968, 76.

51 "about not just couples": James Schiff, *Updike in Cincinnati*, 58.

51 "all the religious ones": Sally Reston, "John Updike Works Three Hours and Poses as a Vacationer," *Vineyard Gazette*, May 3, 1968.

51 "I plotted *Couples*": Charles Thomas Samuels, "The Art of Fiction XLIII: John Updike," *Paris Review*, Winter 1968.

52 "only the marsh geography": Ibid.

52 she felt smothered: "View from the Catacombs," *Time*, April 26, 1968, 76.

52 "It is very tempting": "Musical Beds," *Newsweek*, April 8, 1968, 125.

52 "lot of dry talk": "View from the Catacombs," *Time*, April 26, 1968, 76.

52 "This book deals": Sally Reston, "John Updike Works Three Hours and Poses as a Vacationer," *Vineyard Gazette*, May 3, 1968.

53 Menemsha Beach: Ibid.

53 "I seem to remember": Updike, *Self-Consciousness*, 123.

53 "almost universally anti-war": Ibid. 114.

54 "too reflexive, too Pop": Ibid.

54 "The solution to": Ibid., 115.

54 "lugubrious bojunk": Ibid., 120.

54 "mood of black despair": Robin Brantley, "Knock Knock," *New York Times Magazine*, June 25, 1976, 50.

55 "that *Village Voice* ad": Feiffer, *Backing into Forward*, 361.

55 Martinson/"accomplice": Roth, *The Facts*, 148.

55 "emancipator": Ibid. 149.

56 "bus from Port Authority": Ibid., 156.

Chapter Three: Summer 1968, Politics

57 advanced him $250,000: Ibid., 157.

57 "different from any other book": Sandra Shevey, "I Think It's Just Beginning," *After Dark*, Feb. 1969, 53.

58 "With this book": Mitzel and Abbott, *Myra & Gore*, 63.

57 a near fistfight: Gerald Clarke, "Petronius Americanus," *Atlantic*, March 1972, 49.

58 screen be erected: Bram, *Eminent Outlaws*, 12.

58 "I'm all for the breaking": Paul Jabara, "A Visit with Gore Vidal," *After Dark*, July 1972, 52.

59 "I saw your sign": "More of Gore," *Screw*, Nov. 23, 1970, 8.

59 Andy Warhol spent: Paul Carroll, "What's a Warhol?," *Playboy*, Sept. 1969, 133.

59 "Could I please be": Diaries, unpublished articles by Lance Loud; also Lance Loud to author.

61 Baker agreed but balked: Watson, *Factory Made*, 339.

61 Solanas two thousand dollars /"thief and vulture": Southern, *The Candy Men*, 320.

62 Kenneth's Hair Salon: Bockris, *Warhol*, 297.

62 "Andy, Andy": Mark Shivas, " 'Cowboy' Director Had a Blind Spot," *Los Angeles Times*, April 12, 1970.

62 "John and I": Childers to author, June 12, 2010.

62 "that bunch of perverts": Guy Flatley, "How to Be Very Viva," *New York Times*, Nov, 9, 1969, 17.

63 "Say something to Andy": Mark Shivas, " 'Cowboy' Director Had a Blind Spot," *Los Angeles Times*, April 12, 1970.

63 "There were a few": Morrissey to author; Oct. 13, 2011.

63 "It was amazing": Childers to author, June 12, 2010.

64 "six-day bacchanal": Hellman to author, Oct. 16, 2011.

64 "Darling, they're so": Childers to author, June 12, 2010.

64 "What attracted me": Mann, *Edge of Midnight*, 293.

64 "terribly careful": Frank Spotnitz, "John Schlesinger," *American Film*, Jan. 1991, 36.

64 "It was a book": Kevin Thomas, "John Schlesinger," *Los Angeles Times*, June 29, 1969, 22.

65 "faggot stuff": Peter Biskind, "Midnight Revolution," *Vanity Fair*, March 2005, 314.

65 "The book had": Hellman to author, Oct. 16, 2011.

65 a movie for Elvis Presley: Frank Spotnitz, "John Schlesinger," *American Film*, Jan. 1991, 20.

65 the name Sammy Davis Jr.: Ibid.

65 stronger language, more nudity: Watson, *Factory Made*, 337.

65 "It was the only studio": Picker to author; Aug. 29, 2011.

65 "commercial filmmakers": Rosalyn Regelson, "Where Are 'The Chelsea Girls' Taking Us?," *New York Times*, Sept. 24, 1967, D15.

66 "My partners here": Peter Biskind, "Midnight Revolution," *Vanity Fair*, March 2005, 314.

66 Julie Christie, who showed: Childers to author, June 12, 2010.

66 "It's grim": "Schlesinger Faces Pressure," *Los Angeles Herald-Examiner*, June 22, 1970, A-3.

67 "He was afraid": Hellman to author, Oct. 16, 2011.

67 "We're ready, my queen"/"frivolity": Hoffman to author, Oct. 19, 2012.

68 "All of which changed": Hellman to author, Oct. 16, 2011.

68 "The crew were these": Childers to author, June 12, 2010.

68 "It depressed me": Mann, *Edge of Midnight*, 313.

68 "Neil Simon picture": Childers to author, June 12, 2010.

69 "some nebbish Mike Nichols": Patrick Goldstein, "Midnight Cowboy," *Los Angeles Times*, Feb. 27, 2005.

69 "So I hear": Peter Biskind, "Midnight Revolution," *Vanity Fair*, March 2005, 316.

69 One day, Schlesinger gave: Mann, *Edge of Midnight*, 313-14, 318.

70 "Dustin was prodding": Childers to author, June 12, 2010.

70 "What is my motivation": Buruma, *Conversations with John Schlesinger*, 146.

71 Then there was Brenda Vaccaro: Peter Biskind, "Midnight Revolution," *Vanity Fair*, March 2005, 326.

71 also played offscreen: Childers to author, June 12, 2010.

72 "Well, it's in a movie": Peter Biskind, "Midnight Revolution," *Vanity Fair*, March 2005, 324.

73 "Joe, the cowboy": Childers to author, June 12, 2010.

73 When they'd completed: Mann, *Edge of Midnight*, 291.

73 Elkins met Michael: Childers to author, June 12, 2010.

74 "Why didn't they"/"How dare you": Bockris, *Warhol*, 309.

75 "I vaguely knew": Morrissey to author, Oct. 13, 2011.

75 "When you're young": Watson, *Factory Made*, 342.

76 "There was always": Dallesandro to author, Sept. 30, 2012.

77 "He'd have these plants": Highberger, *Superstar in a Housedress*, 101.

77 "nine-to-fiver": anonymous source to author.

77 "Think of the millions": Dick Lochte, "Conversations with Paul Morrissey," *Los Angeles Free Press*, May 24, 1974.

78 "I was making fun": William Grimes, "A Warhol Director on What Is Sordid," *New York Times*, Dec. 26, 1995, C13.

Chapter Four: Autumn 1968, Revelry

79 "teach Andy"/"Oh no, we can't": Bockris, *The Life and Death of Andy Warhol*, 153.

80 "Do you honestly": Mann, *Edge of Midnight*, 332.

80 "youth adviser": Walker, *Hollywood UK*, 416.

80 "bit more solo": David Del Valle, "Memo from Cammell," *Video Watchdog*, No. 35, 1996, 32.

81 "In Britain, the underworld": Ibid., 31.

81 "I idolized those": John Powers, "Sympathy for the Devil," *L.A. Weekly*, June 3, 1988, 39.

81 "Just a few pages": Lanza, *Fragile Geometry*, 37.

81 "We would rehearse": Salwolke, *Nicolas Roeg*, 2.

81 "This ménage à trois": Special Features, *Performance* DVD.

82 "My first scene": Ibid.

82 "Donald could be quite": Umland, *Donald Cammell*, 104.

82 "Jagger simply took": David Del Valle, "Memo from Cammell," *Video Watchdog*, No. 35, 1996, 32.

82 "But I smelled": Richards and Fox, *Life*, 255.

82 Richards was having sex: Ibid., 256.

82 "twister and a manipulator": Ibid., 253.

83 *"The Importance of Being Earnest"*: Romany Bain, "The Changing Faces of James Fox," *She*, 1972, 21.

83 "He literally became": David Del Valle, "Memo from Cammell," *Video Watchdog*, No. 35, 1996, 33.

84 "each of them"/"Neanderthal gangster": Ibid., 32.

84 "Mick is not acting": Ibid.

84 But he flat out: Lanza, *Fragile Geometry*, 37.

84 "basically harmful": Romany Bain, "The Changing Faces of James Fox," *She*, 1972, 20.

84 arrested on drug charges: Walker, *Hollywood UK*, 413.

85 "very macho, violent": David Del Valle, "Memo from Cammell," *Video Watchdog*, No. 35, 1996, 33.

85 went to South Africa: Walker, *Hollywood UK*, 423.

85 "At the time": Ibid., 424.

85 "We screened everything"/"Bi": Ibid., 417.

86 "Even the bathwater": David Del Valle, "Memo from Cammell," *Video Watchdog*, No. 35, 1996, 31.

86 "This film, for": Walker, *Hollywood UK*, 418.

87 had endured the usual mindless conversations: Mazursky to author; June 21, 2011; also, Mazursky, *Show Me the Magic*, 156; Special Features, *Bob & Carol* DVD.

92 Gerber laughed: Gerber, *Trippin' with Terry Southern*, 109.

92 "It bears precious little resemblance": Southern, *The Candy Men*, 319.

92 "that something ought to be done": Ibid., 320.

92 Buck Henry sent Southern: Gerber, *Trippin' with Terry Southern*, 110.

92 "In spite of": Hill, *A Grand Guy*, 168.

93 "full vag-pen": Southern, *The Candy Men*, 188.

93 "There's something so inappropriate": Ibid.

93 "I'm not aware": Ibid., 267.

94 "Since they are both": Special features, *If . . .* DVD.

94 "if we're naked": McDowell to author, Oct. 4, 2011.

94 "one of the most animalistic": Special features, *If . . .* DVD.

Chapter Five: Winter 1969, Bonanza

95 "It was research": Sappington to author; June 23, 2010.

96 "We just took": White to author, Jan. 21, 2012.

97 "Tynan made a hard": Liberman to author, Dec. 1, 2010.

97 "*Oh! Calcutta!*, he thought": White to author, Jan. 21, 2012.

97 "Ken had a lot": Liberman to author, Dec. 1, 2010.

97 at least four skits: White to author, Jan. 21, 2012.

97 "Tynan was a real": Childers to author, June 12, 2010.

98 "such a dirty show": White to author, Jan. 21, 2012.

98 "It was a theater": Liberman to author, Dec. 1, 2010.

98 "tribute to a great English": Jerry Talmer, "Tynan," *New York Post*, April 9, 1969.

99 "I was afraid": Lewis Funke, "Tynan Plans a Stage Tribute to Eros," *New York Times*, April 9, 1969, 54.

99 "attract the killers": Lewis Funke, "Tynan's Elegant Erotica," *New York Times*, Oct. 20, 1968, 1.

99 "Harold Pinter was tempted": White to author, Jan. 21, 2012.

99 Hilly Elkins and Bill Liberman: Liberman to author, Dec. 1, 2010.

100 "nonorgiastic style": Tynan, *The Life of Kenneth Tynan*, 364.

100 "We're disinfecting": Craig Karpel, "No Penetration in Eden," *Village Voice*, May 15, 1969, 41.

100 "They were, indeed": Liberman to author, Dec. 1, 2010.

100 "actors, and especially English": Kael, "Victim," *For Keeps*, 34.

101 "some middle-aged urban": Bloom, *Leaving a Doll's House*, 128.

101 "I don't mind": "Oh! Calcutta!," *Entertainment World*, Oct. 24, 1969.

101 "We wanted an attractive": *Sex in '69: The Sexual Revolution in America*, History Channel, 2009.

101 "heterosexual fascists!": Barrett, *First Your Money, Then Your Clothes*, 13.

101 "When we take down": *Sex in '69: The Sexual Revolution in America*, History Channel, 2009.

102 "Simultaneously with our": Ibid.

102 thirty helmeted, gas-masked: Tytell, *The Living Theatre*, 257.

102 "What was great": *Sex in '69: The Sexual Revolution in America*, History Channel, 2009.

103 including critic Richard Schechner: Tytell, *The Living Theatre*, 257.

103 "to overcome violence": Malina and Beck, *Paradise Now*, 80.

103 "Jim had decided": *Sex in '69: The Sexual Revolution in America*, History Channel, 2009.

103–104 $2,500 donation: Tytell, *The Living Theatre*, 257.

105 "lewdly and lasciviously": Herman, *Rock 'n' Roll Babylon*, 60.

105 "You're all a bunch": Ibid.

105 "ivory shaft": *Sex in '69: The Sexual Revolution in America*, History Channel, 2009.

105 Jeanne Baretich/"consensual sodomy": "Show Must Go," *New York Post*, March 25, 1969, 24.

105 local clergyman who: Lewis Funke, "City Officials Consulting with 'Oh! Calcutta!' Staff," *New York Times*, May 24, 1969.

106 "rubbing of the genital": John Mullane, "Vow to Keep 'Che' on After Second Arrest," *New York Post*, May 8, 1969, 68.

106 "There have been seventy": Ibid.

106 "If I were afraid: *Sex in '69: The Sexual Revolution in America*, History Channel, 2009.

106–107 A flamboyant showman: Liberman to author, Dec. 1, 2010.

107 "faux-Napoleonic grandeur": Bloom, *Leaving a Doll's House*, 126.

107 "the unmentionable": Ibid., 127.

107 "I was a little": Liberman to author, Dec. 1, 2010.

107 "There's a good chance": Barrett, *First Your Money, Then Your Clothes*, 15.

108 "The worst that could": *Sex in '69: The Sexual Revolution in America*, History Channel, 2009.

108 "I think all"/"guide": Enten to author; Jan. 4, 2011.

108 "no-fuck law": Barrett, *First Your Money, Then Your Clothes*, 17.

109 "How can you touch": Peter Hellman, "Arriving at the Naked Truth," *New York*, June 30,, 1969, 57.

109 "I'd like to": Barrett, *First Your Money, Then Your Clothes*, 25.

109–110 multimedia work/"inhibitions": Childers to author, June 12, 2010.

Chapter Six: Spring 1969, Fetishes

111 censors at the Gray Lady: Craig Karpel, "No Penetration in Eden," *Village Voice*, May 15, 1969, 40.

111 "subject matter of pornography": Intelligent Puritan, "Tynan: And Is That Bad?," *New York Times*, June 15, 1969, 10.

111 "To scotch most": Leo Mishkin, "A Peek at 'Oh! Calcutta!,' " *Morning Telegraph*, May 5, 1969.

112 "Will sexual intercourse": Ibid.

112 "No. We're not": Mishkin, "A Peek at 'Oh! Calcutta!' "

112 "include actual sexual": Henry Raymont, " 'Che!' Tests the Limits," *New York Times*, March 24, 1969.

112 "done it": Tytell, *The Living Theatre*, 259.

112 "I personally would": Jerry Tallmer, "Tynan," *New York Post*, April 9, 1969.

112 "Recommended for mature": Lewis Funke, "City Officials Consulting with 'Oh! Calcutta!' Staff," *New York Times*, May 24, 1969.

112 "unofficially inviting": "Waiting for Calcutta," *Newsweek*, June 16, 1969, 107.

113 "Well, can I": Sappington to author, June 23, 2010.

113 "They offered extremely": "Waiting for Calcutta," *Newsweek*, June 16, 1969, 107.

113 "Tynan threatened": White to author, Jan. 21, 2012.

113 "Tynan's skits": Liberman to author, Dec. 1, 2010.

113 "There is no theatrical": "Waiting for Calcutta," *Newsweek*, June 16, 1969, 107.

113–114 actor Leon Rossom/actress Nancy Tribush exchange: Ibid.

114 "A few times": Sappington to author, June 23, 2010.

114 Nureyev/Dempsey exchange: Barrett, *First Your Money, Then Your Clothes*, 37.

114–115 "full-length play"/"Tynan cast": Feiffer to author, Dec. 7, 2010.

115 world premier: Earl Wilson, "A Night of Nudity," *New York Post*, June 18, 1969.

115 "Opening night was": Sappington to author, June 23, 2010.

115 "People who had": Liberman to author, Dec. 1, 2010.

115 Sardi's party: Wilson, "A Night of Nudity."

116 "Break a member": Feiffer to author, Dec. 7, 2010.

116 "You're a very nice": *Sex in '69: The Sexual Revolution in America*, History Channel, 2009.

116 "They were disastrous": Ibid.

116 "A police official": Earl Wilson, " 'Calcutta' Rolls On," *New York Post*, June 25, 1969.

117 $234,969/"Scalpers were": "$15 Top for 'Calcutta,' " *New York Times*, May 30, 1969.

117 Elkins liked to give: Bloom, *Leaving a Doll's House*, 127.

117 two million copies/"greatest blow": Laura Bergquist, "Gore Vidal," *Look*, July 29, 1969, 73.

117 "We were stunned": " 'Midnight Cowboy' Almost Didn't Make It," *Los Angeles Herald-Examiner*, Aug. 13, 1969. B-6.

117 "There would be seventy-five": Hoffman to author, Oct. 19, 2012.

118 "We felt the X": Mann, *Edge of Midnight*, 332.

118 "I didn't like": Gregory King, "Herlihy's Modified 'Cowboy' Rapture," *Variety*, May 4, 1971.

118 "We filmed two": Mann, *Edge of Midnight*, 314.

119 "I'm afraid I": King, "Herlihy's Modified 'Cowboy' Rapture."

119 "I want to do": Frank Spotnitz, "John Schlesinger," *American Film*, January 1991, 37.

119 "Well, we don't": Ibid.

120 "I met him"/"I told Columbia": Kramer to author; June 23, 2010.

120 "We're paid to": Trevelyan, *What the Censor Saw*, 22.

120 "Trevelyan told us": Kramer, *Women in Love and Other Dramatic Writings*, 64.

121 "It was very emotional": *Making the Boys* documentary, 2011.

121 "This scene is by far": Algate and Robertson, *Censorship in Theatre and Cinema*, 126.

121 "Certainly one lesbian": Judith Crist, "Banned in Boston," *New York*, March 30, 1969, 54.

123 "I wasn't quite out": Special Features, *Women in Love* DVD.

124 "The scene I wrote": Kramer to author, June 23, 2010.

124 Reed made an impromptu visit: Russell, *Altered States*, 67.

125 "You're going to be seen": Special Features, *Women in Love* DVD.

125 "one of the most exposed": Spoto, *Otherwise Engaged*, 106.

125 "full-frontal nudity": Kramer to author, June 23, 2010.

126 The night before: Russell, *Altered States*, 72.

126 "Alan had very little": Kramer to author, June 23, 2010.

126 "Tumultuous applause": Russell, *Altered States*, 72.

126 losing twenty pounds: Special Features, *Women in Love* DVD.

126 "It was a difficult scene": Kramer to author, June 23, 2010.

126 "The task was quite": Spoto, *Otherwise Engaged*, 106.

127 "The scenes in which": Baxter, *Glenda Jackson*, 64.

127 "But I wouldn't budge": Goodwin, *Evil Spirits*, 123.

128 "Poor Ollie": Baxter, *Glenda Jackson*, 63.

128 *Suddenly, Last Summer*: Kramer to author, June 23, 2010.

128 "Trevelyan was a real": Kramer to author, June 23, 2010.

128–129 appropriately sterile/deciding vote: Philip Oakes, "Mister Bluenose," *Sunday Times Magazine*, July 3, 1966.

129 "How can you exercise": Special Features, *Women in Love* DVD.

129 "In the end": Kramer to author, June 23, 2010.

129 "This film included": Trevelyan, *What the Censor Saw*, 117.

129 "Trevelyan had that": Baker, *Director's Cut*, 93.

130 "I remember that after *Blow-Up*": Trevelyan, *What the Censor Saw*, 115.

130 "Because it was the first": Kramer to author, June 23, 2010.

130 "It was known as": Special Features, *Women in Love* DVD.

Chapter Seven: Summer 1969, Revolution

132 "This unpleasantness": Crowley to author, Dec. 1, 2010.

132 "You're the producer!": *Making the Boys* documentary, 2011.

132 "We will replace": Ibid.

132 $1.6 million: Bruce Bahrenburg, " 'Boys in the Band' Becomes Movie," *Newark Evening News*, Aug. 24, 1969.

132 "Crowley knew": *Making the Boys* documentary, 2011.

133 "No fags smoke": Andy Humm, " 'Boys in the Band' Hits 40," *Gay City News*, June 26, 2008, 46.

133 "There was a lot of crap": Alfred Zelcer, "Cliff Gorman—Coitus Interrupted," *After Dark*, December 1971, 18.

133 "monkey house": Thomas Quinn Curtis, "Parisians Hail Premiere of 'The Boys in the Band,' " *New York Times*, Sept. 20, 1969.

133 And down under: Raymond Stanley, "Actors in Aussie 'Boys' Convicted on Vice Squad Obscenity Charge," *Variety*, Aug. 6, 1969. 2.

134 Boris Karloff's co-op: *New York Post*, Sept. 3, 1968, 43.

134 "It's a gigantic": Arthur Bell, "Bell Tells," *Village Voice*, undated clip.

134 "As a straight man": Friedkin, *The Friedkin Connection*, 137.

134 "had gotten bored": *Making the Boys* documentary, 2011.

134 "consciously fag": Bahrenburg, " 'Boys in the Band' Becomes Movie."

135 "Is the country": Katie Kelly, "The 'Boys' Are Having a Bit of a Party Again," *New York Times*, July 13, 1969.

135 "Who can predict": Ibid.

136 "bane of my existence": *Making the Boys* documentary, 2011.

137 "emotional strain": "Los Angeles Judges Act on 'Calcutta,' " *New York Times*, Dec. 19. 69.

137 "genital contact": "Cops Nab Frisco 'Calcutta' Actors," *Variety*, Nov. 5, 1969, 63.

137 management did suspend: Butler to author, Dec. 4, 2010.

138 Warhol's effort to combine: Colacello, *Holy Terror*, 5.

138 "They don't even dare": Taylor Mead, "Lions Love," *Inter/VIEW*, vol. 1, 1969, 16.

139 "Jerry got totally"/"You've got to"/Ellen Stewart: Butler to author, Dec. 4, 2010.

Chapter Eight: Autumn 1969, Trauma

141 "The directors of": Mazursky to author, June 21, 2011.

141 "I've always thought": Bernard Weinraub, "Hollywood Reigns as Film Fete Opens," *New York Times*, Sept. 17, 1969, 50.

142 "This'll give": Mazursky, *Show Me the Magic*, 159.

142 "When you first start": Weinraub, "Hollywood Reigns as Film Fete Opens."

142 "I feel nervous": Ibid.

142 "Mayor John Lindsay": Mazursky to author, June 21, 2011.

143 the phone rang: Mazursky to author, June 21, 2011.

143 "It's nice to be here": Guy Flatley, "How to Be Very Viva," *New York Times*, Nov. 9, 1969, 18.

143 doubled over with laughter: Colacello, *Holy Terror*, 5.

144 Katharine Hepburn: Flatley, "How to Be Very Viva."

144 Warhol courted: Bockris, *The Life and Death of Andy Warhol*, 156.

144 They also arrested: Vincent Canby, "Warhol's Red Hot and 'Blue' Movie," *New York Times*, Aug. 10, 1969, 2.

145 "cheap date": Bockris, *The Life and Death of Andy Warhol*, 154.

145 Golightly/Woodlawn Cemetery: Woodlawn, *The Holly Woodlawn Story*, 3.

145 Holly Woodlawn in *Gay*: Watson, *Factory Made*, 339.

145 "Intrigued by my boldness": Woodlawn, *The Holly Woodlawn Story*, 5.

145 "Hi, Holly": Ibid, 132.

146 "If you were wearing": *Candy Darling* documentary, 2009.

146 "Morrissey was very": Dallesandro to author, Sept. 29, 2012.

146 "Three days of love": Ferguson, *Little Joe, Superstar*, 89.

146 "Stop the Method": Ibid., 97.

147 "so humiliated"/Sylvia Miles: Woodlawn, *The Holly Woodlawn Story*, 144.

147 "forty commercials": Steven Daly, "Swinging into the Seventies," *Vanity Fair*, April 2001, 422.

148 "I am convinced": Brown, *Let Me Entertain You*, 129.

148 "Oh, just leave": Daly, "Swinging into the Seventies."

148 "well-thumbed page": Ibid.

148 "lacked that touch: Ibid., 420.

148 "Perhaps because of": Mark Goodman, "Myra/Raquel," *Time*, Nov. 28, 1969, 86.

149 Nero's mother: "Fellini's Faces," *After Dark*, March 1969, 14.

149 "I never could"/"too choice": Chandler, *She Always Knew How*, 243.

149 stars ranging from: Sandra Shevey, "I Think It's Just Beginning," *After Dark*, Feb. 1969, 53.

149 "I was anointed": *Sex at 24 Frames Per Second* documentary, 2003.

150 "marvelously artificial": Daly, "Swinging into the Seventies," 422.

150 "old hack": Rex Reed, "Myra Goes Hollywood," *Playboy*, August 1970, 80.

150 "I was supposed: Ibid.

151 "epicene Rex Reed": Mark Goodman, "Myra/Raquel," *Time*, Nov. 28, 1969, 88.

151 David Brown broke out: Steven Daly; "Swinging into the Seventies," *Vanity Fair*, 425; also, Brown, *Let Me Entertain You*, 129.

151 "boys' night out": Daly, "Swinging into the Seventies," 426.

151 "She's a sweet": Ibid., 424.

152 "Old Raccoon": Reed, "Myra Goes Hollywood," 80.

152 "She looks like": "Mae and Myra," *VLife*, Nov. 2003, 47.

152 "Darling, don't you": Daly, "Swinging in the Seventies," 424.

152 "wild frenzy dance": Calvin Trillin, "Through the Muck with Myra," *Life*, March 6, 1970, 52.

152 One day, Head asked: Daly, "Swinging into the Seventies," 425.

152 "Oh, this must be": Reed, "Myra Goes Hollywood," 155.

152 "The set was closed": Ibid., 80.

153 "Do you masturbate": Ibid., 155.

153 "We just disagree"/Tom O'Horgan: Joe Broady, "Sarne Stays as 'Myra' Director," *Variety*, Oct. 1, 1969, 7.

153 "today picture"/"Bullshit": Reed, "Myra Goes Hollywood," 155.

153–154 *I Am Curious* account/quotes: Associated Press; also, "Jackie Puts Judo Hold on Newsman," *Temple of Schlock*, Feb. 1, 2009.

155 "Everyone has quit": Joyce Haber, "Shell Shock on the 'Myra' Set," *Los Angeles Times*, Oct. 19, 1969.

155 scent of burning marijuana: Daly, "Swinging into the Seventies," 425.

155 "teenage soap opera": Bob Thomas, "Dolls Sequel for Meyer," *Los Angeles Herald-Examiner*, Sept. 29, 1969.

155 "The previous film": Ibid.

155 "I've considered full": Ebert, *Life Itself*, 22.

156 "20th is letting": Nat Freedland, "Russ Meyer Beyond Nudies," *Entertainment World*, Jan. 30, 1970, 11.

156 "The rushes look": Ibid., 13.

156–159 Altamont/Loud/Hoffman: Hoffman to author; Nov. 21, 2011.

158 Mick Jagger, surrounded: *Gimme Shelter* documentary, 1970.

159 "I have bad news": Bogarde, *Snakes & Ladders*, 297.

160 "demonic, insane": Helmut Berger profile, Internet Movie Database.

160 "Visconti wondered": Bogarde, *Snakes & Ladders*, 298.

161 "We were the hit": Ibid., 305.

Chapter Nine: Winter 1970, Outrage

163 "Doors started opening": Walker, *Hollywood UK*, 419.

164 "Most of the audience": R. Joseph Libin, "Don Cammell," *Interview*, July 1972, 20.

164 censors excised: Walker, *Hollywood UK*, 422.

164 "brilliantly shot": Trevelyan, *What the Censor Saw*, 163.

165 in his coat pocket: Walker, *Hollywood UK*, 411.

165 "I discovered that": Libin, "Don Cammell," 10.

166 Paramount Pictures unveiled: Evans, *The Kid Stays in the Picture*, 171.

166–167 Sarne's idea/young Shirley Temple: Daly, "Swinging into the Seventies," 426; also, Brown, *Let Me Entertain You*, 129.

168 *Midnight Cowboy* R-rating: Phillips, *John Schlesinger*, 129.

168 "No way": Childers to author, June 12, 2010.

168 "I am somewhat": Ronnie Cowan, "Helmut Berger Outspoken Thespian," *Citizen News*, July 27, 1970, 19.

Chapter Ten: Spring 1970, Kisses

171 "I had a very intense": Buruma, *Conversations with John Schlesinger*, 68.

172 "I don't suppose": Buruma, *Conversations with John Schlesinger*, 117.

173 Keller/Schlesinger/Bannen exchange: Daimon Lawrence, "Hiram Keller," *Andy Warhol's Interview*, Vol. IV, No. 10, 1974, 31.

173 "Ian wasn't free": Childers to author, June 12, 2010.

174 phoned her client/"I'm not a queer": Faulkner, *Peter Finch*, 250.

174 "Dear John": Childers to author, June 12, 2010.

174 "That's exactly": Dundy, *Finch, Bloody Finch*, 211.

174 "we became like": Phillips, *John Schlesinger*, 309.

175 "I didn't think": Guy Flatley, "I Suppose Some People Will Be Shocked," *New York Times*, Oct. 3, 1971, 12.

175 "The kiss!": Dundy, *Finch, Bloody Finch*, 310.

176 "John, is this really": Ibid.

177 "I did it for England": Flatley, "I Suppose Some People Will Be Shocked," 12.

177 "You're the hot": Childers to author, June 12, 2010.

177 "To ask them": Flatley, "I Suppose Some People Will Be Shocked," 12.

177 "We screamed": Childers to author, June 12, 2010.

178 "Oh, it's a wonderful": Buruma, *Conversations with John Schlesinger*, 118.

178 "We'd filled the little theater": Ibid., 116.

Chapter Eleven: Summer 1970, Retreat

181 "two men grabbed": Steven Daly, "Swinging into the Seventies," *Vanity Fair*, April 2001, 426.

182 Crowley introduced himself: Crowley to author, Dec. 1, 2010.

182 "The gay boys?": Joseph Modzelewski, "1st Lady of Sex Speaks Out," *Daily News*, June 25, 1970, 4.

183 Brown recalled the scene: Daly, "Swinging into the Seventies," 427; also, Brown, *Let Me Entertain You*, 129.

184 "Nobody can understand": Baxter, *Stanley Kubrick*, 242.

184 "There's no point: Ibid.

184 "definitive blowjob": Gerber, *Trippin' with Terry Southern*, 136.

184 "pornography without"/refused all ads: Southern, *The Candy Men*, 329.

184 "the great Stanley K": Gerber, *Trippin' with Terry Southern*, 136.

184 "The book itself": Southern, *The Candy Men*, 329.

185 "A janitor": *Baadasssss!* DVD, special features.

185 "Of all the ways": "Power to the Peeples," *Time*, Aug. 16, 1971, 47.

185–186 "Some of the actresses"/"clap": *Baadasssss!* DVD, special features.

186 "Dad, is this": Van Peebles to author, Aug. 20, 2012.

186 "I did not altogether": Baxter, *Stanley Kubrick*, 247.

187 "It was the most painful": LoBrutto, *Stanley Kubrick*, 336.

187 Burgess had been here before: Ibid. 337.

188 "It's as though": *Hell on Earth* documentary, 2002.

188 "That's not the way": Lanza, *Phallic Frenzy*, 109.

189 "Look, I've got some bad": Baxter, *An Appalling Talent*, 193.

189 "Because we gave creative": Picker to author, Aug. 29, 2011.

189 "I landed on my ass": Baxter, *An Appalling Talent*, 193.

189 "Mr. Kubrick has": Gerber, *Trippin' with Terry Southern*, 55.

189 "I feared, justly": Burgess, *You've Had Your Time*, 217.

190 "Nothing was a difficult": Nichols to author; June 13, 2011.

190 "From the moment": Bergen, *Knock Wood*, 222.

191 Nichols had her do the scene: Crane and Fryer, *Jack Nicholson*, 80, 84; also, Ann-Margret, *Ann-Margret*, 205.

191 to help Nicholson: McGilligan, *Jack's Life*, 220, 224.

192 "It was this wild": Parker, *Warren Beatty*, 399.

192 "Now, that's what": McGilligan, *Jack's Life*, 223.

192 "the pro": McDouglas, *Five Easy Decades*, 128.

193 "I was one of the first": "*Playboy* Interview: Jack Nicholson," *Playboy*, April 1972, 72.

193 "I appeared puffier": Ann Margret, *Ann-Margret*, 209.

193 "depressive stupor": Ibid., 210.

194 Nichols on nude scenes: *Carnal Knowledge* symposium, Walter Reade Theater, NYC, June 12, 2011.

194 Nichols never stopped working: Feiffer, *Backing into Forward*, 402.

194 He recalled a conversation: Feiffer to author, Dec. 7, 2010.

Chapter Twelve: Autumn 1970, Arrests

197 "vice that won't": "*Playboy* Interview: Gore Vidal," *Playboy*, June 1969, 94.

197 "I felt like Elizabeth": Guy Flatley, "He Enjoys Being a Girl," *New York Times*, Nov. 15, 1970, 15.

198 apartment of Mme. Chardonet: Woodlawn, *The Holly Woodlawn Story*, 11.

198–199 "lift your dress"/"Finally, the police": Flatley, "He Enjoys Being a Girl," 2.

199 "Holly only worked": Woodlawn, *The Holly Woodlawn Story*, 17.

201 Lance approached her: Stein, *Edie*, 413–14; also Lance Loud to author.

202 "If anyone had said": Feiffer to author, Dec. 7, 2010.

202 "it is about Mahler": Bogarde, *Snakes & Ladders*, 298.

202 "All the details": Mann, *Unwritten Memories*, 152.

203 the executives at Warners: Bogarde, *Snakes & Ladders*, 305.

204 Warsaw, Oslo, Helsinki: Bogarde, *An Orderly Man*, 75.

204 "girlfriend"/Berenson: Ronnie Cowan, "Helmut Berger Outspoken Thespian," *Citizen News*, July 27, 1970, 19.

204 "You don't think": Amy Collins, "The Lure of Visconti," *Vanity Fair*, December 2001, 308.

205 "healthy appetite": Bogarde, *An Orderly Man*, 76.

205 "Hell, man, now": Ibid., 79.

205 "Of course it's important," Lanza, *Phallic Frenzy*, 109.

205–208 Redgrave, Paris, Claire, Sutton, Fyles, Gilbert, Vernon, Baird quotes: *Hell on Earth* documentary, 2002.

208 "comfortable thing to do": *Hell on Earth* (documentary), 2002.

208 "These lessons often": Russell, *Altered States*, 105.

209 "shitty": "*Playboy* Interview: Sam Peckinpah," *Playboy*, August 1972, 79.

209 "nice Jewish girl": Simmons, *Peckinpah*, 124.

209 He even wrote: Fine, *Bloody Sam*, 193-94.

209 "religious reasons": Simmons, *Peckinpah*, 129.

210 "What appealed to me": Ibid., 125.

210 "Lolita-ish girl": Ibid., 126.

210 "I do think of Sam": Dan Yergin, "Peckinpah's Progress," *New York Times Magazine*, Oct. 31, 1971, 16.

211 "He was plastered": Hoffman to author, Oct. 19, 2012.

211 "I'm like a good whore": Ibid.

211 "Several weeks ago": The American Presidency Project online.

Chapter Thirteen: 1971, Fatigue

213 "I shot that stag": Dan Yergin, "Peckinpah's Progress," *New York Times Magazine*, Oct. 31, 1971, 16.

213 "Like a princess": Fine, *Bloody Sam*, 200–1.

214 Word of their talk: Ibid., 201–2.

215 "There were only two": Van Peebles to author, Aug. 20, 2012.

215 "the [black] community comes": *Baadasssss!* DVD, special features.

215 "When we arrived": *How to Eat Your Watermelon in White Company* documentary, 2004.

215 "Not only is he baptized": Newton, *To Die for the People*, 118.

216 "Sweetback grew into": Ibid., 122.

216 "Van Peebles pictures": "Black Workshop Charges Racial Sabotage in 'Sweet'," *Los Angeles Times*, Nov. 21, 1971, 22.

216 "Hell, my father": *Baadasssss!* DVD, special features.

217 "I stood a steroetype": *How to Eat Your Watermelon in White Company* documentary, 2004.

217 "cultural genocide": ACLU press release, March 22, 1971.

217 "They don't have": "Civil Liberties Union," *Hollywood Reporter*, March 24, 1971.

217–218 John Erlichman and Bob Haldeman were sitting: Nixon tapes, May 3, 1971; YouTube.

218 "It's gonna go": "*Playboy* Interview: Norman Lear," *Playboy*, March 1973, 62.

218 "We're going to be getting": "*Playboy* Interview: Carroll O'Connor," *Playboy*, Jan. 1973, 74.

218 "fifty stations": "Family Fun," *Newsweek*, March 15, 1971, 68.

219 contract guarantee him: "*Playboy* Interview: Carroll O'Connor," 70.

219–220 Visconti/Warners: Bogarde, *An Orderly Man*, 73.

220 "great scandal": Ibid., 74.

220 "Queen of England": Ibid., 80.

221 "ticket prices": Adair, *The Real Tadzio*, 25.

221 "would have been detrimental": Ibid., 27.

222–223 Xaviera Hollander account: Hollander to author; May 30, 2012; also, Hollander, *The Happy Hooker*, 12, 159, 162, 114, 117, 195, 284, 11.

223 "I'd never negotiated": *The Happy Hooker: Portrait of a Sexual Revolutionary* documentary, 2010.

224 "she was blatant"/"Bob Abel wanted"/"It brought sex": Dunleavy to author, May 31, 2012.

225–226 Oscar campaign to get: Woodlawn to author; May 2, 2011.

225 "If you watch": Ferguson, *Little Joe, Superstar*, 98.

226 He even got Ben Gazzarra: Woodlawn, *The Holly Woodlawn Story*, 159.

226 "I've made my statement": Fine, *Bloody Sam*, 206.

226 "very different animal": Ibid., 207.

226 R, rather than: Simmons, *Peckinpah*, 137.

226 "this venerable member": Fine, *Bloody Sam*, 207.

227 "dubious in its intention": Simmons, *Peckinpah*, 137.

227 "immediately doubled the queues": Trevelyan, *What the Censor Saw*, 217.

227 "I hoped people": Fine, *Bloody Sam*, 208.

228 "Shall I discuss this": Ibid., 210.

228 "There are two kinds": "*Playboy* Interview: Sam Peckinpah," 73.

228 "They were animals": Gibson and McDonnell, *Unfiltered*, 82.

228 "Sometimes I'd have to": Jon Stewart, "Fritz the Cat: America's First X-rated Cartoon," *Ramparts*, March 1972, 46.

229 Malcolm McDowell inquired if: McDowell to author; Oct. 4, 2011.

230 assistant director quit: McDowell to author, Oct. 4, 2011.

230 "Lolita could not": Burgess, *You've Had Your Time*, 244.

230 "Napoleon Symphony": Baxter, *Stanley Kubrick* 258.

231 I thought I was Stravinsky": McDougal, *Five Easy Decades*, 137.

231 forty-five cuts/R rating: "*Playboy* Interview: Jack Nicholson," *Playboy*, April 1972, 84.

231 "The orgasm is audible": Ibid.

231 "unattractive": Ibid.

232 Frankenheimer/Wyler reviews: Feiffer, *Backing into Forward*, 403.

232 "It was assaulted": Ibid.

233 "But what do we learn": Rosalyn Dexter, "Do Men Really Hate Women?," *New York Times*, July 2, 1971, 1.

233 "I've balled all": Thompson, *Jack Nicholson*, 108.

233 "chicks dig it": "*Playboy* Interview: Jack Nicholson," 76.

234 "Men don't like": Feiffer to author, Dec. 7, 2010.

234 "going with Gloria Steinem": Nichols to author, June 13, 2011.

234 "very tough faggots": Mailer, *Prisoner of Sex*, 27.

234 "ego-tripping": Manso, *Mailer*, 523.

235 sometime after: Ibid., 522.

235–236 That spring, Sir John Trevelyan: Mark Kermode, "The Devil Himself," *Video Watchdog*, No. 35, 1996, 54.

236 "There's nothing too subtle": *Hell on Earth* documentary, 2002.

236 "masturbation fantasies": Ibid.

237 "excesses never seen": Phillips, *Ken Russell*, 106.

237 "When one reads": Ibid.

237–238 More problematic than: Kermode, "The Devil Himself," 55–56.

238 "Ashley cut": Russell, *Altered States*, 198.

238 *Sunday Bloody Sunday* made it to premiere night: Childers to author, June 12, 2010.

238 "I make no personal": Guy Flatley, "I Suppose Some People Will Be Shocked," *New York Times*, Oct. 3, 1971, 13.

239 "Americans are taught": Paul Jabara, "A Visit with Gore Vidal," *After Dark*, July 1972, 52.

239 "Lance had this sense": Hoffman to author.

240 would be "fun": Pat Loud to author, June 10, 2010.

241 "the first ones": Loud, *Pat Loud*, 90–91.

241 "This documentary will": Pat Loud to author, June 10, 2010.

241 "no one ever looked": Ruoff, *An American Family*, xv.

241 "That was flattering": Loud, *Pat Loud*, 94.

241 "They were to live": *An American Family Revisited* documentary, 1983.

242 "a nice, quaint": Loud, *Pat Loud*, 96.

242 Alan Raymond, the cinematographer, was receiving: Ruoff, *An American Family*, 24.

242 "I was like a deer": Pat Loud to author, June 10, 2010.

242 "I love it": *An American Family Revisited* documentary, 1983.

243 De Niro, Al Pacino: *Candy Darling* documentary, 2009.

243 Loud Before Pat: Loud, *Pat Loud*, 98.

244 "thickening of the atmosphere": Ibid., 121.

244 "Almost a million": Ibid., 129.

245 "I was so influenced": *An American Family Revisited* documentary, 1983.

245 Raymonds/"terribly avant-garde": Ibid.

246 Edie Sedgwick materialized: Stein, *Edie*, 413–14.

Chapter Fourteen: 1972, Frenzy

249 Burgess consented to join: McDowell to author, Oct. 4, 2011.

249 "Kubrick went on": Burgess, *You've Had Your Time*, 257.

250 "embarrassment": *Crumb* documentary, 1994.

250 "I was not quite": LoBrutto, *Stanley Kubrick*, 360.

250 "the blacks": Burgess, *You've Had Your Time*, 253.

251 "Neither cinema": Ibid., 257.

251 *Detroit News*: LoBrutto, *Stanley Kubrick*, 362–63.

252 Reynolds/*Cosmopolitan* account: Reynolds, *My Life*, 174, 175.

253 "You ought to pose": Hurwood, *Burt Reynolds*, 51.

254 "such a cold day": Brando, *Brando*, 425.

254 "Brando had the personality": Higham, *Brando*, 274.

254 "In Bacon": Bosworth, *Marlon Brando*, 183.

254 "Let's talk about": Carey, *Marlon Brando*, 222.

255 "He wanted me to play": Brando, *Brando*, 424.

255 "No one was willing": Higham, *Brando*, 274.

255 "Films like *Midnight Cowboy*": Picker to author, Aug. 29, 2011.

255 "The sexual scenes": Manso, *Brando*, 737.

255 "Bernardo wanted me": Brando, *Brando*, 425.

256 "like seeing the same one": Carey, *Marlon Brando*, 224.

256 "We have to wait": Manso, *Brando*, 742.

256 Marchak/"I can't": Manso, *Brando*, 742.

256 "for structural reasons": Carey, *Marlon Brando*, 226.

256 "oedipal relationship": Manso, *Brando*, 743.

256 "It was just his complex": Judy Klemesrud, "Maria Says Her 'Tango' Is Not," *New York Times*, Feb. 4, 1973.

257 "You are the embodiment": Manso, *Brando*, 743.

257 "I'm much more free": Carey, *Marlon Brando*, 226.

257 Brando conceived it: Bosworth, *Marlon Brando*, 187.

257 "Maria and I simulated": Carey, *Marlon Brando*, 425.

257 "And I was so angry": Dennis McLellan, "Maria Schneider, 1952–2011," *Los Angeles Times*, Feb. 04, 2011.

258 "do something outlandish": Manso, *Brando*, 759.

258 "I felt I had violated": Ibid., 736.

258 Boreman/burgundy Jaguar XKE: Lovelace, *Ordeal*, 10.

259 "There was no love": Ibid, 64.

259 "sword-swallowing": Ibid., 117.

259–260 Damiano/Traynor/Lovelace encounter: *Inside Deep Throat* documentary, 2005.

260 "I knew some starlets": Lovelace, *Ordeal*, 120.

260 "Six before": Ibid., 136.

260 Adolf Hilter: *Inside Deep Throat* documentary, 2005.

261 "Chuck was an": Simon Garfield, "Deep Throat: The Aftermath," *Independent on Sunday*, June 28, 1992.

261 "Linda needed someone": *Inside Deep Throat* documentary, 2005.

261 "People didn't realize": Ibid.

262 "Suppose your balls": Ibid.

262 Bob Sumner, thought: Ralph Blumenthal, "Porno Chic," *New York Times Magazine*, Jan. 21, 1973, 31.

262 "I'm really offended": "Rabbit, Run," *New York*, Nov. 27, 1972, 46.

262 "Mike Nichols told me": Blumenthal, "Porno Chic," 30.

263 "Once it broke": Ibid.

263 "You lost your cherry"/Shawn: Kellow, *Pauline Kael*, 193.

263 Willis/Ephron/Dershowitz: *Inside Deep Throat* documentary, 2005.

263 "Look, you want me": Blumenthal, "Porno Chic," 31.

263 "My father": Rex Weiner, "Sore from Throat," *Variety*, Aug. 18, 1997.

264 "The government became": *Inside Deep Throat* documentary, 2005.

264 "If it was pornography": Pete Hamill, "Hix Nix Skin Flix," *New York*, Sept. 4, 1972, 66.

265 Candy and Holly: *Candy Darling* documentary, 2009.

266 "I was naked"/ "Lou Reed": Dallesandro to author, Sept. 29, 2012.

266 "He did more": William Grimes, "A Warhol Director on What Is Sordid," *New York Times*, Dec. 26, 1995, C13.

266 "I did those films": Morrissey to author, Oct. 13, 2011.

266 "Paul thought those films": Dallesandro to author, Sept. 29, 2012.

267 "Adding to the": Andrew Sarris, "Confessions of a Porn Enthusiast," *New York Observer,* April 3, 2005.

267 "I could hear her": Ibid.

268 "She single-handedly": Ibid.

268 "The text of the court": Mel Gussow, "Director Claims 'Last Tango' is 'Film on the Present,'" *Los Angeles Herald-Examiner*, Feb. 3, 1973.

269 "cracked, like china": Loud, *Pat Loud*, 134.

269 show would help launch: Pat Loud to author, June 10, 2010.

269 "You won't believe: Ibid.

270 "I knew that everybody"/"This is educational": Loud, *Pat Loud*, 148.

Chapter Fifteen: 1973, Backlash

271 "The sexual preference": Clarence Petersen, "We Were Very Naive about a Lot," *Chicago Tribune*, March 22, 1973, 6.

272 "the flamboyant, leechlike": Anne Roiphe, "Things Are Keen but Could Be Keener," *New York Times Magazine*, Feb. 18, 1973.

272 "The silence of the Louds": Shana Alexander, "The Silence of the Louds," *Newsweek*, Jan. 22, 1973, 28.

274 "Pat was screaming": *An American Family Revisited* documentary, 1983.

274 "We don't say": Ruoff, *An American Family*, 101.

274 talk show's ratings: "The Divorce of the Year," *Newsweek*, March 12, 1973, 49.

274 "I can confirm": Thomas, *Brando*, 262.

274 $100,000 advance/"I look like a criminal": Mel Gussow, "Director Claims 'Last Tango' is 'Film on the Present,'" *Los Angeles Herald-Examiner*, Feb. 3, 1973.

275 Buckley/Reasoner: "'Tango': The Hottest Movie," *Newsweek*, Feb. 12, 1973.

275 "Brando's cock up": Bosworth, *Marlon Brando*, 190.

275 "Can a man": Thomas, *Brando*, 250.

275 "Women are the only": Jonathan Cott, "A Conversation with Bernardo Bertolucci," *Rolling Stone*, June 21, 1973.

275 "Perfect macho soap": Manso, *Brando*, 762.

275 "I consider myself": Guy Flatley, "Bertolucci Is All Tangoed Out," *New York Times*, Feb. 11, 1973, 15.

275 "I'm more than bored": Ibid.

276 "I'm bisexual completely": Judy Klemesrud, "Maria Says Her 'Tango' Is Not," *New York Times*, Feb. 4, 1973.

276 "He was so wonderful": Manso, *Brando*, 736.

276 "got worried about taboos": Klemesrud, "Maria Says Her 'Tango' Is Not."

277 Deep Throat trial: *Inside Deep Throat* documentary, 2005.

278 Mailer party/Sarris quotes: Andrew Sarris, "Confessions of a Porn Enthusiast," *New York Observer*, April 3, 2005.

Epilogue: 1973 and Beyond, Finales

281 Bibles/"I got a lot": Frank Rich, "The Gay Decade," *Esquire*, November 1987.

281 "homo of the year": "The Divorce of the Year," *Newsweek*, March 12, 1973, 49.

283 "one entire chapter": Friday, "Introduction," *My Secret Garden*, xiv.

284 "New American Library saw": "*Playboy* Interview: Erica Jong," *Playboy*, September 1975, 64.

284 "When it was released": Castle, *The Stanley Kubrick Archives*, 173.

285 "I found myself": Nichols to author, June 13, 2011.

285 "porn to end all": Southern, *The Candy Men*, 329.

287 "The straight world": *Making the Boys* documentary, 2009.

288 "the first four minutes": "Child Porno Law Removes '70 'Sweetback,'" *Variety*, Sept. 24, 1980.

285 "A man bearded": Blake Morrison, "Introduction," *A Clockwork Orange*, xix.

289 "Michelle and my daughters": Author observation.
290 "But it's obviously tacked": "Michelle Obama Talks," iVillage, Aug. 21, 2012.
290 "see her pussy": Bart, *Infamous Players*, 94.
291 " 'Brave' is 'naked' ": Helen Jackson, "Brave Are the Naked," *Daily Variety*, Oct. 20, 2012, 11.

Index

Note: Titles of works without attribution refer to both literary works and their film and stage adaptations.